D1422669

Peter Weibel and Andreas F. Beitin (eds.)

Trilogy

Elmgreen & Dragset

Thames & Hudson

ZKM | Center for Art and Media Karlsruhe, Germany

T he three separate exhibitions featured in this catalog – *The Welfare Show*, *The Collectors*, and *Celebrity – The One & The Many* – form a trilogy. Though each exhibition was independently conceived and presented separately, when taken together, they not only form a *tour de force* of the fundamental themes behind much of Elmgreen & Dragset's work, but also represent an attempt to map out in a unique manner some of the key changes in Western culture over the initial ten years of the twenty-first century. Together, the exhibitions encapsulate certain Western cultural values and ideals of this period, exploring recent ideological shifts and their ramifications for individuals and society. Factors influencing the way in which identities are shaped today, in contrast to the past, are linked to the obvious developments in digital media and to the loss of a so-called "community or class-affiliation," as well as to the decline of the welfare state and the phenomenon of an increasingly dominant celebrity culture. The exhibitions are also narrative commentaries on the new and sometimes frightening demands currently being placed on individuals to market themselves as extraordinary and outstanding, in contrast to former eras of social history which upheld fundamental civic obligations, namely, contributing to society as responsible citizens. Categories, such as class, sexual or political orientation, gender or nationality, do not form part of our common understanding as they might have done just a decade ago. The hybrid and exceptional constitution of identity and, by extension, our behavioral patterns, have recently become far more complex and confused. And so have the terms of art. Elmgreen & Dragset's triptych of thematic shows is not a sociological fact sheet of such tendencies, but an uncanny depiction of the current cultural climate as seen from a personalized perspective.

In each of the three exhibitions, the spatial frame of the venue has been dramatically altered: the Bergen Kunsthall in Norway, the BAWAG Foundation in Vienna, the Serpentine Gallery in London, The Power Plant in Toronto (all *The Welfare Show*), the Danish and Nordic Pavilions in Venice (*The Collectors*), and the ZKM | Museum

of Contemporary Art in Karlsruhe (*Celebrity – The One & The Many*), have all been transformed into quotidian spaces, each depicting various cross sections of society. In the installations, viewers experienced subtle voyeuristic twists and turns: a glance into the misfortune or apparent fortune of others, an inside look at high-end design or art works, the tedium of everyday life, the false promises of an excessive lifestyle. In each context, the structures of diverse private and public spaces are exposed, and by exploring and exposing such structures, further light is shed on individual tragedies, desires, dreams and limitations.

Initially, we encounter the *façades*, the surfaces or "the skin," in all three settings. However, a closer inspection of the shows' details reveals the multiple layers of significance embedded in these scenarios. In *The Welfare Show*, the sterile surfaces of public service institutions metamorphose into a bureaucratic nightmare – a Kafkaesque labyrinth in which we lose ourselves – rather than an efficient system that should inspire us a certain trust in organization. This bleak scenario bodes no greener grass on the other side. As we move on to the next exhibition, *The Collectors*, we experience how marital troubles and strained relationships of a family peek through the lavish surfaces of a wealthy collector's private home. Even their neighbor – a single man who has left traces of a rather carefree hedonistic lifestyle – now floats, face down, in his swimming pool. Salvation is again withheld from us when seeking comfort in the ordinary apartment block featured in the third exhibition, *Celebrity – The One & The Many*. Here, the majority of tenants attempt to escape the monotony of their daily routines by way of their vicarious relationship to celebrities and their flagrant deification of the latter. The TV talent and reality shows, the blogs and virtual chat rooms stand in stark contrast to the harsh physical conditions of the cell-like apartments in this architectural unit. Undertones of alienation pervade Elmgreen & Dragset's carefully crafted interior stagings. Emotional similarities may be discerned in spite of the financial disparities: a common sense of loneliness is apparent in all these diverse lifestyles and modes of living.

Michael Elmgreen and Ingar Dragset, from Denmark and Norway respectively, have created a dark commentary on the decline of the Scandinavian welfare system in *The Welfare Show.* In *The Collectors,* the emergence of a new distribution of wealth becomes apparent, which then prompts the urge to distinguish oneself from the mass culture of lower income groups by collecting unique and exclusive items. The perceived correlation between rarity and value coincides with the dissolution of traditional middle class values: the general public is becoming increasingly engrossed in new media and addicted to the instantaneous gratification which modern technology provides. The residents of the housing block in *Celebrity* are more devoted to keeping track of their favorite celebrities than they are to actually interacting with each other. The glamour depicted in the lives of *The Collectors*, or the silhouettes enjoying a VIP party as a play on Platonic shadows in *Celebrity*, do not reflect the experience of the majority of the population. And yet, with the rise of social media and reality TV shows, the lives of socialites and celebrities are more present and available than ever to people whose reality has far more in common with that depicted in *The Welfare Show.*

Visitors to any of the three exhibitions would have experienced different levels of restricted access – a certain exclusion or denial – and would have been confronted with a daunting sense reminiscent of what one might expect to feel as an uninvited guest. In *The Welfare Show* viewers are immersed in a sterile, institutionalized environment, lost amongst the invisible red tape evoked by the waiting rooms and hospital hallways. There is no invitation to interact in any social tragedy when passing by a sleeping baby in a carrying case abandoned beneath an ATM, or when standing face to face with an entire army of bored and silent exhibition guards employed to watch over an empty exhibition hall. And everyone visiting the private homes of *The Collectors* voluntarily becomes an intruder in the private sphere of the fictional characters. The viewer moves around between items of furniture, works of art and intimate items, and may even peek into diaries, photograph albums and letters left behind by the

inhabitants, who never appear to welcome the guests. Similarly, the apartment building in *Celebrity* never really becomes accessible to the viewer, as one has to peer closely through windows or a locked front door to gain any sense of what might be taking place inside. Like much of the artists' work, the duality of simultaneous engagement and disengagement results in narratives both incomplete and open to individual interpretation. There is no definite plot being played out within these arranged spaces; as we lose our way among them so also do we find ourselves lost among the various narrative threads. Elmgreen & Dragset's installations seem to function as film sets without protagonists, where objects, design and architecture propel the narratives. Viewers are invited to complete the story in accordance with their own experiences of similar surroundings, or else by using their imagination.

The decline of the welfare state, extreme wealth and class distinction, and a media-dependent population are issues with which we are familiar from the political arena and newspaper editorials over the last decade. In their work Elmgreen & Dragset seek a different language to question, discuss and express concerns about the accelerated developments of an increasingly global, digital, and socially deconstructed world. What happens to us emotionally and mentally in this world? How do we find our place within it as individuals? Where do we go from here?

Each of the chapters in this publication begins with a presentation of images, which is then followed by an art historical discussion relating to each exhibition. Many of the essay contributions further explore various other issues relating to *Celebrity – The One & The Many*, whereas the text parts of the chapters for *The Welfare Show* and *The Collectors* are shorter. Additional texts relating to these exhibitions may be found in the publication *The Welfare Show* (Verlag der Buchhandlung Walther König, 2006) and as part of the *Bagalogue / Calendar* issued by the artists for the 53rd Venice Biennale, 2009. The appendix sections discuss various ephemera and accompanying material relating to the exhibitions.

Peter Weibel (Chairman and CEO of the ZKM | Karlsruhe)
Andreas F. Beitin (Curator/Head of ZKM | Museum of Contemporary Art)

 zkm | Museum of Contemporary Art, Karlsruhe
07.11. 2010–27.03. 2011

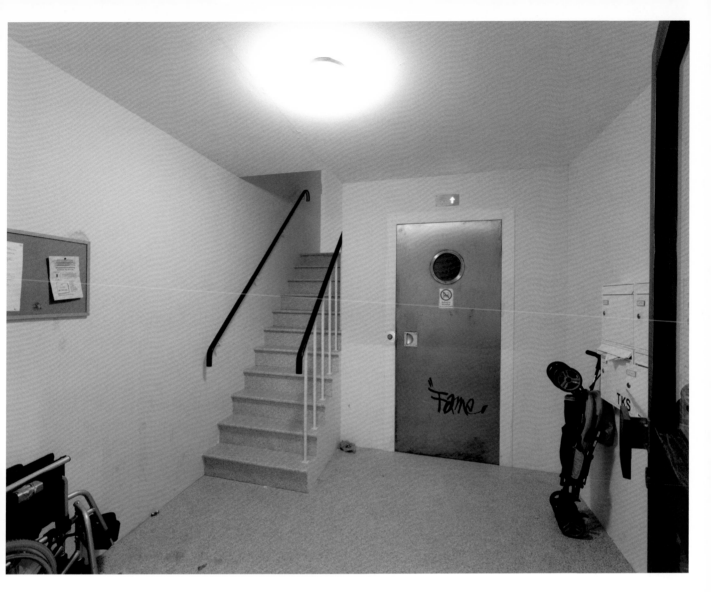

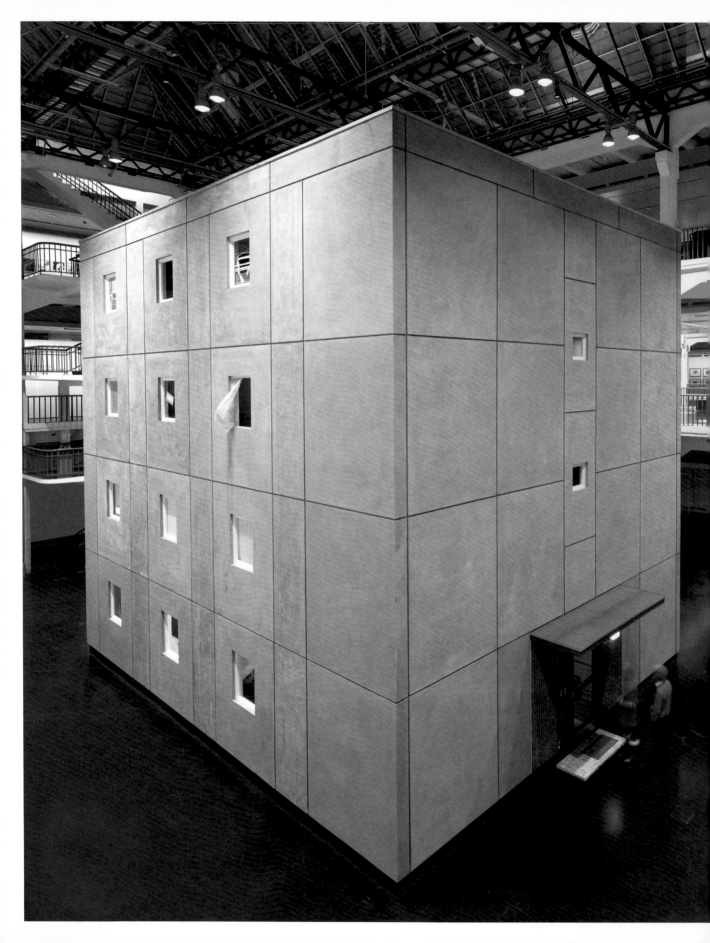

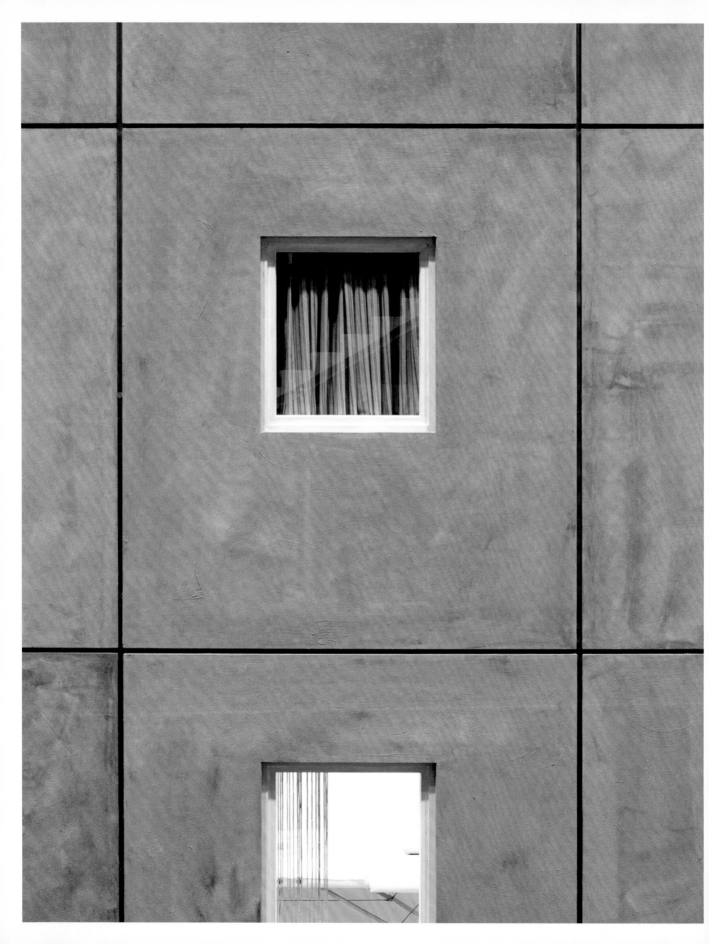

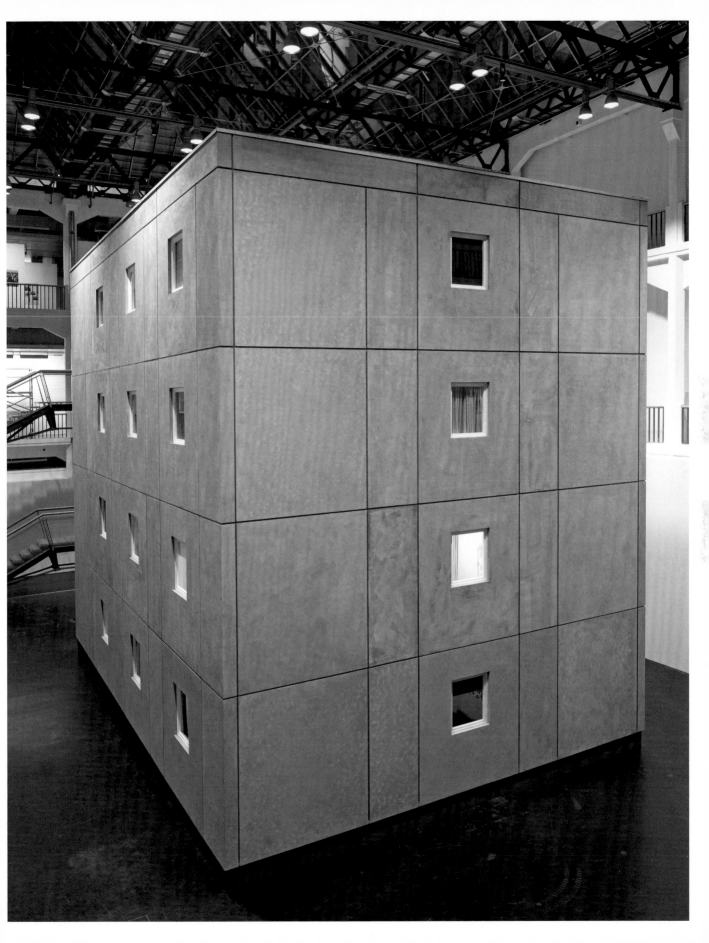

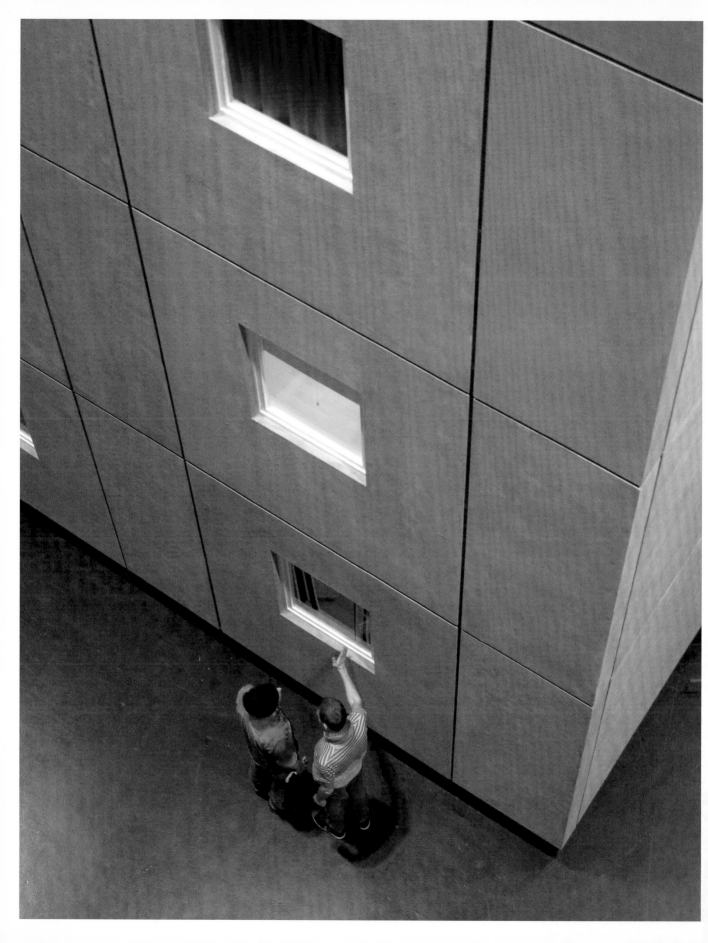

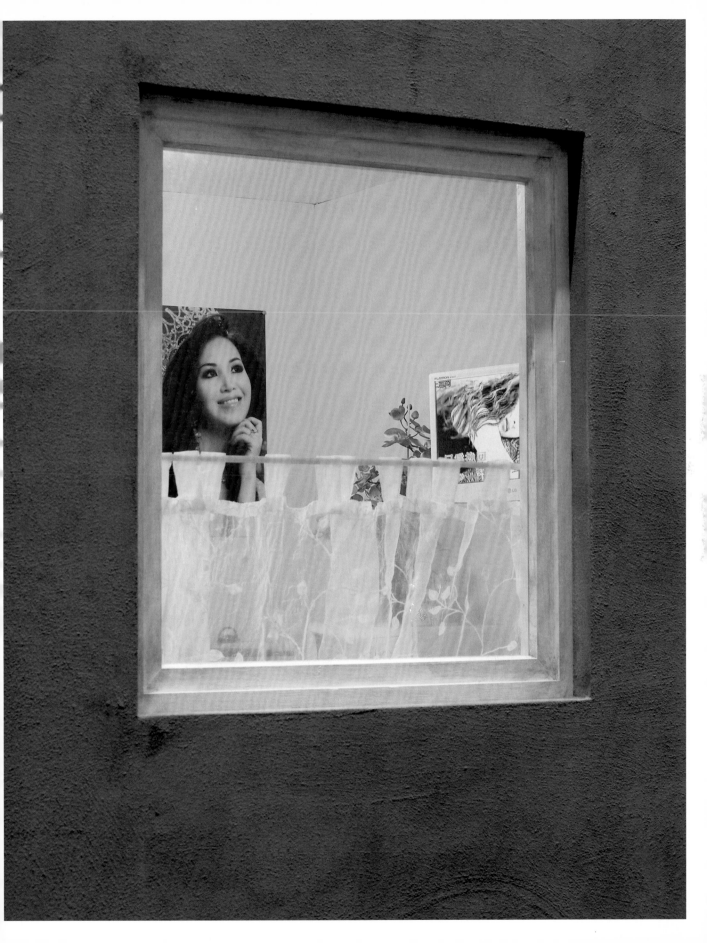

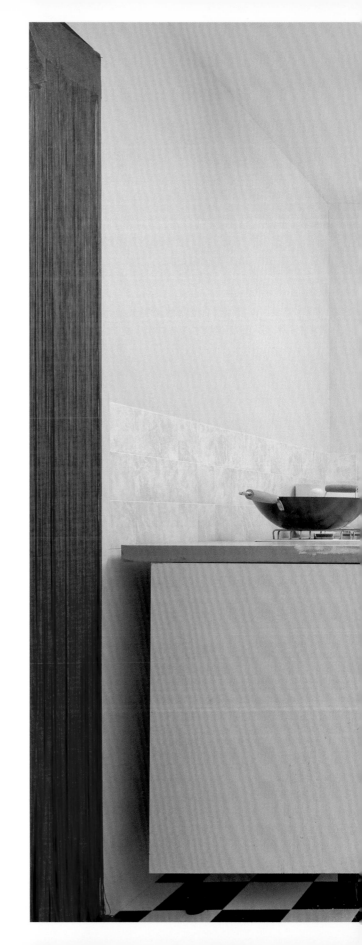

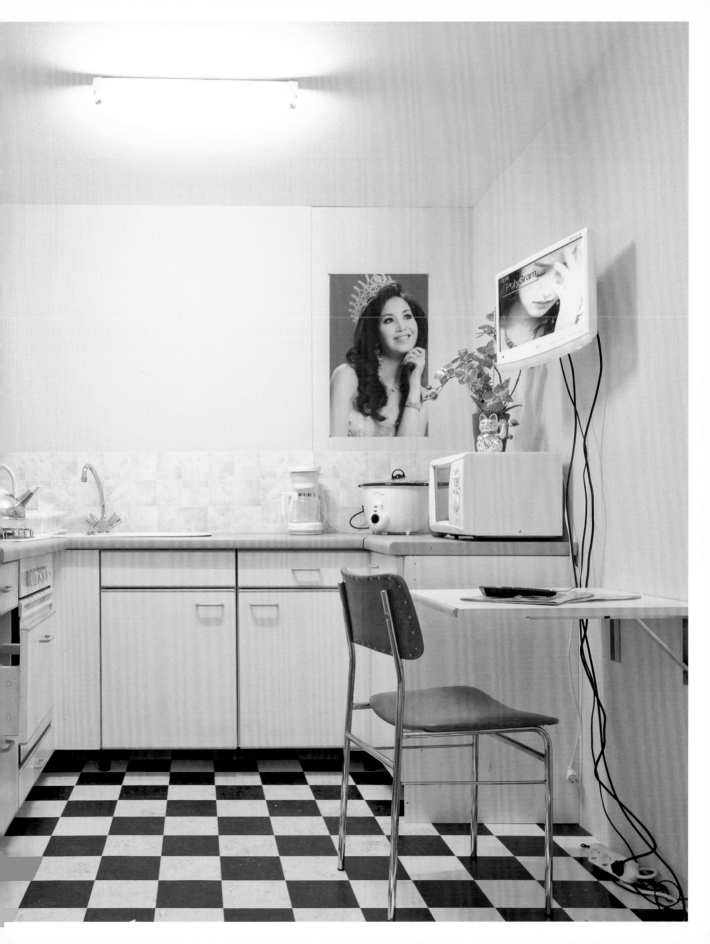

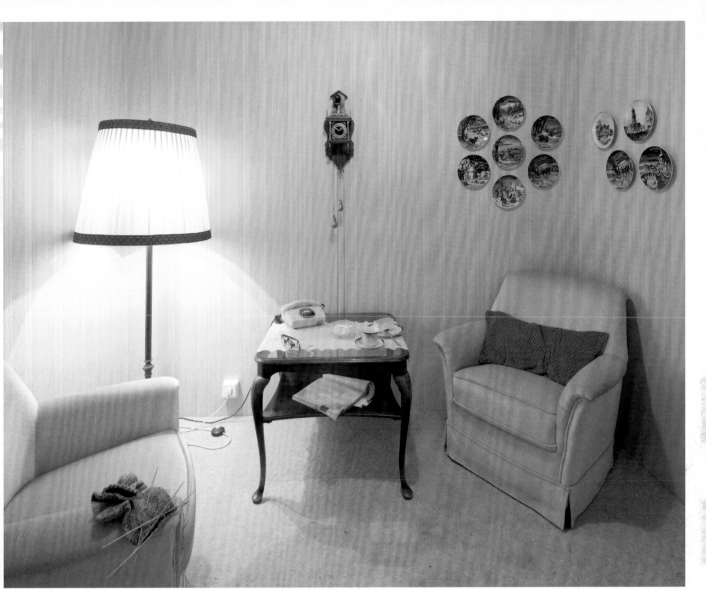

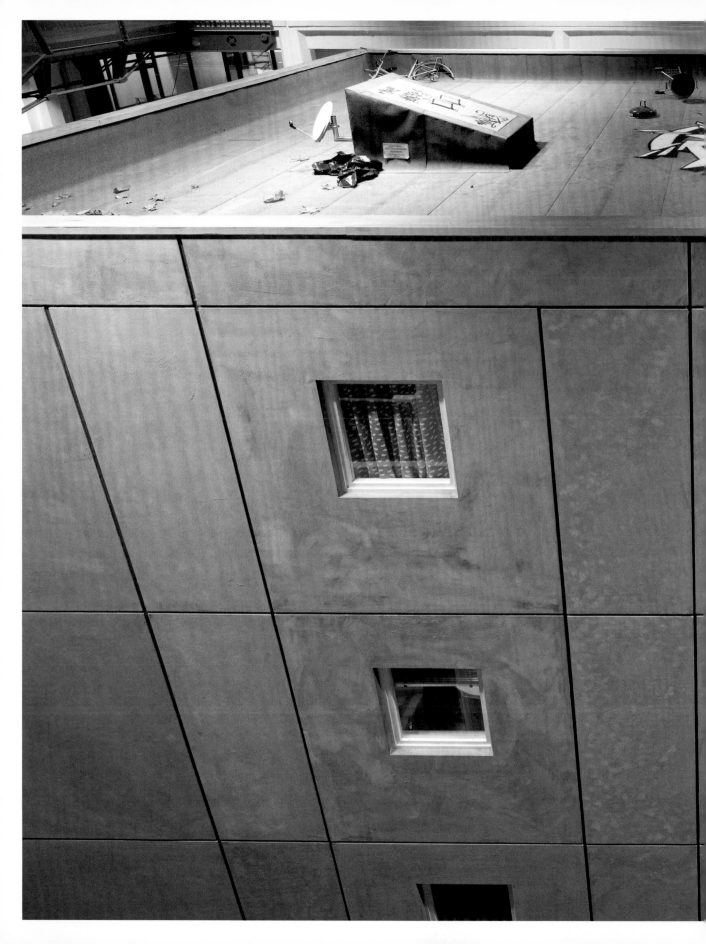

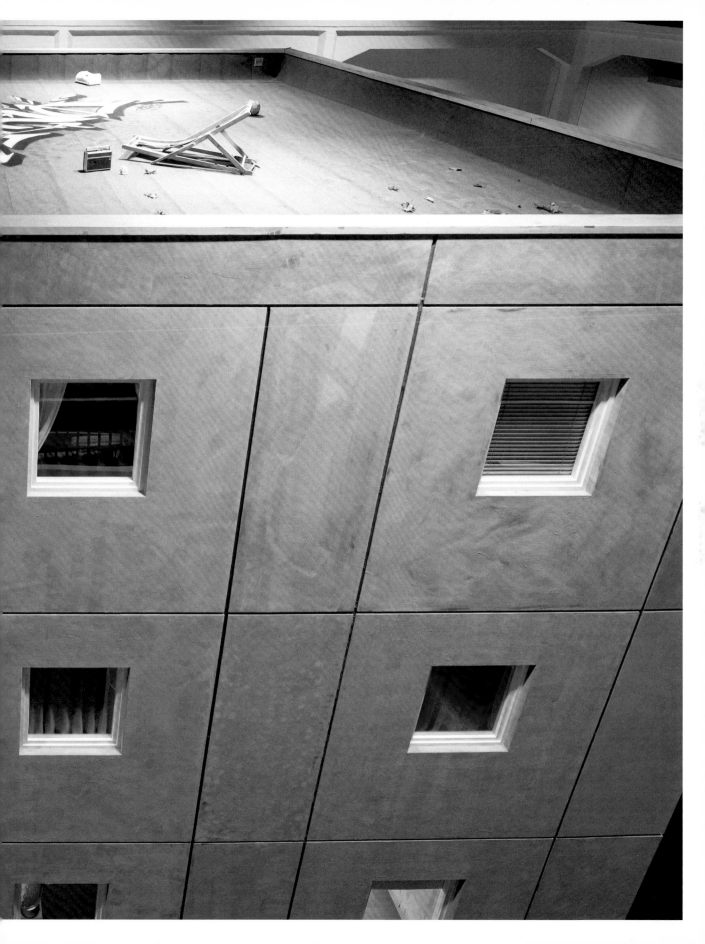

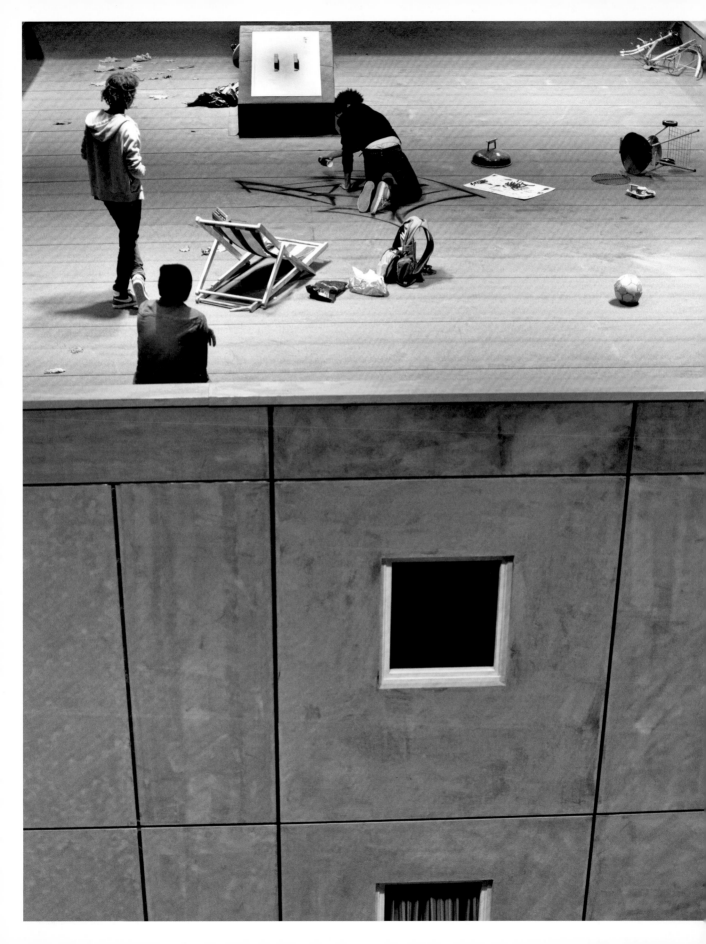

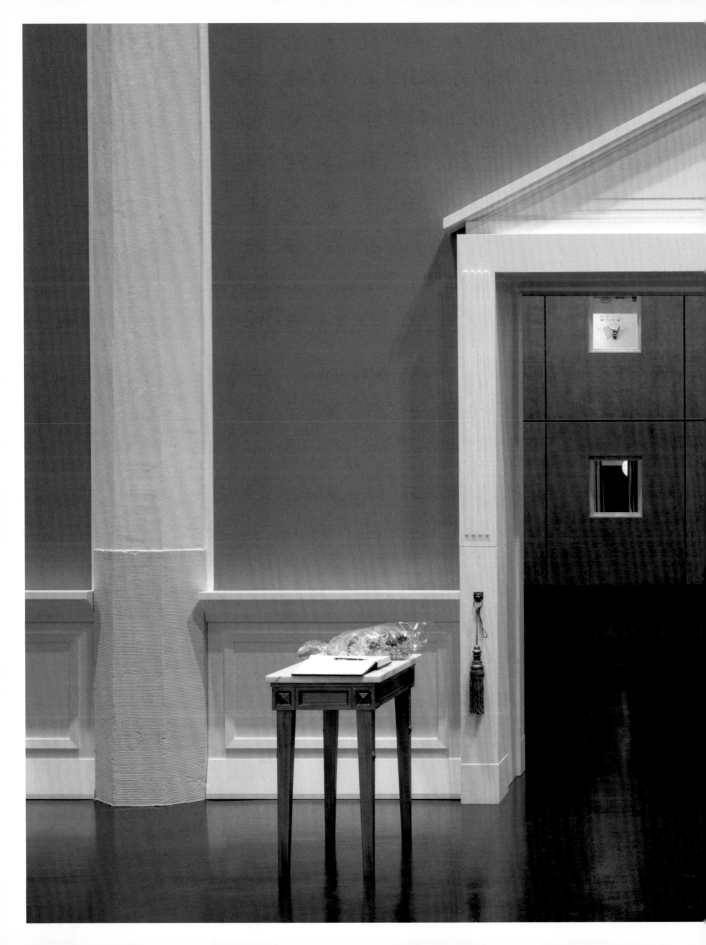

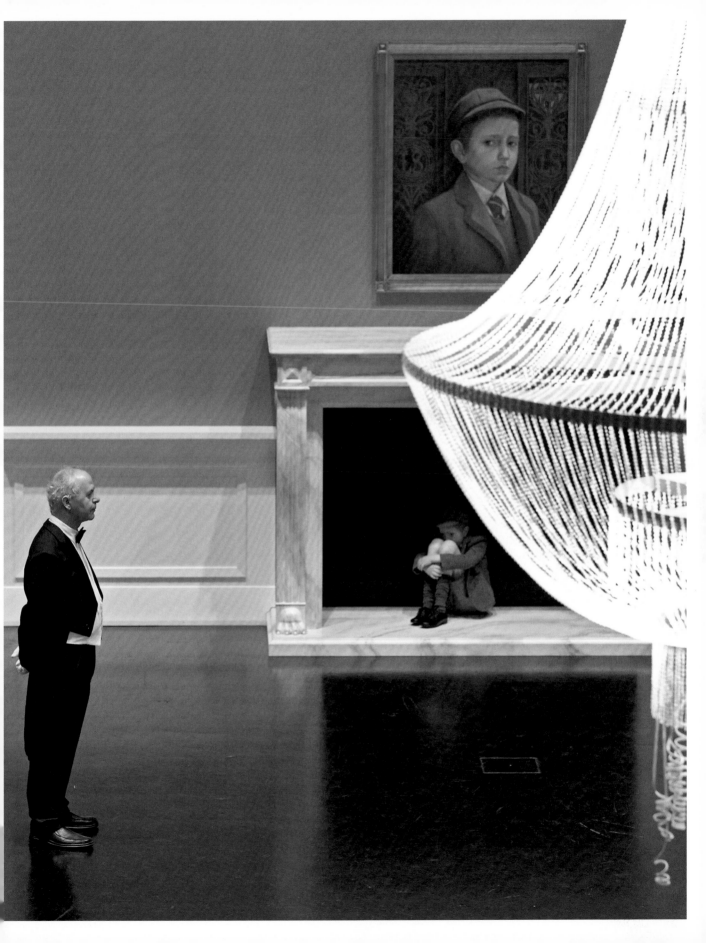

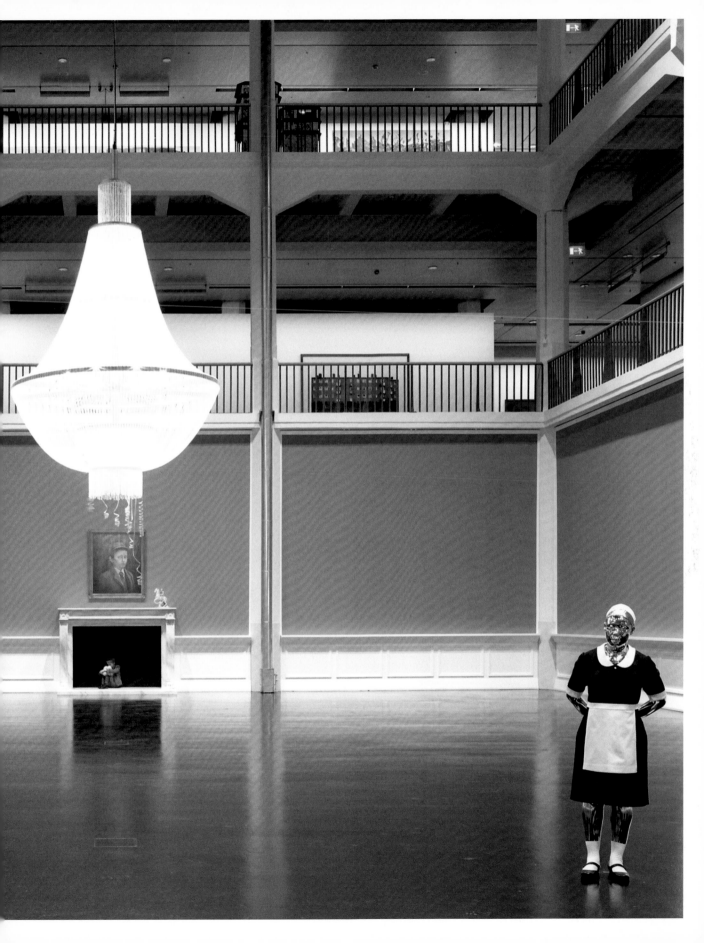

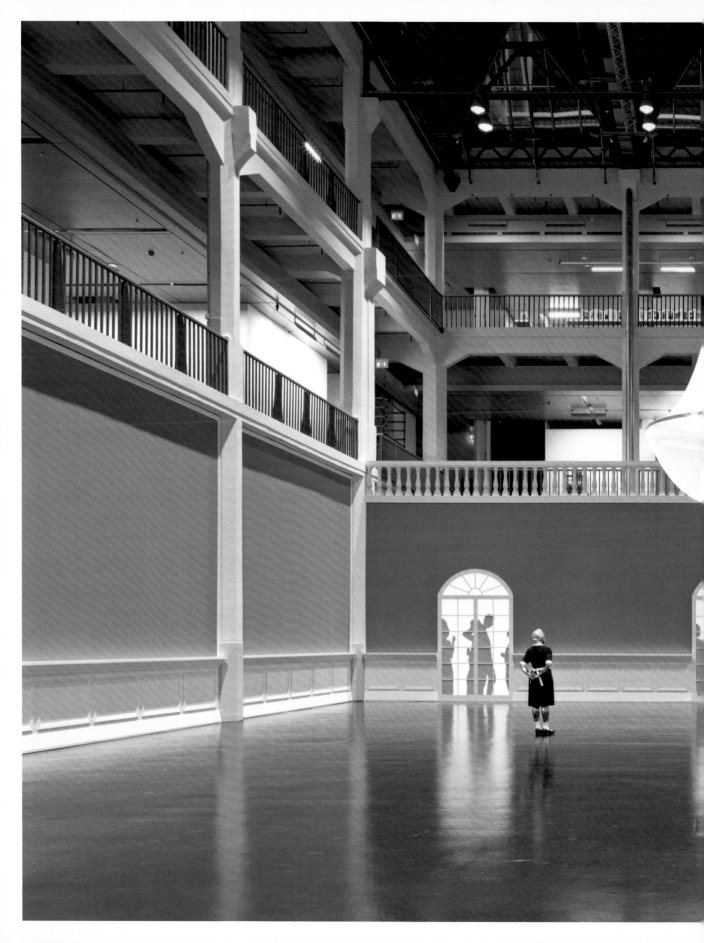

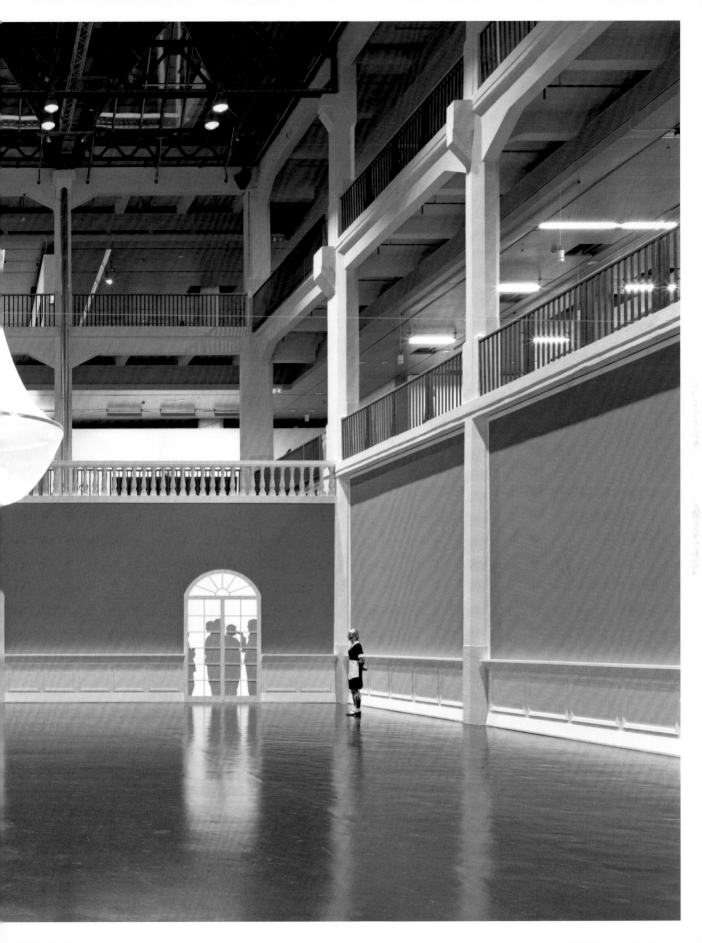

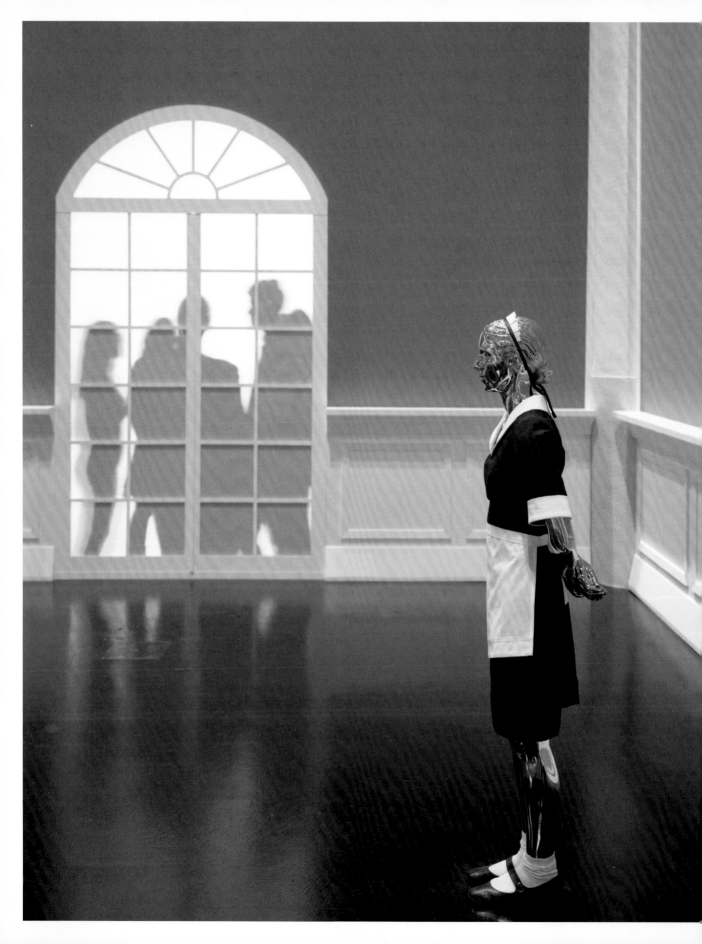

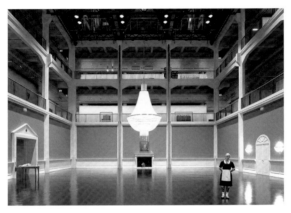

Ballroom, installation view at ZKM | Museum of Contemporary Art, Karlsruhe, 2010. Dimensions: 600 × 1800 × 3000 cm. Courtesy of the artists.

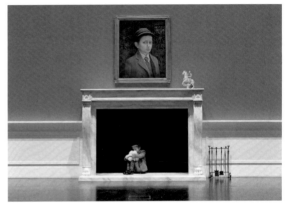

High Expectations
2010. Mixed media. Boy: Fibreglass resin, polyurethane resin, acrylic, wood, acrylic paint, oil paint, hair. Fireplace: MDF, acrylic, wax. Painting: Oil on canvas. Allover dimensions: 300 × 240 × 90 cm. Courtesy of Galerie Emmanuel Perrotin, Paris.

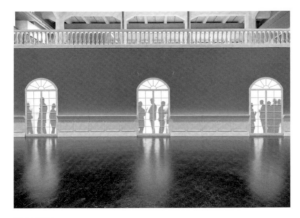

Reception
2010. Three channel video projection with sound, perspex, wood. Dimensions variable. Installation view at ZKM | Museum of Contemporary Art, Karlsruhe, 2010. Courtesy of the artists.

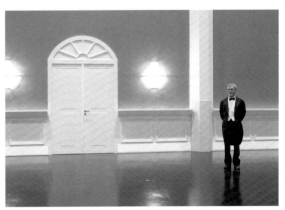

Ballroom, performing guard, dressed in traditional butler's uniform.

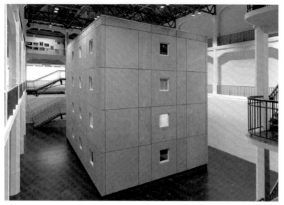

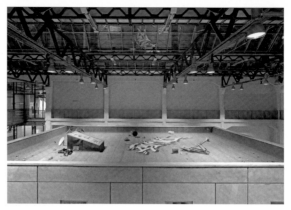

Apartment block. Mixed media. Dimensions: 1050 × 1210 × 860 cm.
Installation view at ZKM | Museum of Contemporary Art, Karlsruhe, 2010.
Courtesy of the artists.

Detail, roof-top

Detail, interior

Detail, interior

Detail, interior

Detail, interior

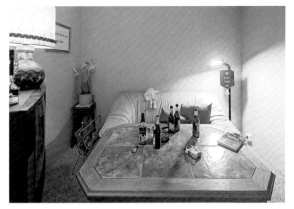

Detail, interior

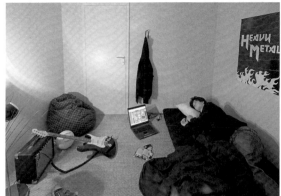

Detail, interior

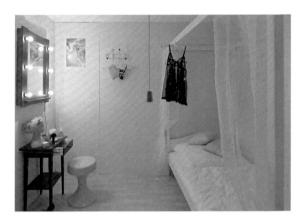

Detail, interior

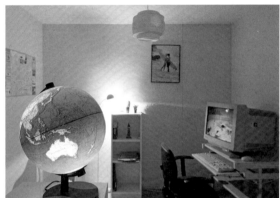

Detail, interior

Detail, interior

Detail, interior

C *elebrity – The One & The Many* at the ZKM | Museum of Contemporary Art is the third and final part of an exhibition trilogy, the first two parts of which took place in various cities, including London and Venice. With two large-scale installations – a social housing building and a ballroom – Michael Elmgreen and Ingar Dragset have staged two diametrically opposed worlds across 3,000 square meters. Not only in terms of their size but also in view of their thematic complexity, the two works constitute a milestone within the artists' œuvre and enrich the discourse on celebrity culture at several levels. Themes such as staging, absence, exclusion, appearance and illusion unfold. Elmgreen & Dragset's artistic analysis of social codes of minimalist spatial structures and furnishings continues here with a general commentary on the changing socio-cultural climate of Western society.

The Appearance of the Demiurges

Elmgreen & Dragset. Celebrity – The One & The Many
Andreas F. Beitin

Context

In the 1967 summer issue of the American art magazine *Artforum*, several authors adopted different approaches to the newly emerging Minimal Art and its relation to Modernism and Abstract Expressionism. Robert Morris, who along with Donald Judd was one of the key proponents of Minimal Art, offered a particularly succinct characterization of works in this style: "Symmetry, absence of traces of the production process, abstractness, non-hierarchical arrangement of parts, non-anthropomorphic orientations, a general holism."[1] In the same issue of *Artforum*, Michael Fried allied himself with Clement Greenberg and others in his now legendary article "Art and Objecthood," which challenged Judd and Morris's claim that they and their art were the heirs of Modernism. Fried countered: "the literalist espousal of objecthood amounts to nothing other than a plea for a new genre of theater; and theater is now the negation of art."[2] According to Fried, the staging or theatricalizing of the presentation of art, and of the relationship between work and viewer, is the wrong approach to

1 Robert Morris, "Notes and Non-Sequiturs," in: *Artforum* (Los Angeles), V, 10, Summer 1967, pp. 24–29.
2 Michael Fried, "Art and Objecthood," in: *Artforum* (Los Angeles), V, 10, Summer 1967, pp. 12–23, reprinted in: Michael Fried, *Art and Objecthood: Essays and Reviews*, University of Chicago Press, Chicago, 1998. By "literalists" Fried means artists such as Donald Judd and Robert Morris; by "objecthood" the "state of non-art."

the reception of art. Whereas in earlier art everything yielded by the work was always localized in the work itself, in literalist art a work is experienced "in a situation" – and in a situation that almost, by definition, "includes the beholder."[3] Finally, Fried distinguished between a theatrical art, that is, art which is staged, and a non-theatrical art, namely, art which is authentic. The styles and artistic innovations that Fried criticized have meanwhile become an essential part of the canon of art. Elmgreen & Dragset's works could be interpreted as a synthesis of the above-mentioned opposing approaches. While from today's point of view the artistic styles of the 1960s are quite clearly defined, contemporary art seems diffuse and eludes attempts at stylistic classification. Accordingly, art criticism has focused on individual artistic positions rather than on movements or styles. If critics now speak of tendencies in contemporary art, then it is to distinguish, among others, between narrative, immersive or participative priorities.

In many of their works and installations, Elmgreen & Dragset have confronted the aesthetics of Minimal Art and *the* postmodern art venue, the white cube. They have also addressed various issues relating to collecting and exhibiting art. Above all, the social functions and social conditioning of architecture and design remain fundamental to their interests. The "reflexive approach" of their often scenographic and elaborately furnished installations is, as Pamela C. Scorzin has observed, "accordingly to be understood always in this dialectical relation to one of the most effective power dispositives of modernism," namely, the neutral white exhibition room.[4] Thus, in over fifteen years of collaboration, the Scandinavian artist duo has sunk fictive white cube art gallery rooms into the ground or made them float on balloons in the exhibition space. During a twelve-hour performance they constantly painted the gallery walls white and, [FIG 1] on another occasion, had painters repeatedly repaint the exhibition spaces white for the entire duration of a show. White was never white enough; the need to paint walls and employ workers was taken to the point of absurdity in the face of the imperative demand for

3 Ibid.; emphasis added by M. Fried.
4 Pamela C. Scorzin, "Michael Elmgreen & Ingar Dragset. The White Cube Recoded," in: *Künstler. Kritisches Lexikon der Gegenwartskunst*, Zeit Kunstverlag, Munich, 2011, p. 4.

a site for the presentation of art as neutral and as anti-septic as possible. The interest in social practices within architectural structures is also reflected on another level, in Elmgreen & Dragset's minimalist *Cruising Pavilions*, for instance. At night, these white, neutral spatial structures become darkrooms (at least fictively), places for interpersonal contact where homosexual practices are decontextualized by bringing them into a museum-like ambience.[5] Elmgreen & Dragset have commented on their preoccupation with the white cube, which takes them beyond the context of art, and art critics' misinterpretations thereof:

"Actually our early projects in relation to the white cube were always less of a specific art institutional critique than more general questions about public space and how we perceive it. We simply wondered why white walls and minimal design was suddenly considered more neutral than other spatial features since the white cube design was a relatively new form of display which derived from the fact that art since the late 1950s was now being shown in former factory lofts in New York (the Vienna Secession is here an exception since it is much older). But the notion of a neutral environment can be found in many public institutions as well such as social welfare offices, hospitals and prisons. To regard our early works as specifically addressing the white cube – and only discuss the policy of exhibition making and museum displays – is a wrong interpretation of these works, since the white cube, for us, was just a symptom of a broader perception of many public spaces and their designs. But many writers describe these early projects as if they were meant purely as an art institutional critique. *Celebrity* is linked to previous exhibitions like *The Welfare Show* and *The Collectors*, but also aesthetically to projects like *End Station* at The Bohen Foundation in New York and to *Prada Marfa*."[6]

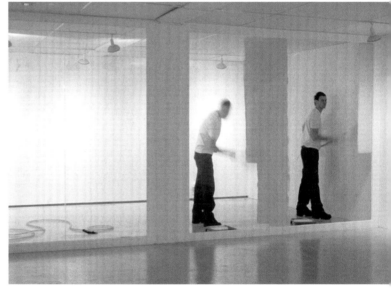

1 **Powerless Structures, Fig. 144** 2000. Glass, white paint, white paint buckets, painting tools, squeegee, water hose, overalls. Glass wall: 250 × 750 cm. Rooseum, Malmö. Performance installation: glass wall dividing the exhibition space into two parts, behind which the artists apply and wash away layers of white paint repeatedly. Courtesy of the artists.

5 As, for example, at the exhibition *Elmgreen & Dragset. Trying to Remember What We Once Wanted to Forget*, MUSAC, León, January 31–June 21, 2009.
6 Michael Elmgreen and Ingar Dragset, March 21, 2011, in an e-mail to A.B.

The theatrical staging and transformation of the places of exhibition into art or vice versa is an essential feature of many works and installations by Elmgreen & Dragset. This is not surprising, considering that Ingar Dragset has a background in performance and theater, where it is common practice to improvise venues. When mention is made in the following to "staging" and "staged reality," it is in terms of a realization of a presence, of a social reality – the presence of a state "in which things in life and the world somehow *concern* us in various ways."[7] In *Celebrity*, the artists present a social reality that most of us probably know only from the media or from a distance. This applies as much to the social housing building as to the ballroom. A social reality, along with its polarization into rich and poor, has been shipped into the museum context.

The Exhibition

With its basic dimensions of nine by twelve meters and a height of nearly eleven meters, the replica of a four-story *Plattenbau* – the type of industrially prefabricated apartment block favored by socialist governments during the post-war and especially Cold War eras – is one of the most extensive spatial sculptural objects to have ever been built for a museum. The building contains ten residential units of almost realistic dimensions. From a total of thirty windows, ten afford a view of the apartments' interiors. Here they live, the "infamous men" whom Michel Foucault described as those not "predestined to cause a stir," those "belonging to the billions of existences that are destined to pass without a trace …"[8] If visitors to the exhibition step up to the front door of the building, they see junk, rubbish and refuse in the stairwell. A wheelchair has been left in a corner, and the letterboxes have been demolished. The visitor ponders which of the buttons to press on the doorbell nameplate to the left of the entrance, and "decorated" with stickers. The rooms, visible on the ground floor, seem as if they have been left only a moment ago: a bottle of beer

is on the table, the television is on, the teatime cake is ready to eat – the tenants could return at any minute to their claustrophobically small rooms. Yet they remain absent. The absence of people is ubiquitous. Their stories are told vicariously through the beer bottles, the blaring TV sports show, the booming karaoke and casting shows, the sedate collection of wall plates. From the upper floors of the museum, the visitor can look, using the binoculars provided, into children's rooms, the treatment rooms of alternative practitioners, and bedrooms; a green curtain flutters in the draft of an open window; another flat is up for rent – an offer for which it is difficult to find a taker. Neither does one see any people in the upper stories of the building, only their furniture and belongings, from which one can learn quite a bit about their lives. The rooms and their furnishings tell of loneliness and the desire to escape from a dreary everyday life, through the virtual parallel worlds of the Internet, the karaoke show or the imagined dream-world of stars and starlets. All the inhabitants have furnished their little refuges according to their tastes and desires. The only human figure to be seen in the building is a teenager lying on a mattress: *Andrea Candela, Fig. 2.*[9] His guitar leans against a wall and on the opposite side hangs a poster of a heavy metal band. On the open laptop the visitor can see that the teenager is chatting online on a gay dating website. Just as Elmgreen & Dragset want to break through stereotypes of supposedly typical homosexuals with this figure – heavy metal guitarists are not generally gay stereotypes – so too do they question our ideas of how a social housing building might look. Going to the top floor of the museum, the visitor sees the remains of a barbecue on the flat roof of the house: a toppled grill, a scruffy lawn chair, autumn leaves and large-scale graffiti.[10] Contemplating this desolate scene and details of the previous evening on the roof, a mood of melancholy, an almost constant undertone of Elmgreen & Dragset's work, soon sets in. The furnishings of the building come from second-hand shops, thus already used and authentic, quasi ready-mades. When viewing the monumental sculpture, one cannot help but think of Allan Kaprow's

7 Martin Seel, "Inszenierung als Erscheinenlassen. Thesen über die Reichweite eines Begriffs," in: Josef Früchtl and Jörg Zimmermann (eds.), *Ästhetik der Inszenierung. Dimensionen eines künstlerischen, kulturellen und gesellschaftlichen Phänomens*, Suhrkamp, Frankfurt/M., 2001, p. 54 (emphasis added by M. Seel).

8 Michel Foucault, *Das Leben der infamen Menschen* [*La vie des hommes infâmes*, 1977], (ed. and transl. by Walter Seitter), Merve Verlag, Berlin, 2001, p. 15 [English translations here by J.U.].

9 This is the work *Andrea Candela, Fig. 2* (2006), mixed media, variable dimensions, Heinz Peter Hager Collection, Bozen, Italy.

10 With previous installations, for example, the project *The Collectors* at the 2009 Biennale di Venezia, Elmgreen & Dragset had already invited artists to participate in the project. In Karlsruhe they engaged a graffiti painter.

call to keep "the line separating art from life [...] as fluid and perhaps as vague as possible."[11] With *Celebrity* his call has been answered in an innovative and contemporary way.

The exposure of the lifestyles of the "many" in the *Plattenbau* is contrasted with the glamorous world of the "one" in another atrium of the ZKM | Museum of Contemporary Art: a sumptuous, neo-classical ballroom. Adapted to the historical architecture of the museum, the ballroom extends over five hundred square meters with surrounding wall panels. A further room is intimated to the rear of the facade: here, behind frosted glass a society of celebrities, laughing and sipping champagne, can be made out in silhouette. The ballroom belongs to a fictitious VIP, whose son, abandoned and alone, crouches in a fireplace. Above the boy, a priviledged type who wears the school uniform of England's most exclusive school, Eton, hangs his own resplendent likeness painted in the style of an old master. Presumably, many portraits of his ancestors were hung there before; his life seems to be already mapped out for him.[12] As in the *Plattenbau*, where some reality finds its way into the exhibition through the figure of *Andrea Candela, Fig. 2* and the online chat, the background noises of the ballroom behind the frosted glass are equally authentic: they are the conversations and sounds of the autumn 2009 opening of the Frieze Art Fair in London, and of two of Elmgreen & Dragset's exhibition openings, recorded by the artists.

As in the preceding parts of the trilogy, *The Welfare Show* and *The Collectors*, in *Celebrity* the museum attendants assume a performative role. While during *The Welfare Show* the museum security guards guarded themselves and in Venice the attendants, staging themselves as hustlers or ex-lovers, sprawled naked in chairs, in *Celebrity* the security guards, personally selected by Elmgreen & Dragset and clad in bow tie and tails, kept watch, as immobile as possible. Many exhibition visitors approached them in disbelief, enquiring as to whether the guards were wax figures or real. Moreover, before the more than one thousand guests at the exhibition opening entered the museum, and as part of a performance, Elmgreen &

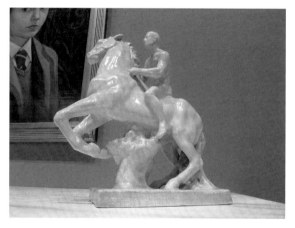

2 **High Expectations** 2010. Detail. *Celebrity – The One & The Many,* ZKM | Museum of Contemporary Art, Karlsruhe.

11 Allan Kaprow, *Assemblage, Environments & Happenings*, Abrams, New York, 1965, pp. 188–189.
12 On the mantelpiece is a Karlsruhe majolica figure from the 1940s that represents, in the aesthetics of Nazism, an unclothed rider on a rearing horse. Bearing in mind Elmgreen & Dragset's design for the competition *Fourth Plinth 2012* in London, which shows a young boy on a rocking horse, the viewer can detect several comparable themes, such as that of the predetermined life of boys from certain social classes or the heroic and prestigious representation of men on horses, whose pathos and claim to power are countered by the rocking horse. (Fig 2 and 3)

Dragset had a horde of paparazzi envelope them on the red carpet in a barrage of flashbulbs, giving the former a feeling of glamour and superiority.[13]

Celebrity Culture

The main theme of the exhibition trilogy is the change in the Western socio-cultural climate. The Karlsruhe exhibition in particular explores various aspects of celebrity culture and the anti-worlds of *The One & The Many*, the observed and their observers. One of these aspects is that all the residents of the *Plattenbau* are "in various ways addicted to fame,"[14] addicted to celebrity. A multifaceted discourse has been underway in recent years on the subject of celebrities and celebrity culture. The hitherto most comprehensive book on the subject was published in 2006 and edited by P. David Marshall, who described celebrity culture as a new form of ideological colonization.[15] The literature on the subject points repeatedly to the close connection between celebrity and art, above all, to contemporary art. Thus, according to Isabelle Graw, artists in general can be seen as the "prototype of celebrity," with Andy Warhol in particular as the founder of celebrity culture.[16] All in all, a consensus prevails in relevant literature that celebrity culture is closely tied to the social and political developments of an increasingly strong neo-liberalism that emphasizes the power of the individual rather than society and suggests that through increasing the efficiency of one's life it is possible to obtain economic and individual advantages. "Celebrity culture is thereby declared to be a form of society appropriate to the bio-economic imperative of value appreciation."[17]

When considering the current phenomena of celebrity culture – that is, among other things, the media-constructed prominence of people whose main product consists of marketing their own lives – it is helpful to take a look at the past. In earlier times, heroes, saints, rulers and sometimes scientists and philosophers were glorified in recognition of the differences between the

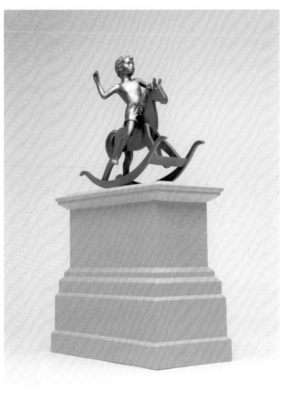

3 **Powerless Structures, Fig. 101** 2010. Maquette. To be realized in 2012 for the Fourth Plinth Commission, Trafalgar Square, London. Courtesy of the artists and Victoria Miro Gallery, London.

13 This paparazzi performance also took place on two other days. The photographs of all three events can be viewed at the exhibition website: http://www02.zkm.de/celebrity.

14 Pamela C. Scorzin in conversation with Michael Elmgreen & Ingar Dragset, in: *Künstler. Kritisches Lexikon der Gegenwartskunst*, Zeit Kunstverlag, Munich, 2011, p. 10.

15 P. David Marchall (ed.), *The Celebrity Culture Reader*, Routledge, New York, 2006, p. 6.

16 Isabelle Graw, *Der große Preis. Kunst zwischen Markt und Celebrity Kultur*, DuMont, Cologne, 2008, pp. 168, 175.

17 Ibid., p. 15. By "bio-politics" Graw means the "politicizing and commodification of life."

venerated person and one's own existence. The hierarchical and spatial distinction was generally a constitutive element of the veneration. In celebrity culture, however, we encounter a "non-aristocratic economy of prominence."[18] Accordingly, the contemporary cult of the media star is structured in a completely different manner. The media world, subordinate to neo-liberal principles and strictly market-oriented, suggests that there is *no* difference between the celebrity and the ordinary person, that everyone can become a star if only he or she wants to and makes sufficient effort: "I am nothing but I can be everything," as the French philosopher Paul Virilio remarked in an interview conducted especially for this publication.[19] In this system of desire, the proof of the purported absence of difference between the "one" and the "many" is often furnished by paparazzi, one of whom serves as the motif for the exhibition poster for *Celebrity*.[20] [FIG 4] In the media world of glamour and illusion, one of the aims of these photographing voyeurs is to market the "everydayness" of stars, so as to provide illustrations for the gossip columns of various magazines: pictures of David Beckham and family at a fast-food snack bar or Paris Hilton shopping. Thus, by demonstrating an apparent lack of difference, the extraordinary qualities of stars and celebrities are diminished by the following inference: the star is doing nothing different from what you do; therefore you too can be a star. This notion is confirmed by the popularity of various television casting shows, which suggest to the candidates that they can potentially become a star. Here, anyone can supposedly become anything as long as he is prepared to give everything, in every sense of the word and, if need be, put his dignity at stake and expose himself to the ridicule of millions of viewers. Those who manage to emerge victorious from these shows then vanish again as swiftly as they appeared. In accordance with the profit-oriented interests of the television channels, they *must* disappear, because the audience's attention is needed again for newly generated "stars." Audience participation in shows such as *Deutschland sucht den Superstar* (the German version of *American Idol* and

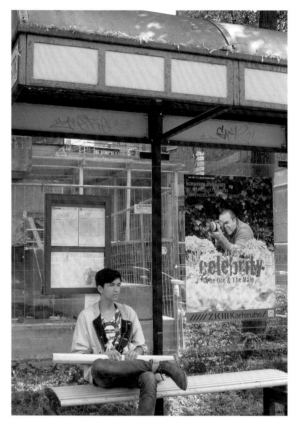

4 Poster for the exhibition *Celebrity – The One & The Many* at the ZKM | Museum of Contemporary Art, Karlsruhe, 2010.

18 Peter Sloterdijk, *Du musst sein Leben ändern. Über Anthropotechnik*, Suhrkamp, Frankfurt/M., 2009, p. 208.

19 Paul Virilio, *Celebration. The World of Appearances*, Paul Virilio in conversation with Sacha Goldman, Paris and La Rochelle, June, 2010, published in this volume, pp. 144.

20 The interview between Ingar Dragset and Eric Brogmus, a twenty-two year-old paparazzo living in Los Angeles, whose picture served as poster motif for the ZKM exhibition, is published in this volume, pp. 172.

the British *X-Factor*) does not really serve the purpose of generating celebrity and elevating the individual above the mass of viewers, but rather only serves the capitalist processes of the media corporations. It is thus merely a pseudo-participation. "[T]he conscious lowering of standards [...] in the business of arousing and harvesting attention [...]" constitutes "a valid means to increase earnings."[21]

The various facets of celebrity culture are of cultural and, therefore, of social relevance. But in addition to their undeniable positive aspects, there are phenomena, especially at the social level, that should be examined critically. These include the exploitation of people for the sake of others' economic interests and the loss of dignity. "In the context of Western civilization, the guarantee of human dignity means nothing more than the freedom to trade with one's dignity like any other commodity," observes the philosopher Boris Groys; "accordingly, every individual can turn his dignity into a commodity, on both the symbolic and financial levels."[22] In our society, which is dependent on media attention, many people make abundant use of this commodity, for which various television channels provide diverse opportunities, especially with casting shows. These shows focus on diverse target groups and their principles rest on competition, selection and ranking procedures, the real and sole purpose of which is to generate attention, for only attention promises profits. Currently, German television airs twenty such programs. In view of all this, the media researchers Bernhard Pörksen and Wolfgang Krischke refer to what they have dubbed the "casting society."[23]

Imitation

In the Western world we live in a complex society, differentiated according to various functions. The individual citizen, however, still believes "I'm like any other everyman."[24] This amounts to a frustrating experience for many people, because they desire to stand out from the crowd as a unique individual. Along with this desire

for individualization comes a wide array of corresponding media offerings. These purportedly offer people the opportunity to individualize themselves – for example, on attention-promising TV shows which suggest that participants can reach the final stage of differentiation in which they become a star. With considerable foresight, the media and communication theorist Norbert Bolz observed even in 1999 that "If our culture promises everyone uniqueness, then there is only a single path open to uniqueness: the copy."[25] That this, in fact, contradictory development has come about may be seen in numerous examples from various spheres: in the above-mentioned shows the same hits are performed again and again; thousands of forearms blazon the tattooed name of the beloved as David Beckham has shown us how to do; everywhere we see the hairstyles of Amy Winehouse or some other popular star, and various fashion styles copied from celebrities, and so on. The list of examples, which could go on indefinitely, illustrates the dilemma in which adolescents and those seeking orientation often find themselves: while desiring to shape a particular individuality they also want the security of already exemplified and positively sanctioned lifestyle. None of these ideas are new or particularly shocking, for we are deficient beings and therefore predestined to imitation. What is unusual is the speed with which the models change and the multitude of accompanying phenomena – both made possible by increasingly sophisticated technologies and the development of various communication structures.

When Bolz refers to "copy," and thus to imitation, one ought not overlook the recently "rediscovered" sociologist Gabriel Tarde, who was one of the most important French social scientists at the turn of the nineteenth century, and later almost forgotten. Tarde saw his work *The Laws of Imitation* as a comprehensive theory of society.[26] His theory, which he proposed not only for the spheres of family, politics, language and fashion, but also for that of art, relates on two levels to different aspects of this exhibition. Tarde's sociology of imitation is "a sociology of desire," for it is love or veneration that forms

21 Georg Franck, "Celebrity and Populism. With regard to Pierre Bourdieu's economy of immaterial wealth," published in this volume, p. 112.

22 Boris Groys, "Die Körper von Abu Ghraib," in: Peter Weibel (ed.), *Boris Groys. Die Kunst des Denkens*, Philo Fine Arts, EVA Europäische Verlagsanstalt, Hamburg, 2008, p. 77.

23 Bernhard Pörksen and Wolfgang Krischke, *Die Casting Gesellschaft. Die Sucht nach Aufmerksamkeit und das Tribunal der Medien*, Cologne, 2010. See also their contribution to this volume: *The Society of Excessive Attention*, pp. 124.

24 Norbert Bolz, *Die Konformisten des Andersseins. Ende der Kritik*, Wilhelm Fink, Munich, 1999, p. 11.

25 Ibid.

26 Gabriel Tarde, *The Laws of Imitation* [*Les lois de l'imitation*, 1890/1895], transl. Elsie Crews Parson, Henry Holt & Co., New York.

the basis for a social relation which elicits the desire to imitate. In the context of the exhibition, this desire to imitate can be seen in some of the inhabitants of the social housing building – in their television viewing, for example. At the same time, however, Tarde also provides an early theoretical foundation for an expanded concept of art, since he uses "art" as a general "umbrella term for making or doing."[27] Jean-Philippe Antoine has pointed out that, although Tarde distinguishes between a "general" and a "narrow" meaning of art, his actual use of the term undermines this distinction, so that its general meaning could be seen as a connection to Marcel Duchamp's and Joseph Beuys's concepts of art, for example.[28] With these reflections we come full circle to *Celebrity*, for while the staged reality of the *Plattenbau* is not a Duchampian ready-made in the true sense, it comes very close through its use of everyday objects and its seeming authenticity.

The issue of the desire to imitate brings us back to the social dimension of celebrity culture, which is strongly influenced by strategies of copying. Social relationships are vitally important for human beings. As shown in Abraham Maslow's hierarchy of needs (first presented in 1943), following survival-related and necessary basic needs such as food and security, social contacts are the most important for human life. We need not discuss their full importance here, but it suffices to point out that for several years now, technology has been influencing how people interact socially. While affiliation-strengthening, (putatively) community-building and integrative structures such as the Internet platforms Facebook and Twitter have been playing an increasing role in society, people have also been forming so-called parasocial relationships, preferably to others who approximate their own ideal. A parasocial relationship is the one-sided relationship between media users and people who constitute a subjectively valid role model for the respective individual; for instance, the relationship between television viewers and celebrities or soap opera stars. As a recent study has shown, the formation of such structures is independent of an individual's level of education and self-esteem; not even chronic loneliness can be regarded as a reliable indicator of the probability of entering into parasocial relationships.[29] In real relationships no one can be spared disappointment or rejection; hence one advantage of parasocial relationships, especially for people who are socially inept or have low self-esteem, may lie in the enjoyment of factors that enhance self-esteem from which they would otherwise be barred. In principle, the study argues, such relationships should not be condemned so long as they are supplementary and not exclusive. It concludes that "even 'fake' relationships with celebrities, relationships without any actual contact, can have benefits for the self [...] the psychological effects of them could be quite real."[30] The loss of a comprehensive, psychologically and socially integrative sense of belonging, like that conveyed by religion and which, at least in the Western world, is waning, is in part compensated by parasocial relationships. Today, when "every surplus of meaning" is called a "religious experience,"[31] it is not surprising that we can see in the "worship of celebrities [...] a new form of the veneration of saints," for the gossip about relationships, drug or career problems of the glamorous, as portrayed by the media, can be regarded as having "the character of biblical stories, which must serve as parables for one's own life."[32] Although loneliness is not an adequate indicator of the probability of entering into a parasocial relationship, these relationships nevertheless bring about social isolation which, in turn, contributes to the success of such formats as casting shows. At the same time these shows fuel an escapism from everyday life. This too is a theme of the exhibition:

"The loss of the feeling of belonging to a community is an important issue for this exhibition. Instead of identifying with an interest group or a class it is common nowadays for a lot of people to feel the pressure of marking themselves – as an individual to stand out and to be extra-ordinary."[33]

27 Jean-Philippe Antoine, "Tardes Ästhetik. Kunst & Kunst oder die Erfindung des sozialen Gedächtnisses," in: Christian Borch and Urs Stäheli (eds.), *Soziologie der Nachahmung und des Begehrens. Materialien zu Gabriel Tarde*, Suhrkamp, Frankfurt/M., 2009, p. 167.

28 Ibid., pp. 167 ff.

29 See: Jaye L. Derrick, Gabriel Shira and Brooke Tippin, "Parasocial relationships and self-discrepancies: Faux relationships have benefits for low self-esteem individuals," in: *Personal Relationships*, 2008, 15, 2, pp. 261–280.

30 Ibid., p. 276. The authors refer to their research desideratum: to discover what the potentially positive as well as negative consequences of parasocial relationships might look like.

31 Sloterdijk, op. cit., p. 689.

Detail from *The One & The Many* at the Submarine Wharf, Harbour of Rotterdam/Museum Boijmans van Beuningen, 2011.
Actors portraying a single teenage mom and car mechanics.

Against this background, it is not surprising that many people are better informed about a star's latest cosmetic surgery than the health of their immediate neighbor.

Exclusion

Exclusion is one of the problems that our society needs to solve. In the exhibition the visitor is equally excluded from the world of the *Plattenbau* and the world of the rich and famous, both of which exist behind closed doors. There is no inside outside, and no outside inside. Although visitors can walk around the ballroom, they have no *entrée* to the actual party so they find themselves in a quasi-inclusion, a phony integration. In this way the exhibition visually takes up the issue of the pseudo-democratic mechanisms of TV corporations and the illusoriness of the celebrity world. If we applied a probably obsolete model of social classes here, we could conclude that the underclass excludes us no less than does the upper class. Here we have the social reality – conditioned by neo-liberal structures – that has been looming for years in the Western world in a nutshell: the disappearance of a middle class that formerly comprised much of society. The middle class no longer exists, for only the rich and the poor remain, the result of a "breathtaking widening of the income gap" which Pierre Bourdieu noted more than a decade ago.[34] However, it is Elmgreen & Dragset's view that a working class, in the original sense, no longer exists:

"We have no working class anymore, I would claim. It died with New Labour. With all its class dignity it disappeared. No one is really proud of being third generation coal miner or steel worker today. It all turned into lower-middle-class norms. Not that anyone from a lower income group would earn more today than before but the identity of the working class has vanished. Even capital is more centralized than before – with bigger social differences as a consequence. It seems like the values, when

32 Graw, op. cit., pp. 174 f. As part of the events accompanying the exhibition *Celebrity*, and in cooperation with the Roncalli Forum Karlsruhe, a podium discussion took place on 6 January, 2011 at the ZKM bearing the following title in the form of a question: "Celebrities – The New Gods of Today?" The event made clear the qualitative difference between the veneration and even worship of celebrities and Christian or other religious faiths with all their social and individual significance.
33 Michael Elmgreen and Ingar Dragset, March 21, 2011 in an e-mail to A.B.
34 Pierre Bourdieu, *Gegenfeuer. Wortmeldungen im Dienste des Widerstands gegen die neoliberale Invasion*, Universitätsverlag Konstanz, Konstanz, 1998, p. 116.

it comes to morality, dreams and political opinion have all become very middle class – the mindset of a 'petit bourgeois' but taken over by a population who actually have no means and no economical power."[35]

Considering the mounting debt of German households in recent decades, the display value of supposedly middle-class goods such as houses, cars, expensive brand-name clothing and jewelry as status symbols proves illusory, since they are financed to a considerable degree by borrowing. Because of the erosion of the middle class, the question of inclusion or exclusion has become more virulent than ever in many social spheres. Financially precarious circumstances dictate whether people can afford to participate in cultural and sporting events, to go on vacations, to enjoy a good education – or not. Naturally, one could succumb to the "illusion of a hitherto unachieved level of inclusion," as the social scientist Niklas Luhmann suggests, yet "exclusionary effects [can form particularly] at the margins of the system." "For actual exclusion from a functional system – no work, no monetary income, no ID [...], medical and nutritional underprovision – restricts what can be achieved in other systems and defines more or less large parts of the population who often also live in separate neighborhoods and so are rendered invisible."[36] Luhmann finally considers that "within the area of inclusion, human beings [seem to] count as persons," whereas in "the area of exclusion they [seem to] matter almost only as bodies."[37] We find a visualized analogy of both these assessments in the exhibition, not only in the absence of people in the *Plattenbau,* but also in the emptiness of the ballroom: while the assembled high society laugh and party behind the frosted glass doors, two gilded bronze statues of maids stand alone in the ballroom. Only their corporeal presence matters and only their physical services are important; this is emphasized by the material-statuary of the sculptures, which are casts of women originating from continents and countries from which domestic service workers are commonly sought: Africa, Mexico, the Philippines, and the Ukraine. These regions and countries, some of which were also formerly European colonies, rank among the newly industrialized countries and the so-called Third World. Again, the ever-prevalent principle of inclusion and exclusion is reflected here. The motif of exclusion is closely tied to the history of Western civilizations. Prime examples include the ongoing conflicts and tensions on borders where the First World meets the Second or Third World, such as the American-Mexican border or southern Europe. Ingar Dragset confirms that this global problem can also be experienced on another level in everyday life. He sees London, which along with New York is probably the best example of a multi-cultural city, as a city of exclusion: "The VIP door is locked. That's how London works. Every time I'm here, I find myself going to parties. Either I'm too late because everything closes early – or you don't have the 'code name' to get into a place. [...] London is all about exclusion, isn't it?"[38]

Narratives

The exclusive world of glamour and show business feeds off stories, gossip and rumors. *Celebrity,* however, tells other stories – stories of longing, of loneliness and illusions. Narrative has played an important role in the work of Elmgreen & Dragset from the beginning of their career. The bearer of these narrative elements has always been architecture and furnishings: "Architecture tells the story!" the duo has declared. Accordingly, the exhibition, especially the ten visible rooms in the *Plattenbau,* contains numerous stories that contribute to the multiple levels of *Celebrity.* Referencing various earlier works, Elmgreen & Dragset have said:

"In general we prefer to create art works which can function on various levels and can be read from different angles. When we make a Prada shop in the middle of a desert, even the truck drivers who pass it on Highway 90 stop their lorry to take a closer look at this strange shop

35 Michael Elmgreen and Ingar Dragset, March 21, 2011 in an e-mail to A.B.
36 Niklas Luhmann, *Die Gesellschaft der Gesellschaft,* Suhrkamp, Frankfurt/M., 1998, pp. 630–631.
37 Ibid., pp. 632–633.
38 Ingar Dragset in: *How Are You,* a film by Jannik Splidsboel, Copenhagen, 2011. This statement was made in the context of the exhibition *Too Late,* which took place at the Galerie Victoria Miro in 2008 and was intended as a commentary on the culture of exclusion.

selling fashionable high-heeled shoes and expensive handbags. [FIG 5] But they might not even know Prada and what the brand stands for. The truck driver most likely doesn't know about how Prada as a fashion brand was a key topic at art biennials during the late 1990s and how its minimal, discreet and good-taste design has been the gallery owners preferred dress code for decades. And many of those who see the shop might not think about the link between the shop's box-shaped interior and the minimalist Mecca of Donald Judd in Marfa not far away. But they get an experience out of it anyway. As a strange phenomenon – a kind of mirage – here in the middle of the desert landscape. The narratives in *Celebrity* at ZKM as well as in *The Collectors* in Venice are important to us – as the narrative layers constitute a certain kind of logic throughout the show – they spin the different elements and threads together. But that doesn't mean that the exhibition cannot be de-coded by the viewer beyond these stories, which are embedded in the exhibition. Some might look at parts of the show more like symbols in a social critique – others might focus on the spectacle aspect – while others again choose to go deeper into the many stories which unfold if one spends a longer time with the works."[39]

So let us take a closer look, and cast an uninhibited voyeuristic glance into the flats of the absent tenants, whose furnishings Elmgreen & Dragset assembled as carefully as they would when composing a portrait.

He is single, has never been married, is a chain-smoker and beer drinker, who watches sports shows all day long and still lives in the 1970s, when he and his buddies were still agile and athletic.[40] Anton Pilz finds it embarrassing that after so many years with his old company he is now a recipient of Hartz-IV welfare assistance. He is 58 years old and drinks a cold beer on his greasy leather sofa, over whose armrest hangs his sweaty, yellowed, ribbed undershirt. On the disposable lighter we can see, in the charmless light of an energy-saving lamp, the decal of a plump busty girl.

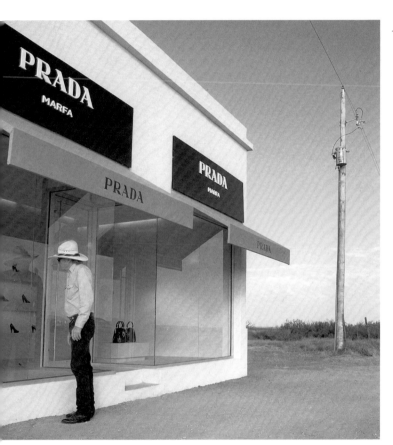

5 **Prada Marfa** 2005. Adobe bricks, plaster, aluminium frames, glass panes, MDF, paint, carpet, Prada shoes and handbags. 470 × 760 × 480 cm. Sealed mockup of a Prada boutique, located in the vast American desert near Marfa. Courtesy of the artists, Art Production Fund, New York and Ballroom Marfa, Texas.

39 Michael Elmgreen and Ingar Dragset, March 21, 2011 in an e-mail to A.B.
40 This and all the other narrative descriptions are free associations and could, of course be imagined quite differently. The names come from the doorbell nameplate at the entrance of the house.

While her neighbor imagines himself as a super jock, Miss Wong dreams herself into the glamorous world of the beauty queen depicted in the poster hanging on the rear wall of her kitchen over a rice-cooker. Judging from the few dishes on the sink, we see she lives alone, too. She came to Germany a couple of years ago with her family, but her parents and siblings have moved to another city because of work. They meet up as often as possible, but Miss Wong's workdays are long. She needs two jobs in order to earn a living and to send some money home. She therefore needs to divide her time economically: the flat screen hangs above the dinner table so that while she eats she can learn a few new songs from the repetitive karaoke videos.

Prowling further about the house, we hear a din of music thudding against a window: announced by a mix of pounding beats, snatches of Carl Orff's *Carmina Burana* and popping sounds, it's the ultimate TV show – *X Factor*. Here are the "stars" of tomorrow, giving their all before the camera – girls howl and shriek, singing for all they're worth, guys undress and display their sculpted torsos, all to become real stars. The room is clean and tidy, everything nicely arranged. After Britta Schmidt gave up smoking, she treated herself to new furniture – exclusively from the four big Scandinavian letters. She wanted everything to look a bit smarter, very fashionably minimalist, like it is now. The gray square on the wall was her own idea. She has hung framed photos of her daughter on it. The place of honor, however, above the sofa, is reserved for her ex, whom she still thinks of with nostalgic longing.

There is still time before coffee at three-thirty, but the cake can already be put on the table – Mrs. Stemmer allows herself this little treat even if her pension is now of far less value. The old lady has lived in this building right from the start. Back then, naturally, with her husband, but he has now been dead for a while, as have many of her former colleagues from work, so the telephone hardly rings any more. But the wall plates are beautiful, aren't they? She has brought them back from various holidays, and the clock too, by the way. The scarf she's knitting is for the charity bazaar in autumn.

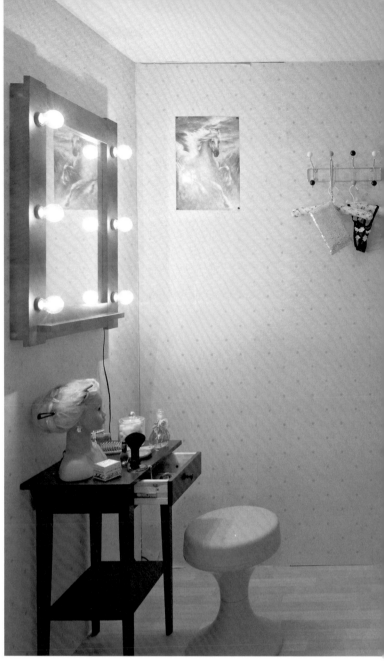

6 Interior detail of the flat in the apartment block, *Celebrity – The One & The Many*, ZKM | Museum of Contemporary Art, Karlsruhe, 2010.

Because rents in the city center are too expensive, Inge and Klaus Walter had the idea of setting up the treatment room in their flat. Fortunately, Mr. Walter's parents gave him some money so that he could afford a new massage table.

Pink is her favorite color. It makes the room look somewhat playful, but that's how she likes things. When she puts on her blonde wig and wears her black *negligé*, the guys forget the surroundings anyway. And in any case she's only doing this until she's finally been discovered and can get out of here. The neighbors with their constant staring are a real pain in the neck. [FIG 6]

To get out – that too has long been Hakan Celik's dream. But the supermarket employee doesn't earn enough to afford the trip to Australia he longs for. The screen saver on his PC, however, is an underwater video of the Great Barrier Reef: that's where he wants to be. And once he's there, he might not come back at all – once he's learned to surf and found his dream girl and made a lot of money.

A cheap ceiling mirror from a DIY superstore is glued above the bed. It provides that extra kick in love-making on the faux-fur coverlet. There are condoms at the ready: better to stay safe. The dream boy, whose picture graces the back wall of the room, doesn't really look like his boyfriend Jürgen Frisch, but Franz Bauer is still quite happy.

These and all the other stories are individual interpretations and could of course be quite different. "I would not like to have a palace, for in this palace I would live in only one room," Jean-Jacques Rousseau has Émile say in his eponymous novel;[41] the inhabitants of the *Plattenbau* do not have this freedom of choice. As Elmgreen & Dragset emphasize in the above quote, a common motif connects the diverse narrative levels to be found in the building. One such characteristic strand is longing, the longing for another world, which touches on the notion of escapism. Life in the here and now is more or less frustrating for the *Plattenbau* tenants, the desire for a change of time and place can be sensed everywhere. One reason for this sort of escapism is the loneliness that can be felt in every flat. Each inhabitant lives in his or her own little world, only made more depressing by the glamour of celebrity.

Appearance and Knowledge

While no one is really interested in the *Plattenbau* tenants' stories of loneliness and exclusion, stories from the world of celebrities sell like hot cakes. Their cosmos is based mainly on illusion and appearance, and maintaining both to the point of manipulation and creating deliberately false pretenses. Yet "appearance is not the product of perception, but an epistemological category."[42] Here, we flash back to another time. In a fictional conversation between Socrates and Glaucon, Plato has his teacher recount the allegory of the cave, in which people are constrained from birth to see only the shadows cast by things that are moved in front of a source of light, a fire; they cannot see the things themselves. The parable tells us a great deal about the extremely restricted perceptions and experiences of the cave dwellers, but little to nothing about the agents behind the scenes. This parable, probably one of the most influential philosophical texts ever written, begins with a consideration of manipulation, appearance and illusion.[43] The prisoners of the cave see only the shadows of objects, which they take to be real because they know nothing else.

The shadow projection *Reception* in the exhibition *Celebrity* constitutes a sort of link between the Platonic cave, which is actually an epistemological hell where prisoners see only shadow images, and the celebrities' world of fake appearances. Everywhere in this glossy world of appearance, things and people are fake, air-brushed and made up, with lips and breasts injected; failures are turned into success; tales of domestic bliss fabricated, and so on. Interestingly, the origins of celebrity culture coincide with the shift from an economic framework of real capital to one of financial capital increasingly operating with fictive money which, in part, contributed to the still lingering crash of financial markets in 2008 –

41 Jean-Jacques Rousseau, *Émile: or on Education*, Basic Books, New York, 1979.

42 Thomas Mayer, *Die Inszenierung des Scheins. Voraussetzungen und Folgen symbolischer Politik. Essay-Montage*, Suhrkamp, Frankfurt/M., 1992, p. 31.

43 Plato, *Republic II*, Loeb Classical Library, no. 276, transl. Paul Shorey, Harvard University Press, Cambridge, Mass., 1980, pp. 118 ff.

despite their differences, both are worlds of appearance. I have already suggested the proximity of the spheres of celebrity and art. With this in mind, Elmgreen & Dragset – as participative observers, as it were – talk about appearances in the art world:

"It is very easy for an art professional today to get sucked into the whole reception, VIP and glamour side of the art world but it is important to consider that part – as only a 'shine' [a pun on the German *Schein*, appearance. Transl.]. The art world exists outside the art fairs, the gallery openings, MoMA benefit parties or the cover of Art-Forum. Art is produced and viewed in a huge number of small project spaces, is discussed in dirty bars, is taught to students in art schools, is made as experiments and viewed on blogs and in other unauthorized media by a lot of people who just happen to be interested in contemporary visual statements. But exclusion within the art scene is part of its reality, too."[44]

Just as the world of celebrities is based on appearance and show, and the more or less adroit staging of one's own personality, this social construction also corresponds to the technical realization of the exhibition, as the illusion of the magnificent ballroom only functions from within. When viewed as a whole from outside, the fake becomes apparent through the disclosure of the wall construction. [FIG 7] The chandelier, too, only looks expensive at first glance; it is in fact a confection of simple, gold-painted metal and plastic crystals. And the magnificent-looking fireplace is actually made of MDF panels. This is a world of show, of appearances, a world that, according to Plato, should be left behind.

The exhibition is a total simulation in its staged realities. The term simulation is ambivalent in that it has the connotation of false pretences, but it also has a positive meaning, as in a scientific context where a physical, psychological or other situation is constructed virtually – simulated – so as to gain important insights. Simulation

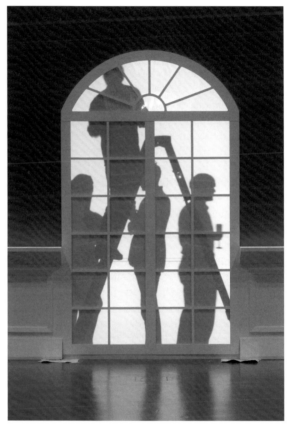

7 Technician installing video display in the ballroom section of *Celebrity – The One & The Many*, ZKM | Museum of Contemporary Art, Karlsruhe, 2010.

44 Michael Elmgreen and Ingar Dragset, March 21, 2011 in an e-mail to A.B.

and appearance are not synonyms, yet they are closely related – and in this exhibition appearance serves insight. Since art can hardly operate any longer through direct provocation, but rather through subtle affirmation, in *Celebrity* two simulations accordingly confront one another: the sphere of the many, financially less well-off people in their social housing building, and the sphere of a single, wealthy and famous personality. Analogous to the distribution of capital in most societies, the available space is also unequally distributed here. In his *Aesthetic Theory*, in which Theodor W. Adorno provided both a social critique and a theoretical foundation of modern art, he pointed out the connection between the appearances of art and the bedazzlement of society.[45] Norbert Bolz, in his discussion of Adorno's theories, sums up the idea as follows: "The self-confessed semblance of art is the mask of truth in a society of total appearance."[46] Appearances can, as we have seen, serve truth, provided that appearance is recognized as such. While the *Plattenbau* in the museum is fake, since its authenticity is mere pretence, in its confrontation with the ballroom it stages a social reality which is critical through its very polarization.

In art history, Benjamin H. D. Buchloh has formulated similar thoughts. He drew up a definition of modern sculpture that applied to Vladimir Tatlin as well as to Marcel Duchamp and that is still essentially true: "... the dialectic of sculpture between its function as a model for the aesthetic productions of reality (e.g., its transition into architecture and design) or serving as a model investigating and contemplating the reality of aesthetic production (the ready-made, the allegory). Or, more precisely: architecture on the one hand and epistemological model on the other are the two poles towards which relevant sculpture since then has tended to develop ..."[47] Both tendencies would ensure that traditional sculpture becomes superfluous. Here we can see that Elmgreen & Dragset's sculptural installations in *Celebrity* form a synthesis of Buchloh's oppositional diagnosis, for in *Celebrity* we are not only dealing with an architecture, but also with an epistemological model that makes us see reality for ourselves.

The End

In this essay I have repeatedly drawn on art-historical references that illustrate how the *Plattenbau* and the ballroom of *Celebrity* fit into various traditions of Western art. In its specific links to various stylistic, formal and theoretical models that go beyond the sphere of the visual arts by integrating participatory and performative strategies, along with the inclusion of socially critical themes, *Celebrity* – together with the first two parts of Elmgreen & Dragset's trilogy – represents a singular position in international art in the realism of the *Plattenbau*, the theatrical staging of the ballroom world, the Platonic presentation of celebrities, the various narrative levels that unfold in the social housing flats, the inclusion of the visitor in the scenery as a voyeur and as a participant in the performances, and various other aspects. In his interview about the exhibition, Paul Virilio says that in the future celebrities will be replaced by celebration. People, individuals, will then no longer play a role. The exhibition *Celebrity* reflects this increasingly complex society, with its sometimes contradictory, even paradoxical developments, and the question of our future – on both the individual and social levels. Good art poses good questions. We must find the answers for ourselves.

Translated from the German by Jonathan Uhlaner.

45 Theodor W. Adorno, *Gesammelte Schriften*, (ed. Rolf Tiedemann in cooperation with Gretel Adorno, Susan Buck-Morss and Klaus Schultz), Suhrkamp, Frankfurt/M., 1997, vol. 7, pp. 199 f.; *Aesthetic Theory*, trans. & ed. Robert Hullot-Kentor, University of Minnesota Press, 1996.
46 Bolz, op. cit., p. 132.
47 Benjamin H. D. Buchloh, "Michael Asher and the Conclusion of Modernist Sculpture," in: Richard Hertz (ed.), *Theories of Contemporary Art*, Prentice-Hall, Englewood Cliffs, 1985, p. 227.

Celebrity (over) Culture

Peter Weibel

Assuming that modernity began around 1800, and that the cult of fame has now been in business for roughly two hundred years, we may conclude from this shared period of modernity and celebrity culture that celebrity is an epiphenomenon of modernity. The history of celebrity belongs to the history of modernity. That modernity and celebrity form a common epoch is conspicuous.

Fame and recognition are terms which, in the centuries leading up to modernity, were used to refer to those individuals who had made a mark for their outstanding achievements in science, in culture or in war. Every decade or century brings forth only a few such individuals, which is why they are referred to as elite. Honor, fame, and recognition for achievements are not the same as glamour and celebrity. Like modern culture, the transition from fame to celebrity is linked to the ascendency of the media of mass communication, to the city, to democracy and to capitalism all of which has resulted in "the society of the spectacle" (*La société du spectacle,* Guy Debord, 1967). Interestingly, the word "spectacular" appeared for the first time in the *Oxford English Dictionary* in 1901.

We can precisely determine the date of birth of the century of the spectacle, and of the scandalous, which led to celebrity. *The School for Scandal*, by Richard Brinsley Sheridan, the most successful eighteenth century comedy of manners, was first performed in 1777. The title refers to a group whose members took pleasure in undermining the reputation of innocent people by way of weaving an intricate web of fabrication, and who had perfected such gossip to a high art. The above-cited play testifies to the fact that scandal and gossip, intrigue and impropriety, lies and illusions have comprised the essence of celebrity culture from the outset.

Even the playboy, that hero of the initial phase in the dominance of celebrity over culture is no contemporary phenomenon. John Millington Synge's *The Playboy of the Western World* was published as early as 1907. It was the

paparazzi and the mass-illustrated magazines of the 1950s and 1960s that first made the playboy the linchpin of their reportage, and, consequently, the focus of adolescent dreams and phantasies. Thus, while celebrity is not a contemporary phenomenon, it has exploded in the present-day only because, from being formerly restricted to an elite phenomenon, it has now evolved into a phenomenon of the masses. The title of the exhibition by Elmgreen & Dragset is significant since today, celebrity pivots on the relationship of *The One & The Many*. Clearly belonging to the development of modern culture are those conditions which similarly make up the ingredients of celebrity culture.

Celebrity and the Media

The logic of fame, the inception of which can be traced back to mid-eighteenth century London and Paris has remained unchanged until today: building on mass-media communication, initially in the newspapers and their gossip columns and later on the television, "scandalous" behavior is rewarded by mass-media attention. Thus, newspapers are required to generate scandals which the masses then understand. Instead of acquiring respect and recognition by virtue of achievements, fame is celebrated for its scandals. This is because scandals arouse the reader's attention. Newspapers search for scandals, which they in fact initially produce themselves through publication for the purposes of acquiring greater numbers of readers. Public and newspapers converge towards the lowest common denominator. The celebrity adept is quick to learn that, actually, there is no achievement, but rather that celebrity replaces respect and achievement and that one is rewarded for *no* achievement at all. In other words, for the first phase of the cult of celebrity we may determine that cities and urban life are required for the existence of newspapers, which then report on urban life; for these reports to be read, city dwellers were required, something that, in turn, necessitated the corresponding events for public attention the main sources

Screen shot, www.newsoftheworld.co.uk, 2011

of which were derived from culture and the fashion industry. Politicians and economic forces, however, could afford neither scandal nor misbehavior. For this class of individuals pre-modern categories were still valid, such as fame and honor for accomplishments achieved. Politicians and business people would have been toppled by scandals, and they could never really have become celebrities. Hence, it is for this reason that until today grand social events such as balls and awards ceremonies to which only politicians and business people are invited remain somewhat plain and unglamorous events. Only representatives of culture and fashion work for the needs of the gossip columns. For them every scandal is in the service of fame. Scandals are what make stars, from nude photographs through to alcohol excesses. Thus, society divides itself in two classes: the famous and the not famous. Only members of the cultural class (singers, actors, etc.) can be adopted into the celebrity class. Hence, every event which the mass media designate as v.i.p. requires the presence of singers and actors to guarantee glamor and celebrity. Within this celebrity class there are various other gradations: a-list, b-list and c-list celebrities, etc.

Celebrity as Effect of Distribution Technology

Celebrity is, in other words, the product of culture and technology, or mass media communication. The new technologies of distribution, the mass media are the fundamental mechanisms, the carrying media of the celebrity. Formerly, the singer and the actor were referred to as the "travelling people," since, prior to the invention of radio, record, television, video, CD, DVD, etc., the singer or actor had to be physically present in front of an actual public. They would consequently speed throughout Europe, from court to court, from day to day, to exhibit their arts to a paying public. A new local public had to be found every day. Nobody could become rich this way. The local public was too small to be able to earn a living from it.

With the emergence of the city the mass of local spectators was such that singers and actors were no longer obliged to travel and could remain at a fixed location. The *stagione* business consequently came into being. Dancers, singers and actors were attached to one house (opera, theater), at one location. As a result of this they could at least be "decently" remunerated. Through numerous returning visitors and reviews by the dailies they became locally, nationally and even internationally famous, as noted in such examples as Alexander Girardi, in Austria and Sarah Bernhardt in France, who also achieved fame following her tours through the USA.

And yet, from around 1900 onwards, technological inventions were made which began to make touring superfluous. By way of the magnetic tape (1901) a voice could be recorded and stored, likewise on the record (1909). With the magnetophone and gramophone, the voice could be played back. The message, the spoken or sung language no longer required a messenger to travel. The body of the singer remained at home, and the voice travelled solo. The voice could be multiplied millionfold. With the aid of a record, the singer, who until then made only one appearance for which he received one evening fee, could make an appearance a thousand times in one evening, could be played a thousand times and receive an evening fee a thousand times. The technical carrying medium reproduced the voice of the singer, but more than anything else it distributed and disseminated his voice. The singer, at least his voice, multiplied itself. The first singer stars were Enrico Caruso or Beniamino Gigli.

The effect of multiplication, of being able to make an appearance everywhere and at the same time, was enhanced by radio and television. Now, in one evening, a million people could listen to the singer on the radio or see him or her on television. In the 1950s and 1960s, TV stars, showmasters, talk show hosts, etc., began to make their appearance. The importance of the local public waned in comparison to the "virtual" non-local public, which was not present on site.

So long as footballers were confined to playing in a stadium and played in front of a real audience, their earn-

ings were low; they were not stars and did not lead a life of luxury. Thanks to television, they now play in front of millions of spectators who are not at the stadium, but at home in front of the television and who nevertheless still pay by way of television license fees. The number of "virtual" (non-local) visitors to the football match eventually by far exceeded the number of locally present visitors. And through its licensing fees the medial public generated a far greater profit than did local stadium visitors. At the same time, footballers have become advertising media because they can be seen for almost two hours on the mass medium of television, and earn even more from this, both inside and outside the stadium. Consequently, footballers become millionaires over night, far wealthier and famous than a professor, research scientist or inventor could ever become. Solely by way of distribution technology, from radio through to television etc., singers, athletes, and actors can multiply themselves almost to infinity, and such that they no longer have to themselves appear before a public. Record players, videos, CDs and DVDs etc., are enough. Without this electronic distribution technology there would be no celebrities. This is, in fact, the real medium of celebrity – far more than the newspaper. Newspapers created their own heroes, namely, singers, writers, actors and industrial magnates, who publically display their life or their wealth. The film industry, however, created a new category of celebrity: the film star. Thus, what we see is the advancing industrialization of fame. The consumer industry of mass media created an industry of celebrity in the twentieth century.

Celebrity and the Gossip Industry

What became evident over the course of this development is that it is the private life of the stars which interests people more than their professional life. What the masses find most interesting in the private life of the stars is their most intimate, sexual life. Ever since the appearance of Oscar Wilde's *Lady Windermere's Fan. A Play About a Good Woman* (1892), sexual liaisons, infidelities, adulteries, etc., have not only become the object of high culture, but also of the yellow press and the tabloids. Essentially, the celebrity industry was a gossip industry and the gossip referred increasingly to the sexual behavior of the protagonists. Only recently have alcoholic or pharmaceutical aspects joined the private sexual. Alcohol, drug consumption, and sex addiction became the most favored topics of the celebrity press. Celebrity became a synonym for scandal.

High culture recognized early on that scandal was the gateway to fame. Lord Byron (1788–1824) was among the first to celebrate the options of fame in all openness through his work and influence, through his books and his private life. He was emulated during the nineteenth century by French poets and painters of the likes of Rimbaud and Manet, Baudelaire and Gauguin. Whether *Les Fleurs du Mal* (1857) or *Le déjeuner sur l'herbe* (1863), public scandal now emerged as the ideal of fame. Henceforth, a "scandalous" life, especially a scandalous love life – whereby "the scandalous life" was itself a media construct – belonged to the repertoire of fame. Today, one does not even require a scandalous work as one did in the nineteenth century; today a scandalous love life is enough, as the example of talentless pop singers demonstrates. The industry of fame has become so hungry and greedy that it devours everything with the result that the existence of talent and work is no longer held in esteem. In many cases dyed blonde hair and cameras thrust up against artificial breasts suffice as required credentials for becoming a member of the celebrity family. Rock singers without talent, but periodically attached to famous models, footballers without fortune, but attached to former singers, actors without roles, but attached to ex-rock singers all make their living in the reality TV series and in talkshows. Today, the celebrity family propagates itself not only through newspapers and magazines but, above all, through television. To ensure that fame does not fizzle out altogether, from time to time recourse is made on Youtube to shows of alcohol excesses, lapses into drug abuse or recordings of private porn sessions.

The lesson of the fame factory has been understood: the formula for success is "private is porn."

However, art paved the way for this equation. Artists have likewise learned the lesson that the masses have no interest in the work itself and in professional life, but in sexual private life and thus declare their private life as their work for the purposes of evoking mass-media attention, and to infiltrate the circle of celebrity. To this end, Tracey Emin, for example, exhibits her bed together with the name of her lover in the Tate Gallery London (*My Bed*, 1999), or Elke Krystufek masturbates at the exhibition opening in the Kunsthalle Wien in front of the public (*Satisfaction*, 1994). The museums therefore subject themselves to gossip tabloid tastes so as to achieve public, namely, medial attention. Art has for a long time been part of the trash department of celebrity culture. This trend is further endorsed by the vulgar taste of the purely private collector (in midlife crisis). The fame factories, based on Andy Warhol's Factory and his superstars of the 1960s, is today satisfied with the talentless of lower-class television in search of ever new superstars (*Pop Idol, Star Search, X–Factor, DSDS*). Today, the celebrity machine churns out a new celebrity at twenty-four hour intervals; it has become a mass production machine. Whereas fame was an affair of the few throughout the eighteenth and nineteenth centuries, today it is an affair of many. The gossip columns of the mass media newspaper (introduced around 1900), signaled the beginning of this new industry of fame without achievement, which as a consequence of film and television, namely, audiovisual mass media, would later lead to unforeseeable depths.

In some senses, the film *High Society* (Charles Walters, 1956) came too late, since, by 1960, the social register of the select few had long-since vanished and been replaced by mass culture. The year 1960 in which the film *La Dolce Vita* by Federico Fellini was released, marks the ascendancy of the party girl and paparazzi epitomized in the *Sweet Smell of Success* (Alexander Mackendrick, 1957). Paparazzi and gossip reporters were the new bouncers for the halls of fame in which film stars, wealthy industrial-ists, down at heel aristocrats, boxers, racing car drivers, playboys, starlets and models celebrated. With massive telephoto lenses, the paparazzi zoomed in on the stars' moments of weakness. They would lay in wait in front of hotels, discotheques, bars, and swimming pools just to catch the stars in a state of vulnerability, of collapse, of accident. "Disclosure" became a profession of the paparazzi, a paraphrase of *Mrs. Warren's Profession* (1894), as George Bernard Shaw would refer to prostitution in a famous play. *Vile Bodies*, so ran the title of Evelyn Waugh's novel (1930), populated the gossip factories.

The art of painting (for instance, Gustav Klimt and Egon Schiele) was also to increasingly become a social register, mirroring the famous of an era, culminating in Andy Warhol as the visual gossip columnist of New York high society. It was not for nothing that Ron Galella, the infamous gossip column photographer, was the favorite photographer of Andy Warhol. The latter knew full well that with his silkscreen paintings of celebrities, such as Elizabeth Taylor or Jacqueline Kennedy, he shared his motifs with Galella or that he was competing with the latter for the same subject, and that he was thus the Ron Galella of painting. Galella was the gossip photographer, and Warhol was the gossip painter – the painter of the gossip columns. He would attend all openings, just to appear in all the gossip columns. "I even go to the opening of a toilet seat," he once said of himself. Hence, Warhol ran his own Fame Factory with films, records and gossip columns (*Interview* is the name of his gossip magazine), and so himself became judge of a social register the influence of which would spread across to Europe. There is hardly an industrialist in Europe who does not have a Warhol portrait of himself just so as to clearly underline the fact that he also belongs to the mass media fame machine, the mass media high society, the high society of gossip.

And yet it was not only the stars of the silver screen and other heroes of the mass media, such as athletes, who were to profit from the mass media fame machine of the first half of the twentieth century. Politicians as well, above all dictators such as Mussolini and Hitler, recog-

nized the political value of celebrity and honored them-selves as media stars for the new mass media radio and film. With studied, grandiloquent gesturing and mimicry, with exaggerated voice, and those uniforms and haircuts with which we are today so familiar among pop stars of infantile repression (Michael Jackson for example) on television, they evoked the singularity of their star status. In the mass media age of film and television, politicians make their appearance much like media stars, without, that is, being subject to the daily or weekly commentaries and critiques of their acting talents. Since they make their appearance first and foremost as actors, and not as politicians, politicians should be criticized as such. Their thespian talents are honored only before elections during television duels.

The canons, the criteria and the power of the celebrity were introduced in all social fields, from the economy to science. After and alongside film and television, sport, music and fashion are the most concentrated capital fields of celebrity. Art and culture have been marginalized by the celebrity industry because the revenues of living star artists cannot keep pace with those of mass media stars, with The Beatles, for instance. The revenues of the most famous artists, composers and writers cannot be compared to the revenues of pop musicians such as Michael Jackson, or sportsmen of the likes of Tiger Woods and Michael Schumacher (900 million Dollars upwards per year). The biographies of sporting heroes and rock stars go into mega-editions compared with literary bestsellers. "The Race is run" (Mary Wollstonecraft): Armani over Arman, Versace over Verdi ... the celebrity culture has triumphed over culture.

Celebrity and the Public

What celebrity requires above all else is a medium. The primary media of fame were painting and sculpture. For centuries, if not from time immemorial, in public spaces we find statues of personalities in honor of their achievements, and to perpetuate and immortalize their memory as politicians, poets, scientists and artists deserving of remembrance. Thus, painting and sculpture are primary media of immortalization, the function of which is to commemorate the achievements and data pertaining to important personalities or events of historical significance.

Until the emergence of photography, it was chiefly the preserve of particular social classes, the aristocracy, high-ranking military personnel, high clergymen, and the upper classes to be represented in prestigious paintings and, if possible, to thereby achieve immortality. In public squares and in churches those paintings and sculptures can be seen which served to immortalize the fame, the social status and the deeds of those portrayed and to convey this to the general populace. Celebrity, therefore, requires a medium, a technical carrier medium. In former times, this would have been painting and sculpture. Today, it is newspapers, television, posters, radio, film and the Internet. Painting and sculpture were locally tied: the public were required to journey to the sites of fame, whether battlefields, paintings in churches and palaces or sculptures in public squares. The new media of celebrity, by contrast, are not locally bound; they come to the public. The new media of celebrity are the media of distribution. It is through these means that they reach an infinitely larger public. The mass media are the media of celebrity for the masses. Before mass media became widespread, fame was to a certain extent an affair of select clubs. Famous personalities numbered only a few select individuals, but so also was the size of the public relatively small. Fame was an affair of the "happy few." Fame, however, not only requires a medium, but a public as well. Without a public there would be no fame. Technical changes to the medium of transmission, from a locally bound medium to a placeless distribution medium, similarly initiates changes to the character of celebrity: one may become famous without any achievement at all. It is this status of fame that is called celebrity. If someone is famous today this does not mean that he has achieved anything extraordinary, but only that the media ceaselessly report on him.

Just as the medium of celebrity has transformed itself, so also has the character of celebrity and, by extension, the public as well. These days there are no masses of fourteen-year-old girls who drop to their knees in fits of hysteria to applaud a saint, as witnessed at pop concerts with the singer and his band. Today, all around the globe masses of underage girls faint when worshipping an underage singer. No classic writer, to say nothing of a scientist or philosopher, would have been so admired, so rich and so famous during his life as a dozen or so male or female teenagers per year are in our time; this can be seen in the example of seventeen-year-old pop singer and actor Justin Bieber, who became famous with hits such as *Baby*, *One Time* or *One Less Lonely Girl*. Justin Bieber has written his biography even before he has begun to really live. This biography will be read by millions of girls who have similarly not yet begun to live. In other words, celebrity is an implant of simulated life in a real life that is none. In the age of media hysteria, there is also a kind of hysteria of fame. It is called celebrity. Celebrity is the cult of fame in the absence of achievement, the cult of fame through the masses, the cult of a fame of everybody, namely, the elimination of achievement as the actual source of fame in the name of mass tyranny. But how did this come to pass?

Painting, Photography and Celebrity

Originally, painting and sculpture were the media of fame. Their function could only be fulfilled, however, so long as there was a public that paid tribute to it, and which desired to know something of the life of the famous.[1] In other words, in addition to a medium and a public fame also required agents in the form of the painter, the sculptor, the author who captured the acts and the achievements of the famous, and who conveyed to the practically pictureless and illiterate masses something of the life and the ideas of the ruling classes. The artist and the author divided between them the tasks of conveying the life and achievements of the famous to

the non-famous. The portrait painter was the paparazzo of the aristocracy. Consequently, the artist would have been in many cases a high-ranking and highly talented paparazzo of the elite. The paparazzo of today is nothing more than the mass media version of the court artist, who gives to the people in pictures whatever they are curious to know about the ruling classes; he is the portrait painter of the media aristocracy.

In short, today, the paparazzi's field of operation is no longer restricted to historical aristocracy, but also extends to the moneyed nobility and, above all, to media aristocracy. The paparazzi are the painters of celebrity culture. Naturally, there are sculptors and painters who are both, namely, classical portraitists and paparazzi such as Andy Warhol, for example.

With the technical transformation of the picture carrier from painting to photography, the change was also initiated from fame to celebrity. Portrait photography now assumed the function of praising and of being there formerly carried out by portrait painting. Hence, from the outset, famous individuals count among the most favored motifs of portrait photography. The first ever photographic interview took place in 1886 between the famous photographer, Felix Tournachon Nadar, and the famous chemist and theorist of color Michel Eugène Chevreul, who had played an instrumental role in the development of Impressionism.[2]

The interview is both the duty and the free choice of the celebrity. Andy Warhol's celebrity magazine bore the name *Interview*. Here Warhol sought to participate in the fame of others so as to secure his own fame. The interview is a form of literary self-expression by way of a *souffleur*, the person who asks such questions of others that leave sufficient space for the celebrity to express himself. In the reflection of the other, the sun may reflect one's own fame.

Photographic portraits are visual interviews. Here also, by means of the *souffleur's* camera, the famous individual manages to achieve visual self-expression. Added to this is the fact that both interviewer and photographer who conduct the interviews and take the photographs may

1 This is why, from the outset, one of the most influential works on the history of art is entitled: *Le Vite de' più eccellenti pittori, scultori et architettori, scritte e di nuovo ampliate da Giorgio Vasari con i ritratti loro e con l'aggiunta delle vite de' vivi e de' morti dall'anno 1550 infino al 1567*, Giunti, Florence, 1568, 3 vols.: The only full English translation of Giorgio Vasari's *Lives of the Most Excellent Painters, Sculptors and Architects* is that by Gaston du C. de Vere, London, 1912/1915.
2 In this interview, which was carried out on the occasion of the hundredth birthday of Chevreul, Felix Nadar acted as interviewer and his son, Paul Nadar, as photographer.

themselves achieve fame simply because they interview and photograph the famous, and because the public may more easily note the name of the photographer when viewing the famous. This is why portrait studies of the famous are as popular among a large public as they are among a large number of photographers. Among the well-known photographic portrait studies of famous personalities such as André Malraux, Walter Benjamin etc. taken by Gisèle Freund, who herself became famous as a result, through to the glamour pictures of the well-known photographers Richard Avedon, David Bailey, Irving Penn and Helmut Newton, we can find numerous examples of the continuation of portrait painting in photography. If fame was not enough, then the famous personality would be photographed in the nude, preferably in front of a famous painting and in a famous museum; in one of Jürgen Teller's photographs, for example, the actress Charlotte Rampling posed naked in front of the *Mona Lisa* at the Louvre. This compression of famous location, famous portrait painting and famous star is what ought to guarantee top place in the attention charts. Should this not be enough, then the naked photographer snuggles up to the naked actress in bed, as Jürgen Teller next to Charlotte Rampling, for example. These examples point exactly to those squalid transformations of portrait painting into photography. While the photographer in the media age repeats the function of the portrait painter in the age of court society, in the age of media he fulfills a new function: he not only serves the interests of those portrayed, but also the interests of the masses. These masses, however, are less interested in achievement, for example, in a Nobel Prize winner in chemistry whose discoveries heal millions from illnesses, or in the magnificent poetry of Nobel Prize winner Wisława Szymborska (1996), but far more in the mistakes of peroxide-blonde bearers of silicon breasts and inflated rubber lips. Thus, it is not Wisława Szymborska who receives daily mass media coverage, but rather Anna Nicole Smith and others.

Andy Warhol's canvas portraits based on Polaroid photographs of members of the international media

Paul Nadar, *Felix Tourchnachon Nadar, Michel Eugene Chevreul*, 1886.

aristocracy and gossip-column society (between 1972 and 1987 he had apparently produced between fifty and one hundred such schematically colored portraits per year) owe their popularity to the affirmative and servile mechanisms of erstwhile portrait painting. The age of court society continues where this, thanks to photography, assumes the function of painting. In feudal society, only a very few were able to paint portraits (the painter as expert), but also only a few could pay for one (worldly and ecclesiastic aristocrats). And yet if anybody can photograph anybody, something which the photographic apparatus makes possible, then anybody can become famous. In the age of photography, anybody can, indeed, photograph anybody, and anybody can have his picture taken. Thus runs the democratic promise of photography. As is known, before the law all are equal; now, with photography, all are equal. In contrast to the aristocratic pictorial medium of painting, photography is a democratic picture medium. Whereas, previously, there were pictures of kings, cardinals and merchants, now there are pictures of common people. The pictures of cardinals and kings are paintings in museums, churches and palaces. The pictures of normal citizens are photographs in private households and in public media. A democratization of fame begins to emerge in photography, which then, in the age of mass media, mutates into celebrity. Fame is an echo from the age of achievement; celebrity is a celebration of non-achievement in the age of mass media.

In a kind of logic of incarnation, a remarkable shift came about in the transition from painting to photography, not unlike the processes in dreams and the mind's unconscious activities. The popularity of photography reflects the social unconscious, the desire of the lower classes to achieve the status and the privilege of the higher classes through their potential representation. Whereas, in former times, only the wealthy and the powerful enjoyed the possibility of having themselves depicted in the medium of painting, the new social classes were similarly inclined to the fallacy of counting themselves among the rich and successful and to have a claim to immortality,

were they to have their portrait painted, albeit only in the medium of photography. By adopting the medium of the picture, they also aspired to inherit the fame and the social status that went along with it. As a pictorial medium, painting was unsuited to guarantee the pictorial status, to guarantee the possibility of representation of all members of society. Not everyone can paint everyone. In the world of image-making, photography, by contrast, dismantled class barriers. Unlike the aristocratic pictorial medium of painting, photography is a democratic pictorial medium. Whereas, the subject of paintings was mainly confined to cardinals, merchants and kings, photography now also depicted normal people. Initially, the fascination of photography turned on the fact that everyman could believe himself wealthy, important and powerful because a picture of him also existed. One may thus appreciate that around 1860 a wave of small portrait photographs began to emerge, that was to subsequently never achieve comparable levels throughout the world. In 1854, André-Adolphe-Eugène Disdéri invented a patent with which he was able to supply the portrait to the masses in small-format, the *Carte-de-visite*-photography. Disdéri was the Warhol of his day, a Warhol, though, for the masses, since, with the *Cartes-de-visite*, he made portrait photography affordable to everyman. Napoleon III commissioned Disdéri to take his portrait photograph in 1859. Thus ennobled, his *Cartes-de-visite* became popular overnight since, following the above-mentioned logic of incarnation, every common subject was now susceptible to the illusion of being something special if portrayed by an artist who had also portrayed Napoleon III. The association with the famous, photographically documented, apparently ensured the fame of the hitherto not so famous, since they were at least photographically close to the celebrity. The medium of photography facilitated a kind of imaginary ancestral genealogy, a forum of fame and celebrity to which many more people now had access than had previously been the case with painting. With the *Carte-de-visite* now in his hands, every person could imagine himself part of the painting gallery of the great. A calling card epidemic erupted, one

of the first forms of media hysteria, which persisted up until the 1920s.

The effects of the epidemic calling card virus, was based on the descriptive circulation of fame. Confident of the original model, namely, that only famous people were captured for posterity in a painted picture, those depicted in a photographic portrait likewise began cultivating illusions of *grandeur* about also being a celebrity. The guarantee of immortality for those portrayed became greater the more famous and eternal the painter or photographer. The result was a reciprocal legitimation. Naturally, the portrayed and the portraitist sought to secure their own importance through their fame. Thus, a multilayered cycle then emerged derived from the historical function of portrait painting. The famous seek the proximity of the famous. The photographer becomes famous by photographically copying the famous. The customer portrayed by a famous photographer thus hopes that he may himself become a celebrity. The photographer participates, parasitically, on the fame of the personality he portrays. The portrayed subject participates, parasitically, on the fame of the photographer. Portrait photography thrives, parasitically, on the famous. But it does, indeed, make famous since otherwise unknown people may become famous by way of famous photographers. Hence, essentially, this circulation of fame is a parasitic cycle, a parasitic response. In paparazzo photography, portrait photography becomes perfectly parasitic. And yet it is not solely the paparazzo that may be considered as a parasite of fame, but the public as well.

The Illustrateds or the Public as Parasite

The conservative portrait photography that had adopted the function of portrait painting, which is why I opt to designate it conservative, is thus characterized by a parasitic structure. The phantasm of the parasite is the public, since, as said, fame does not come about without a public. The hope of a public that believed in the early days of photography that it could itself become famous by means of this medium, were disappointed, since photography joined forces parasitically with print media. This happened because the image of photographic portraits in the mass media, and not just the photographic image itself produced celebrities from those they portrayed, thus introducing new class divisions: between those who are photographically illustrated in the mass media, those whose pictures cannot be seen in the media, and those who buy and read the mass media only so as to participate in the lives of those portrayed – if nothing else to at least imaginatively become a part of celebrity. Unable to prevent class divisions and class hierarchies as it had once promised, photography has only contributed to their intensification. By its use in illustrated mass media, this intensification of class divisions again divided into popular and pauperized, into stars and masses *Celebrity – The One & The Many* (Elmgreen & Dragset). The photographic interview, as mentioned above, between the two celebrities Chevreul and Nadar was published in the "journal illustré." The illustrateds are thus named, one must recall, because they not only illustrate the life of the rich and famous, but because they photograph and thus produce the illustrious. The illustrateds guarantee fame and popularity, not the photography itself, but the circulation of the photographs in the mass media. The illustrateds make people illustrious, in other words, famous. Portraits serve to guarantee portrayed fame and glamour, veneration and immortality. This function continues to be reflected today in the so-called illustrateds. Illustrious, Lat. *illustris* – standing in the light, means something like glittering. To illustrate, Lat. *illustrare*, means something like illumination, to beautify. The word luster, the designation for grandiose and glittering chandelier, stems from the word illustrious, namely, shining brightly. The word illustrated is thus synonymous with famous, standing in the spotlight of the media. This accounts for the gigantic chandelier in the ballroom installation of the exhibition *Celebrity – The One & The Many* by Elmgreen & Dragset, namely, points out the connection between chandelier, illustrious and illustrated as elements of celebrity culture. *Illustris* was also the rank for the highest

dignitary of the church and of the aristocracy. Thus, the illustrateds of today portray the dignitaries and glittering heads of media or mass society. They have assumed the aristocratic function of portrait painting. By way of this function, the mass media are a medium of class division and class hierarchy, a medial re-feudalization at the center of democracy. The poor masses purchase masses of mass magazines, in which the rich, successful and famous are photographically illustrated so as to, at least parasitically, take part in their lives. The principle of conservative portrait photography is, therefore, the parasite. The current name for the parasite is "paparazzo."

Portrait, Paparazzo and Celebrity

The practice of the paparazzi began around the mid-1950s and was linked to the rise of stars such as Marilyn Monroe, Jayne Mansfield and, above all, with European counterparts such as Brigitte Bardot, Sophia Loren, and Anita Ekberg. The uncommon beauty of these women and the desire to identify with them aroused the greed of the masses to know more about their idols and to be within their proximity. The compulsion to seek proximity then reached voyeuristic proportions. A professional class began to form signifying a vulgar invasion into the private life of the stars as disseminated by mass media. The private was perforated. Quite literally, from holes (hiding places), the paparazzi would shoot their "money-shots," as the paparazzi photographs were called, since huge amounts of money could be earned from that decisive moment, that snapshot of illegal privacy. Agencies of desire begun to emerge; a traumatic business, which, while not fulfilling dreams, did arouse them. The voyeurs of the world united as thieves, as thieves who worm their way in just to photograph especially that moment in which the stars violate sanctimonious public morality. Paparazzi publicized that which was, in fact, publically forbidden. This is what makes paparazzi photography obnoxious: while ostensibly serving a morality which pats itself on the shoulder in the name of good customs,

2 Marcello Geppetti, *Anita Ekberg's Assault on the Paparazzi Using a Bow and Arrow*, 1960.

it is at the same time desirous of amoral pictures, and through this appetite generates such pictures which then break with good customs. The paparazzi, then, were not in the service of libertinage, but in the order of things. They were the police of good customs, who themselves infringe good customs, such as decency and respect for private life, and for the standards and rules of civic life. They were thieves who stole the moments of privacy for the public. Tazzio Secchiaroli, Mario de Biasi, Marcello Geppetti and other pioneers of paparazzo photography were, however, almost magicians in the phantasmic field of pictures, which is today processed by vulgar tramps simply interested in "money" and not on the "shot."

Felice Quinto, the apparent king of all paparazzi, deserves a more detailed account. He achieved his initial successes in 1955 with photographs of Silvana Mangano. Federico Fellini even used him as supporting actor in *La Dolce Vita*, in 1960. Quinto exploited his roles so as to secretly take photographs of the leading actress, Anita Ekberg. He surprised her in a *café* in Rome embracing a married producer. The photograph was published. The ensuing *éclat* propelled Quinto to fame. Anita Ekberg surprised him with his camera in front of her house at around 5 am in the morning of October 20, 1960. [FIG 2] A well-known photograph – which I assume was staged – shows how, armed with bow and arrow and clad in a black dress and nylon tights, though without shoes, she steps towards him. After marrying, Quinto moved to the USA in 1963 with the North American teacher, Geraldine del Giorno. He remained true to his calling as portraitist of famous personalities. However, he no longer photographed in secret and anonymously, but completely officially. A series of shots of prominent visitors from Warhol to Liza Minnelli and Bianca Jagger were taken at the New York discotheque, Studio 54, during the 1970s. Ian Schrager, Studio 54 founder, claimed that his success was partly owing to Felice Quinto's spectacular photographs that had been published worldwide.

From the agencies of desire arose the industry of violation and slander, a criminal *Economy of Attention*.[3] Paparazzi are brokers of attention. They observe not only the market value of the notables, but produce them as well. But if the notable the share of accumulated popularity, sinks and disappears from the circulation of capital market prominence, the paparazzo will be the first to not waste another second on his former victim.

Scene and Celebrity

The fashionable, and today, so popular scene photography – for instance, those of Robert Mapplethorpe – is a bastard of conservative portrait and parasite paparazzo photography. The combination presented in scene books of successful and well-known artists with those only known within the scene itself is a technique of reciprocal legitimation. It satisfies the public's hunger in a number of ways. On the one hand, it allows the masses voyeuristic insights into the life of the rich and "happy few," and the poor "unhappy few." On the other hand, through this mutual legitimation the boundaries between mainstream and fringe groups begin to blur. In reality, by way of the photographic satisfaction of the public's voyeurism, the socially marginalized of the underground scene are placed on the same medial level as the harmless and assimilated members of the mainstream. The authors of social misery are put on the same level with the victims on the market of the celebrity scene. The socially excluded become the medial included – this is the crime the illustrateds and scene photography commits against the outcast. Social misery never fails to produce a good picture. Scene photography has something pornographic about it. In this field of universal pornography, where everything, even that which is most private, can become a public picture, a capital of attention – according to the motto "private is porn," every erect penis, whether or not Mapplethorpe or a paparazzo does the photographing, every opened pair of thighs and every pair of blue eyes whether a drug addict's or an It-Girl's – is a share of equal value. The paparazzo is only the most excessive symptom; the scene photographer is his wealthy relative. Both are ex-

3 Georg Franck, *Ökonomie der Aufmerksamkeit* [The Economy of Attention], Carl Hanser, Munich, 1998.

pressions of the crisis of portrait art in the age of mass media hysteria. The paparazzo is the *agent provocateur*, he who exploits and enlarges the class divisions which the media obscures. With the telephoto lens he shoots photographic projectiles "shots" over the chasm of insurmountable extremes between rich and poor, which, though apparently injuring the rich, in truth anaesthetize the poor and their legitimate claims of annulling class divisions. The "shot" in the veins is the analogue to the photographic "shot." The paparazzo is a blackmailer *par excellence*, profiting from the unsolved conflicts within the social contract. He first blackmails the famous, since the famous need the paparazzo in order to become famous and to remain so. The paparazzo is the putty between the public and the "popular peoples." Secondly, he blackmails the mass media, since the media require his pictures in order to obtain high circulations. Thirdly, he blackmails the public whom he has made into an accomplice. His photographs provide the public with pictures from the world of the famous. This extortionate function of voyeuristic insight into the life of others may also be attributed to scene photography, from Larry Clark through to Nan Goldin, which portrays subcultural scenes such as the rock and drug milieus, and youth culture. This is because scene photography still retains a certain glamour tradition characteristic of conservative portrait photography, while at the same time including and using socially excluded mass material.

Another tradition of portrait photography is justified simply by the fact that it divests itself of the historical function of portrait painting, which is to produce photographs of pillars of society. Neither its technique nor its *sujets* are "high-key." I would characterize such portrait photography as progressive simply by virtue of the fact that it does not adopt the function of the pictorial medium that preceded it. In this tradition of portrait photography, from Brassaï, John Thomson via August Sander through to Doris Ulmann, Walker Evans, Diane Arbus, etc., the concern is not to reproduce the status of a dominating social class or to popularize personalities, but to honor the promise of photography as an egalitarian and democratic medium. These photographers are democratic portrait artists. Their medium is thus not the illustrateds, but remains photography itself. Their photography does not hire itself out for illustrateds. Their *sujets* are, in fact, the unknown, the subjects of the masses, the nameless. In their photographs, we as viewers do not become voyeurs in the life of others, and paparazzi accomplices. It is for this reason that, as a rule, these pictures are not appropriate for the mass illustrateds and for curiosity driven customers. These photographers are not obsequious reporters participating parasitically in the court of the rich and famous, so as to sell to a pauperized public the visions of a *dolce vita*. They do not become artists by portraying other artists. These photographers do not play the game of parasitic publicity. On the contrary, in the aesthetic democratization of the medium, they democratize the figure of the artist itself, and place it on the level of the everyday neighbor. The artist is thus dethroned from his elevated position, and demythologized. Not everyman becomes artist, but the artist becomes everyman. The razzamatazz of stardom is struck out of artistically appropriate, social critical portrait photography: the breath of eternity elapses over snapshots, and art photography (both artist and medium) is disenchanted. Everyone can photograph everyone. This is not art and no artist is required for it. One photograph is as good as the next. Photography could be the medium of reality, the recovery of reality. This aesthetic perspective becomes important in that historical moment in which, under the influence of modern media, paparazzo photography aspires to dominate and transform all portrait photography. It was not only the media hysteria surrounding the accidental death of Lady Diana in 1997 which first brought our attention to the extent of the paparazzi's power. The reception of the photo portraitist Ernest J. Bellocq on the occasion of his exhibition at the Museum of Modern Art towards the end of the 1970s helps to visualize the conflict between paparazzo and portrait photography. John Szarkowski, former director of the photographic department at MoMA, and curator of the exhibition, introduced the

world to the legend that Bellocq, like Toulouse Lautrec, had been physically handicapped. The prostitutes he portrayed in the bordellos of Storyville, New Orleans, allowed themselves to be portrayed laughing and naked only out of sympathy for him, as only a woman can do if the portraitist is not at the same time a punter. This legend had first to be invented before the Bellocq's pornographic paparazzo shots could be awarded a place in the august halls of the MoMA. It later emerged that Bellocq was, in fact, a punter of normal stature and that the women's laughter was most likely of a professional nature. The paparazzo effect, the section for scene photography, was shut down for ideological reasons and re-labeled as classical portrait photography. By contrast, the film based on Bellocq's photography, *Pretty Baby* (1978) by Louis Malle, once again enhanced the paparazzo effect. Behind the mask of photography, the voyeuristic and at times, pedophile needs of the public were satisfied in a bourgeois and hypocritical manner. The virtue of contemporary paparazzo photography is that it has at least desisted with this kind of sham and flagrantly reveals its inhumanity. Not unlike the spaghetti western, which renders explicit the hypocritically concealed ethos of violence in the US western by way of its brutality, paparazzo photography discloses the hypocritically hidden voyeurism of bourgeois portrait photography and society. Paparazzo photography underscores the parasitic core of portrait photography and the greed of neoliberal media society for capital popularity as a form of profit. Through paparazzo photography, the naive innocence of portrait photography now reveals itself as a Pilate strategy.

In the age of media hysteria (from the Gulf War and Lady Diana's accidental death through to the special investigator Kenneth Starr as super paparazzo), during which a pact of anti-democratic complicity was sealed between the mass public and a mass media, and the virus of modern hysterical media epidemics[4] was nourished by this parasitic pact, the objective would be to liberate photography from the clinch of mass media. Where heroes and high-gloss aesthetics are lacking, nourishment for parasites remains deficient. Where everyone photographs everyone, there is no place for paparazzi. The photographic intensification of class hierarchies by the separation in published and public, in illustrious and illustrated readership by way of paparazzo photography, this impoverishment of the social function of portrait photography, is no longer possible on the horizon of the aesthetic credo of the amateur on Youtube. The amateurism in the medium of the Internet deprives historical media of its basis for complicity with the masses.

The Subject of Celebrity

In the media Tsunami, the classical ego breaks apart. The celebrity, the star personality, glides along the spume of media waves like a surfer. That which is of foam remains foam. The historical self of authenticity and originality collapses under the crushing waves of total medial penetration of the private. By contrast, the self of celebrity culture arms and stages itself for this medial disclosure. The celebrity knows that in the age of media, the map designs the country, that media generates reality, which is why the purpose is not to be yourself, but to represent yourself, to maximize the fallacy to such an extent that it really works. In celebrity culture the self is, *per se*, imitation, staging, simulation and fiction. The self of celebrity is the sum of many actors, who stage their appearance on the media stage for the relevant context. The celebrity has recourse to techniques of self-construction inseparable from the appearance of the modern concept of the subject which dates back to the Renaissance. In his book, *Renaissance Self-Fashioning: From More to Shakespeare* (1980), Stephen Greenblatt shows that in literary texts, from Sir Thomas More through to William Shakespeare, there is not one single history of the self: "There is no such thing as a single 'history of the self' in the sixteenth century [...]. Self-fashioning is achieved in relation to something perceived as alien, strange, or hostile. [...] hence [...] any achieved identity always contains within itself the signs of its own subversion [...]."[5]

4 See Elaine Showalter, *Hystories: hysterical epidemics and modern media*, Columbia University Press, New York, 1997.

5 Stephen Greenblatt, *Renaissance Self-Fashioning. From More to Shakespeare*, The University of Chicago Press, Chicago, London, 2005, p. 8 f.

In the authoritarian structures of the sixteenth century, subjects had to be actors in order to survive political waters. As Niccolò Machiavelli wrote in *The Prince* (1532): "[…] the gulf between how one should live and how one does live is so wide […]."[6] Self-fashioning is also a strategy between submission and self-realization, between the life one leads and the life that one would like to live. The media become a stage on which to simulate a life that the masses would like to live. The women's magazines in doctor's waiting rooms and at the hairdresser's, those profane contemporary sites of self-fashioning, evidently have just this purpose, namely, to take part in the feigned life of the media stars by reading and looking. The celebrities supply the template for which they are thought of, loved and heaped with flattery, whereas the masses, by contrast, provide the money. In other words, through these magazines one may subscribe to the participation in self-fashioning. However, what for the media star amounts to no more than simulation, deception and fiction is, for the subscribers, reality. This is the deceit of the mass media towards the masses. The subscriber to mass media is presented with a choice between imitation of the other and self-imitation, between self-staging and self-optimization.

Celebrity and Label

The subject in the age of media is no longer only a prisoner of nature, or of anatomy and physiognomy, but has also become prisoner of the image. The task is now to discover a new logic which can liberate the self from both prisons – from the prison of the picture and from the prison of anatomy. The "escape-button," however, is called self-fashioning, though in this context, in connection with medicine. The new "escape-button" is called plastic surgery. One voluntarily undergoes surgery just so as to be acknowledged in the way one wishes to be perceived. The self follows the dictatorship of photography, of the image. The imitation of the self becomes identical with the extrinsic perception. The self stages itself for others, becomes the self of the other. One fabricates oneself as an image and then conforms to the image others have of one. In the gene-technical age, the image of the self is oriented on the image of the other. The grand promise *Sua cuique persona* ("to each his own mask"), [FIG 3] this great promise of the Renaissance in the person of Ridolfo del Ghirlandaio, the painter,[7] is honored today by cosmetic surgery. In a certain sense, the face becomes the venue of the war between the subject, as it is, and the subject, as how it envisages itself becoming. Whereas for the Greeks the term "person" still encompassed the meaning "face" and "mask," Latin introduced distinctions, subsuming under *persona* only the term "mask"; when referring to the face, other terms were required.[8] The face is, accordingly, a cultural phenomenon, not a natural one. In celebrity culture, every face is a mask, every person is only a *persona*.

The Latin word *persona* is derived from *per-sonare* (literally: to sound through), since the actor who conceals his face behind the mask, for example, operates with his voice.[9] In this respect, voice and face are bound to one another. In the age of the media, the promise "to each his own mask" – and not only for gene-technical reasons, or reasons of technical-medial reproduction – seems to be that the mask does not conceal the face, but is itself the face. This is axiomatically valid for the age of media. A tremendous machinery is in place that ensures the production of apparently self-selected masks which, in reality, please others. Masks are machines for the creation of the contemporary self, self-imitation according to the image, the self-image and image of the other.

Celebrity culture is itself a product of the media, and so corresponds to its logic of treating the face simply as an image. The face, which insists on eternal worship, becomes fetish and icon. For this reason one of the most famous cover girls, Jean Shrimpton, is simply called "The Face." And a magazine is likewise titled *The Face*. Essentially, the face becomes a bunker, becoming more of a mask with each attempt to keep it from transformation. The famous don smiling masks, but they no longer have any face. The face means everything, but the face which

6 Niccolò Machiavelli, *The Prince*, Penguin, London, 2002, p. 49.
7 An ensemble of mask and inscription is attributed to the painter Ridolfo del Ghirlandaio (1483–1561).
8 Hans Belting, *Das echte Bild. Bildfragen als Glaubensfragen* [The Real Image: Questions of Pictures and Belief], C. H. Beck, Munich, 2005, p. 46.
9 See ibid., p. 75.

always looks the same can only be maintained as a mask. The members of celebrity culture are not in possession of a classical ego. As their body is, for the most part, comprised of implants, so their ego is likewise chiefly constituted of "ego implants" taken from an arsenal of masks. The contemporary person is nothing other than a staged portrait, an implant of ego stagings, a colorful bunch of foreign egos, a register of masks which, depending on the occasion, may be called up (on demand).

A tragic example of the staging of ego implants is Michael Jackson, where the entire arsenal of operative masks through to plastic surgery was recognizable. His success, like the success of Madonna, clearly lay in the fact that the majority of fans were in love with the staged ego implants. One might go as far as to say, that they recognize themselves in the ego-implants. The masks, which Madonna and Michael Jackson carry or rather carried, from clothing to bodies, are evidently those their public would themselves like to carry. In the age of the media, each ego becomes a ghost, a zombie which survives through implants. This insight finds clear expression in the famous dance of the zombies in Michael Jackson's music video *Thriller* (1982). Self-fashioning thus persists in the ego-implant.

Thus, what can be clearly discerned in these ego-implants, in these ego-stagings adapted to the media images and expressive of the desire to finally look like those others in the media images, is a death wish. The self-portrait is a ruin of the self. The portrait of today reports more about ruins, about ghosts, zombies and the living dead. Celebrity culture is populated by them; individuals and personalities do not move around within it, but rather the ruins of individuals inflated by the drug of fame, from the drug of their own intrinsic value all propped up by stagings, operations and implants. The production of the individual in the age of the media is fabricated in and through the media itself. The product is called celebrity. Celebrity is the brand for the individual, in other words, the opposite of anonymous. Every anonymous member of mass society would like to participate in media society by taking part in one of the countless number of TV cast-

3 Ridolfo del Ghirlandaio, *Sua cuique persona*, ca. 1510, Galleria Nazionale degli Uffizi, Florence.

ing shows, and so themselves become a celebrity, even if only for a short time. Being famous is equated with being individual. The human being no longer wishes to become an individual, but rather only desires to be famous. The ego-implant is the drug or the fuel for fame. The self in celebrity culture no longer exists, only more implants. Thus, many do not become individuals, the "one," but ego-implants. Consequently, the mass media not only create promises they do not keep, but, in fact, the very nonfulfillment of the promise is the precondition of the promise. Much like the rainbow: as the fairytale promises, a pot of gold waits at the end of the rainbow. And yet everyone knows that the rainbow is an anamorphically distorted image of the sun and is therefore nothing more than an optical illusion, an airy creation, an illusion. The rainbow changes according to the position of the viewer. The viewer, ergo, will never reach the end of the rainbow. This is precisely the function of celebrity culture: the promise of a golden life that nobody will ever find. It is for this reason that in German the medium which transports this promise to the masses is called *Regenbogen-presse* [literally, rainbow press: Engl. – yellow press]. Thus, the empire of the illustrateds, the empire of the rainbow moves between the brackets of the illustrious and the illusionary, between fame and appearance.

Celebrity Culture as Monster

The world of celebrity culture is a world without secrets. Secrets are not only flaunted or put on the market, no; they are quite literally burned onto the skin. The members of celebrity society carry their skin to market on which their secrets are visibly tattooed for the public, from "marry me" to "honey bunny." But because the objects of desire are changed more often than are undergarments, these tattoos are permanently eliminated and replaced with new ones. The love tattoos are vouchers without value; their expiry date is as short as is the word short. For this reason, the images and texts of celebrity culture amount to short-lived truths. Yesterday still

pregnant, or true, today already slim, or untrue. Genital instead of genial – simply superb, simply uninhibited, indefinitely simple. Stylistically confident, the party princess comes under the crossfire of criticism. The party animals, perfectly made up, cuddle up to the photographers just to demonstrate their readiness to take risks. Miss shyness is at the bar ensconced in a coaching session; her curves vie with those of the hostess in naked clothing. If weddings can be sold to the colorful media, then so can any divorce. When all the bells are ringing even when the baby alarm goes off, then the birth of a child is an extreme sensation, which belongs on the cover of all illustrateds – as if a woman had never given birth to a child. When wedding bells ring, then one must act, at all costs, as if the event would interest all humanity, and weeks before hosts of cameras are lined up and directed at the Lotto Queen of future luck. The casino sexuality of high society, especially of the blue-blooded variety, is particulary suited to the colorful world of the high-gloss magazines. In the glittering Elysium, and clad in an insanely zany outfit, the bride scores as a paparazzi eye-catcher. Merely being the sister of the bride is enough to become world famous. But the girl destined to become the most famous is the one who shows the photographer when stepping out of the taxi, that not so much as a slip covers the bareness of her naked thighs. It could not be more private and more embarrassing. No day passes without an infringement, no night without a violation; thus rages the clash of the cultures in global reportage. Counting among the hundred most influential people of the world are those who, in a civilization conquered by celebrity culture, are not only Nobel Prize winners of economics such as Joseph E. Stiglitz, presidents, like Barack Obama, footballers such as Lionel Messi, singers like Bruno Mars, but also teen idols such as Justin Bieber and, naturally, the young bridal couple William and Kate from the "Fun Palace." The wow moment of fame is determined by a jury made up of former beauty queens, talk show masters, musical blondes, star make-up artists, columnists, journalists, ringmasters of the celebrity circus, TV moderators and

other top jurors. Style up your life, which means leave the direction of your life to the top journalists and other show masters, since, as Jesus of Nazareth has already shown, every life knows a comeback. The styling finale of the year with the model of the year as a jury member is worth its weight in gold. Optometrically tested contact lenses advertised by Formula 1 drivers guarantee enhanced perspective. However, the celebrities are paid for wearing the contact lenses, made possible only because every-day people pay high prices for the glasses and lenses. The public is, in fact, the real service personnel of notables. The public pays for the existential modes of notables. The public is the sponsor of sport glasses, sunglasses etc., which are worn everyday by the stars, and of the toilet seats which have been opened, or will be opened each day by notables, see Andy Warhol. Sensationalist media are the pimps of media notables. Celebrity culture is nothing more than a new business model in the age of service technology. Here, journalism and the print media are given the task of bringing the products with which (and for which) the stars advertise – from clothes to glasses, from shoes to slips, their creators, brands and labels which they permanently name – closer to the readers. Journalists are agents, not only for the entertainments industry, in that they not only permanently report on products (films, TV series etc.), but also for the product industry, in that they constantly report on the lifestyle of the stars and their insignia or utensils. In fact, the journalists and the print media ought to be on the direct payroll of these industries, since this involves flagrant and unconcealed surreptitious advertising or open product placement. The hypocrisy with which direct product placement in the mass media is denied is unsurpassable and is a disgrace to any democracy. Consequently, it is the consumer who finally has to pay several times over, both for the star's lifestyle as well as for the court reporting of the colorful mass media. In other words, celebrity culture thrives on the exploitation of the lower classes. This is the destiny of the "one" and the "many," though this destiny is not chance or divinely ordained, but socially constructed.

The fun factor is constantly increasing in a world in which the celebrity culture feigns an all-inclusive deluxe life. Naturally, the "many" of the masses wish to be there in the five-star zone of the all-inclusive club of life – even if only as virtual onlookers via reports in the illustrateds. Nobody wishes to be excluded from the exclusive club. For this reason, the many follow the schedule of the illustrateds, each day brings a lottery, and each day is a favorite day. By regularly purchasing an illustrated, the many subscribe to real dream vacations and super winnings, either way. But the kind of disaster to top all disasters has yet to come, albeit that for the mass media it signifies nothing short of a premium announcement. One man's catastrophe is another man's fat profit. According to the New York Daily News, Kim Kardashian advanced to second place among the world's greatest half-wits. She found this ranking "just fantastic," since her reality series *Keeping up with the Kardashians* demonstrates how, without talent, one can become the most Googled star on the planet. First the sex-process and then the drug excess: scandals and riots aplenty never fail as sure-fire methods for storming the charts. The priest as pederast, the teacher as pedophile, the policeman as criminal, the exclusive interview with the rape victim, these are the maxi-reports down on Pulp Fiction-Avenue, these are the sensation shows of the tabloids. The most effective provocations, however, are the embarrassments. Without these, neither is being talentless any good on the ascent to celebrity. If not only footballers were to advertise underpants in the future, but museum directors as well, and if, in the future, not only the status of an athlete but the status of a philosopher were to be guaranteed by photographs of beautiful women, then brutality would become banality and banality brutality, namely, precisely that which celebrity culture is: the brutality of banality, the violence and power of the world of make-believe. Unlike the *Pirates of the Caribbean*, the pirates of celebrity do not create exotic birds, but monsters.

Environmental tragedies are only acknowledged when decried by the stars of celebrity culture. Tragedies of starvation in Africa interest the media only if the masses are able to look on, just like George Clooney watches hungry children. Life still has value only in the form of a soap opera. This is the life-threatening Fascism of the entertainments industry. Culture is interesting for the mass media, and is only then perceived if it is part of the celebrity culture. And culture increasingly adapts to these requirements of mass media.

Pop culture is the extended arm of celebrity culture, and thus the attack of celebrity culture on culture. In their propaganda, the generals of these attacks promise incessantly that high and pop cultures will seamlessly interpenetrate one another. What they suppress, however, is the asymmetry in the relationship: the elevator operation between low and high culture only goes up and not down, and so, moving in one direction, is one-sided. Low culture arrives at the top, but high culture does not arrive at the bottom. Mass culture and celebrity culture penetrate high culture, but the same cannot be said for high culture in the mass culture of mass media. We experience the porn shop, the peepshow and the station kiosk in museums or at the theater, but not high culture on the football field. We do not experience the opera and the museum at the porn shop or down at the station kiosk. This is what is fraudulent when mention is made of the pervasion of pop and culture, from celebrity and culture. We see biker pictures (of Richard Prince, for example) in the museum. Trivia of the American civilization penetrate the high culture and are enthusiastically welcomed there, but mathematics is not discussed at the beer counter, nor algorithms at the biker club. The exchange is absolutely one-sided and one-dimensional. Pop music does not improve in an upward direction (twelve-tone music is still not popular), but high culture inclines downwards. The French National Library displays memorabilia of the American way of life by Richard Prince: dime novels,

An actor (left) portrays a young gay hustler. Detail from *The One & The Many* at the Submarine Wharf, Harbour of Rotterdam/Museum Boijmans van Beuningen, 2011.

half-nude photos, photographs of biker chicks, cartoons from *Playboy*, advertising photographs, autographs of Pamela Anderson and various other trash. Is this spiritual high culture? I read no treatise on the Poincaré conjecture, or about Arabia's contribution to the discovery of perspective in *Playboy*, but I do see *Playboy* pictures in museum catalogs and on museum walls. Is this not a sign that high culture is an island in danger of being swamped by trivial pop and celebrity culture? While the history of celebrity may be short,[10] its ramifications and effects are long-lasting.

The masses do not reflect themselves in exceptional mathematicians. The masses reflect themselves in mass media. The mass media become a mirror of illiterates, of the lower classes. It is in the moron, unable to talk or to sing, that the masses are reflected. It is no longer the extraordinary achievement but the ordinary, non-achievement which is applauded. With the *Transfiguration of the Commonplace*,[11] art has advanced this trend under the name Pop Art.

In reality, through celebrity culture and its affiliated industries, class distinctions are merely suppressed and played down: gossip consumption instead of class consciousness. Communicative consensus is feigned so as to suppress the brutal antagonism between the One and the Many. The exhibition by Elmgreen & Dragset at the ZKM | Museum of Contemporary Art, Karlsruhe offsets, indeed, shows just who pays for this consensus and gossip, namely, the many. The dismal life of the Many finances the multi-billion Dollar business of the celebrity (the One). The architectonic forms of Elmgreen & Dragset's installations (e.g., an extremely spacious lobby to the one side and a small room in a social housing block for the many) unambiguously underscore the gulf between the One and the Many in a visual language of parataxis reminiscent of Kafka's prose. In the opening passages of the present text, I introduced the hypothesis that celebrity is an epiphenomenon of modernity. Today, "instant fame reigns." While being famous is everything, the reason for it is utterly superfluous. This not only leads to the circumstances that the perpetrators of school massacres feature on the covers of leading news magazines, whereas the faces of important scientists, artists, authors and inventors do not. This not only lead to the publication of biography of a prostitute who murdered her client, a book which went on to become a bestseller before being filmed by Hollywood (*Monster*, 2003), with Charlize Theron as the serial killer Aileen Wuornos. Film critic Roger Ebert referred to it as "one of the greatest performances in cinematic history." For this role, Theron received the Oscar for Best Actress at the 76th Academy Awards in February 2004, as well as the SAG and Golden Globe awards. This not only led to the Museum of Modern Art in New York announcing an exhibition for 2012 in cooperation with Volkswagen Plc and already publishing the names of the celebrities such as Madonna and Courtney Love for the advertising campaign, and to not one reference being made to one of the exhibition's artists. What this leads to, above all else, are to the conditions under which culture becomes suppressed and ostracized: no less than education, culture is not a medium of fame. The famous require neither education nor culture – a circumstance which is confirmed by the mass media on a daily basis. Celebrity culture as epiphenomenon of the modern, devours culture. If celebrity culture is a part of art, which is, indeed, the case today, if mass media pervade and occupy art, and not art the mass media, then this heralds the end of art as we have come to know it. Celebrity culture signifies the implosion of culture.

Translated from the German by Justin Morris.

10 Fred Inglis (ed.), *A Short History of Celebrity*, Princeton University Press, Princeton/ Oxford, 2010.

11 See Arthur C. Danto, *The Transfiguration of the Commonplace*, Harvard University Press, Cambridge, Mass., 1981.

"——— e've become a race of Peeping Toms. What peo-
ple ought to do is get outside their own house and
look in for a change," the nurse Stella (Thelma
Ritter) complains in Alfred Hitchcock's *Rear Window*
[FIG 1], as she enters the home of her patient, the injured
photojournalist Jeffries (James Stewart), who observes
the various activities of his neighbors. The photographer
broke his leg when taking a daring shot and his cast has
rendered him housebound. Out of boredom he stud-
ies his neighbors' activities in the courtyard behind his
apartment in New York's Greenwich Village with great
curiosity. Hitchcock makes his audience into a voyeur's
accomplice, who is presented with the local goings-on
behind windows and curtains, as if on a stage. Here, a
female dancer, surrounded by adoring men, strikes a
timeless pose; there, a lonely, elderly woman imagines
a man in a short-lived illusion. A childless couple with a
dog resides on the floor above, while, in the apartment
below, a salesman finally puts an end to his wife's ranting.
As contemptible as the protagonist's insatiable curiosity
may be, it ultimately leads to solving a murder case. The
photographer's handicap exposes his vision; the disabil-
ity has activated his awareness – a gaze armed with bin-
oculars and a telescopic lens now drives the investigation.
When the murder suspect finally threatens his surveil-
lant in the dim light, Jeffries can defend himself only by
triggering a storm of flashes from his camera. The tem-
porarily incapacitated assailant, however, finally forces
the photographer out the window. The down-to-earth
photojournalist is thus ultimately punished for his obses-
sive curiosity by a second broken leg, although he is still
able to patch things up with his beloved, the well-to-do
Lisa (Grace Kelly). With *Rear Window* (1954) Hitchcock
realized a "filmic film"[1] in the context of a self-reflective
cinema, in which seeing itself becomes the subject. The
window constitutes the dominant motif, which "as it
were, appears like an image aperture before which, as if
in front of a stage, a curtain is raised."[2] The setting for the
crime milieu study is comprised of the stage of a detailed
backyard scene Hitchcock had constructed entirely in the
studio. By way of true-to-life "doll houses," the lives of

Staging the Spectator

Martin Hartung

The outside is always an opening onto a future:
Nothing ends, since nothing has begun,
But everything is transformed [...] and the thought of the
Outside is a thought of resistance.

Gilles Deleuze, *Foucault*

1 Francois Truffaut, *Mr. Hitchcock, wie haben Sie das gemacht?*, Heyne,
 Munich, 2003, p. 211.
2 Friedrich Teja Bach, "Der Schwindel des Sehens," in: Thomas Hensel,
 Klaus Krüger, Tanja Michalsky, *Das bewegte Bild. Film und Kunst*,
 Wilhelm Fink, Munich, 2006, pp. 373–396, here p. 381.

others may be vicariously experienced in the interplay of intimacy and distance, imagination and reality.

For their exhibition *Celebrity – The One & The Many* Elmgreen & Dragset made use of the ZKM | Museum of Contemporary Art's two atria, which formed the architectural framework for a four-story apartment building, approximately ten meters high, directly adjacent to where a classic, 18 × 24 meter ballroom was built into the museum architecture. The constructions in the narrative exhibition set mark a course of inclusion and exclusion, whose parts are connected by the strolling visitors. Along the stair landings and the different levels in the atria, visitors can use binoculars to zoom in on the various interiors. Each field of view is limited to the small windows of the fictive living-cells and to the relative location along the structure, so that not only is the view (and with it, that which is to be seen) directed, but a negotiation of the view is also required: the goal becomes finding the ideal position for observation. As in Hitchcock's classic, viewers are forced to become voyeurs: while the plush ballroom is accessible to all, it is precisely the social housing that cannot be entered. The apartment building has been constructed only as a spectacle. Like pictures in a gallery, in all thirty windows are positioned in the outer walls of the cement dummy construction; among the windows, only ten offer views into the arranged living spaces, corresponding with the visible number of rental units on the decrepit doorbell plates in the house's entry area. The other spaces remain hidden from view. Insight is blocked either by curtains or blinds, whose monochrome or striped-pattern designs may recall the work of artist colleagues in the concept-based, (neo-) minimalist or institutional critique contexts that comprise the greater part of Elmgreen & Dragset's artistic production. At the same time, visitors are excluded from the illustrious party society, alluded to by the shadow outlines in three high windows at the end of the ballroom and by a sound set, consisting of, among others, audio takes from the Frieze Art Fair of 2009. These, in connection with the set constructions in Karlsruhe, refer to the relationship of the exhibition parts.

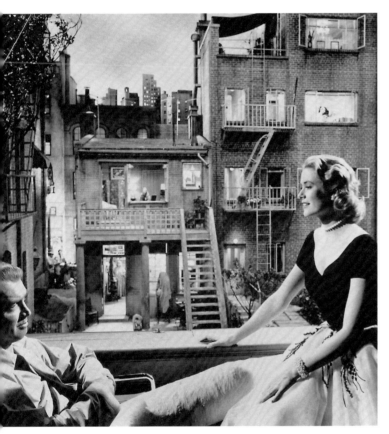

1 Alfred Hitchcock, *Rear Window*, 1954, James Stewart and Grace Kelly on the filmset.

Parallels can be drawn to the *Welfare Show*, in which Elmgreen & Dragset opened a three-part exhibition series in 2005 and 2006 at several venues, among them in the Bergen Kunsthall and the London Serpentine Gallery, the midpoint of which was the presentation in Venice; the constructions in Karlsruhe mark the finale. In the *Welfare Show*, the artist duo explicitly confronted questions of social inequality, international security debates, and social exclusions, in which, for example, an ATM machine was arranged as a dysfunctional baby drop-box or in which a number of security guards were placed in a "white cell" for silent self-surveillance. Subsequently, against the backdrop of the global financial crisis, they staged *The Collectors* in Venice, using both the Nordic and Danish pavilions as collector-properties, the interiors of which the artists had populated with contributions by contemporary artists and designers. The owners of the fictive homes appeared to have been badly hit either by financial setbacks or material surplus: while the naked lovers of the first still lounge around the elegant house, the owners corpse ended floating facedown in the pool, the other is utterly burnt out and, along with his entourage, now miles away. The latter's family estate up for sale is made attractive to the Biennale visitors by way of a house tour, led by actors playing real-estate brokers. In *Celebrity*, these worlds are now placed directly opposite each other, which in the two previous presentations had been negotiated separately. Also in the fictional context of the Karlsruhe construction, an apartment is available for rent. The artists dedicate each of the arranged homes to citizens whose lives are oriented primarily on the lives of others, whether stars or starlets, as they are known from cinema and night-time television, or other idols who might also be found in chat rooms and on Facebook. Less interesting, however, are the boy next door, or the lonesome neighbor, who, like the elderly woman in Hitchcock's *Rear Window*, could be so lonely as to contemplate suicide. Instead, Elmgreen & Dragset situate in the social housing building the model residences for people whose views are preferably oriented at distant, largely unattainable possibilities, even if the contempo-

rary celebrity machine promises those who engage with it rapid success and financial security. After all, television will have soon cast half the world.

In Western European interiors of the latter half of the twentieth century, seating arrangements are grouped around the television, such that the only movement within the living room, often enough, is the frequent flickering images on the screen. Television had early on been compared to a window to the world by way of reference to Leon Battista Alberti's vivid metaphor, who during the Renaissance envisioned the picture as an "open window" allowing for perspective in viewing. Television, this "blind window in the room,"[3] turns perspective around, suggesting that unfiltered reality can be transported into one's own four walls. The passivity of the spellbound viewers cannot even be altered by active channel hopping. Isolation by means of the channeled tele-vision from a secure distance is closely related to cocooning, the much-discussed flight from civil society by withdrawing into the private sphere.

Loneliness stands in contrast to Elmgreen & Dragset's reference to the phenotypical, frequent appearance of high-rise concrete blocks found mainly in urban centers of former East Germany, whose conformist architecture primarily served to promote social cohesion based on equality in accordance with the idea of the "socialist community." The concepts behind all apartment types in the GDR were oriented on the "minimal existence residences" of the 1920s, whereby the public areas were given far more priority than private living spaces. It was only after German reunification that *socialist* concrete tower block, so called *Plattenbau*, became *social* housing, often experienced as a sort of prison for those seeking a reason to escape through the gates of mass media. Although the apartment block by Elmgreen & Dragset should not be understood explicitly as a GDR *Plattenbau*, it borrows formally from the typical "social housing" that one also finds in the outskirts of Berlin. Beyond the "cubic box" of diverse pre-fab modules, it also refers to the formal vocabulary of the artist duo's other works. Each room open for view in the apartment block that

3 Thomas W. Gaehtgens, "Der kritische Blick durch das Fenster. Die Künstler und das Fernsehen," in: Wulf Herzogenrath, Thomas W. Gaehtgens, Sven Thomas, Peter Hoenisch (eds.), *TV-Kultur. Das Fernsehen in der Kunst seit 1879*, Verlag der Kunst, Dresden, 1997, pp. 78–86, here p. 78.

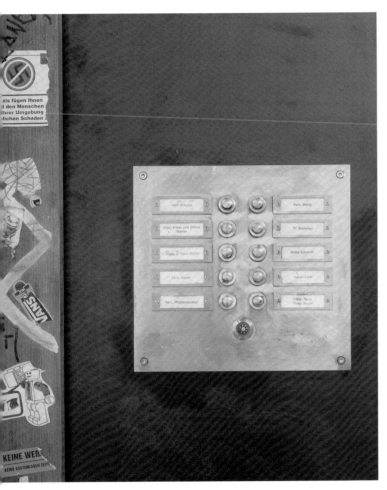

Elmgreen & Dragset designed for *Celebrity* is lit up and equipped with everyday objects, which, in part, also include functioning televisions that produce a sound stage, thus suggesting that the residents have just left the room for a while. The prying exhibition visitor has no choice but to gaze shamelessly into the private sphere, following clues left in the interiors: objects which are representative of their fictive owners and indicate the inner lives of the supposed residents. The names on the doorbell plates of the dingy entrance reveal a cross section of German society. The apartment building's location is no more precisely defined than its presentational context in the exhibition venue, yet most of the names on the doorbell plate like "Pfützenreuther" and "Müller" [FIG 2] along with various other objects of *décor* and accessories clearly indicate a German localization. "Britta Schmidt" evidently has a physical therapy office on the third floor. It is also easy to see that the "Wong's" kitchen is situated on the ground floor and at least one family member, if the box of blonde hair color on the kitchen table is anything to go by, is fixated on the European ideal of beauty. The "cells" of the apartment block are projection rooms for prejudices and *clichés*.

"Wohnst du noch oder lebst du schon?" [Are you still simply residing, or have you already begun to live?], ran a well-known furniture franchise advertisement thereby translating into marketing terms the meaning of an apartment as "the cosmos of the soul"[4] or "the *etui* of the private individual,"[5] as Walter Benjamin once described the bourgeois interior. It marks the "perspective of the subject, its relationship to itself, as well as to the world."[6] Accordingly, "Anton Pilz" almost certainly occupies the very bottom left, directly adjacent to the "Wongs". The gray wall-to-wall carpeting, yellowing wallpaper, faded leather sofa, and rustic tile table that adorn the living room of the beer-drinking smoker suggest not only a preference for light upper body covering. The aged tenant also appears to have won the pennant "Flotte Kugel" [Speedy Ball] at a local bowling tournament in the year 1975, a pun, to be sure, on his beer belly. Aside from the recreational-sport enthusiasm suggested by the trophy

2 Detail of the apartment block, *Celebrity – The One & The Many*, ZKM | Museum of Contemporary Art, Karlsruhe, 2010.

4 See Bazon Brock, in: Markus Brüderlin, "Introduction Interieur/Exterieur. The Modern Soul in Search for the Ideal Housing," in: ibid. (ed.), *Interieur/Exterieur: Living in Art. From Romantic Interior Painting to the Home Design of the Future*, exhib. cat., Kunstmuseum Wolfsburg 2008, Hatje Cantz, Ostfildern, 2008, pp. 13–33, here p. 13.
5 Walter Benjamin, *The Arcades Project*, ed. Rolf Tiedemann, transl. Howard Eiland and Kevin McLaughlin, Harvard, Mass., 1999, p. 9.
6 Beate Söntgen, "Interieur. Das kritische Potential der Gegenwartskunst," in: Angela Lammert, Michael Diers, Robert Kudielka, Gert Mattenklott (ed.), *Topos Raum: Die Aktualität des Raumes in den Künsten der Gegenwart*, Akademie der Künste, Berlin, Verlag für Moderne Kunst, Nuremberg, 2004, pp. 363–375, here p. 363. See Brüderlin, op. cit., p. 13.

cup on the television set – the third prize that "Herr Pilz" won eight years later at a Berlin dart tournament – a special interest in model trains is indicated by the "Typenkunde deutscher Elektrolokomotiven" [Classifications of German Electric Locomotives] on the living room table. Unusual in the context of the apartment, an embroidered picture reading "HOME IS THE PLACE YOU LEFT" hangs on the wall to the left – reference to an exhibition of the same name, which Elmgreen & Dragset organized in 2008 at the Art Museum in Trondheim, Norway, Ingar Dragset's place of birth [FIG 3]. Friends and colleagues made various contributions to the show and the accompanying exhibition catalog. The participants each approach the topic "home and homeland" from their own personal points of view. The initiators elucidate the guiding ideas of the project in the book's foreword: "Home traditionally alludes to family, local context and nationality – to structures which are preset and often disconnected to one's individual desires. We sometimes experience a painful clash of a self image. Why would one ever want to recreate anything as complicated as 'home'?"[7] Nancy Spector reflected on the remembered home within the context of its partly nostalgic distortion: "Most individuals carry this place called home within themselves throughout their adult lives; it becomes a theatrical backdrop of sorts, against which the present is enacted."[8] In his essay *"Wohnung beziehen in der Heimatlosigkeit"* [*Making a Home Without a Homeland*], Vilém Flusser concludes that while we generally think of a homeland as being permanent while a home is exchangeable, the opposite is in fact the case: "You can change your homeland or be without one; however, you always have to live somewhere, wherever you might be."[9] Being at home is "a central cultural event, the form *par excellence* for staging private, everyday life."[10] Living room and bedroom are considered fundamental spaces for retreat, centers of intimacy, which have been separated, at least since the Middle Ages, as the hall and the chamber, the latter of which was first separated from the main room by a curtain, and which was still dominated by bustling activity despite the retreat into the private

3 Outside view of *Home is the place you left*, Trondheim, Norway, 2008.

7 Elmgreen & Dragset, "An Introduction," in: ibid. (ed.), *Home is the Place You Left*, exhib. cat., Trondheim Kunstmuseum 2008, Verlag der Buchhandlung Walther König, Cologne, 2008, p. 3.

8 Nancy Spector, "Robert Gober: Howeward-Bound," in: *Parkett*, Nr. 27, March 1991, pp. 80–88, here p. 80.

9 See Vilèm Flusser, "Wohnung beziehen in der Heimatlosigkeit," in: ibid., *Von der Freiheit des Migranten. Einsprüche gegen den Nationalismus*, Philo, Berlin, 1994, pp. 15–30, here p. 27.

10 Gert Selle, *Die eigenen vier Wände. Zur Verborgenen Geschichte des Wohnens*, Campus, Frankfurt/M., 1999, p. 9.

sphere. Urban society in the early Renaissance created the division of the *sala* and the *camera*, whose counterpart in the nineteenth-century middle-class home was the salon. The separate private room has continued through to the present; the *sala* was transformed into the parlor, whereby the *camera* became the bedroom.[11] In *Celebrity*, in just this kind of room on the front side of the apartment building's first floor, lies the figure of a youth on a mattress. Lost in thought, he has just received a new message in a gay chat room. Elmgreen & Dragset completed the wax figure between 2006 and 2007, with the titles *Andrea Candela, Fig. 1* and *Virtual Romeo*, whose profile they created displaying photos of the fictional young man on GayRomeo, Europe's largest Internet platform for the homosexual community. During an exhibition at Milan's Galleria Massimo De Carlo, visitors could experience the many inquiries and invitations by virtual admirers. The musical and melancholy youth's counterpart in *Celebrity* is a boy [FIG 4] who, disappointed and alone, crouches inside the fireplace of the adjacent ballroom. Dressed in the building-block-gray uniform of the elite school Eton, considered Britain's most exclusive place of education for upper class offspring, he retreats, of all places, into the spacious hall's small fireplace, which does as poor a job of keeping him hidden as it does warming him up. The uniformed maids *Rosa* and *Dinah*, archetypes like the boy in the fireplace, also offer no help. Rather, their gold-washed countenances wait in a dystopian torpor for new instructions. Similarly, the live butler, for whose role the exhibition attendants, in changing order, are engaged as actors, is instructed to stay still: a detail which also generates a certain playful confusion among exhibition visitors.

The abandoned youth in the fireplace, who, for all the exclusivity of his class necessarily excludes himself, is at the same time the connecting element and the culmination of the diametric exhibition situation. His representational portrait over the fireplace mantel is a reminder that much is expected of him. However, the likeness does not reflect the ideal. "Etiquette prohibits one to fall out of the frame; while it is the normative power of

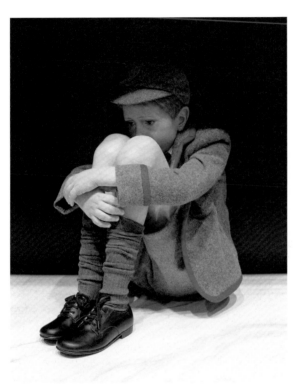

4 **High Expectations** 2010. Detail, *Celebrity – The One & The Many*, ZKM | Museum of Contemporary Art, Karlsruhe. Courtesy of Galerie Emmanuel Perrotin, Paris.

11 See ibid, p. 13.
12 Bärbel Hedinger, "Trompe-l'oeil. Eine moderne Gattung seit der Antike," in: Ortrud Westheider, Michael Philipp (eds.), *Täuschend echt. Illusion und Wirklichkeit in der Kunst*, exhib. cat., Bucerius Kunst Forum Hamburg 2010, Hirmer, Munich, 2010, pp. 10–15, here p. 10.

the aesthetic border that prevents stepping out of the frame."[12] The curiosity of the young "dropout," who, in the Madrid painting *Escaping Criticism*[13] [FIG 5] by the Spaniard Pere Borrell del Caso (1874), in astonishment steps out of the frame – and thus Alberti's classic window dispositive is not shared by Elmgreen & Dragset's contemporary boy. Significant aspects of the *trompe-l'oeil*, the art of optical deception, which in Antiquity first thematized the mimetic qualities of naturalist painting, are actualized in the twentieth century by the inclusion of real objects in representational contexts through material collage, ready-mades and Combine Painting, in which the image subjects push into the real space of the beholder. Not least through hyperrealist sculptures, installations, and models, which also form the subject motifs of contemporary photography positions, *trompe-l'oeil* has persisted through to the present time by processes of deception in the art space. It shows reality in an extraordinarily realistic form, yet in its quality as a deceptive image that reaches out into reality, it breaks with the possibility of a detailed localization. Models, too, form their own realities as simulated components of the world. As visible modular parts, they can also facilitate the understanding of complex phenomena, in so far as they define the subject's elemental components, and thus reveal that which is at the core of such phenomena. In their *Powerless Structures* series Elmgreen & Dragset operate with hyper-mimetic models of reality, whose relational structures they disrupt by making them unstable and by disempowering their premises. The signature "Fig." allocated to each of the works indicates the model character of their sculptures and installations, which, by way of ascending intermittent numeration, defy systematic classification. Nevertheless, the objects and installations thus designated retain the character of test arrangements that are also undertaken in sterile laboratory situations, whose counterpart serves the artists primarily as the hermetically inherited White Cube.

That models can also produce illusions is seen in the works of the Swiss Peter Fischli and David Weiss, who

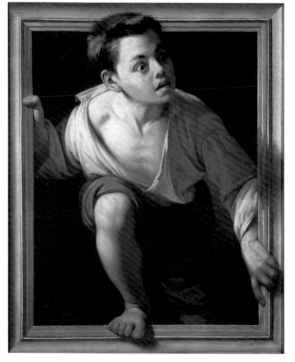

5 Pere Borell del Caso, *Escaping Criticism*, 1874, Collection of the Bank of Spain.

13 Bärbel Hedinger has pointed out that the title *Escaping Criticism* is a reinterpretation from a later date, since the painting was originally titled "Un cosa que no pot ser" (freely translated: "A thing of impossibility") whereby the mock character of the *trompe-l'oeil* has at the same time been remade as the subject of the painting, intrinsic to the genre. (See Westheider, Philipp, op. cit., cat. no. 46.)

have worked together since 1979. In their sculptural works, they play with the expectations that beholders have of the objects presented and the environments in which they are located. Although their staged objects seem to originate from familiar, everyday contexts, a closer examination shows them to be handcrafted objects made of polyurethane. In the spirit of consistently questioning one's own art, and not without a certain crafty humor, they have taken the Duchampian ready-made *ad absurdum* by creating, much like handymen, non-functional representations of industrial products, which also display feigned traces of having been used. Moreover, they often present their polyurethane objects in contexts surprising to beholders. At the Museum of Modern Art in Frankfurt am Main, they filled a room under the staircase, in *Raum unter der Treppe* (1993), with diverse objects, among them a wash basin, furniture, painting utensils, tools, and a shipping box, the kind generally used to mail artworks. The illuminated "broom closet" could not be entered; at most it was visible through a window in the door, suggesting that visitors could receive a view behind the scenes of an institution, as if someone had merely forgotten to switch off the light. The art public must have also come in for a surprise in 2001 by the mischievous contemporary that Maurizio Cattelan has break through the floor of the painting collection in the Boijmans Van Beuningen Museum in Rotterdam, with which the Italian artist also satirized his breakthrough into the art world. Cattelan, who with the confrontational power of a trickster exposed the economic and cultural power relations of the culture and exhibition business, thus broke open the aesthetic borders of his institutional environment with the *trompe-l'oeil* copy. As with the installation works of Elmgreen & Dragset, who invited Maurizio Cattelan to participate in *The Collectors* in 2009, the Italian artist creates model situations with an "artificial realism," which implicates the viewer as an actor in the staged situation: "Just like in theater, where everything is processed as a realistic illusion, there is an uneasiness with regard to the characterization of the realism of the scene."[14] Also the narrative-structured,

process-bound examples of the duo's installations are arranged like theater acts in which visitors are not only confronted with objects but also enter into situations which can become "components of an architectural, atmospheric, and social relational field."[15] The apartment building and the ballroom in *Celebrity* can thus be thought of as "theater installations," as site-specific room scenarios to be deciphered by the viewer: "Whether visitors walk through a series of individual scenes or whether they (must) move themselves freely through an area, in each case a staging arises only through the movement of the visitors through the room, which is bound to a direct interaction with the architecture, the landscape, and the actors involved in it. Thus, the particular location is not only a background for the staging, but it also brings out its institutional, social, or architectural function, its historicity and its materiality."[16]

From the outset, theater has been the central moment in the collaboration between Michael Elmgreen and Ingar Dragset – ever since their first encounter in Copenhagen, in 1994, when the latter was part of a small experimental theater group. Michael Elmgreen was already active in the Stockholm art scene and wanted to show knitted objects, for which he sought someone who could knit. Since Ingar Dragset had a command of the craft, they began to work together in 1995 as part of a performance in which the artists knitted white skirts worn with black suspenders. When taking the occasional break from work, the artists unraveled the knitted pieces such that the skirts became progressively shorter. Unraveling the product of a craft which is traditionally the preserve of women, led to "a peep show in slow motion,"[17] an act explicitly thematizing their homosexuality. It was around this time that Ingar Dragset had discovered his interest in performance through texts about The Living Theater. The ensemble, founded by Judith Malina and Julian Beck in New York, in 1951, was oriented on politically motivated theater of the years before the war, and developed after 1958 under the influence of works by Antonin Artaud into an action-based theater group that staged literary works. At the same time, artists such as Allan Kaprow,

14 Madeleine Schuppli, "Es geschah am hellichten Tag," in: *Maurizio Cattelan*, exhib. cat., Kunsthalle Basel, 30/1999, unpaginated.

15 Barbara Gronau, "Aufgeführte Räume. Interferenzen von Theater und Bildender Kunst," in: Erika Fischer-Lichte, Kristiane Hasselmann, Markus Rautzenberg (eds.), *Ausweitung der Kunstzone. Interart-Studies – Neue Perspektiven der Kunstwissenschaften*, transcript, Bielefeld, 2010, pp. 73–88, here p. 74. See Barbara Gronau, *Theaterinstallationen. Performative Räume bei Beuys, Boltanski und Kabakov*, Wilhelm Fink, Munich, 2010; and Erika Fischer-Lichte, "Der Zuschauer als Akteur," in: Erika Fischer-Lichte, Robert Sollich, Sandra Umathum, Matthias Warstat (eds.), *Auf der Schwelle. Kunst, Risiken und Nebenwirkungen*, Wilhelm Fink, Munich, 2006, pp. 21–41.

16 Gronau, Bielefeld, op. cit., p. 77.

17 See Jens Hoffmann, "Small Twists – Bigger Splashes! Interview with Michael Elmgreen & Ingar Dragset," in: Daniel Birnbaum (ed.), *Spaced Out. Elmgreen & Dragset*, exhib. cat., Portikus, Frankfurt/M. 2003, Portikus, Frankfurt/M., 2003, pp. 26–29, here p. 27.

Claes Oldenburg and Robert Whitman adopted avant-garde theater experiments within their happenings, although they did not take place on a stage, but rather as Action Theater within environments. Space-filling interiors replaced theater architecture, hence making the beholder a (participatory) observer. Depending on what kind of happening it was, the audience became a viewer or participant in an action. Observers found themselves suddenly surrounded by the work and could no longer grasp it comprehensively. As involved members they rather had to reconstruct it processually. Thus, Allan Kaprow, in his first environment of 1958, broke with an art concept that determined the position of the beholder as static in front of the "closed" artwork. The modernism represented by Michael Fried and Clement Greenberg upheld an "aesthetic border" between the work and its surroundings, the suspension of which contradicted environment and happening in the context of a "relativity of the observer in the dimensions of space and time."[18] This discrepancy also forms the foundation of Fried's criticism of minimalist objects of the 1960s, in which he disparagingly defines a theatrical presence in the space, since the objects can be experienced only processually, and the viewers are therefore brought outside of their (ultimately passive) role while standing *in front of* an artwork, because they are calculated *into* the work.[19] Hence, Fried deemed the objects of Minimal Art, in their role as artworks only as poor actors.[20]

Six years before Fried's general dismissal of Minimal Art, Walter De Maria's work *Walk Around the Box* [FIG 6] from 1961, combined performative aspects as part of a shifted concept of sculpture: an unsightly, small wooden box stands at a certain distance to the wall on which a panel with the painted image of the box has been hung, and a hand-written text in uppercase letters requests that the beholder walks around the "original." Thus, the viewer plays the lead role in the work: "The 'box' around which Walter de Maria asks us to walk is grasped in an experimental and contextual sense. It can become a performative space of experience, a political stage and one for institutional critique, a room for action and agitation, a

6 Walter De Maria, *Walk Around the Box*, 1961, Collection Walter De Maria.

18 Thomas Dreher, *Performance Art nach 1945. Aktionstheater und Intermedia*, Wilhelm Fink, Munich, 2001, p. 95.
19 See Michael Fried, "Art and Objecthood," in: *Artforum*, V, 10, Summer 1967, pp. 24–29, re-published in: Michael Fried, *Art and Objecthood: Essays and Reviews*, University of Chicago Press, Chicago, 1998, p. 153. Dorothea von Hantelmann concludes: "The Minimal Art of the early 1960s, with its orientation on space and the (observing) body, created a new awareness for the concrete situation in which the artwork would be perceived and experienced. Thus, art no longer simply fit into a given museum or exhibition context; rather it laid claim to the creation of the context." in: Dorothea von Hantelmann, *How to do things with art. Zur Bedeutsamkeit der Performativität von Kunst*, Diaphanes, Zurich, 2007, p. 9.
20 See Juliane Rebentisch, *Ästhetik der Installation*, Suhrkamp, Frankfurt/M., 2003; and Georges Didi-Huberman, *Ce que nous voyons, ce qui nous regarde*, Minuit, Paris, 1992.

station for transmission and reception, *inter alia*, where the speaking, listening, seeing and touching subject is made to relate reflexively to the systems of representation and the media and apparatus (re)producing them."[21] Here, in accordance with Silvia Eiblmayr's description of the artwork as scene, in *Celebrity* exhibition visitors are asked to walk around the model of a social housing building. Understood by the artists as a large sculpture, which contains a complex system of spatial-temporal references, it belongs to a tradition of modern sculpture originating in the works of Rodin: with the elimination of the pedestal, his *Citizen of Calais* from 1884 was the first work to blur the border between the real and the art space. With this, the sculpture lost its function as monument, from which, according to Rosalind Krauss, its "logic" emanated.[22] Once sculpture was liberated from the pedestal and could be confronted at eye level, beholders could ultimately take up the space themselves with Carl Andre's floor pieces [FIG 7].[23] Andre's flat works, which have been created from various materials such as metal, bricks, or wooden logs since 1966, enact the exhibition visitors as if on a stage, who see themselves thus confronted with a game of changing perspectives as they walk around or on the works. "Through the physical contact with the artistic work, the status of the subject changes from a passive beholder to participant in the situation which, however, is characterized not by their activity, but merely by their physical presence."[24]

Just as the sculpture *sans* pedestal successively penetrated the space of the viewer, the *environmental theater* had brought about the prior suspension of a static separation between the action space and the audience space. Happening and Performance Art offered forms of action in which, unlike theater performances, there was no written dialogue, and the actors were generally not trained. Instead, the course and planning of an action are communicated to the either participating or observing audience processually. Allan Kaprow sought the direct integration of exhibition visitors, namely, as participants in the actionist event, while other artists in the circle of New York Action Theater chose the structure of a

7 Carl André, *Equivalent VIII*, 1966.

21 Silvia Eiblmayr, "The Site of Sculpture. The Transformation of the Notion of Sculpture in Terms of the Performative," in: Sabine Breitwieser (ed.), *White Cube/Black Box*, exhib. cat., Generali Foundation, Vienna, 1996, pp. 87–96, here p. 92.

22 See Rosalind Krauss, "Sculpture in the Expanded Field," in: *October*, vol. 8, Spring 1979, pp. 31–44.

23 See Markus Brüderlin, "Foreword: ArchiSculpture," in: ibid. (ed.), *ArchiSculpture. Dialogues between Architecture and Sculpture from the 18th Century to the Present Day*, exhib. cat., Fondation Beyeler, Riehen, 2004, Hatje Cantz, Ostfildern-Ruit, 2004, pp. 15–25.

24 Nina Möntmann, *Kunst als sozialer Raum*, Verlag der Buchhandlung Walther König, Cologne, 2002, p. 29.

non-participative happening, such as Claes Oldenburg describes in 1965: "The place of the audience in the structure is determined by seating and by certain simple provocations."[25] The environment as actionist room was borrowed by Oldenburg from theater tradition: "I think of space as material as I think of the stage as a solid cube or box to be broken."[26]

From 23 February to 26 May, 1962, he organized the ten-part series *Ray Gun Theater* in the three rooms of his New York studio, in which the audience could follow the socially critical performances only through windows. In the performance *Store Days I* a bed, a chair, and a broken radio were placed in the smallest room, which was painted completely black with the floor covered in photographs, newspaper excerpts, and trash. Lucas Samaras "acted" by sitting or lying on, or under the bed, or else walking around the room with bare, painted feet, dressed in boxer shorts, black jacket, yellowed shirt and bowtie. Thus, he let the closed-off actionist space seem like a cell that was something between a cave and a prison. With his Action Theater, Oldenburg questioned the possibilities of individuality in a corporatively organized world of goods.[27]

Two years later the artist carefully constructed *Bedroom Ensemble* in the space of the Sidney Janis Gallery in Los Angeles as an environment that could not be utilized. His room uncovered the distribution channels of the consumer world by depicting it as a distorted reality: borrowing from furniture company advertising brochures, Oldenburg reconstructed the furniture of an artistic "paradise" at three-quarter scale to create the effect of alienation, and to evoke a state between wake and sleep. The viewers, separated from the ensemble by a chain, can only imagine the inhabitants of this psychedelic lucid dream. Oldenburg, who from 1960 to 1967 produced many happenings in environments featuring painted and sculpted elements, leaves the participation open in his *environmental theater*: "I prefer the physical movement in the spectator [...] not in the work. Its definition depends on his position in time and space and in imagination. He invents the work."[28]

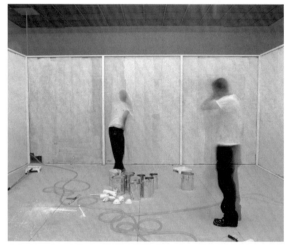

8 **Powerless Structures, Fig. 44** 1998. Steel, glass, white paint, aluminium paint cans, painting equipment, water hose with high-pressure gun. 230 × 600 × 600 cm. Secession, Vienna. Glass cube inside which the artists repeatedly paint and hose down the walls during the opening. Courtesy of the artists.

25 Dreher, op. cit., p. 103.
26 Coosje van Bruggen, *Claes Oldenburg: Nur ein anderer Raum*, Schriften zur Sammlung des Museums für Moderne Kunst, Museum für Moderne Kunst, Frankfurt/M., 1991, p. 25.
27 See Dreher, op. cit., p. 111.
28 Ibid.

This principle of a passively involved observer through whom the room-based artwork unfolds, is also followed by Elmgreen & Dragset whose performances and installations in most cases exclude direct participation by those who receive the work. A prime example of this is their performance *Powerless Structures, Fig. 44* [FIG 8] in the framework of the exhibition opening *Junge Szene* [Young Scene] at the Vienna Secession in 1998, during which they continuously painted a glass cube from the inside. They thereby successively created a non-standardized double of the White Cube surrounding them, which as a room in a room emerged through a process of progressive obliqueness. While the artists were prisoners behind a glass *façade*, the beholders were reflected in it. With the gradual neutralization of the cube within which Elmgreen & Dragset broke open the rigidity of minimalist formal language through multiple overpaintings, differing degrees of visibility were created between the audience and the artists, who increasingly disappeared behind the *façade* so that the beholder was finally left to him- or herself. The performance is reminiscent of Denis Diderot's concept of the *Fourth Wall*, which, in the eighteenth century, he considered as an "unseen" wall between the stage and the auditorium, separating the isolated world of the stage from the real world of the observer, and with it enclosing the visible within the fictional: "Imagine a huge wall across the front of the stage, separating you from the audience, and behave exactly as if the curtain had never risen."[29]

Diderot not only analyzed the type of performance, but the act of viewing as well. In the theater of the 1960s, groups such as The Living Theater and the New York Performance Group under Richard Schechner effected a symbolic tearing down of the Fourth Wall, thus thematizing acting in opposition to viewing precisely by activating the audience as participants. Such a "renovation" was described by Jacques Rancière, in an elaboration of Diderot, as the "paradox of the viewer": "Whoever watches a play sits still and has no power to intervene in the action. Being an observer means being passive. The observer is excluded equally from the ability to know as

9 **How are you today?** 2002. Aluminium ladder, plaster, wood, perspex dome. Dimensions variable. Galleria Massimo De Carlo, Milan. Courtesy of Galleria Massimo De Carlo.

29 Denis Diderot: „On Dramatic Poetry" (1758), in: Barrett Harper Clark(ed.), *European Theories of the Drama. An Anthology of Dramatic Theory and Criticism from Aristotle to the Present Day*, Crown, New York, 1947, pp. 286–298. See Ilse Lafer (ed.), *Hinter der Vierten Wand. Fiktive Leben – Gelebte Fiktionen (Behind the Fourth Wall. Fictitious Lives – Lived Fictions)*, exhib. cat. Generali Foundation, Vienna 2010, Verlag für Moderne Kunst, Nuremburg, 2010; and Jörg Dünne, Sabine Friedrich, Kirsten Kramer (eds.), *Theatralität und Räumlichkeit. Raumordnungen und Raumpraktiken im theatralen Mediendispositiv*, Königshausen & Neumann, Würzburg, Bielefeld, 2009.

from the possibility to act."[30] During the 1960s, around the time of Fried's critique of the theatricality in Minimal Art, the theater promoted awareness of observation as a social activity by forcing the direct participation of the viewer and proceeded, as it were, against a divisive superficiality, which Guy Debord describes of man in his 1967 *The Society of the Spectacle*: "The more he observes, the less he lives."[31]

Elmgreen & Dragset, in an updated reference to the visual and theater art positions of the 1960s and 1970s, stage the spectacle as a result of the spectators' directed activities. The artists do not directly integrate the viewers into the work's execution but rather leave them in their passive role, in which, ultimately, the gaze itself is performed. Diderot, with his dispositive of the Fourth Wall, finally thematized the totalizing effect of the gaze whereby "one could see and be seen, yet never see one's own gaze."[32] The Fourth Wall shuts the observers out of the literary acts on stage and renders them spectators, by creating an interior determined by the person viewing it.[33] In the course of their installation *How Are you Today?* [FIG 9] in 2002 at the Gallery Massimo De Carlo, Elmgreen & Dragset let viewers climb an aluminum ladder, at the end of which one person at a time could stare through a half-spherical glass lens into the kitchen of a woman, who indeed lived just above the gallery, and observe her everyday activities. The gallery visitors, offered nothing at all in the actual exhibition space, were made by the art industry into legitimate voyeurs, unable to communicate verbally with the woman they observed: "The viewer and the resident became active objects of observation, whose subjective personalities remained undisclosed to the other. The gallery space no longer served as an exhibition space for art works, but was at most an access area to a room in which social life played the main role."[34] The common theme running through the duo's works is the gaze of the voyeur whose (secret) longing to spectate at a distance implies the compulsive search for images, and is historically anchored in a negatively connoted sexual desire. Thus, with the underlying idea of allowing for a dual usage, Elmgreen & Dragset built *glory holes* into their 1998 *Cruising Pavilion* at the

10 **Powerless Structures, Fig. 255** 2003. Stainless steel, paint, glass, tiles, urinals. 240 × 240 × 120 cm. Skulptur-Biennale Münsterland, Warendorf, Germany. Transparent glass pavilion with two urinals installed back to back. Courtesy of the artists.

30 Jacques Rancière, "The Emancipated Spectator. Ein Vortrag zur Zuschauerperspektive," in: *Texte zur Kunst*, 58, 2005, pp. 35–51, here p. 36.
31 Guy Debord, *The Society of the Spectacle*, Rebel Press, London, 1983, p. 16. See Jan Deck, Angelika Sieburg (eds.), *Paradoxien des Zuschauens: Die Rolle des Publikums im Zeitgenössischen Theater*, transcript, Bielefeld, 2008.
32 Johannes Friedrich Lehmann, *Der Blick durch die Wand. Zur Geschichte des Theaterzuschauers und des Visuellen bei Diderot und Lessing*, Rombach Cultura, Freiburg im Breisgau, 2000, p. 58.
33 See ibid., p. 157.
34 Katharina Schlüter, *Installationen: Systeme im Raum. Vier Positionen 1990-2001. Monica Bonvicini, Michael Elmgreen & Ingar Dragset, Franka Hörnschemeyer und Gregor Schneider*, dissertation, Universität Hamburg, 2008, p. 112.
35 The sculpture appeared as a picture in 2002 on the stage curtain for the Comic Opera in Berlin.

Danish Aarhus. In *Viewing (Looking back)* the left eye of a wax head stared through a peephole in the wall.[35] In *Powerless Structures, Fig. 255* [FIG 10], the artists built a transparent glass pavilion for the Münsterland Sculpture Biennial in 2003 in Warendorf, Germany, in which two urinals were placed opposite from each other, giving the outsider an unobstructed side view of the genitalia of potential users. Symbolically, Elmgreen & Dragset reactivated Marcel Duchamp's 1917 readymade, the discarded urinal *Fountain*, in double form in their park installation.

In the course of the *Welfare Show* exhibition visitors could drop a coin into a telescope to observe the bookkeeper of the Bergen Kunsthall at her work, whose activities would normally require the utmost discretion. In *Celebrity* the exhibition visitor's voyeurism was underscored by the use of binoculars which, among other things, not only made it possible to survey the rooms of the apartment building, but also offered a view of other visitors in their visual tour through the staged world. The course could thus make visible what Gilles Deleuze described in an extension of Michel Foucault's theory at the beginning of the 1990s as a transition from a *disciplinary society* to a *control society*. Instead of separate institutions and milieus (schools, military barracks, factories, etc.), which the subject traverses during his or her life, here the modes of regulation, which make use of the dynamics of exclusion and inclusion mechanisms, institutionalize a permanent rivalry among individuals as well as a continuous and comprehensive monitoring.[36]

The apartment building in *Celebrity* shifts associatively between Jeremy Bentham's panopticon and John de Mol's *Big Brother* container residence: on the one hand, the fictive residents are brought before the eyes of the exhibition visitors as pure informational subjects who, through their absence, are *a priori* excluded from communication – the classical definition of absolute power, "seeing without being seen," is imagined and at the same time revealed as an illusion.[37] On the other hand, contemporary surveillance scenarios are thematized, which are trivialized in the television format *Big Brother*. With its first broadcast in Germany, ten candidates volunteered to be enclosed in a sparsely furnished residential container and monitored by 28 cameras and 60 microphones from March until June 2000. The material could be seen daily on prime-time television in an edited version, or around the clock on the Internet. Meanwhile, the audience was asked to judge the people in the containers and to vote them off the program according to their estimation: the commercialization of people. "Under the surface of images, one invests bodies in depth."[38] The desire to observe and the obsession to control collide in Elmgreen & Dragset's *Celebrity* and have lost nothing of their relevance since Hitchcock's *Rear Window*, which has been repeatedly compared with Bentham's "prison of observation."[39]

The casting show as celebrity generator is a direct descendant of reality TV. Both formats "employ excerpts of reality, in order to use it to stage stories whose goal is the voyeurism of the audience."[40] Reality TV ultimately also reached the art world. Since June 2010, the US-based Bravo network has broadcast the show, *Work of Art: The Next Great Artist*, in which artists vie for a solo exhibition at New York City's Brooklyn Museum and for a prize to the value of $100,000; the artists are advised by mentor and auction house owner Simon de Pury.[41] The gaze and the stage are the parameters of an entertainment society that can only possibly be amusing to those who do not lose their *image*.

Translated from the German by Charlotte Eckler.

36 Lutz Ellrich: "Gefangen im Bild? Big Brother und die gesellschaftliche Wahrnehmung der Überwachung," in: Leon Hempel, Jörg Metelmann (eds.), *Bild-Raum-Kontrolle. Videoüberwachung als Zeichen gesellschaftlichen Wandels*, Suhrkamp, Frankfurt/M., 2005, p. 38. See Gilles Deleuze: "Postscript on Control Societies," in: *Negotiations* 1972–1990, transl. Martin Joughin, Columbia University Press, New York, 1995, pp. 178; and Thomas Y. Levin, Ursula Frohne, Peter Weibel (eds.), *CTRL SPACE]. Rhetorics of Surveillance from Bentham to Big Brother*, exhib. cat., ZKM | Center for Art and Media, Karlsruhe 2002, The MIT Press, Cambridge, 2002; and Dietmar Kammerer, *Bilder der Überwachung*, Suhrkamp, Frankfurt/M., 2008.

37 Jeremy Bentham's never-realized prison design, the panopticon of 1787, provided a central tower from which a guard could see the surrounding isolated, individual cells at all times, whereby he was protected from being seen. "The panopticon is a kind of theater; what is staged is 'the illusion of constant surveillance: the prisoners are not really always under surveillance. They just think or imagine that they are.'" (Reg Whitaker, *The End of Privacy. How Total Surveillance Is Becoming a Reality*, The New Press, New York, 1999, p. 33).

38 Michel Foucault, *Discipline and Punish. The Birth of the Prison*, Vintage Books, New York, 1995, p. 217.

39 Peter Springer, *Voyeurismus in der Kunst*, Reimer, Berlin, 2008, p. 313.

40 Bernhard Pörksen, Wolfgang Krischke (ed.), *Die Casting-Gesellschaft. Die Sucht nach Aufmerksamkeit und das Tribunal der Medien*, Halem, Cologne, 2010, p. 35. See also their essay in this volume, p. 124.

41 See Berin Golonu, "Tune In, Tuned Out: Work of Art: The Next Great Artist and the politics of spectatorship," in: *Art Papers*, Nov/Dec 2010, pp. 11–15.

Sarah Thornton

O
n a sunny afternoon in October, Michael Elmgreen and Ingar Dragset drive up to their Berlin studio in a nine-year-old wreck of a Range Rover. "It's a good vehicle for the studio. Everyone uses it," says Dragset to today's studio visitor, a writer, betraying a concern that the brand might be sending the wrong message. He descends from the driver's seat, then adds, "Michael knows absolutely everything about cars but he doesn't have a driver's license." Elmgreen slams the passenger door and says, "I would be much too aggressive behind the wheel."

Elmgreen & Dragset's studio is majestic. Built as a water pumping station in 1924, the structure boasts a single room that is three stories high. The glorious interior is announced on the outside by tall columns of windows. Many of Elmgreen & Dragset's works go by the name of *Powerless Structures* but their studio is unambiguously powerful. Due to Berlin's hospitable attitude towards artists, they were able to buy the building "for the price of a two bedroom flat in Copenhagen," as Dragset puts it. The studio is now a hot spot on architectural tours of Berlin.

The artists have five staff and a sprinkling of interns. As they enter their studio with several bags of groceries, they encounter Jan, their studio manager, and Nils, "an all-round practical genius," ushering a large wooden crate out of the building. The crate contains a replica of a waiting room – a row of four seats, a ticket dispenser, an electronic number display that flashes "000," and a door that leads nowhere. The installation was first shown in their solo exhibition *The Welfare Show* at London's Serpentine Gallery then in Toronto. Now it's on its way to Amsterdam.

Inside, the grand main room is dominated by experiments and partial constructions of the two large-scale installations that will make up *Celebrity: The One & The Many*, an exhibition that opens in a few weeks at the ZKM | Center for Art and Media in Karlsruhe. One installation, titled *Low Profile*, will feature an apartment building, thirteen meters high, with carefully curated interiors that reveal the tenants' immersion in celebrity culture. The piece features no real pop stars or Holly-

wood icons but focuses on the self-celebritization efforts of "the many." The other installation, called *High Expectations*, is a full-scale mock up of a swanky reception room containing an oversized fireplace above and below which will be a painting and sculpture depicting a seven-year-old blonde boy in his school uniform. In this instance, he appears to be "the one."

Elmgreen and Dragset are both in their forties and six foot three. Elmgreen is a fair-haired Dane whereas Dragset is a Norwegian with brown hair and a beard. As the artists move through the studio, they stop to decide which specialist restorer to use for creating the surface of the fireplace. They look at examples of painted fake marble and select one without hesitation. Then they move on to choose a blue for the surrounding walls. Nils, a sturdy man with a pierced eyebrow and black tuque, holds up a panel with two nineteenth-century paint samples: gray-blue on the left and greeny, gray-blue on the right. Dragset points to the one on the right and says, "I think it looks quite castle-like." Elmgreen crosses his arms in judgment. "It's the color of the director's office at the Victoria & Albert museum," he says. (The artists will be doing a project there in 2013.) They walk away, still uncertain that either color is quite right.

Any given art work involves thousands of small aesthetic decisions, particularly as Elmgreen & Dragset no longer outsource their work to middlemen that liaise with fabricators on the artist's behalf. At the moment, Elmgreen & Dragset are dealing with all sorts of carpenters, painters, wax casters, and metal workers. "It is much better to have direct communication with someone who loves his wood," explains Elmgreen, "than a businessman who solves artists' logistical problems all day."

Vertical shafts of sunlight pour into the space. "Everything in the studio usually goes really smooth. The people here don't make major mistakes," says Elmgreen. But the workshops sometimes screw things up so badly that a piece needs to be entirely re-made. "We are always anxious to know: did they fuck it up or have they fulfilled our expectations?" says Dragset. Their project manager, Sandra, often deals with the workshops. "She is good with having our critical eye. She knows what is okay and what will upset us," says Elmgreen. "It is not just about information, but the ambience of the piece, creating the right atmosphere in the work."

The artists make a few more decisions then walk up the stairs. The back of the building is laid out like a townhouse with four rooms stacked on top of each other – a kitchen-dining room, a guest room and separate bedrooms for Elmgreen & Dragset. A giant living room with an A-frame roof runs the length of the building above the studio space. The artists were keen to mix public and private, work and play so the studio would have an "unprofessional" feel.

Dragset and Elmgreen stroll into the kitchen with floor-to-ceiling Art Deco windows on three walls. They unpack groceries and prepare plates of cheese and bread. They are both wearing shirts with fine checks that match their trainers, jeans and bomber jackets. Elmgreen's ensemble is red and black. Dragset's is royal blue and white. A doting mother might color code her twin boys in such a way. Neither is obsessed with designers. "I'm not anti-fashion," explains Elmgreen, "but I am not really interested in staging myself through clothes as a conceptual project."

Elmgreen & Dragset met in a gay bar called "After Dark" in Copenhagen in 1994, became lovers, and then began collaborating. Elmgreen was a fledgling poet who had staged his words on video, while Dragset was involved in the performance and street theater scenes. Neither had gone to art school, although Dragset had attended a couple of years of university doing studies that he describes as "part clown, part Shakespeare."

Elmgreen sits at the head of the table, Dragset takes a seat to his left, while their guest sits to his right with her back to the windows. The writer is interested in what makes these artists tick. She opens with a question favored by psychotherapists: "What's on your mind?"

"Oooh aaah oooh aaah … That's the sound on our minds," jokes Elmgreen.

"It's like a busy signal," adds Dragset, as he slices some bread. The artists are juggling about ten projects in different states of completion.

"What did your parents do?" she asks, attempting to ascertain their class background.

"My mother is a primary school teacher and my father is a businessman," offers Dragset.

Elmgreen, by contrast, stares at her calmly and says nothing. She looks back at him with benign curiosity. "They're dead," he says eventually.

"When did they die?" she prods.

"My dad had me really late so he died naturally and my mother committed suicide. I moved away from home when I was sixteen and I never saw them again, so it doesn't matter. They are non-existent," says Elmgreen. "When I was seven years old, I didn't like who they were. I remember thinking that was weird at the time."

"Perhaps your mother didn't much like herself either?" offers the writer.

"Maybe," replies Elmgreen. "I kind of adopted myself into a classmate's family. His dad designed stereos."

The name "Elmgreen" suggests a landscape painter while "Dragset" sounds like a cross-dressing performance troupe. Together, the names befit a Scandinavian law firm. "How did you come to call yourselves 'Elmgreen & Dragset'?" she asks.

"We didn't," says Dragset. "Our names were shortened by organizers of group exhibitions. We don't see ourselves as a brand. We are not something like Bang & Olufsen …"

The writer interrupts, "Did the dad who designs stereos, by any chance, work for Bang & Olufsen?"

"Yes," admits Elmgreen with a tilt of his head.

"I guess you could say that we were inspired by Gilbert and George," says Dragset. "Gilbert and George were early in doing a sustainable collaboration. Our work is not much like theirs, although our first works were about gay identity and being a couple."

"We take our humor very seriously," says Elmgreen. "Gilbert & George's singing sculptures are highly comical."

"Our initial ambition was to express our worldview more publicly," says Dragset. "It was not so much that we thought we were special. It was about a lack. We missed seeing our perception of the world represented."

Ingmar Bergman, *Brink of Life*, 1958, film still.

"It is really hard to be in love with other people's neurosis."

"Ingmar Bergman!" announces Elmgreen. "He's an inspiration. He's dead cool."

"He's definitely dead," quips Dragset.

"Bergman's project was about people who set out to do something good and become very evil in the process," says Elmgreen with some glee. "He was in love with his own neurosis."

"Are you in love with your neurosis?" she asks Elmgreen with a smile, then turns to Dragset, "Are you in love with *his* neurosis?"

"It is really hard to be in love with other people's neurosis," says Elmgreen preemptively.

"Michael wouldn't be this amazing person without his neurosis," says Dragset sweetly.

"You are not very neurotic," replies Elmgreen matter-of-factly. The artists rarely revert to the third person for the benefit of the interviewer when referring to each other. Instead, they tend to address each other as "you" in front of her.

Dragset oozes goodness. He comes across as fundamentally happy and even-keeled. Elmgreen, though physically fairer, is the psychologically darker side of the artistic duo. He has a more menacing demeanor. Evidently, the combination is professionally productive.

"Bergman's interview scenes are brilliant," says Elmgreen, returning to a pet topic of conversation.

"Have you seen Bergman's *Scenes from a Marriage*?" Dragset asks the interviewer. "You must, *must* see it!"

"When did you break up as a personal couple?" she asks.

"Six years ago," says Dragset. "He went off with another guy, didn't he!" The artist explodes in peels of laughter.

"Can you imagine both living and working together, sharing every single moment, all your economy, all your friends, all your holidays," says Elmgreen. "After ten years, there is not so much surprise." He pushes his plate aside and pulls out a pack of Danish cigarettes called Prince.

"In retrospect, I can see how we moved into a corner. I didn't realize it at the time," says Dragset, who reaches for a pack of Gauloises Blondes.

When Elmgreen and Dragset broke up, they wondered whether they could continue as artistic partners. They

cancelled and postponed quite a few exhibitions. One show that they followed through with was for Tate Modern. "As artists, you can turn negative situations into positive ones," explains Dragset. "You can put your situation on covert display. We started out with several ideas but, in the end, the whole exhibition was reduced to a dying sparrow placed between two window panes." The sculpture was animatronic so the bird twitched in endless, agonizing death. It was titled *Just a Single Wrong Move*.

"Can you see a difference in your oeuvre after the break up?" asks the writer.

"It's better or far more challenging in a positive sense," affirms Elmgreen. "If you survive that, it gives you the strength to make the stakes higher."

"Do you have arguments?" she asks.

"We just had a big fight before you arrived!" admits Dragset. "We can have huge fights, of course, mostly about silly things, just like a married couple."

"Our fights are usually due to pressure from the outside," says Elmgreen. "A piece fucks up with a fabricator, a deadline is too close, galleries are squeezing you or they don't pay on time … practical things. When you are two, you don't have a nervous breakdown, you say, 'WHY DIDN'T YOU DO THIS?' It's a relief to be able to blame each other sometimes."

Shortly after their break up, Elmgreen & Dragset made *Marriage*, the first in a series of paired porcelain sinks whose long, winding pipes are ensnarled in a knot.

"There is a lot of love in our work," says Dragset.

"It's about love, not labeled as love," qualifies Elmgreen. "It's very Bergmanian. Don't patronize me with your love. Don't show me compassion in a dominating way." The artists' postures mirror each other with uncanny frequency. Elmgreen is smoking with his left hand, Dragset with his right. Their free hands are both on the table. Their legs are crossed towards each other and their eyes are locked in contact. "I believe in the ideal of soul mates," says Dragset. "To make relationships function or to last, at least."

The sinks are not the only works by the artistic duo that involve domestic doubling. The artists have also made

"No audience, no artworks. I wouldn't do it for fun."

sculptures of bunk beds in which the top bunk faces down and pairs of doors, which are linked together by a single chain lock. They also had the pleasure of transforming two pavilions into fictional homes at the Venice Biennale.

"Every time we put something in singular form, it feels a bit funny," says Dragset. "But it can be interesting too, such as the title of our exhibition, *This is the First Day of My Life*."

"That title is spoken by the third person that exists between us," explains Elmgreen.

"It is not me or you," says Dragset.

"It is like a little vulnerable character," continues Elmgreen.

"It's the repressed side of us. It is not us as real people. It's a fiction – a little bohemian, romantic, immature, insecure character."

Dragset raises his eyebrows; he doesn't appear to have heard this before. The identities of interesting artists are invariably complicated, all the more so when there are two personalities sharing a single career. The interviewer seizes the opportunity to ask one of her favorite questions: "what kind of artists are you?"

"I don't have the taste in my mouth or smell in my nose of being an artist. I'm a cultural producer," says Elmgreen without a moment's hesitation.

Dragset shakes his head. "I'm an artist. I wouldn't call myself anything else," he says. "I remember very well making the decision to accept myself as an artist. I had my 30th birthday in New York City. We had a residency there. Up until that point I had felt embarrassed, uncomfortable, then I thought, fuck it. I can be just as much an artist as anyone else. There is no set definition on how to fulfill that role."

"I don't have more intense feelings than the average person," says Elmgreen, taking a swing at a *cliché* about artists. "I may be good at choreographing emotional experiences and combining them with exaggeration and lies, but we are not *feeling* our way to our visual statements." Outside the art world, the Van Gogh myth of emotion-driven art is still remarkably pervasive. "No audience, no artworks. I wouldn't do it for fun," he adds.

"It's banal, the idea that art is devalued by popularity."

"Art is a dialogue. We value our audience. If you make art for yourself, why show it to others?" Indeed, within the art world, the idea that authentic artists are driven by a loop-tape of conceptual obsessions that disregard the viewer is the art insider's version of the myth. "The artwork, once made, doesn't get any better because it's hyped or sold," continues Elmgreen. "And it doesn't get any worse either."

"It's very banal, the idea that art is devalued by popularity," says Dragset in agreement. "It happens in music all the time. It's another way by which groups preserve their exclusivity."

"The avant-garde notion that you are only noble if you are misunderstood and unappreciated persists," says Elmgreen. "But it is actually easier to talk to a narrow audience because your vocabulary can be tighter."

"I know it's a dumb question but what would you say is your signature?" asks the writer.

"Asking dumb questions," says Elmgreen.

"No, no. That's my signature!" says the writer.

"Okay, I'll come up with something else," says Elmgreen. He looks at Dragset to think, then says, "We are like small mice, avoiding being trapped or cornered. We change our formal language quite often but you can never escape from yourself, so there will be recognizable elements." He pauses, thinks some more. "We like the here and now," he says. "Most two-dimensional works have a reference to a past or a reality somewhere else. Performance and sculptures are a bodily meeting in the present." Elmgreen considers the question further. "Our work is not a symbol of something bigger," he says. "It is not about universal truths. All we do is to tell small lies."

Elmgreen has been living in London since 2008 and comes to Berlin once or twice a month while Dragset lives in Berlin fulltime. When apart, the pair talk on the phone, skype and email every day. "How do you come up with your ideas and lies?" asks the writer.

"We have good ideas when we are together," says Elmgreen, "and when we are out of the daily routines of the studio because the studio is ..." He lowers his

"There's nothing wrong with a bit of masturbation."

"True, but you don't need to do it in public."

voice to a whisper, "business." The two artists, who are children of the Scandinavian welfare state models, are clearly not comfortable with the business side of their artistic activities.

"In the studio, you adjust the ideas, you refine them," concurs Dragset. "But there is no time or intellectual energy for the start of an idea. There is too much noise and too much daily routine."

"Where exactly do you have your best ideas?" she inquires.

"In other time zones," says Dragset. "Feeling foreign makes you feel free. Hotel rooms or gritty gay bars allow you to enter your own world."

A draft of the invitation for their upcoming *Celebrity* show is lying on the table.

"How did you come up with the idea for *Celebrity – The One & The Many?*" asks the writer.

"Exactly the same way as we came up with the idea for the pavilions in Venice," replies Elmgreen. "We went into the space and asked ourselves, 'what belongs here?'"

Architecture is often a point of departure for the artists. They are keen to reveal the social structures and power dynamics that underlie the design of public spaces.

"*Celebrity*, like *The Welfare Show* and *The Collectors* (our pavilions in Venice), describes a change in the cultural climate," says Dragset. "The exhibitions are about the ways that a positive sense of community has been overthrown by the demand to be an outstanding individual." The artists see these three exhibitions as a trilogy that explores new social identities, such as citizens unhinged by governments' disregard for their well-being, the new super-elite's increasing distance from the general population, and the way reality shows and social networking sites constantly individuate the crowd.

The invitation for *Celebrity* depicts a mirror in which the steam has been wiped away by a finger to reveal the show's title. "That is part of our control-freaking," says Elmgreen, gesturing to the card. "We create the whole graphic profile for the show – the identity for the banners, the invitations, the ads in *Artforum*. We like to do it because it affects how the show will be perceived."

"We don't like to get sucked up by institutional visual languages," adds Dragset.

On the floor is a scale model of the interior of the ZKM museum, which includes a wooden maquette of the apartment building in which the artists will create ten imaginary lower-income living spaces of people hooked on celebrity culture. It's inevitable that taste will be a theme. Taste is somewhat taboo in the art world; art is supposed to be above its vagaries. In the context of their impeccably tasteful studio, the writer wants to know: "what springs to mind at the mention of the word taste?"

"I guess taste is about smoother and clumsier ways of expressing yourself," says Elmgreen. "I hate myself for looking down on bad taste."

"I have a collection of Venetian glass, Murano vases from the 1970s," admits Dragset.

"Ingar's boyfriend and I are going to share the responsibility when we smash them up," laughs Elmgreen.

"They may not be beautiful but I love them," declares Dragset.

"The thing I don't like about Murano vases is that they speak with these high-pitched voices," says Elmgreen. "It hurts my ears when there are too many of them in the room."

"They tell me little secrets," says Dragset, who then makes the burbling sound of underwater chatter. "All objects have voices. They don't just have messages, but personalities. They all speak to you."

For their play *Drama Queens*, Elmgreen & Dragset created voices for a range of historic sculptures including Alberto Giacometti's *Walking Man*, Sol LeWitt's *Four Cubes* and Jeff Koon's *Bunny*. A poster for the premiere of the play in Münster hangs behind Dragset in a cheap metal frame.

"Nowadays, artists who aren't even mid-career are invited to do retrospective exhibitions." "We don't do surveys!" says Elmgreen. "Retrospectives come when the autumn leaves are falling off the tree."

Sandra comes into the kitchen to tell them that it's time for a production meeting about a public sculpture of a mermaid-like boy who will sit on a rock next to the sea in Denmark. The artists say that they'll be with her in a minute.

"Each show opens a conversation," says Elmgreen. "Doing a retrospective is the end of the conversation." He takes a fast inhale and a slow exhale of his cigarette. "We have a deep respect for the audience," he continues. "If you do a retrospective, it's not sex, it's not love, it's masturbation."

"There's nothing wrong with a bit of masturbation," says Dragset.

"True," says Elmgreen. "But you don't need to do it in public."

elebrities are the aristocrats of media society. But are celebrities society's elite? Or are they the product of a lavish populism as staged by the media? Such questions are linked to uncertainty as to whether the difference between elite and popular still holds as a means for describing a cultural hierarchy. Would such doubt substantiate our view, then one of the core writings of present-day sociology would be affected. Pierre Bourdieu's *Sociology of Social Difference* is a theory of the difference between elite and popular culture. Bourdieu addresses the question of social stratification as a class relationship deriving from the unequal distribution of economic capital as well as the issue of the unequal distribution of cultural capital and social relationships.

While Bourdieu's description of the "subtle differences"[1] which separate the social classes is both detailed and poignant, his book *On Television*[2] remains superficial and poorly defined. His criticism is merely a moralizing platitude that fails to go beyond the media's own grievance about the deterioration of ethics in journalism. It thus lacks a theoretical analysis of the mechanisms which lie behind manipulation and popularization as practiced by mass media. One might expect that a theorist whose core thesis revolves around cultural and social capital would consider the mechanisms inherent in the mass media's business of attracting and directing attention.

Media Celebrity

To be a celebrity is to be someone who enjoys a huge income of attention and who is generally known for being such a big earner. Being a celebrity is a sociologically objective category as determined by empirical criteria. The word "elite" is consequently difficult to classify. To be regarded as a member of an elite one has to have made extraordinary achievements in a sophisticated field. However, to give a precise definition of what and what may not be considered sophisticated is not easy. And who would be competent enough to stipulate the

Celebrity and Populism

with regard to Pierre Bourdieu's Economy of Immaterial Wealth
Georg Franck

1 Pierre Bourdieu, *Distinction: A Social Critique of the Judgement of Taste*, Harvard University Press, Cambridge/MA, 1984.
2 Pierre Bourdieu, *On Television*, New Press, New York, 1998.

requirements? What is the effective distinction between normal and extraordinary? The sociological definition of elite is based on the assumption that it is in fact possible to identify something like a social pyramid, namely, as a stratified structure with a broad base culminating in an apex.

Media society has not only one but many apices. Neither are there any general rules governing "high performance" in media society. What, in the last analysis, unites the many high points and special features of high performance is the extraordinarily high level of name recognition. If there is such a thing as a common denominator for today's, still recognizable, elite then it would be celebrity. However, it does not follow from this that only those who perform extraordinary things in prominent positions become celebrities.

In media society celebrities are fabricated by the media. The media has the means to muster the huge amount of attention which feeds the class of prominent people. To be sure, the media is not a charitable institution. The media have commercial interests and release whatever promises they think will enhance their own income of attention. The media elevate people to celebrity status only once, and, by virtue of their own popularity, they are able to enhance the media's popularity.

Whoever seeks success in the business of mass attention cannot afford to be choosy about who applauds them. In the business of arousing and harvesting attention, the conscious lowering of standards is regarded as a valid means to increase earnings. The business of attraction is infiltrated by the temptation to have populist appeal. The production of celebrities is not immune from this temptation. One of the characteristic traits of mass media is their use of low-standard genres as a means for manufacturing celebrities *en masse*.

Paris Hilton and Robert Pattinson are genuine celebrities. But to which elitist standards should they comply? Is the question as to the existence of such standards not *passé*? Or is it simply that those who feel themselves to be members of an elite group are allowed to be part of it? There is a current trend to attribute to oneself "elite status." As soon as the word elite loses its ideologically objectionable meaning, self-attribution begins to spread. But surely, if considering oneself a member of the elite were to become fashionable wouldn't this social position then be rendered obsolete? While an affirmative reply to this question would stand to reason, Pierre Bourdieu's sociology maintains the contrary.

Cultural and Social Capital

In short, Bourdieu's sociology presents a political economy of immaterial wealth. Central to the description of "delicate distinctions" and the "hidden mechanisms of power" are the concepts of cultural and social capital. Cultural capital is that with which those who set the tone of a scene are equipped. Social capital is what is available to those who have the right connections. Bourdieu's elite is a class of capitalists. One cannot simply define oneself as a capitalist without owning the means for excelling over others. Such means of assertion enable one to acquire the surplus value which accrues in one's sphere of business. Surplus value of cultural and social capital accrues in the form of prestige, kudos and prominence. If it were possible to define the difference between the means of assertion in the theory of capital in both high and popular cultures, then the contradiction between elite and popular could be resolved.

Bourdieu's theory of cultural and social capital is concisely summarized in the essay "The Forms of Capital."[3] "Depending on the field in which it functions, and at the cost of the more or less expensive transformations which are the precondition for its efficacy in the field in question, capital can present itself in three fundamental guises: as *economic capital*, which is immediately and directly convertible into money and may be institutionalized in the forms of property rights; *cultural capital*, which is convertible, on certain conditions, into economic capital and may be institutionalized in the form of educational qualifications; and as *social capital*, made up of social obligations ('connections'), which is convertible, in certain

3 Pierre Bourdieu, "The Forms of Capital," in: A. H. Halsey (ed.), *Education*, Oxford University Press, Oxford, 1997. There is a more extensive version of the essay available in German: "Ökonomisches Kapital – Kulturelles Kapital – Soziales Kapital," originally published in: *Soziale Welt*, Sonderband 2: *Soziale Ungleichheiten*, 1983; reprinted in: Pierre Bourdieu, *Die Verborgenen Mechanismen der Macht. Schriften zur Politik und Kultur 1*, Margareta Steinrücke (ed.), Vsa, Hamburg, 1997, pp. 47–58.

conditions, into economic capital and may be institutionalized in the form of a title of nobility."[4]

Cultural capital exists in three different guises: in the embodied state of formation and appropriated behavioral disposition, in objectified cultural artifacts such as theories or art works, and in institutionalized titles and official authority. In all these forms the capital character is a result of the investment of actual time, and time already crystallized into cultural capital. On each occasion the aim of this investment is to increase the effect of the time spent in the future. Bourdieu's cultural capital is not just symbolic, even if its various appearances may adopt a symbolic character. The investment is lucrative, it yields interest, and the profit is paid out in the form of social recognition. Interest can also be measured in time. Social recognition demands more than just words. Words are cheap. Recognition only counts if words are accompanied by attention, and the time spent in paying attention is not cheap, but scarce. The social asymmetry to which capital ratio gives rise is the ratio between the time a socially important person spends herself or himself and the time she or he earns in terms of being paid attention. The capitalists of this immaterial economy are those who receive orders of a magnitude exceeding the degree of attention they would be capable of reciprocating.

Social capital also exists in incorporated, objectified and institutionalized form. Social capital is incorporated in the habitus, such as the scent of the right stable by which the members of high society recognize each other. It is objectified through signs of social difference, such as the set of adopted manners and tactful behavior. It is institutionalized by the mutual relations of knowing and accepting one another. The reproduction of social capital relies on the constant cultivation of relationships, and this cultivation of relationships uses up real and already capitalized time. The application of real time is more effective the more accumulated capital is already available. "This is one of the factors which explain why the profitability of this labor of accumulating and maintaining social capital rises in proportion to the size of the capital.

4 Ibid., p. 47.
5 Ibid., p. 52 f.

Paparazzo-performance during the inauguration of *Celebrity – The One & The Many*, ZKM | Museum of Contemporary Art, Karlsruhe, November 11, 2010.

Because the social capital accruing from a relationship is that much greater to the extent that the person who is the object of it is richly endowed with capital (mainly social, but also cultural and even economic capital), the possessors of an inherited social capital, symbolized by a great name, are able to transform all circumstantial relationships into lasting connections. They are sought after for their social capital and, because they are well known, are worthy of being known ('I know him well'); they do not need to 'make the acquaintance' of all their 'acquaintances'; they are known to more people than they know, and their work of sociability, when it is exerted, is highly productive."[5]

Without doubt, the concept of a class capable of monopolizing vast holdings of social and cultural capital comes very close to the concept of elite. One could even say Bourdieu rescues this term for sociology by simplifying. There is ample empirical work on the ownership of cultural and social capital. Nevertheless, how is it possible to bring Bourdieu's observations into line with the evidence which shows that celebrities are the common denominator of today's visible elites? And how does Bourdieu's theory of capital go together with the phenomenon of the mass media's assembly-line production of celebrities?

Capital and Distribution

Celebrities are more than just the class of people rich with attention. This class also receives orders of attention of a magnitude exceeding what it is capable of spending itself. In this sense, Bourdieu's concept of elite is synonymous with the classic notion of prominence. That concept fails, however, to account for that novel class of TV celebrities. The celebrities presented by the mass media neither match elitist standards nor appear to be a class which monopolizes the ownership of cultural and social capital. These celebrities find their counterpart in members of the *nouveau riche* who make easy money on the stock market.

This analogy is not just metaphorical. The mass media does indeed function as a stock market – quite literally like a capital market. Presence in the media is a form of quotation of market value. This presence measures the market value of the capitals which make up the wealth of the paraded celebrity. However, the mass media are capital markets which Bourdieu's conception fails to sufficiently describe. Cultural and economic capital in Bourdieu's definition and in the case of economic capital, assume the same form as real capital. They consist of heterogeneous accumulations of characteristics, skills, goods and attributes. On the other hand, the capital, the market value of which is marked via media presence, exists in the form of financial capital. Financial capital is the form real capital must assume before the heterogeneous collection can be measured in homogeneous units.

Bourdieu sees a problem in this measurement, namely, that accumulations of skills, goods and attributes only change into the general form of capital once measured unitarily. From whence, however, is this homogeneous standard to be taken? What do attending a French elite school, owning a collection of early porcelain and an academic title have in common? Through which kinds of transformation do a well-chosen wardrobe, a good address and a noble family name become sums of a homogenous entity? The type of transformation on which Bourdieu focuses is the classic theory of labor value.

"The universal equivalent, the measure of all equivalences, is nothing other than labor-time (in the widest sense); and the conservation of social energy through all its conversions is verified if, in each case, one takes into account both the labor-time accumulated in the form of capital and the labor-time needed to transform it from one type into another."[6]

By way of this recourse to the theory of labor value Bourdieu's theory of capital is seriously handicapped. Neither are the embodied hours of work sufficient for determining the value of cultural and social capital, nor work time a suitable measure of the cost of transforming one form of capital into another. It is simply not true that an artwork is of higher rank just because it took more labor-time to produce it. It is simply nonsense to say that a certain scientific theory is superior to another because its development required greater effort. One cannot even apply this simple time calculation to the value produced by education, even though the services producing education immediately consist of labor-time. Although nobody would doubt that it takes considerable effort to build up relationship-networks, it is arguable that this work alone is not enough for success. To be sure, considerable work goes into educating people to be well-mannered and to have the right appearance, but this does not mean that their value as social capital is higher because the production costs are higher. How much work time would have to be invested in order to attain the state of nobility?

By referring to the theory of labor value, Bourdieu pays homage to the economist Karl Marx. Consequently he does a disfavor both to himself and to Marx. He does himself a disfavor because his theory fails to examine the function of banks and the stock-market, which lies behind the way contemporary forms of cultural and social capital materialize. And neither does he do Marx a favor by ignoring the recent advances made by Marxist-trained left-wing theorists of political economy.

The subsumption of things as heterogeneous – as those summarized by the terms "cultural" and "social capital" under the highly specific and functional term "capital" – is only possible under conditions of functional equivalence. The subsumption remains economically questionable, so long as the price system, which changes the qualitative differences into quantitative differences, has yet to be agreed upon. In the case of cultural and social capital it is possible to achieve an equation since a system of equivalence is inherent. A deficiency in education may be offset by extraordinary possessions. An ordinary ancestry may be compensated by way of a brilliant career. A sonorous name can be transformed into hard cash. Bourdieu is right in saying that the medium of this equation is not simply money. If there is a price system behind the system of functional equivalences it is one of prices in a different currency.

6 Ibid., p. 54 f.

The urgency in the quest to find the mechanisms of price formation is underlined by the development undergone by Marx's notion of capital since its inception. Considerable progress has been made in this field. It has been possible to prove that the value of the entity "capital" will remain undefined so long as it is not related to the division of the social product into basic forms of income, viz, into wage and profit. The value of capital is calculated from profit not vice versa. This was concluded in a discussion on the theory of capital which came to a head during the 1970s and entered the history of theoretical economy under the title "Cambridge, Massachusetts, versus Cambridge, England."[7] Through this clarification it was possible to refute the claim that profit could be explained through the productivity of the "factor" capital. It was shown by the critics of the neoclassical mainstream that this "factor" becomes a source of income through the way in which the social product is distributed or socio-politically asserted. This makes it redundant or even counterproductive to use the theory of work value in order to theoretically consolidate the aims of political distribution. The assumptions of the theory of work value are very hard to verify empirically and make the argument susceptible to criticism. Suffice it to say that the value of capital follows from distribution and not the reverse.

Even Bourdieu's capital theory cannot elude this conclusion. In order to make his theory about the concept of capital more than just metaphorical, one would have to determine the value of cultural and social capital from the income derived from social and cultural capital ownership. Hence the question: what kind of non-pecuniary income is extractable from the possession of cultural and social capital?

What makes the different kinds of real cultural and social capitals comparable and connected with one another is the prestige or kudos they bring. While prestige and kudos concern social distribution, they most certainly do not concern the distribution of a money-valued social product. The distribution of prestige and kudos within a given society is the expression of the distribution of attention interpersonally exchanged within such a society. Those who have prestige attract considerable attention, and those who have none attract little. Those who are known for attracting plenty of attention have kudos. Hence, the possession of cultural and social capital depends on the overall distribution of interpersonal attention. On the other hand, might it not be any less valid to assert that the value of cultural and social capital is calculated on the basis of the income of attention to which its possession leads?

We thus find ourselves confronted with the question after the financial form of real cultural and social capital. Prestige and kudos not only generate attention, but are themselves its product. Prestige is an expression of the present value of a past flow of significantly high attention income.[8] Kudos is the form into which the income of attention, as observed and whispered by third parties, has evolved and been turned into a subject of public opinion. Prestige and kudos are therefore forms of accumulated income of attention. They are themselves forms of capital – forms of capitalized attention.

In fact, the value of this capital is derived from the prospective stream of attention income. Past revenues become values of the present because they are being used to predict the future. The size of prestige is therefore also an expression of the amount of attention income anticipated by possessing it. The amount of kudos is also an expression of the stream of discounted present value in anticipated attention. Previous income generation has to be projected in both cases. The same happens in the evaluation of economic capital.

Consequently, prestige and kudos have always already taken the form of financial capital. They have assumed a form that renders cultural and social capital susceptible to measurement in homogenous terms. However, their size signifies more than just the value of real capital, from which the income is drawn. The capitalized income of attention yields interest in its own turn. Prestige and kudos attract attention by themselves and independently from which the originally accumulated attention was paid. Nothing seems to enhance one's beauty more than

7 For an overview see: C.G. Harcourt, *Some Cambridge Controversies in the Theory of Capital*, Cambridge University Press, Cambridge, 1972.
8 For further detail see: Georg Franck, *Ökonomie der Aufmerksamkeit* [*The Economy of Attention*], Carl Hanser, Munich, 1998, chapter 4.

when one's wealth of attention becomes well-known. A person who has prestige is given attention purely because he or she attracts such considerable attention. Kudos makes attention available even if the original cause of attractiveness has disappeared. This is why the wealth of attention underlies not just the possession of cultural and social capital but also the wealth of attention itself. Wealth, by becoming conspicuous, itself turns into a source of income. The class of attention-rich people is not only capitalist in terms of Bourdieu's theories, but also includes rent earners receiving an "unearned" surplus on the (normal) profit.[9]

The Medium as Bank and Stock Market

Were it possible to separate the income components accrued by the possession of cultural and social capital from those components originating in the self-enhancement effect of conspicuous income, then the terms cultural and social capital could be immediately restated on the basis of the new distribution theory of attention income. It would then be possible to distinguish prestige from celebrity in the following way: prestige could be defined as the form of capital derived from immediate cultural and social capital income, whereas celebrity as this former capital plus a surplus due to the self-enhancement of conspicuously high incomes. As still needs to be shown, the mass media assembly-line production of celebrities is based on the exploitation of the self-enhancement effect of attention paid in masses. Therefore, one could try to find the difference between the elite as traditionally understood and the *nouveau riche* TV celebrities, by dividing the portions of income. The problem with the distribution-theoretic reinterpretation of Bourdieu's theory of capital is that profits and rents fuse into one undifferentiated magnitude. Profit and rent, while different in theory, are impossible to distinguish empirically. The original force of attraction and the self-enhancement effect amalgamate indissolubly when seen as a part of the same system of wealth and value.

If it is impossible to separate the original from the profit-yielding part of attention income, then the appropriate differentiation of prestige and celebrity is pointless. So how can we save Bourdieu's capital theory approach to explain the social differences? How can we re-interpret his notion of the elite? And how can we grasp the difference between high and popular culture by the means of the revised notion of capital? To grasp this clearly I will first turn to the capital market on which TV celebrities have made their fortune.

The business practices of mass media stand behind the new wealth in attention. The trade of mass media is to attract and gain attention in masses. They attract attention by offering content (information, be it news, entertainment, "infotainment," "edutainment" or "whatever tainment"). Most attention is attracted by those media which most accurately identify what it is the masses want to see, hear and read. The higher the medium's income of attention, the greater is its power to attract the aristocracy of celebrities. It is this success of attraction on which not only the power but also the financial revenue of the medium depends. The first and most general reason for spreading populism amongst the mass media is that attraction is the preponderate business objective. However, the business of attraction does not stop at the publication of eye-catchers, sensational headlines and ear-worms. It also recruits and builds up the crowd pullers who are then sent into battle to attract the most attention. Nothing seems better suited to attract attention in masses than the display of wealth of attention. In order to run the mass business of attention, those rich in attention must be persuaded to display their wealth. Before being capable of display, fortunes have to be built up. It is only through the media itself that conspicuous wealth of attention may be amassed. In fact, the media themselves act as credit grantors for financing this build-up by way of granting attention income in advance.

The mass media invest presentation space and time in people whose appearance promises to raise ratings and circulation figures. Ratings and circulation figures measure the attention the medium is capable of granting to

9 Regarding the function of "rent-seeking," see: Robert D. Tollison and Roger D. Congleton (eds.), *The Economic Analysis of Rent Seeking*, Edward Elgar, Eldershot, 1995.

those displayed in advance. The credit thus granted consists of the presentation space and time invested by the medium. The value of invested presentation space and time depends on the medium's profile, i.e. how much attention one can expect by appearing in this medium. The person invested in can expect a credit of guaranteed (or anticipated) attention from this appearance. The borrower has to practice usury with this credit because it makes it possible to realize otherwise unobtainable profits. If these profits are realized the medium gains profit like a bank. The profits realized through the appearance in the medium determine the popularity and therefore the value of the presentation space and time. The medium can reinvest this capital, which means it would grant another credit, or sell it directly as advertising space. Modern mass media, like commercial television, distinguish themselves from older forms by making all of their money through the sale of the services of attracting attention to whatever the buyer wishes.

The media invests presentation time and space in order to gain circulation and quotas. The bigger and better positioned the presentation space and the longer and better situated the time of presentation, so the higher is its investment in a candidate. Only those candidates capable of maintaining or promising to increase the circulation or the quota appear on front pages and on prime time. The investment measures the expected strength of the candidate to attract attention. This strength is to a crucial extent dependent on already gained prominence or, alternatively, the prominence pre-produced by manipulative presentation of the person. It may thus be claimed that the invested presentation space and time quote a market value of capitalized income in attention. Circulation and quotas measure the business result. Because this result determines the subsequent development of market value there is more at stake for the presented person than just the immediate gain in attention: it always revolves no less around maintaining the market value with which the capital of their prominence is traded.

Not surprisingly, the business of trading with this capital is extremely speculative. It is not only speculative in the sense that wild betting goes on, but also in the sense that the bet influences the business result. The higher the expectation of attraction, the more substantial and better placed the presentation. So the presentation quotes a market value which is in itself dependent on this quotation. Much like a self-fulfilling prophecy, the quotation can harvest the income, which is expressed by its expectation. The strength of a personality's attraction also grows in proportion to his or her wealth of attention. If someone is well-known, this prominence alone attracts attention. Once this person is prominent, he or she will become even richer, purely because everyone knows that this person is rich in attention. As I have shown in the case of prestige and kudos, the wealth of attention pays for itself through pure self-amplification.

In the case of TV celebrities, media and celebrity gain in the same way from this self-amplification. Nothing feels more attractive to the audience than the display of wealth of attention. If one wants to attract attention *en masse* one requires celebrities *en masse*. Hence, it is important for the business of mass media to attract the crucial amount of attention necessary for igniting the self-amplification effect. The pressure to reach this critical mass is also what makes the business of attraction so uninhibited. This pressure permits officially rejected values to become effective as professionally required means of attraction. The second, and more specific, reason for the populism of the mass media lies in the fact that at the point at which the critical mass is reached the power of attraction assumes the effect of a self-enhancing snowball. Whenever the media works towards reaching this snowball effect, the business becomes literally packed with populism.

This has an effect on the newly gained wealth: this "fast happiness" exists because the events which launched the career are soon forgotten, or at least submerged by other events. The rising star causes such a stir because everyone assumes that all eyes are on him or her. The foundation for this wealth is a bet which is on only for as long as everyone directs their gaze at it. A well-conceived insinuation at the nakedness of this person can quickly disrobe them again.

Wealth built on such foundations as these lacks most of the qualities which Bourdieu attributes to his elite. First of all, the class of rich people to have gained its wealth in this way lacks the selectivity expressed in the snobbish traits of the elite. Secondly, it lacks the indispensable distinction required to produce the distance that separates the elite from the mainstream. Thirdly, the wealth that results from mass suggestion must be capable of managements without the foundation of a solid factual basis. The special selectivity, distinction and factual basis constitute the attributes of the consolidated wealth of attention Bourdieu ascribes to the vast holdings of cultural and social capital. If the adaptation of Bourdieu's capital theory to the new distribution theory is to be successful, then it must first be proven that it is not the value of the capital which founds this wealth, but the special income which founds the value of the capital.

The Formation of Social and Cultural Capital

Bourdieu had good reason to assume that owning cultural capital makes one more attractive in the eyes of those who themselves possess it. The possession of social capital, therefore, makes a person particularly attractive in the eyes of those who themselves have good connections at their disposal. The exclusivity of this "wealthy owners of cultural and social capital club" is not only based on the rarity with which these vast forms occur. Above all, it is based on tacitly exclusive behavior. This exclusivity is based on personal qualities and attributes to which the wealthy owners attach great importance in social intercourse. Does this selectivity mean that wealthy owners only accept other wealthy owners? Or could the particular importance laid on distinction revolve around the particular appeal of attention which is itself "packed" with received attention?

A kind of social instinct allows us to react differently to the attention paid to us by famous people as opposed to the attention paid to us by the average person. Not that one could but help to feel flattered if a well-known person notices us, but it takes considerable self-control to suppress our vanity in order not to discriminate. Where vanity takes its course it aspires to make the wealth on the part of those paying attention subservient to its cause. And where vanity finds nourishment such indulgence makes it all too eager to be pampered.

Those who allow themselves the luxury of such pampering are those who take great pride in receiving only that kind of attention which has itself been lavished with attention. And those who grant themselves the luxury of this selectivity are highly rewarded. Whether or not they want it, they appear distinguished. They are now members of the club of high earners of social and cultural capital, no matter what they do or do not possess.

The luxury of this selectivity is unaffordable to those who have to fight for presentation space and time in the media. Those having to fight this battle feel obliged, even forced, to take whatever comes their way. For the soon-to-be media celebrity it is sinfully snobbish not to feel committed to being popular with the masses. For them distinction would mean defrauding themselves of the best, namely, their popularity. For those on the ascent in this popular domain the path to the club of the most exclusive classes is only opened if their wealth has been consolidated. This happens when they no longer need to scrimp and save for the self-enhancement of attention.

For those who have made it, the qualities, skills and attributes which gain the attention of those rich in attention themselves pay off and become cultural or social capital. However, the qualities, skills and attributes become capital not because their owners have surrounded themselves with objects which are part of the inventory of cultural capital, or because they have taken on roles which place them in the vanguard of society. They become capital because the earned attention has begun to pay off interest in a certain way. The qualities, skills and attributes become capital through the effect of capitalization of attention income.

Now what does it mean when a stock of capitalized attention starts to pay interest in a certain way? Is one interest different from another? Interest can actually only

vary in its value when it accrues as money. But received attention has a quality that received money does not possess: from whom the received attention comes is important. We appreciate the attention we receive the more we appreciate the giver of the attention, and so, in turn, the more he or she appreciates us. The value of the exchanged attention is not only to be measured by the length and intensity of the devotion, but also by the social affiliation and appreciation, which connect the giver and the recipient. This appreciation is initially dependent on the special personal relations and on the individual preferences and aversions. But it also follows general rules. The generalized attribute of vanity commonly brings a person to appreciate the attention she or he receives according to the income of attention obtained by the donor. The given attention then epitomizes not only feelings of personal appreciation but also power of judgment, education and taste. Where the attention is appreciated for the sake of such qualities its exchange-value will change accordingly.

A stock of capitalized attention definitely starts to yield interest if the interest accrues in terms of the attention paid by people of high prestige. Social capital, according to Bourdieu, comes into being when spectacular qualities, skills and attributes help attract the attention of people well-known for being rich in attention. Cultural capital comes into being when achievements which have become noticeable attract those interested and competent in cultural affairs. The value of this capital is the expected future flow of interest discounted to its present value.

In what way does the divide between high and popular culture occur according to this concept of distribution theory of cultural and social capital? Society has different ways to define cultural competence. A person in possession of cultural competence not only needs to develop special personal qualities and skills – he or she also needs to define what society regards as culturally important. Those who are acknowledged as having the power to determine what defines culture are those who are given cultural competence. Now the realization of this power of determination is what separates the popular from the high field. In the popular field the power to determine has to be achieved over and over again. In the high field this power refers to a line of transference from generation to generation. In the popular field the cards are constantly being reshuffled. In the high field competence evolves through the principle of *ancienneté*. An *impresario*, critic or someone in a similar position can become competent in the popular field by having placed his bet on the right horse. Competence in the high field comes into being through transference: through the acknowledgement from those who, in the public's eyes, have acquired competence. The key to success in the popular field comes from popular success. In order to climb the Parnassus of high culture it is sufficient to gain public approval as "high priest of culture," placed in this position by a predecessor.

The difference between high and popular culture lies in the specific age of the cultural capital. Now this does not mean that the age of the opus in high culture's portfolio has to be older than those in the portfolio of popular culture. In fact it means that to those who are granted high power of judgment, a specific high percentage of attention has been awarded by people themselves acknowledged as competent by their predecessors. Here, the attention that counts is interlaced with other attention that counts. High culture has a deeper footprint of this interlaced attention; high culture's footprint of this attention is deeper than that of popular culture. This attention has the power to transfer things nobody has ever dreamt of, and things that had not even been regarded as art, into the ranks of avant-garde art.[10]

Conclusion: the Capitalist System of Attention

The general notion of elite as elucidated by Bourdieu defines a class which exploits a specific difference between income as money and income as attention. Regarding money, it does not matter where it comes from. Attention, however, is a different case. The elite, as Bourdieu

10 See Georg Franck, op. cit., p. 159 ff.

understands it, does not consist of those who are rich in attention, but of those who are rich in a special kind of attention. This special attention stems from people who are already rich in attention. If one wants to define elite through the theory of distribution it is not enough to pay attention to the quantitative only, or rather to the current distribution of income in attention. Differences in quality, in a quality, though, that historically can be largely reduced to quantitative differences, also count.

There is a social disparity of attention income and a disparity in the attention which is socially distributed. The different scale of popularity enjoyed by members of society is the expression of quantitative differences in attention income. A system of classes of income starts to develop if the differences in income are recognized and publicly registered. We are dealing with a capitalist system of classes if the differences in income begin to enhance themselves in favor of the rich. In a capitalist class society of attention, celebrities stand for the class of the rich, who, because of the self-enhancement effect, earn considerably more that they can reciprocate.

Media society may be characterized as the society in which the capitalist traits of the economy of attention have not only taken shape, but turned into a kind of "turbo-capitalism." It is here that an infrastructure supplies households with information in the same way as the latter are supplied with water and electricity. This information, however, is not paid by money but attention. In addition to high-technology in information and communication there is a high-technology of attraction. The high-technology of attraction has its origin in fashion, product design and advertising. It has now developed into a generally usable stock of professional know-how to develop popularity. This advanced attraction technology is the technological counterpart to the institutional change of media into banks and stock markets.

In the turbo-capitalism of attention the media have taken on the function of the financial sector. They act as capital markets of attention. Like unleashed money capitalism, the effect of mass media's turbo-capitalism is to relativize the conventional system of wealth without abolishing it. There are still clubs which claim to represent more than just wealth of attention. As a result we have a spectrum of cultural entitlements that ranges from historically deep-rooted criteria of the power of judgment to those which do not accept anything but individual taste and the latest fashion.

Bourdieu's notion of elite highlights these clubs. Indeed, his notion of cultural capital tends to render absolute that side of the spectrum which has a long history. He does not come to grips with relativization through mass media's attention capital because he fails to develop the difference between real and financial capital. He also works without the notion of a particular income, which underlies the crassly unequal distribution of social and cultural capital. Nevertheless, it should be possible to renew Bourdieu's theory within the scope of a comprehensive economy of attention.

Originally published in: *Berliner Debatte Initial*, vol. 11, no. 1, 2000, pp. 19–28. Several amendments have been introduced to the present version. An earlier English version of this text appeared in G.R.A.M (Günter Holler-Schuster, Ronald Walter, Achim Remer & Martin Behr), *Paparazzi*, Fotohof Edition, Vienna, 2009. Thanks go to G.R.A.M and to the anonymous translators for permission to make use of this translation.

Paparazzo-performance during the inauguration of *Celebrity – The One & The Many*, ZKM | Museum of Contemporary Art, Karlsruhe, November 11, 2010.

T he very existence of someone seeking to establish a foothold in casting society is entirely beholden to public opinion. *Here, to exist means, above all, to take place medially.* And, depending on format and public, one takes place by supplying whatever it is that so happens to be desired: stories, striking pictures, conflicts, spectacular fates, persons capable of arousing suspense, salient formulations, and clear-cut judgments. And people are evidently prepared to perform the most astonishing antics just to achieve media acknowledgment. While some might kneel before a jury member of *Deutschland sucht den Superstar* [Germany in Search of a Superstar] others contrive to demolish a guitar by dashing the instrument over their heads during casting sessions. A beauty queen once published the ultrasound pictures of her yet unborn child before elucidating further on the respective act of procreation. A politician (the current German Foreign Minister) toured up and down the country in his vivid yellow bus, painted the desired electoral results on the soles of his shoes and made the grade for an appearance in the *Big Brother* container, that forum of public discourse.

One could continue citing such examples ad infinitum, and yet they all point to one common trait. In the ever more rabid jostling for attention for the sake of heightened publicity, the various agents involved will not only trade information, but from time to time intimacy, vulgarities or various idiocies as well. One construes scandals and piquant anecdotage, yields to the strictures of prevailing selection procedure by any means at one's disposal, and delivers a form of exhibitionism in conformity with the rules of media representation. But, one might object, there is nothing new about any of this, since after all the collective desire for dramatization has long been a well-known phenomenon. One is aware, at the very latest since the publication of Erving Goffman's genius book *The Presentation of Self in Everyday Life* (1959), that each of our everyday encounters and interactions bears the stamp of the will to make a mark and to manipulate events. One searches for the right expressive pose, to conceal the undesirable and, for strategic considerations,

The Society of Excessive Attention

Bernhard Pörksen and Wolfgang Krischke

to present the persona desired, and anyone who cares to take a second glance at the staged pranks of members of the political cadre in Germany is left in no doubt that this is mostly certainly the case. One recalls those heart-warming summer-time pictures of Helmut Kohl among the deer at Wolfgangsee, or of Joschka Fischer who, when being sworn in as Minister of the Environment for Hessen, opted to sport a pair of gym shoes to assuage his hand-wringing electorate that even as appointed minister he will never really be an establishment man, and finally, of former Defense Minister, Rudolf Scharping who had himself photographed by the pool in the company of his female companion, an instance of authentic self-expression that happened to backfire and culminate in his dismissal from office.

Whereas such examples are endless, they all bear the same stamp, namely, of people's apparent readiness to ingratiate themselves with the media, and of the paltry symbolic reduction of attributes and complex personalities. What is novel, however, is the sheer ubiquity of media-compliant exhibitionism and the wooing of public attention. Fame junkies are long-since to be found in every nook and cranny. Now having evolved into a global casting-platform, YouTube has proceeded to generate its own star system. Thousands display their photographs on Flickr. Statistics indicate that every citizen within German territory owns more than one mobile telephone, in most cases equipped with camera and video functions for photographing one's self and others. In other words, according to sociologist Geoff Cooper, an entire populace now contributes to the dissemination of a "technology of indiscretion" facilitating sustained reciprocal observation and a training in media that pervades everyday life. *I want to take place!* – runs the casting society's slogan. "To take place," formally possible only at events or in presentations has become the aim of the casting show candidate who conceives of himself as event: *I make an appearance, therefore I am!* This attitude towards life, which renders the desire for public presence the core of one's own existence, was once the preserve of professional actors, musicians and dancers. The same drive is what today animates

a gargantuan army of nameless candidates between the ages of ten and thirty all of whom hustle for jury and audience recognition, and are propelled onwards in anticipation of a career as star singer, top model, dancing queen or super talent in shows such as *Deutschland sucht den Superstar*, and *Germany's Next Top Model*. And in their endeavors to ascend to the glamorous heights of media celebrity, these aspirants of stardom freely concede to being bawled at, commandeered around and instrumentalized. To these hopefuls, even the risk of possible scorn and mockery live on camera before a public of millions is never too high a price.

The Democratization of Celebrity

The situation becomes more complex due to the fact that under present-day conditions the celebrity business is currently in the throes of radical transformation: the *status and performance celebrity* has long-since relinquished its hegemonic grip. A large number of, for the most part, self-appointed *media celebrities* manifestly lacking any outstanding achievement, any recognizable aptitude, or any per se interesting social status (high office, famous name, etc.) has now been in existence for quite some time – the nouveau-riche of the attention business most of whom fade from the television stage by the end of each new season. With these ever burgeoning droves of *network celebrities*, the connection between status, achievement, ability and degree of fame has collapsed entirely: it is here that aspirants find a millions-strong public, and can become known simply by virtue of one single farcical idea with no conclusively apparent reason for the concomitant sudden burst of excessive attention. Evidently, this amounts to the still enigmatic and arbitrary butterfly effects of a novel economy of perception as organized by networks. Andy Warhol's prophetic claim of 1968, that in the mass-media future everyone will be world-famous for fifteen minutes, is rapidly becoming true. The number of people to have appeared at least once on television is swiftly growing.

An increasing number of average citizens have switched roles from spectator to actor, have become familiar with the staging business and, for one ephemeral moment have contrived to draw towards themselves the gaze of millions of others. Media psychologist, Jo Groebel, sees a "democratization of celebrity" in these shifts. The superstar in the age of media reproduction is losing what had formerly defined his mystique: that "nimbus of the elusive" (Miriam Meckel) and the never fully reducible arcanum shrouding his persona. In theory, whereas the superstar may still be marveled at, one is now able to meet his match. "In place of the hierarchically ordered class system," writes Ijoma Mangold in a perceptive essay, "the schism now appears between those seen on the television screen and those sat in front of it. And because society is aware that nobody can be expected to eternally view the world from the vantage point of the couch, it has created permeable inroads or routes, one might say, paths to lesser glories."[1]

Behind what has meanwhile become a widespread nisus to "take place", media theorist Georg Franck discerns an "economy of attention," something which also induces such people otherwise way out of their depth in such situations to go in front of the cameras. But, leaving to one side the question as to the value of their performance, one thing they have grasped is that *attention becomes a value in itself: regard appears to be the central capital.* "The maximization of attention," according to Georg Franck in an interview, "is even viler than the maximization of momentary gain, since in the former instance we penetrate far deeper into the psyche. To put it bluntly, the amount of self-confidence we are able to afford is in direct proportion to our income of attention. And this is what now drives these unfortunate and unwitting individuals in front of the camera, a position in which they have otherwise no right to be." Thanks to their facility for manufacturing bulk celebrity at high speed, casting shows are the generators of attention *par excellence.* In the words of Georg Franck "what is indeed interesting about casting shows is that they show how to become a celebrity. Television is far better placed than any other

The Mirror 2008. Detail. Victoria Miro Gallery. Elmgreen & Dragset transformed the gallery into a gay club, open to the audience for one night only. The exhibition included the remains of the party. Courtesy of Victoria Miro Gallery, London.

medium to produce celebrities. It has access to incredible resources of attention. Every living room is plugged in, just as it is equipped with electricity and gas. Naturally, the meter, which is the quote, is ticking. Every household is sucked up, whereby very different magnitudes of attention are amassed than are observed in other conventional forms of media. Hence, mass media are able to quite literally 'nourish' an entire class of nouveau-riche, an enterprise which, for them, amounts to nothing short of a very lucrative business, since it is just these Rich, those the media mold into celebrities, who function as draft horses for the attraction industry. Consequently, part of their trade pivots on assembling celebs with whom they then proceed to hash out yet another show."[2] In extreme cases, the system feeds on itself. Celebrities emerge who then become famous by virtue of their being famous. Casting shows, scene parties along with their media milieu fabricate a perpetually regenerative class of provisional celebrities. Only a few manage to be retained in public memory, and to eek out penumbral media existences tagged as "musician" or "presenter."

La Grande Amnesia

Following the logic of the fast-track economy of attention, practically all those "stars" to have once risen through the ranks of the German casting shows have long been consigned to oblivion. Among others, this also implies that *the aim of a casting show is a casting show,* not the furthering of the talented who would seize the first given opportunity to once and for all sally forth into a new life. That it is the producers, managers, presenters and juries who really stand to profit is something that became evident to Markus Grimm who, emerging as winner of the ProSieben casting show *Popstars* with his band Nu Pagadi in 2005, went on to rock the charts before fizzling out altogether soon thereafter: "there were many who earned a pretty penny – except us. The broadcasting and production companies made huge profits during the broadcasting phase through advertising and telephone

voting. Who earns what is contractually regulated afterwards: fifty percent of the gains go to ProSieben simply because one takes place only due to the broadcasting company. To a certain extent this is justified, since it is thanks to *Popstars* that aspirants may take a significant shortcut into showbiz. A further twenty percent goes to the management. And we also had to pay for video shootings, costumes, promotion costs and so on. Not much was left over."[3] Also among the winners in a broader sense are users of the casting shows. In the first place, these are the broadcasting companies themselves who recycle their shows and furnish their online portals with montages. Moreover, an entire armada of print and online media sails around the backwaters of broadcasting companies, the thematic agenda of which is occupied first and foremost by casting shows along with their presenters, their stars and their scandals. Personalization, emotionality and conflict potential make the shows ideal themes for the tabloids by boosting circulation which, in turn, increases the shows' audience rating. In this reciprocal endorsement of media associations and circular chain of exploitative potential, the repeated due reprimands and punitive damages to be paid by the Board of Directors are nothing but welcome advertisement. For Roger Schawinski, former Managing Director of the private TV channel SAT.1, the State Media Authorities constitute "part of the principle." "One always," so he claims, "takes it to the edge, ferrets out the scandal, tries to kick up a ruckus and if the State Media Authority intervenes against whatever it is that one does, then one is headlines in yet another newspaper. This is one superbly functioning method for generating attention."[4]

The Super Zeitgeist

Anyone wishing to comment on German casting society will inevitably encounter *Deutschland sucht den Superstar* and the entertainer Dieter Bohlen. The latter not only presents Germany's most successful casting show, but has virtually become the figurehead of the casting

1 Ijoma Mangold, "Amoklauf in Emsdetten: Der hässliche Ruhm," 2006, see: www.sueddeutsche.de/kultur/839/407615/text/
2 Georg Franck, "Die Währung des Glotzens," in: Bernhard Pörksen, Wolfgang Krischke (eds.), *Die Casting-Gesellschaft: Die Sucht nach Aufmerksamkeit und das Tribunal der Medien,* Herbert von Halem, Cologne, 2010, p. 129.
3 Markus Grimm, "Der verlorene Sieger," in: Bernhard Pörksen, Wolfgang Krischke (eds.), op. cit., p. 262.
4 Roger Schawinski, "Helden und Schurken," in: Bernhard Pörksen, Wolfgang Krischke (eds.), op. cit., p. 140.

principle, and, for media criticism, the epitomic figure of contention. Whereas the jury members around him are frequently replaced, Bohlen has remained the hard-hearted lynchpin of the show since the first season in 2002. Considered purely in terms of age he could be the candidates' father, though one would be hard-pressed to impute any fatherly feelings to him. His popularity is not owing to any praise he may occasionally bestow upon the candidates, but to the savage humor running through his plebeian turn of phrase, such as "your singing sounds as if a toilet brush has lodged itself up yer arse," which, though apparently occurring to him spontaneously, has in fact been premeditated and designed to verbally trounce the candidate. With respect to social sensibility, Bohlen, who puts the boot in whenever deemed favorable to entertainment purposes, represents the antipode of a "goody two-shoes." He represents the perfect embodiment of the zeitgeist as cultivated over the foregoing two decades that manifests itself in the form of stock-market greed, unfettered financial markets and dilapidated social systems. *Deutschland sucht den Superstar* functions as a public magnet because the producers and editors implement the corresponding scenic concept underlying the basis of the casting genre. It serves audience expectations better than any other among its rivals, namely, that motley of schadenfreude, latent sadism and social Darwinist sentiment of a public for whom the word "victim" is anathema. But, of course, the *Deutschland sucht den Superstar* not only stands for the inclement aspects of the ideology informing media selection, but also for the joyous message it contains: *You can get all the way to the top if you give your all and really believe in yourself!*

The Melodrama

Casting show apologists are serious advocates of the star pretense, fond of presenting the casting tribunal as a sort of national schooling familiarizing the public with the idea of performance and achievement. Here, the casting show appears as one among many selection procedures that – from interview to rendezvous – define one's entire life. And yet a cursory glance reveals that casting shows have little if anything in common with the actual application situation since, unlike the latter situation, the search for genuine talent by the show's producers is, at best, of secondary importance. The selection procedure in fact functions as a mere smoke screen behind which a melodramatic tapestry of hope, fear and trembling, of rise and fall, of desperation, sentimentality, struggle and intrigue is woven together. To this end the threadbare stock-in-trade role types to be occupied range from the bitch, the striver, the ingénue, the underdog, the sensitive one, the embarrassing one and the unrecognized genius. Candidates are instrumentalized so as to epitomize these roles, and are required, furthermore, to make available their private lives as a reservoir for poignant anecdotage. Emotive accounts of the sick sister, the recently deceased mother, the drug-addicted boyfriend and of one's own experience behind bars are faded in during the show before being disseminated and elaborated on by various other media channels. A generous shot of obligatory venom rounds off the melodramatic concoction of the casting show. Conflicts and intrigues, fed into the act by behind the scenes editors ensure thrills and spills: provocative perfidiousness and solidarity, evocative victory and defeat, the hero and the reprobate are all stirred into the scene. Of greater consequence, however, is the staging of embarrassing failure. To hammer home such questionable attributes, over the course of this multiphase procedure a mixed-bag of other hopefuls are selected alongside moderately talented candidates, whose disgrace is calculated into the equation from the outset, and whose humiliation before the panel of judges constitutes an integral part of the show. This vilifying effect is further augmented by means of camera zooms, compromising perspectives, derisive jingles, and sardonic commentaries and captions.

Bread and Circuses

The analogy of the casting show and the Roman circus of antiquity has meanwhile established itself as a topos in media critique, the point of departure of which, however, is rather moral than analytic. In spite of this, an interesting parallel may still be discerned in that pronouncing on the combatants constitutes an integral feature of both Roman arena and present-day television casting – albeit with differing outcomes: in the TV circus, the proverbial thumbs down does not indicate the contestant's biological, but rather medial last gasp. And, much like the show in antiquity, the television equivalent exhibits a smorgasbord of both dictatorial and plebeian elements, the attraction of which is nourished by way of its being in stark contrast to the abstract and opaque procedures of actually existing parliamentary democracy. In addition to high authority – Imperator in the amphitheater, Jury in the TV studio – the "people" also partake in the process of forming judgments. Much like the "spectators" who lined the tiers of Roman theaters, the casting show audience similarly exerts substantial influence on the destiny of the respective contestants, since the jury frequently settles the question as to which candidates are to be disqualified and which are to advance to the next stage only during the preliminary rounds. Once the field has been reduced down to ten or twenty candidates, although the jury will continue to comment on their performances, the vote is now in the hands of the public which then determines by poll who is to ascend to the next round. This fee-paying telephone democracy that fills the broadcaster's coffers with substantial revenues conveys to the audiences the sense of satisfaction that accompanies direct participation.

Staged Authenticity

The public, however, is entirely savvy to the staged character of the program. According to Norbert Bolz, "the

But I'm on the Guest List 2007. Varnished wood door, stainless steel door handle, stainless steel profile lettering; 228 × 116 × 21 cm. Courtesy of Victoria Miro Gallery, London.

audience is a chip off the same old block as the candidates." "There is no basis for imputing a naivety to it. In other words, the audience sees right through this media staging – and simply because it has been familiar with the various shapes and sizes of these formats for years. Indeed, audiences have been willingly susceptible to a little deception ever since the invention of theater – consensually deluded into believing that what they experience is actually unadulterated emotion. Hence, audiences deactivate their own skepticism, their own critical disbelief: this amounts to the self-deception of authenticity which gives birth to that sweet paradox: staged authenticity."[5] The concept with which producers responded to the audience's desire for authenticity, its resolve to blend out the staged character of the program so as to experience "real" destiny and genuine feelings on screen, was so aptly dubbed by Jo Groebel as "authentic public privacy": so as to make the authenticity of the performance convincing, one selects quasi key stimuli, inflates them and then renders them dramaturgically appropriate. The public's will to concede to this semi-authenticity provided the basis for the success of a certain Paul Potts, the bulging mobile phone salesman with aberrant dentures and a run-of-the-mill voice who, and in spite of such liabilities, went on to become an acclaimed singer of arias – or was it perhaps just such deficits that transformed this male Cinderella into an operatic prince?

Fame and Performance

Do casting shows promise the primrose path to glory? Do they propagate the idea of reward without effort? This apparent contradiction is resolved once one has understood that the casting show constitutes the foundation of a new standard of achievement. It is no longer a matter of acquiring life-long aptitudes and gradually ascending the career ladder. While candidates may accept that some effort is involved they do so only to shape themselves within a media-compliant, fast-track process and to train themselves for that one crucial moment:

convincing the tribunal and the public that they are of the stuff of which stars are made. Performance and self-sacrifice are short-term investments along the express line to glory and money. The more ambitious among the candidates allow themselves to be disciplined and drilled for the stage, the catwalk and the studio. The casting regime not only subjects them to a regimen of movement, clothing and hairstyles, but also to the design of their bodies – here, the starvation diet of aspiring "top models" is a rather more traditional approach, where the more advanced method is plastic surgery, which is becoming increasingly commonplace as a means of body styling beyond the world of showbiz. According to recent calculations, in Germany an annual rate of roughly one million people submit themselves to such surgery. Assuming the accuracy of data provided by the Vereinigung Deutscher Plastischer Chirurgen [Association of German Plastic Surgeons], estimates show that ten percent of these are below twenty years of age. Essentially what this means is that a broad public is training the "surgical gaze." They perceive themselves through the eyes of a media geared to perfection – and aim for radical transformation, also in the form of the immediate and current overcoming of a recently spurned self, spurned because hitherto insufficiently recognized. Inherent to the logic of this development, is that shows such as *The Swan* turn the operating theater into an arena of contest and the scalpel into a weapon whereby, thanks to plastic surgery, "ugly ducklings" can now await their turn to become "beautiful swans."

No new phenomenon, the desire for instantaneous discovery before meteoric flight up into the spangled heavens of the stars is as old as showbiz itself. However, this desire was at odds with the work ethic governing erstwhile industrial societies that emphasized diligence, endurance and professional proficiency in return for the promise of security and a long-term career. Today, by contrast, the mentality of instant success reflects the dynamic of a working society rendered flexible by short-term and precarious working conditions along with changing and rapidly devalued competency profiles. To

5 Norbert Bolz, "Wettkampf der Feuerwerker," in: Bernhard Pörksen, Wolfgang Krischke (eds.), op. cit., p. 74–75.

cite Norbert Bolz, "what casting show candidates learn, or rather what they test out, is how well they are able to sell themselves on the market within an exceptionally short space of time. From being an absolute non-entity of whom nobody has ever heard, is it possible for me to now become a star within three minutes or, in other words, to steer the attention of a mass public towards me? Since hundreds of applicants scramble for a single position, this ability is most likely to become increasingly important. Many young people sense that success most often turns on the ability to give the right performance at the critical moment."[6]

Victim or "Victim"

In December 2001, Lisa Loch, sixteen years-old at the time and contestant in a modelling competition shown by RTL, was repeatedly showered with pornographic innuendo by Stefan Raab in his ProSieben show *TV Total*. Lisa Loch went through a living nightmare: she was forced to endure months-long taunting at school, coarse wisecracks on the way back home and anonymous nocturnal telephone calls. After filing a law suit against the presenter and his broadcasting company, the court awarded her 70,000 Euros in compensation for personal suffering. The trial was understood as a precedent for successful grievance filed by a non-celebrity against a broadcasting company. At the same time, the latter case is a typical instance of the misrepresentation of victim and perpetrator by way of which those responsible, along with their sympathizers, seek to justify themselves. In their opinion, Lisa Loch only had herself to blame since she ought to have anticipated the inevitable double-entendre around her surname – a view, moreover, implying that she also exploited the episode, albeit without having intentionally instigated it, just so as to launch her career.

Should, as in Lisa Loch's case, even the victim's own name be considered open invitation to media invective, then the same would doubtless hold for the "phony" look or appearance in front of the camera. According to this take on the issue, whoever has a bad hairdo, sings out of key or has a stain on their pants, deserves to be lampooned by compromising close-ups, cuts, commentaries and captions in front of a television public, in tabloids and on the Internet. Since Google never forgets, it is above all the Internet which ensures that such casting victims continue to be pilloried for years after the event. *Even marginal "misconduct" remains publicly accessible and present worldwide.*

One must ask, however, whether any talk of "victims" is at all appropriate. Who was it that dreamed up the idea of accusing a circus clown of whacking on some other figure? To dismiss moral indignation over defamatory conduct as merely naive while going on to emphasize the fictional character of the casting show suggests a particularly well-reflected grasp of the media. Be that as it may, it is still misguided since, in spite of its staged elements, the casting show is not a fictional genre. The candidates do not appear on stage as actors each playing out their roles, but as themselves. And neither are they perceived by the public as actors: as real persons, they experience vulgar remarks, telephone terror and hate-comments on the Internet in their everyday lives, not as thespians enacting a film script: casting shows succeed because the victims are at least real.

The question as to whether the victims carry responsibility for their media destiny is directed elsewhere. In being familiar with television casting shows, should not candidates know what it is to which they are about to be subject? This question is repeatedly taken up and discussed from various perspectives. Interestingly, critics of casting shows uphold the legitimacy of media "execution" in such cases in which, in their view, candidates are mature enough to estimate the consequences of their performances. For all intents and purposes, the fact that human dignity is an inalienable good, even befitting someone opting to voluntarily "reduce himself to a public laughing stock," now appears to have become a foreign idea. Intimately bound up with this is the fact that public communication is no longer considered a sphere deserving of the kind of minimal respect which

ought no less to inhibit the exhibition of self-destruction than it does the mass media's broadcasting of defamation when cast in a jargon of filth. Standpoints such as the foregoing meanwhile prompt knee-jerk accusations of paternalism or else of elitist arrogance. In an age in which the kind of code formally restricted to the ghetto "comes across" best in the media, the notion of civility in social intercourse can no longer be taken for granted.

Death and the Show

A hybrid form of casting show and documentary soap opera is to be witnessed in programs such as *Big Brother* or *Dschungelcamp* [Jungle Camp]. Here, the pretence of talent hunting on which the casting show is based, has been dispensed with. What remains is the casting of stereotypical roles, the staging of conflicts, the exposure of candidates and the audience's selection of winner and loser. The framework is a microcosmos hermetically sealed off from the outside world in the form of a container, or camp where the inhabitants are required to solve the kind of "tasks" often consisting in tests of courage and the overcoming of revulsion. More extreme than other formats, such shows revolve around audience voyeurism and the exhibitionism of participants who subject themselves to round-the-clock camera observation. With close-ups of maggots and worms, especially trite, at times racist wisecracks, and sex in front of the camera, all of which is underscored by a demonstrative cult of illiteracy, this type of show constitutes the avant-garde of endeavors to raze the last remaining bastions of bourgeois taboo. Hence, the simple logical consequence of this is that for the first time within such a format the show potential of fatal illness could be plumbed. Among the pioneers of public death was the British woman Jade Goody, who announced her imminent demise from incurable cervical cancer before running cameras and microphones in an Indian version of the show *Big Brother*. What followed was a premortal media career in which, together with her manager, Jade

Goody optimally marketed her death as melodramatic story. This young, uneducated woman from the working classes, whose diagnosis of cancer received limited sympathies among the public and journalists, not only became a millionaire overnight, but a secular saint to whom even Prime Minister Gordon Brown proffered his respects. Attended by the throngs who lined the streets, Goody's funeral resembled a state funeral.

Whereas Jade Goody's end may not have drummed up comparable magnitudes of hysteria as had the death of Princess Diana some years before, in both cases the emotional material, rehashed and enhanced by the media, triggered a need among the population for public demonstration and common mourning. However, one essential difference was this: that whereas Diana, the "Princess of Hearts" was a member of the peerage who died in her attempt to elude the media, Jade Goody, from the lowest class of society positively fled to the bosom of the media, so as to make her ascent with their help. She achieved her objective by casting aside the bourgeois norms attached to the intimacy of death. In the words of her PR advisor, Max Clifford, "it was her wish to die as the most famous reality-TV star in the world, and this she certainly succeeded in doing."[7]

Reality in Reality-TV

Only one other format has succeeded in impacting the German media landscape over the last two decades with a force comparable to the casting shows: reality TV, with programs such as *Super Nanny*, or *Bauer sucht Frau* [Farmer in Search of a Wife] and *Raus aus den Schulden* [Free Yourself from Debt], stage dramatic treatment of challenges and conflict-charged situations such as dating, unemployment, family conflicts, problems at school or corpulence. The spectrum of these programs and their titles, from "Reality Show," through to "Docu-soap" and "Pseudo-Reality-TV" reflect in varying degrees the relationship between reality and staged production, and it is not uncommon for the producers of these hybrid forms

7 Max Clifford, "Der Strippenzieher und der Tod," in: Bernhard Pörksen, Wolfgang Krischke (eds.), op. cit., p. 88.
8 Natascha Birkhahn, "Die Wahrheit vom Grill des Glotzens," in: Bernhard Pörksen, Wolfgang Krischke (eds.), op. cit., p. 66.
9 Tom Sänger, "Brennen für die Quote," in: Bernhard Pörksen, Wolfgang Krischke (eds.), op. cit., p. 251.

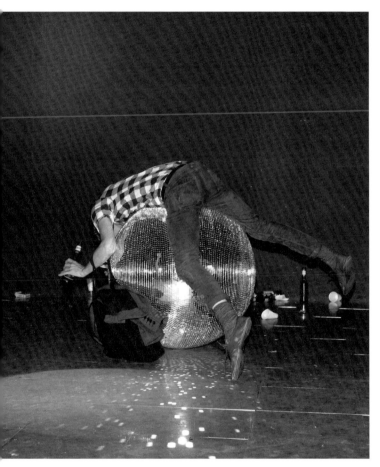

Snapshot from the process of making **Too Late** at Victoria Miro Gallery, London, 2008.

to be averse to closer investigation: *staged production is both obvious and taboo.*

While talent and reality shows have both evolved into successful formats within the same space of time, each has to a large extent remained the preserve of private-sector television, since the components that have ensured their success – scandal, vulgarity, discrediting as well as the blurring of fact and fiction – conflict with the political legitimacy of broadcasting under public law.

Casting and reality shows draw on excerpts from reality as aids to staging stories aimed to evoke public voyeurism. Whereas the casting show presents amateur-like poseurs, the reality show directs the gaze to the family disaster next door. Natascha Birkhahn, protagonist with her family in diverse reality programs, knows the score. "Most people," she says, "are interested in what other families are up to; they want to see what other living rooms look like, what is served up there. Once discovering that circumstances are even worse there than they are within their own four walls, they can then breathe a sigh of relief. A program only then becomes interesting when there is friction within the family."[8]

Just as the casting show adjusts the promise-threshold of the golden free-market to the conditions of its public – from dishwasher to president – so the reality show promises its audience comfort and social orientation in the ever harsher realities of the everyday. *"Super Nanny* offers the audience the possibility to classify and orientate themselves," says RTL Director of Entertainments, Tom Sänger. "Curiosity, voyeurism and comparing are the three factors which in Germany, in contrast to other countries, play an integral role and constitute the attraction of this program."[9]

Like the casting show, reality TV also requires certain types and constellations: the shattered family, the overstrained mother, the runaway youth, the insolvent small business, and the vulgar unemployed. Both forms of programs create situations, provoke reactions, intensify and dramatize the course of events by the editor's cut whilst at the same time feeding off the flair of "authenticity." This is the crucial paradox: *One offers apparently*

unadorned reality in an extremely staged mode; one supplies authenticity all according to cliché and prescription – and, whenever necessary, justifies oneself by insisting on the caritative value in providing scripts for successful lives. A journalist worth his weight in salt endeavors to enlighten and to orientate; the makers of reality TV are adamant about the therapeutic value of their aim – the coaching of the desperate, the therapy and mentoring in and for the public. Whereas casting shows can hardly bemoan insufficient numbers of candidates, many of the reality shows are gradually running out of protagonists of real cases – what sector vernacular refers to as "protags." Broadcasting companies have meanwhile found a way out of this quandary with what is called "scripted reality." In this case, while amateur actors may follow scripts susceptible to a yet greater intensification of the plot, they persist in their search to affect documentary style. At the same time, the protagonist's dilettante and lay abilities implicitly serve to reaffirm truth. Such dire acting cannot possibly be staged. It is by way of this thoroughly staged "reality," which one ought to in fact impute far greater accuracy than the pseudo-realism of television, that the threshold between "staged authenticity" and fiction has now been finally crossed.

What began as the recognizably contrived ambience of the casting and reality show, might conceivably one day filter through into the news business and political sphere – if only there were enough geniuses of fusion and waggish PR advisors who would understand the basic laws governing the casting society: with individualized self-portrayal one can make a dent publicly only by adhering to the rules of media representation; the idea is to fuse these rules with one's own intentions until both appear as natural self-expression. Thus, a variously deployable media figure must first and foremost possess the ability to translate personality and biography into dramatic narrative. And this self-fictionalizing, which may be augmented ad infinitum, could only be successful by drawing on a stock of plausible clichés, by skillfully anticipating the needs of an imaginary public and by otherwise functioning in conformity with prescribed roles. Consequently, according to this reasoning, being authentic means the ability to evoke the impression of an authenticity the reliability of which we can agree upon – that is, until we become savvy to the ploy.

Translated from the German by Justin Morris.

The above essay is based on the authors' book entitled *Die Casting-Gesellschaft: Die Sucht nach Aufmerksamkeit und das Tribunal der Medien* [The Casting Society. The Search for Attention and the Tribunal of the Media], published in 2010 by Herbert von Halem Verlag, Cologne.

Celebrity History and Contemporary Art

Tom Mole

C elebrity is everywhere now: proliferating, metastasizing, colonizing new areas of culture from sport and politics to art and the academy. To understand its pervasiveness and power we need to grasp the vocabularies, media and genres that combine to create celebrity as a cultural apparatus. That apparatus is not simply a product of new media, generic innovations or different ways of talking about the forms of public recognition. Instead, it begins functioning when changes in all three areas converge to produce a new cultural formation; one that is now capable of structuring the circulation of information, the work of several related industries and the leisure of a mass audience. In this essay, I will suggest that the vocabularies, media and genres of celebrity characteristically adopt and adapt earlier terms, technologies and generic markers. These are, in turn, adopted and adapted by visual artists who engage critically with celebrity culture. When these artists carry elements of celebrity culture into the realm of art, they risk becoming part of the celebrity culture they critique.

At the birth of our modern celebrity culture, people found themselves searching for the right words to describe new kinds of prominent individuals, and a new vocabulary of celebrity emerged.[1] The *Historical Thesaurus of the Oxford English Dictionary* reveals an explosion of terms in English at the beginning of the nineteenth century to describe the people who inhabited the developing culture of celebrity. Different areas of cultural production formulated their own vocabulary for these individuals – from literary lions, to theatrical stars, to musical virtuosi, to sporting champions – but they all participated in the same grand shift towards a modern way of being well known. New nouns were created for the new celebrities: one could be a "notable" (1815), a "notability" (1832), or a "notoriety" (1837). But nouns which had been mostly obsolete for long periods were also revived to label individuals who had obtained this new kind of recognition: a "swell" was a piece of arrogant behavior as early as 1724, but was used for a famous person from 1786; such a person could be called a "lion" as early as 1715, but the word fell into disuse before it

1 For a detailed account of the historical emergence of modern celebrity culture, see: Tom Mole, *Byron's Romantic Celebrity*, Palgrave Macmillan, New York, 2007, pp. 1–27.

was revived as a hotly contested term in the 1830s;[2] a famous person could be called a "name" in 1611, though that term fell out of use before being revived in 1826. The term "virtuoso" underwent a similar transformation: up to the middle of the eighteenth century, it was primarily used for an amateur enthusiast who was knowledgeable in the arts or sciences, or who was a connoisseur of a particular field; but from the late eighteenth century onwards, this meaning was displaced by the dominant modern sense, in which a "virtuoso" meant a musician of superb technical accomplishment and a celebrated, flamboyant performer. The emergence of such a variety of words for prominent individuals over such a short period, and the need to revive words that had previously fallen out of use to describe the famous, suggests the effort required to come to terms with the new kinds of fame that were available in the mediated culture of the nineteenth century.[3]

By the middle of the nineteenth century, two very old words had been recruited and revised to describe this new, implicitly inferior kind of recognition: "celebrity" and "star." The word "celebrity" lost its older meanings concerning the conduct of rites or celebrations, becoming, first, a word for a certain kind of fame and, later, a noun for an individual who possessed that kind of fame. In 1849, using a form of the word was evidently still unfamiliar; one of the characters in Dinah Mulock Craik's first novel, *The Ogilvies*, asked another, "Did you see any of those 'celebrities,' as you call them?"[4] "Star" underwent a similar transformation. In 1761 the critic Benjamin Victor described the actor David Garrick as "a Star of the first Magnitude," but he was using the word as part of an extended and self-conscious metaphor that figured Garrick as "a bright Luminary in the Theatrical Hemisphere."[5] Such metaphors retained their currency into the nineteenth century; in 1819, a journalist signing himself "Q" remembered Samuel Taylor Coleridge arriving in Bristol in 1794 "like a comet or meteor in our horizon."[6] Thomas De Quincey referred in 1856 to seven of England's most famous prose writers as "a pleiad, a constellation of seven golden stars, such as no literature

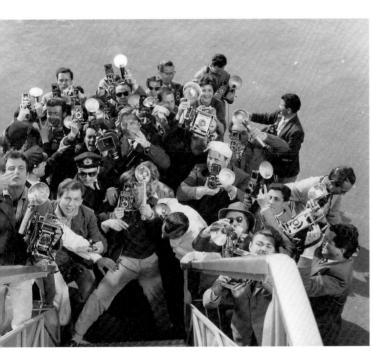

Federico Fellini, *La Dolce Vita*, 1960, film still.

2 Richard Salmon, "The Physiognomy of the Lion: Encountering Literary Celebrity in the Nineteenth Century," in: Tom Mole (ed.), *Romanticism and Celebrity Culture: 1750–1850,* Cambridge University Press, Cambridge, 2009, pp. 60–78.

3 All dates of usage in this paragraph are drawn from *The Historical Thesaurus of the Oxford English Dictionary,* Oxford University Press, Oxford, 2009, entry 02.01.17.05.03.01.

4 Dinah Mulock Craik, *The Ogilvies,* Harper and Brothers, New York, London, 1878, p. 25.

5 Benjamin Victor, *The History of the Theatres of London and Dublin from the Year 1730 to the Present Time,* 2 vols., printed for T. Davies, London, 1761, vol. 1, pp. 61–62.

6 Quoted from: Richard Holmes, *Coleridge: Early Visions,* Penguin Books, London, 1990, p. 92.

can match."[7] Through the first half of the nineteenth century, however, such constructions slowly lost their metaphoricity and "star" became a simple signifier for a new kind of publicly recognizable individual. "Star" was first defined by the *Oxford English Dictionary* as meaning "a person of brilliant reputation or talents" in 1824, with citations that refer to actors and boxers. From the end of the eighteenth to the beginning of the twentieth century, then, the ways in which famous people were categorised and discussed underwent a radical shift. Familiar words no longer seemed adequate for the new varieties of fame now available and the new species of person who grabbed the public's attention. As a result, a variety of existing words altered their meanings and renewed their currency, and a variety of obsolete words re-entered common use, providing a way to talk about a new kind of famous person, with a distinctly modern kind of public profile.

These shifts in vocabulary unfolded alongside technological developments occurring in several different areas that helped to put certain celebrated individuals in the spotlight – literally. In the two most important theaters of London, Covent Garden and Drury Lane, lighting technology greatly improved at the beginning of the nineteenth century, as smoky tallow candles were replaced with high-quality wax ones equipped with polished reflectors to direct the light onto the stage. In 1817, Drury Lane theater installed gas lighting. Limelight was first introduced at Covent Garden theater in 1837 and rapidly spread to other theaters.[8] Produced by heating a cylinder of quicklime (calcium oxide) with a mixture of burning hydrogen and oxygen, limelight creates a bright light that can be focused tightly on a particular spot. This allowed individual star performers to be picked out from other actors and the surrounding scenery in a much more distinct fashion than had previously been possible. Being "in the limelight" quickly became a general-purpose term for celebrity, which could be applied beyond the theater and retained its currency even after limelight was replaced by electrical followspots at the end of the nineteenth century.

Those celebrities who found themselves in the limelight – literally or metaphorically – became public personalities when their names and images circulated through new media. The first medium for information about celebrities was the printed page. The Stanhope Press, the first printing press constructed entirely of iron, was invented around 1800. Steam printing followed soon after and was adopted by the *Times* newspaper in 1814. These new technologies allowed newspapers, magazines and books to be produced more cheaply and in greater numbers than ever before. They brought information about celebrities to a wider audience faster along improved distribution infrastructures such as macadamized roads, canals and railways. Alongside gossip about celebrities, images of them circulated in engravings, and later in photographs and films. In each case, the advent of a new medium or a new technology produced a modification in the celebrity apparatus, as it adapted to new cultural conditions. With each new medium, celebrity seems to take on an unprecedented intensity or reach, with the result that commentators often mistake its co-option of new media for its historical origin. But when celebrity culture colonizes new media, it does not abandon existing media. Rather, existing media continue to operate alongside new media. Print media such as newspapers and magazines continue to report on celebrities from the media of film or television, while the Internet provides a new distribution network for celebrity photographs.

Within these new media – mass circulation print, photography, film, television and the Internet – celebrity requires new genres to function. While the culture of celebrity continually colonizes new media, it is not determined by the media that make it possible, but relies on those media being put to particular uses. Mass circulation newspapers do not produce celebrities simply as a result of the technology employed: that technology has to be used to produce gossip columns, interviews and profiles.[9] The technology of photography does not determine the emergence of paparazzi. The invention of film does not determine the emergence of film stars. In each case the available technology has to be put to use

7 Thomas De Quincey, *Confessions of an English Opium Eater* (1856), Wordsworth Editions, Ware, 1994, p. 48. De Quincey was defending England's prose writers against the strictures of a French critic by drawing an analogy to the group of seven sixteenth-century French writers led by Pierre de Ronsard called *La Pléiade*.

8 M. Lindsay Lambert, "New Light on Limelight," in: *Theatre Notebook*, 47, 3, 1993, pp. 157–163.

9 Charles L. Ponce de Leon, *Self-Exposure: Human-Interest Journalism and the Emergence of Celebrity in America, 1890–1940*, University of North Carolina Press, Chapel Hill, 2002.

in a specific way. For celebrity culture to take shape, the technologies of film, print and photography have to be tied to genres such as the star vehicle in film, the gossip column in newspapers and the (apparently) candid shot in photography.

In each case, the forms, genres and practices of celebrity culture transform, remediate or retool existing forms, genres and practices. The star vehicle in film remediates an existing star system in the theater, which structured theatrical practice from the second half of the eighteenth century. Star actors such as Sarah Siddons, Edmund Kean and William Charles Macready had minimal rehearsal with the rest of the company, who were expected to accommodate their performances. They toured alone, working with local companies each night and, without a modern conception of the director, they were entirely responsible for their own interpretation of a role. Their salaries reflected their increased status; they greatly exceeded those paid to other members of the company, and they might be doubled by a successful benefit performance. As a result, audiences came not to see *Hamlet*, but to see Kean playing Hamlet, not to see *Macbeth*, but to see Siddons playing Lady Macbeth. Cinema did not immediately adopt this star system; so long as the medium itself remained an object of fascination, the cinema of spectacle dominated filmmaking, and actors were not billed by name in film credits. Several film historians date modern celebrity culture from the story of Florence Lawrence. Her fans knew her as the "Biograph Girl" until 1910, when her employers apparently planted a false newspaper report of her sudden death. A few days later they placed an advertisement in *Moving Picture World*, with a photo, refuting the first story and confirming that Lawrence now worked for them at IMP.[10] This is one of the first examples of an actor's proper name being used to market films. What we witness here, however, is not the primal scene of celebrity culture, but a moment of remediation, where film constructs its own version of the star system by adopting almost wholesale the existing, fully functioning celebrity culture of the theater.

Photography similarly transforms existing genres to make them function within the celebrity apparatus. In the eighteenth century, Joshua Reynolds began to produce portraits that depicted his aristocratic clients in the style of figures from classical history painting, which Reynolds valorized as the highest form of art in his *Discourses* and delivered in his role as President of the Royal Academy. Reynolds employed similar techniques when he painted the celebrities of his day, depicting Sarah Siddons as the tragic muse and Mary Robinson (an actress, author and sometime mistress of the Prince of Wales) as a society lady. By combining the cultural capital of history painting, the lucrative business of portraiture, and the famous individuals of the day, Reynolds both fueled and legitimized the emerging culture of celebrity.[11] Portraits taken from life circulated widely in engravings both authorized and unauthorized. Unauthorized engravings were often based on other engravings rather than on the original painting, and so variations were introduced, partly in the process of reproduction and partly in a deliberate attempt to avoid copyright issues. In this way an individual's image could circulate widely in cheap copies. All these images might be based on a relatively small number of authorized originals, but the more often the image was re-engraved, the further it departed from the authorized version.

As with film, photography did not immediately lend itself to celebrity culture. Long exposure times made portrait photography difficult, and early photographs by Louis Daguerre and William Henry Fox Talbot are more often influenced by landscape painting, architectural drawing, genre painting and still life. Photography was not suited to celebrity culture until reduced exposure times made portraits easier to produce, and the development of the halftone process in the 1870s and '80s made them easier to reproduce in mass-circulation newspapers. As exposure times dropped, posing for a photographic portrait became not only more comfortable than it had previously been, but also more comfortable than sitting for an easel portrait. As a result, newspaper interviews by the end of the nineteenth century were commonly accom-

10 See: Alexander Walker, *Stardom: The Hollywood Phenomenon*, Michael Joseph, London, 1970, pp. 31–39; Richard Dyer, *Stars*, British Film Institute Publishing, London, 1998, pp. 9–10; Janet Staiger, "Seeing Stars," in: Christine Gledhill (ed.), *Stardom: Industry of Desire*, Routledge, London, 1991, pp. 3–16.

11 Martin Postle (ed.), *Joshua Reynolds: The Creation of Celebrity*, Tate Publishing, London, 2005.

panied by a photograph of the subject, often taken in his or her own home.[12] These photographs took on the role previously played by engravings, with one crucial difference: whereas engravings departed from the original in the process of reproduction, photographs produced identical copies.

In the twentieth century, when exposure times dropped to a fraction of a second, glass plates were replaced by rolls of film and then flash memory cards, and cameras became small and light enough to carry easily, the genre of the "candid" photograph emerged and with it a new kind of photographer, the paparazzo. Occasioned by the name of society photographer, Paparazzo, in Fellini's film *La Dolce Vita* (1960), the word paparazzo, and its invented plural paparazzi, entered the English language in the 1960s. Typically, Paparazzi photographs are taken without prior arrangement, and often without the subject's consent (although such photographs may be minimally staged with the subject's complicity). As a result they revise both the conventions of the formal photographic portrait and its predecessor the engraved portrait, and offer a new kind of intimacy. Where photographing a celebrity in his or her home offered a window into the individual's domestic life, paparazzi amplify this demand for intimacy by offering what Chris Rojek calls "out of face" encounters with celebrities.[13] By capturing a celebrity apparently going about his or her daily life, unprepared and unstaged, paparazzi photographs tell us both that celebrities are just like us (they go shopping, eat in restaurants, take vacations on the beach) and nothing like us (their shops, restaurants and vacations are not the same as ours, and their every move is recorded by photographers and mediated to fans). Whereas engravings repeated and modified the same image over and over again with increasing variation, sometimes for several years, paparazzi photographs are typically reproduced widely for a very limited time before a new photograph is required to satisfy public curiosity, and each new photograph captures its subject anew rather than referring back to previous depictions.

When visual artists address celebrity culture, they participate in this ongoing saga of transformation, appropriating the forms, genres and media of celebrity in order to critique, parody or comment on them. Some contemporary artists have placed celebrities at the center of their work. Andy Warhol's screen prints of Marilyn Monroe, Jacqueline Kennedy and Elvis Presley, based on newspaper photographs, repeat the celebrity's image with only minor variations. While a single portrait – in the tradition of Reynolds – might contribute to the celebrity of an individual, Warhol's repeated images make the process of duplicating and circulating images into the subject of the artwork as much a part of this work as the individual depicted. The process of screen-printing, which produces an image at once mechanical and handmade, draws attention to the industrial reproduction of the celebrity's image by using a technology of reproduction that duplicates images but introduces variations in color and detail. In this respect, Warhol's screen prints look back to the engravings of nineteenth-century celebrities.

Sam Taylor-Wood's video installation *David* (2004) and Juergen Teller's celebrity photographs similarly twist the conventions and genres, remixing them with the traditions of high art.[14] Taylor-Wood's film of a sleeping David Beckham refers to at least three artistic precursors. Its title playfully invokes the ideal beauty of Michelangelo's *David*. It references the artistic tradition of depicting sleeping models, usually women, as an expression of erotic intimacy between artist and subject and a source of voyeuristic pleasure for the viewer. And it pays a slanted homage to Warhol's film *Sleep* (1963), in which a static camera depicts an anonymous man (actually Warhol's lover, the poet John Giorno) sleeping. Taylor-Wood's film suggests that, in the modern age, notions of ideal beauty and erotic fantasies are both shaped by celebrity culture (what would it be like to share David Beckham's bed?), while also invoking Warhol's artistic treatment of celebrity (in addition to his screen prints, Warhol reportedly wanted to make a film of Brigitte Bardot sleeping). But along with these high-art references, her film, composed of a single take for over an hour played on a

12 Richard Salmon, "Signs of Intimacy: The Literary Celebrity in the 'Age of Interviewing,'" in: *Victorian Literature and Culture,* 25, 1, 1997, pp. 159–177.

13 Chris Rojek, *Celebrity,* Reaktion, London, 2001.

14 On Sam Taylor-Wood and celebrity culture, see: Catherine Fowler, "Spending Time with (a) Celebrity: Sam Taylor-Wood's Video Portrait of David Beckham," in: Su Holmes and Sean Redmond (eds.), *Framing Celebrity: New Directions in Celebrity Culture,* Routledge, London, 2006, pp. 241–252; on Juergen Teller's celebrity photographs, see: Adrienne Lai, "Glitter and Grain: Aura and Authenticity in the Celebrity Photographs of Juergen Teller," in: Ibid., pp. 215–230.

continuous loop, also invokes at least two modern genres of celebrity. Firstly, it is the ultimate star vehicle – a movie so completely devoted to exhibiting its star that it features him in every frame and allows no one else to appear. Secondly, it recalls the genre of the paparazzi photo, albeit negatively. While paparazzi photographs snatch an unguarded moment from the celebrity's everyday life, Taylor-Wood's film sustains its intimate glimpse for longer than most viewers' attention spans. To walk away from the installation, to lose interest in the sleeping figure before the camera is turned off, is to acknowledge the limit of our fascination with celebrities, to consider the possibility that they might be ordinary, even boring. Juergen Teller similarly places his celebrity subjects in the grey region between the ordinary crowd and the extra-ordinary individual. Minimally staged and lit, his photographs are distinguished precisely by the extent to which they make their celebrity subjects look undistinguished. Un-made up and un-retouched, his subjects appear ordinary. These photographs rethink, indeed invert, the standard generic markers of fashion photography or celebrity branding. In doing so, they straddle or blur the boundaries between the photographic genres that sustain celebrity profiles. On the one hand, Teller's photographs appear in glossy magazines, as part of advertising campaigns for high-profile brands that have made the photographer rich. Several of his most famous images are taken in the opulent surroundings of luxury hotels – for example his photographs of Kate Moss in the Ritz and Charlotte Rampling at the Hotel Crillon (both in Paris). These aspects of the photographs adopt or invoke the generic markers of the high-gloss photography that sustains celebrity profiles by depicting celebrities as they want to be seen. On the other hand, the apparently unstaged and candid nature of the images eschews or inverts the conventions of that photographic genre and instead recalls the improvisational, snatched style of the paparazzi snapshot whose aim is to depict celebrities as they do *not* want to be seen. Uniting elements of both genres, Teller's photographs draw attention to the internally conflicted nature of celebrity, which tells us both that celebrities are remarkable and that they are ordinary.

One thing that these widely different examples have in common with each other, as well as with other engagements between visual art and celebrity culture, is that they repurpose or riff on celebrity forms, styles or genres. In this, they participate in a vibrant tradition of co-opting "popular" culture for "serious" art, which puts into question the boundary between popular and high culture even as it seeks to cross it. But simulating the genres of celebrity, however obliquely, is a risky way to critique celebrity culture in a world where the entertainment industries are becoming increasingly ubiquitous, and the prestige of art increasingly fragile. Who is serving whom here? Is the artwork conferring distinction on the celebrity or the celebrity conferring distinction on the artwork? Even as it offers an implicit critique of the culture of celebrity, Taylor-Wood's *David* is part of the celebrity apparatus, contributing to Beckham's A-list status. Even as one of Teller's photographs of Winona Ryder playfully invokes the scandal of her 2002 conviction for shoplifting, it contributes to the celebrity apparatus's co-opting of that scandal as a source of publicity and profit. When modern and contemporary artists take celebrities as their subjects, then, they find themselves in complex and conflicted relationships with the celebrity culture they critique. Because the celebrity apparatus itself functions by appropriating and transforming existing media and genres, artists who attempt to critique celebrity by appropriating and transforming *its* media and genres all too easily become a part of that apparatus.

Elmgreen & Dragset take a different approach in their installations for *Celebrity – The One & The Many*. Unlike Warhol, Taylor-Wood or Teller, they do not depict a celebrated individual. Nor do they depict themselves in a way that blends self-portraiture in the tradition of Dürer and Rembrandt with modern promotional culture that seems inevitably to make the artist into a celebrity. Where artists such as Frida Kahlo, Gilbert and George, and Marina Abramović (as well as Warhol in some of his works) place themselves at the center of their art – seri-

ously, mockingly, ironically, or in some combination of the three – Elmgreen & Dragset disappear from view, leaving viewers to experience the environments the artists create. By neither depicting a celebrity nor presenting themselves as celebrities, Elmgreen & Dragset show that their topic is the cultural apparatus of celebrity itself, rather than any individual within it. But they also choose not to repurpose an existing celebrity genre such as the paparazzi photograph, magazine photoshoot, film vehicle, or newspaper interview. By declining to adopt and adapt a celebrity genre in the manner of previous artists who have engaged with celebrity from Warhol onwards, they resist becoming an adjunct of the apparatus they scrutinize.

Instead, they are concerned with how the apparatus of celebrity is transforming our public sphere and our sense of self. In their *Celebrity* show Elmgreen & Dragset confront us with two drastically different environments. In the first, we glimpse the undistinguished lives of "the many" through the uniform windows of their apartments. In the second, we find ourselves on the margins of the elite, almost within reach of the A-list, but always excluded from its presence. And yet, while apparently opposite, the two parts of this extended sculptural diptych are actually similar. In both cases we are offered a window to the lives of others, which is both intriguingly revealing and frustratingly limited; our curiosity is aroused and sustained, but not satisfied. Why do the lives of some individuals fill us with fascination, while the lives of others fill us with indifference? By pairing the glass windows of the apartment building with the glass doors that lead to the party, Elmgreen & Dragset foreground the apparently absolute difference between the one and the many and the scandal of their similarity.

This pairing of two apparently opposite environments foregrounds the strange new sense that celebrity has entered what I have elsewhere called a "hypertrophic" phase, in which our fascination with the apparatus of celebrity outstrips in some cases our interest in the people whose images it promotes, and famous and ordinary people start to seem oddly interchangeable.[15]

This latest phase of celebrity culture demands a new vocabulary more urgently than at any time since the early nineteenth century, which gave us our modern terms "celebrity" and "star." On the one hand, there are now so many celebrities, and the media churns through new ones with such rapidity, that we contract "celebrity" to "celeb" (first identified by the *Oxford English Dictionary* in 1913); on the other hand, the media landscape seems to be so cluttered with stars that a further distinction is required, and "star" has been inflated to "megastar" (1978). Academic critics of celebrity have offered a variety of new terms for this phenomenon, from James Monaco's "quasar" to Graeme Turner's (et al.) "accidental celebrity," to Chris Rojek's "attributed celebrity" and "celetoid."[16] The fact that these terms have yet to gain a degree of common currency, however, might suggest that before we can talk about postmodern celebrity meaningfully, we need ways to experience and reflect on it. Elmgreen & Dragset provide one such way. As you walk through the paired environments of *Celebrity – The One & The Many*, you encounter not a representation of a celebrity, but a laboratory model of the celebrity apparatus, in which the limelight swings capriciously from one individual to another, elevating one of "the many" to the coveted but debased, ubiquitous but transient status of celebrity.

15 Tom Mole, "Hypertrophic Celebrity," in: *M/C: A Journal of Media and Culture*, 7.4, 2004.
16 James Monaco, *Celebrity: The Media as Image Makers*, Delta, New York, 1978; Graeme Turner, Frances Bonner and P. David Marshall, *Fame Games: The Production of Celebrity in Australia*, Cambridge University Press, Cambridge, 2000; these "taxonomies of fame" are surveyed in Graeme Turner, *Understanding Celebrity*, Sage, London, 2004, pp. 20–23.

Celebration – The World of Appearances

SACHA GOLDMAN: The times are becoming increasingly illegible. A new reading matrix is required.

PAUL VIRILIO: We are presently entering unpredictable times. Twenty years ago I introduced the "concept of speed" to understand the topography of events. Today, we are entering an epoch in which celebrity yields to celebration. Permit me to elaborate: history and celebrity go hand in hand. The course of history, or the long-run, is real celebrity – that of a Plato or Shakespeare. In short, ever since the nineteenth century, and especially during the twentieth century, we have been witnessing an acceleration of history. Daniel Halevy pointed this out as early as 1947. While celebrity itself is accelerating concurrently with the acceleration of history, celebrity is also entering what I have coined "the aesthetics of disappearance," in much the same way as has occurred in the arts. With abstraction in art and cinema, art has shifted into the aesthetics of disappearance. This is the age of cinematics, the age of what I call the "energy of the visible," by which I mean that the real has become like images unfolding in film – as shot in sequence. Reality has been modified by this acceleration of history such that it is itself accelerated. From this point on, now, in the twenty-first century, we find ourselves within an acceleration of the real. This not only calls into question Braudel and the Annales school's notion of world history, but also challenges the idea of a history of events which we grasp through the important ones, for example, May '68, 1914–1918 … From now on history is accidental, instantaneous; it cancels itself out by becoming an event without reference or equivalent, the ternary fission of past, present and future. It is an event without reference – something which, as yet, philosophy has not dared analyze. It is without reference, not merely from the standpoint of the present, as argued by Hartog and others … a kind of present-ism, but rather as an instant for the sake of instantaneity.

Paul Virilio in conversation with Sacha Goldman
Paris – La Rochelle, June 2010

Short Cut 2003. Mixed media, ca. 250 × 850 × 300 cm. Installation view, Museum of Contemporary Art, Chicago, 2005. Courtesy of Nicola Trussardi Foundation, Milan and Galleria Massimo De Carlo, Milan.

We live in the instant of the real, which is the acceleration of reality that completely effaces historicity. It is no coincidence that there has been much talk about memorial history, a law of memory, of identity. This is because historicity is disappearing completely and celebrity, in turn, is ceasing in favor of pure celebration. By celebration I mean an industry of appearance and disappearance with its automated procedures that disassociate the event that is the presence of a man or a woman, an artist or a genius, from his or her work, from writing and its value. The work itself is rendered useless. Permit me to remind you of what a young man said on a reality TV show. When asked what he would like to do in the future, he responded by saying "I want to do celebrity." He did not want to become a Picasso, a Shakespeare or a Godard, but to "do celebrity." He had understood perfectly that celebration would allow him to become a celebrity without any works to his name.

After the era of abstract, non-figurative art comes the era of abstraction from work and its merits, but also from the author. The work disappears: it is useless. The merits of the work, whether good or bad, are useless and, along with them, the author. Genius, hero, and historical figure are finished. I stress again: the genius, the hero, the life-size historical figure are finished. Instantaneity has supplanted eternity. This is fundamental. Eternity was the domain of the spiritual, by which I do not mean the religious. It was also the domain of the Greek philosophers with the immortality of the soul. Well, instantaneity has now replaced eternity. The eternity of the famous immortals of *l'Académie française* must be dissolved immediately. Stop. Eject!

———— SG: In the same vein, one of the largest commercial TV channels brought the great Aimé Césaire to meet the young winner of *Star Academy*, both of whom come from Martinique. Disconcerted, the poet asks him "oh, are you an academic?"

Becoming a celebrity is a preoccupation that has become an occupation devoid of any sense of authenticity.

———— PV: Occupation is a state, either as victim or perpetrator, executioner. When you are occupied, you experience a phenomenon which psychologists and psychoanalysts refer to as "derealization," a kind of panic event. There is a panic of occupation, a kind of fear comparable to anguish. And today, reality occupies us and preoccupies us by its very acceleration: hence the splitting of reality. We no longer believe in it. What I have called a mono-atheism is in the works. Allow me to elaborate: monotheism is the belief in one god, whether Jewish, Christian or Muslim. Mono-atheism is a belief in nothing at all. It is not simply a matter of not believing in Christ, Abraham or Mohammad, but rather in not believing in anything that might have to do with the *great*, the Great One. It is not even nihilism, it is sur-nihilism, much in the same way that realism stands to surrealism. And I think that the relationship between celebrity and celebration is also linked to this. We are no longer able to believe even in genius. We cannot believe in a hero, because we do not believe in anything. Atheists do not believe in God, but mono-atheists do not believe in anything that might relate to the Great One. So the hero, the saint, and the righteous are eliminated in this kind of totalitarian atheism. Something is being played out that the great Hannah Arendt did not deal with. "Globalitarism" goes much further than the totalitarianism she so perfectly analyzed. I announce the dawn of globalitarism, in other words, this nihilism, this sur-nihilism that no longer believes in any god or hero, prophet or great individual, or else any other permutation of the Great One. I think this is an event that calls history into question. And by challenging history, the great history, the one that extends into the past and that has a future, progress itself is called into question, by which I simply mean progression, the movement of a here to a there. The era we live in is thus unprecedented; these are unprecedented times. The term "unprecedented" is a landmark word of our era. In my opinion, those who seek celebrity today have not understood that from now on one has to be unknown to become a celebrity, one has to be anonymous.

There are already signs of this, which I will come back to later. In chronological order: there was Henri Michaux,

well known, of course, but who fled representation albeit in a less grandiose manner than those who came after him. He did, though, start to flee from it. One senses this in his poetry. In the postwar era of the surrealists, and unlike Aragon, André Breton and the surrealists, though similar to René Char, Henri Michaux was a man on the run. We might cite an American whom I very much admire, Thomas Pynchon, as an example of this. We have photographs of Pynchon when he was sixteen. He never gives interviews and, in my view, he is the greatest American writer alive today. There are others whom I much admire such as Edgar Allan Poe … but Pynchon is a man about whom we know nothing and who we never will come to know – unless, that is, somebody takes his picture on his death bed, a mortuary mask. Here we would have a sign.

But we also have comparable signs in the sciences. For example, the great mathematician Grigori Perelman refused the Fields Medal (the highest honor in mathematics) and the Millennium Prize together with the prize money that goes along with it. He did not want it. To exist, all he needs is to have resolved the previously indecipherable Poincaré Conjecture.

The longing for anonymity is the sign of forthcoming celebrity, the aesthetics of disappearance of the great mathematician or poet or novelist. In my opinion, the same will soon be true of the politician. And then there will be a crisis of political representation, a crisis of representative democracy. If democracy is no longer representative, then it is abstract.

And where, or to what does an aesthetic of disappearance lead – to a super-monarchy, perhaps? However, I understand that the crisis of political parties on both the left and the right is not a revolutionary sign. It is a *revelationary* sign. I use this word intentionally and hold to it. From now on we will be dealing in revelation. The days of revolution are over. This is not a pun. An event like this, the challenge to history by the acceleration of reality, is a major event, a singularity as the physicists would say – a singularity of history, an unprecedented event. And so, those who think of themselves as celebrities are

those who never will be again. Hence it is imperative to cultivate a kind of humility or modesty. Humility is not just a Christian virtue. It is a necessity of being. I take the example of the great stoic Marcus Aurelius, Roman emperor, the Great One. Marcus Aurelius said: "I have been everything, and everything is nothing." Today, the proposition is reversed. *I am nothing, but I can be everything.*

———— SG: There is a strange sense of a death drive, an involuntary will to "have done with it," a negative reflex of reason; another sort of negationism.

———— PV: I'm interested in an emerging negationism that seems to be a trick of history: the negationism of the *Blitzkrieg*. There were two negationisms after the occupation: that of the Shoah, in other words of extermination, the purpose of which we are well familiar, and another which is currently developing, namely, the negationism of the *Blitzkrieg*, of lightning war, in other words, of an acceleration of history leading to that acceleration of reality of which we just spoke. As usual, I take World War II as an example. When we speak of the Shoah, we speak of extermination, not occupation. My generation, however, thought of concentration camps as deportation camps. We knew that there were gas chambers, but deportation was always in the foreground. In his book, Raul Hilberg speaks of the destruction of the European Jews. What is of interest here is the prominence he attaches to deportation by asserting that "if it had been possible, the Nazis would have deported the Jews [all the way] to Madagascar." So the real critical move of the Fascist futurist – we shall turn to this once again – was developed during World War II, by Mussolini and Italian Futurism, with Marinetti, the Russian futurists, the Melnikovs … *and* with the Nazi futurists. The extent to which we do not refer to the *Blitzkrieg* as futurist is astonishing. I myself was a victim of it and we are now claiming it never happened; that it was the French who did not know how to fight, even though they did actually put up a good fight. That Pétain guy … No! The acceleration of history destroyed Europe and destroyed the Jews of Europe, as Hilberg rightly notes. And yet there

are no more gas chambers. However deportation is just beginning. Sixty-three American cities are in the process of being depopulated. Four hundred cities in Russia are currently being depopulated. We are heading toward the end of a sedentary era. Urban migration is an extension of the rural migration of the nineteenth century. We are currently witnessing the setting in motion of a great exodus. A closed-circuit exodus: no longer a linear movement toward an imagined promised land, but a circular exodus. And for this exodus, there exists an exceptional model in the great circular accelerator of Geneva. We cannot speak of negationism without speaking of the acceleration of the real. Negationism negates reality. It not only simply negates the fault, the responsibility of this or that people, the Germans, Pétain … It negates the *real* by accelerating it up to the speed of light through the great ring, the great collider, that underground cathedral of Geneva. This speed ring is a perfect metaphor for the reality of a world too small for progress, and running the risk of a black hole.

———— SG: Like the myth of the Tower of Babel, revisited. By wanting everything, we get nothing. It is an industry of emptiness, like propaganda that empties from its content that which it intends to promote.

———— PV: In the beginning, there was the propagation of the faith. *Propaganda fide*. Its aim was to convert. But originally, the propagation of faith had nothing to do with propaganda. It was an apostolic mission, only later becoming proselytism, in other words, propaganda. This religious model was then appropriated by the Enlightenment philosophers. In other words, progress was accelerated from the French Revolution onward. It accelerated machines, production, quantities, transportation … and speed became the propaganda of progress. In other words, speed became the proselytism of progress. It is impossible not to believe in progress. This is where *mono-atheism* poses several weighty questions. We do not believe in God, but we do believe in progress, until such time, that is, in which we no longer believe in this either. The propaganda of progress leads to a dead end, a *cul-de-sac*. Hence, it is crucial to remind ourselves that

the acceleration of time is the propaganda of progress. Time was circular in the past, a time of cycles, the time of the great religions for which time is circular, where it operates a return by way of metempsychosis. Our Judeo-Christian, Greco-Latin society invented linear time before Enlightenment philosophers then directed it towards progress rather than eternity or eternal life. Today we ask: what is the cycle of accelerated time if it is thought in terms of instantaneity, in terms of the speed of light, that is, in terms of the great collision? Here we should recall that the accelerators of particles, as metaphors, have become colliders. We used to have a linear accelerator that has now become circular. This device in Geneva is a kind of cathedral of the future, of the crisis of thought, of time and of tempo.

When I say "the propaganda of progress," I mean that progress is inevitably propagation. So much is clear. In the same way as faith is propagated, so is progress. But things that are propagated are not necessarily propaganda: a growing child or tree *propagates* itself without being propagandist. Propagation has thus been perverted into propaganda. This is important since we are dealing with ideology here. And we know that the nineteenth and twentieth centuries were the centuries of the great ideologies and ideological wars. The propaganda of progress is linked to the development of the great ideologies: totalitarianism, whether Fascist, Italian Fascist, communist, Maoist or Nazi. I find this important because I am a thinker of movement and speed. And so one must keep in mind the dynamics to which we are referring here: the dynamic of progress in a linear movement towards improvement, before then suddenly turning on itself. In a sense, this is the limit both of progress and the idea of propagation. It is a tremendously important event that we should also discuss with physicists, as it appears to be a complex accident, an integral accident.

———— sg: Culture is transmitted through anonymous, rhizomatic channels. Celebrities without content emerge from an intensification of the process of celebration. The media conglomerate is a decisive actor in this process of overexposure.

CERN, Geneva.

PV: Gods, kings and emperors were celebrated through glorifying monuments, and not the maker of the temple. Something has been displaced today: instead of celebrating the master, God or genius, monuments have come to celebrate the architect.

The media is a machine in the process of breaking down. The Internet will break down and it will be an integral accident.

SG: It is from anonymity, from the *minor* that greatness ensues.

PV: The great well-known "unknown" is Kafka, certainly the greatest writer of the twentieth century but also, the quintessentially furtive writer. Furtiveness is a key strategic element. Not appearing is to save one's life. And not to appear in literature, as Kafka would have it, is to save his work. In my view, Kafka's work exceeds as well as includes literature proper, alongside his journals, *The Metamorphosis* and *America*. He is first and foremost an epistolary writer (like Flaubert, whom Kafka admired, and others … I'm thinking of Paul's epistles, for example). Hence, Kafka did not want to appear, even at the moment of his death. He withdrew definitively by asking his literary legatee to destroy all his writings. Kafka's act goes much further than the question of celebrity by questioning the work itself. Will the work of art also disappear? Though verging on nihilism, this likewise stems of the times. When Kafka effaces himself, Europe is about to enter the most tragic period of its history, that of the Shoah, of extermination. Europe wishes to extinguish its greatness. Some have said that there can be no writing after Auschwitz, no painting, no poetry. But Kafka was the first to formulate it thus. His is a prophetic understanding of the fate of literature.

Here we meet Deleuze and Guattari on the question of minor literature, namely, at the point at which they meet Kafka. Celebrity used to be linked to history and to the author, the great author. First, to the creator, whom Nietzsche declares dead: the death of God was followed by the death of the author. In some way, Kafka prefigures the death of the author. He is Nietzschian not in announcing the death of God but the death of the au-

thor. There is something very powerful here whereby Deleuze and Guattari generously find hope by claiming that the future will spring from what is deemed minor. Minor literature (*minora*) is by no means a desertion of greatness. To be minor is to lie in wait of what is to come, refusing the end: refusing finitude, refusing the Great One. Hegel's *Schöne Totalität*. It is to take refuge in the minute mark that is the dot of the question mark. The story of minor literature (*minora*) is an old one: it commences with the hermits, those who would disappear into the desert, and was later taken up by clandestine artists, the Damned (*les Maudits*) and so, too, by Kafka, that great well-known "unknown."

SG: One is not an artist solely by dint of one's will. Paraphrasing the title of your book, *The Aesthetic of Disappearance*, are we not witnessing the disappearance of aesthetics in contemporary art?

PV: There is an important point anticipated by abstract art in general, and by *musique concrète* which brings us back to the war and postwar periods. Art and culture were also victims of the war. Contemporary art is crippled, all the more so as it fails to acknowledge its infirmity. Instead of stating "we were victims of a culture war (WWII was not just a political war but an ideological one) which was also an art war"; instead of acknowledging it, "I am nothing, I was injured, I am a disabled member of my culture," contemporary art – as represented by the New York school, and in contrast to the Paris school and the Europeans who remained behind – continued to work and proclaim the future and its magnificence. To them it was of course magnificent! They were on the other side of the Atlantic. The European artists who stayed and worked on the ground in occupied territory – in France and Germany – were eliminated by, I would say, the vainglory of those who escaped the war, by those who deserted Europe.

Let me open brackets here for those who returned to join the Resistance. There were not many, but there were some. So art is a victim of war and continues to bear the scars to this day. Everything we have been saying revolves around this: the postwar illusion of success borne

by the New York school, by those who did not suffer the tragedy, those who did not live through extermination. Something was played out here which, I think, is crucial to the history of art. The victors, the heroes of contemporary art, the great artists who found refuge in the United States, are in fact lost. However, those who were injured and acknowledge it in their work, in their poems, in their music, in their painting or their architecture (there are not many but there are some), these stand along with Kafka as signs of the future.

The other aspect I see as being linked to the technological revolution is that art has reached as far as the eye can see. When I used this as a title for my book, I pointed out that I was not referring to blindness. I meant an art that had so strayed from history and from reality that it had moved beyond it: it no longer exists because it has reached further than the eye can see. Because of its arrogance, or the arrogance of those who won the postwar era, they are now out of sight. It is a very costly process and the art dealers live off their backs. It could be that contemporary art is already dead and we are only just beginning to understand it. So the art market is a market of the dead.

———— SG: To be sure, we have great unknowns in the present who are protecting themselves by working behind pseudonyms. They are present in their absence (and preserved for the future).

———— PV: There must be a few. I can mention one atypical character that stands outside the norm, ensconced in this postwar history and the history of American art landing in Europe, and he is present to this day. I am thinking of Chris Marker who is one of the great masters of images, an emblematic figure of the dissolution of celebrity. For celebrity was not eliminated, it was dissolved. It is not a rewinding revolution. The aesthetic of disappearance is dissolution, not just a cinematic disappearance, but dissolution of the work itself first and then its author. But a man like him is not dissolute. He is alone. In dissolution there is also solitude. And solitude goes hand in hand with genuine celebrity. The saint, the celebrity, or the prophet necessarily stands alone. He does not start a school. If he does, he is no prophet and he is no saint.

Chris is a very important figure of our time. The last time I saw him he was in full battle dress, wearing rangers, a helmet, and biker gear for the wheels he still sported at his advanced age. All that was missing was that his helmet be army issued. I am just thinking of this now because the people we carry close to us are so embodied somehow that we do not notice these things. This is a good illustration of grandeur, I would say. To be embodied. They are such a big part of our lives that we no longer think of them. In a sense, it is like the love of your life; she is so embodied that at times, you forget her.

———— SG: We cannot continue discussing celebrity without asking, "where would Paul Virilio be situated?"

———— PV: I flee. I do not go claim medals or accept prizes. I flee celebrity. Not from some sense of modesty or humility, you understand, but because I do not believe in it. I am an atheist when it comes to celebrity, simply because all of my work discloses this impasse in which celebrity finds itself. I have no desire to make my way into that dead end.

There is a wall here, in La Rochelle, around the beltway. They call it the suicide wall, because there are a lot of bikers around here who die in speeding accidents … Nobody talks about it for fear of inciting panic and thus turning it into an attraction. Well, people rush to see it anyway. It has become a metaphor, a symbol, a monument.

———— SG: You left Paris, the megalopolis, fifteen years ago, to live in La Rochelle? Is this choice due to the wisdom of the urbanist that you are?

———— PV: I wanted to spend my last years on the edge of the world. And to me, the Atlantic coastline, the threshold of the ocean, is the Last Frontier of history. History is not just about centuries and events. It is also about places. And borders are historical sites where wars have been waged, people massacred, invaded and destroyed. I think these borders have lost their significance due to the acceleration about which we have been speaking. If proof be needed, we have it in the concrete of all the walls built after the Maginot line or the Siegfried line that were the very basis for WWII. Walls are being built

along the US-Mexico border extending 1500 km in length; around Israel, and they are even being built around Italian towns in the South. The Berlin wall has fallen but only to crop up again and be multiplied everywhere. So, when we build walls borders are disappearing.

However, the one border that will never disappear is the coastline. It is the Last Frontier of history. The beaches on the seashore are the end of history. In fact, my work began with displacement and the *Blitzkrieg* that we have touched upon. The invasion and the *Blitzkrieg* ran aground in the bunkers of the Atlantic wall, on the beaches where I rediscovered them. To those who say that "this is an odd move for you who spent so much time working on speed and concrete," I reply "no! It's that speed has run into concrete, into inertia and into useless, absurd ideality." So it is quite consistent for me to have worked on invasion and on the construction of the Atlantic wall, the Western wall as it was called – because this is where history is taking place today. On a coastline we stand on the edge of the world, which is just where I wanted to spend my last days – on the ocean's edge.

———— SG: The finitude of the world, the foreclosed world is slamming up against this Last Frontier, its own horizon.

———— PV: There are two horizons: one horizontal, delineated by sea and the other vertical, drawn by the sky. On the beach, you see both: this is the end of the world. Because I believe in eternity, this is where I wish to end my days. I do not believe in instantaneity. And here is where the door opens.

The shoreline of the coast is the last frontier of history. Following the movement of mankind over the millennia that have passed – ever since prehistoric times, since Neolithic times, we witness that men were first lake dwellers, later settling around rivers, deltas, the Nile, the Rhone. And today, the attraction to coastlines, to this particular horizon line is worldwide: two thirds of the world population lives less than hundred kilometres from a coast. More and more people gravitate towards the coast, the great oceanic coastlines. Across the ocean is America. But that is at the other end of the world. Somehow, the

End Station 2005. Mixed media, ca. 450 × 2050 × 975 cm. The Bohen Foundation, New York. Courtesy of the artists and The Bohen Foundation, New York.

end of the world is bound to contact with water. It is tied to contact with the horizontal coastline, the ocean and its horizon line but also to the vertical, the end of surfaces, the end of oceans and the beginning of a great atmospheric void, an interstellar emptiness. Thus it is here that history comes to a close. Having emerged from the oceans in evolution, stepping out from the great depths, the great aquatic world, mankind is now flocking back there. Land is not exactly being abandoned, but neither is it really inhabited. People are attracted to the coast, to the limit, to the only remaining border. State borders are disappearing one after the other. The construction of 1500 km of wall between Mexico and the US means that the border is disappearing. However, the thresholds of continents are not. They are the ultimate borders between solid and liquid. Tomorrow's history will take place between the dynamics of fluids: ocean fluids, flows, and the dynamics or mechanics of land. In other words, where the beach dives into water, where the shore extends to the ocean floor. This is why states are scrambling to claim territorial waters and to plant flags on the ocean floor, like Russia has done in the North Pole.

We stand on the coastline before the end of the world, the finitude of the world. The historical world comes to a close with the populating of coastal areas, where the coastline is inscribed; the limit between earth and sea. As for the phenomenon of submersion, which seems inevitable with the melting of the poles and rising sea levels, is concerned, this too will be a playing field.

We may suppose that just as national borders were the site of conflict between nations, hence the Maginot line, the Siegfried line, and the ramparts, today's line of defense will be drawn against submersion, against the conflict within a conflict between the dynamics of fluids and the mechanics of landmasses – hence, perhaps a shift in terrain from geopolitics to *Meteo-politics*. I believe that the future will bring about a grand Ministry of Time and Weather, of weather changing with meteorology, and of the time that passes with *Chrono-politics*, its rhythms and its flux. It seems strange, but it is hard for us to think about the beach as threshold. We refer to it in relation to seaside resorts, water sports, swimming, while in effect, it is the last of frontiers, the last of all limits.

Globalization ends by the sea where the conflict between lithosphere and hydrosphere is played out in the atmosphere. Something is happening here, something that is the ultimate limit of history. Of history that will plunge back into the ocean. An ocean of waves, flows from the sky, flows from waves, flows of information. It is a singular period in time in which geopolitics gives precedence to Meteo-politics, in other words, to randomness – a vision that no longer refers solely to solids, but also to fluids and liquids.

Another history will begin at the edge of the world. Though not a sad story, it is a tragic one which deals with questions that have not been posed since antiquity.

To live the end of the world each day – at every moment – is unrivaled.

Translated from the French by Lisa Damon.

Paul Virilio performing the notion "dead end."

T he present age is the age of the "star" – the pop star, the sports star, the political star, the star expert. *Both* the English and the German word "star" contain various meanings. The English connotes what is meant by celebrity, the *one* who stands out, while the other denotes a species of bird. In the English language, however, the word also means sun or planet. If this were a mere coincidence, it would be a most remarkable one indeed. The parallels between today's celebrity culture and a swarm of stars gathering in fall before commencing its journey south are profound and deep: like a multitude of stars or a swarm of fish, present-day human society is organized in swarms. We see swarms gathering in politics and media around certain topics, only to move on once the topics have been exhausted. We see swarms of speculators around certain topics and areas. We see swarms at *events*.

The logic of the swarm is the logic of the fastest, the smartest; the logic of the moment. Traditional societies, even dictatorships, have permanence and structure, whereas in the swarm there is only action. Strength remains only the strength of the moment, since everything can change within seconds: a new member leads, a new direction is taken. In the swarm, everybody has a chance to lead for a fleeting instant. The urge to be famous, however ephemeral, is very strong.

The forces of the human swarm are wealth and attention. They permeate all other aspects of public existence.

The Star and the Audience

Disinformation and the Logic of the Swarm
Max Otte

Everything else dwindles in comparison. Knowledge and education are of interest only insofar as they may be converted into attention or wealth. Life achievements become "history" the moment they cease to catch attention, or else they are not manifested or convertible into wealth.

Attention: Andy Warhol spoke of the "fifteen minutes of fame" that each person would experience in the future. Our casting society has come dangerously close to this. In the swarm society, attention is not gained by complex argumentation. Attention results from something done at the right moment, at the right time – from a simple, context-bound argument, from something conspicuously outrageous, from something that *stands out* – good, bad, beautiful, ugly, relevant or irrelevant. All of a sudden, atoms of gas display uniformity and order, as in a laser. Walter Scheel, a former President of the Federal Republic of Germany once said before the Association of German Newspaper Publishers: "Sensation is disinformation, because it destroys the context of things." This is as true today as it was in the 1970s, though only very few would listen.

The desire to be a star, to stand out, if only for fifteen minutes, is becoming a driving force in society. While the star does not claim to be any different from his or her audience, what does set him apart from the latter is not a certain set of characteristics, but the attention and recognition he is given. In essence, the star is the audience: tomorrow, somebody else might be the star.

Wealth: In the swarm society, fast wealth is not obtained by sustainable business models. Hedge funds, social networks, computer games, fast business models with a time span of a few years or less are the dominant forces. In 2005, SPD [the German Social Democratic Party] politician Franz Müntefering rightly referred to hedge funds as "swarms of locusts" descending on a vast area before moving on to ravage the next one.

The extreme swings and tendencies of present-day financial markets go hand in hand with the swarm society in which it is possible to make or lose millions, even billions, within short periods of time, and without any consideration for the future: tomorrow is the next round of the game. Our political system has no interest in stabilizing financial markets. The swarm thrives on turmoil.

The Age of Disinformation

The swarm society would not be possible without a growing mass of disinformation. Information is a coordinate system that allows members of a society to find their place. If reflexes – and only reflexes – are to take over, such information must be destroyed.

Three major forces drive disinformation society: the interest of (large) economic actors in disinformation and confused consumers, the role of the experts, the weakness of media and journalism and the impotence of governments and politics.

1. The interest of (large) economic actors in disinformation and confused consumers

Information and standards are the quintessential public good. Large economic actors want us to remain in a state of confusion. They are averse to information and open standards, which, if in place, would mean that they could be compared, and so would rather impose their own standards.

Consumer information on food, for example, is in small print, in many languages and misleading. Consumers simply do not have the time and knowledge to evaluate it. In Germany and Europe, the simple "traffic light model" (green – yellow – red) has been stopped by food and financial products lobbies. Electric utilities and telecom companies confuse us with ceaselessly changing tariff structures and price initiatives. The display of products in supermarkets changes every so often to confuse us and shake up our routines so that we can be led to new products we do not want.

Even reference points – clear measures for the quality of products – are being systematically destroyed. Instead of octane numbers, a simple and clear scale for gas in a gas station, one chain now introduces names only so

that consumers memorize names, but fail to make an objective comparison of gasoline quality. All of a sudden, the yoghurt in the supermarket costs seven Euros – until, that is, one notes that the reference is now one kilo.

2. The role of experts

We live in an age of experts – something which unfortunately perpetuates confusion rather than endorses clarity. We allow experts to carry out public debates, before we are then asked to judge and decide. Often, we are left confused: is there really something like global warming? What are its causes? What are we to do? What will the consequences of the financial crisis be?

Many experts, many answers, many confused citizens. There is something to be said about expert culture, about careful deliberation and well-informed expert decision, so long as these remain under democratic supervision. But to throw expert knowledge at citizens without due process leads to confusion and disinformation. Knowledge has to be structured, and knowledge has to be digested, since otherwise it will lead to information overflow and ultimately disinformation.

Moreover, experts themselves take on the role of stars. At various times I have been called a "star economist" after precisely predicting the current financial crisis. The label is incorrect. I do not like it at all. I was pretty much alone in making a correct prediction, which drew attention towards me. In the aftermath, I sensed that the audiences I addressed or the media wanted to ascribe "star" and "guru" status to me.

3. The weakness of media and journalism

Unfortunately, media and journalism do little if anything to divert disinformation. Here, too, the logic of the swarm is in full action. If a topic is "hot" everybody discusses it, if it is exhausted, then on to the next one. Few media still devote themselves to continuous background coverage. The public thought that TV was a threat to objective background reporting. The rise of private broadcasting gave rise to specific TV programming for the lower classes, creating false realities, *panem et circenses*.

But the real threat to the information society is the Internet, where business models are driven by the merciless logic of the click. Portal operators can measure the attention span of stories in real time, and those obtaining the most clicks are promoted to first page. Web.de is an Internet portal I used for news until three or four years ago. There were subject categories on the first page on politics, business, finance etc. I could acquire information quickly and in self-directed manner. Nowadays, there are just a few society, sensationalist and gossip stories on the front page. How Amy Winehouse got herself to vomit, for example, or how bizarre dancers expose themselves in a talent show. Apparently, it is these that get the most clicks. Kai Diekmann, editor-in-chief of the popular German tabloid *Bild*, called it the inborn disease of the Internet that content is free of charge. Naturally, it is not free. We pay for content through clicks and advertising. The conventional newspaper, one of the pillars of democracy, has its back against the wall. Many newspapers will not survive the age of the click and the image.

There is little hope that blogs and "citizen" reporters will rectify the situation. Citizen reporters may do well in reporting abuses in closed societies and dictatorships, and they may send pictures of airplanes conducting emergency landings in water, but they are neither trained nor paid to carry out extensive background research or investigative journalism.

Social networks are the ultimate swarms. If somebody, or a video, or a topic, gets a lot of clicks, they ultimately attract more. Tomorrow, another topic might attract attention. Critical debate among citizens is heading towards zero. Thus, Twitter is the ultimate swarm machine.

4. The impotence of governments and politics

We cannot hope to get help from politics. Politics itself is increasingly driven by the star logic. Good-looking, articulate politicians can gain approval in "town meetings" – just because they look good and act "cool." Arguments and positions are secondary. Relatively young and good-looking politicians are being promoted to ministerial

positions. They may be smart, but they do not have the same stature as their predecessors twenty or thirty years ago. They are pawns in the game, not rooks or knights. Formally, wealth and power were always connected. But today, wealth *is* political power through the use of public relations agencies and lobbyists. Corporations evoke "corporate social responsibility" to justify the dismantling of governmental oversight. Remember BP? It used to paint itself especially "green."

Law firms draft laws. In Brussels, over sixty lobby groups work in finance alone, mostly behind closed doors. Politicians are being courted. Once leaving office, they are often offered lucrative positions in the private sector. Politics now often serves the largest corporations and the most powerful industries. The power of government to set standards for public interest, e.g. in the information sphere, is rapidly waning.

The End of Reason

The Revolt of the Masses (Ortega y Gasset, 1930) has been raging for more than a century. We are the masses! They are everywhere. *We* are everywhere. As the last ties to traditions are cut, as the last remaining boundaries are transgressed and social customs crumble, we increasingly begin to resemble freely mobile atoms, moving without plan or structure.

Nations and traditional institutions are seen as relics of the past, social distinctions become fragile, and even the sexes become alike. But the more traditional distinctions and customs disappear, the more we think and act alike, the more we yearn for uniqueness. Such uniqueness, however, is transient. Andy Warhol's fifteen minutes of fame for everybody *has* become the dominant paradigm of our times.

In *The Assault on Reason* (2007), former U.S. Vice President Al Gore draws a frightening conclusion. We are leaving enlightenment behind us. Reason is no longer the driving force in many areas of society. Al Gore puts his hope in a citizen society. I am skeptical.

Knowledge *is* hierarchical. Monasteries that preserved the knowledge of humanity in dark times were hierarchical. Theories are true or false, regardless of how much attention they receive or whether people agree with them. Some men are wise, some are ignorant. There is deep knowledge and there is shallow knowledge. We are *not* alike.

The logic of the swarm, however, depends on agreement and attention, on uniformity. Taken to its extreme, the logic of the swarm would ultimately be the end of reason.

We now clearly see the outcome of the great struggles of the twentieth century. Humanity had the choice to organize itself along the lines of a beehive or a swarm; it has rejected the beehive, the dictatorships that loomed large, and chose to organize in swarms. In a beehive there is a queen, and there are workers and drones. Roles are fixed. A beehive is static, but it is capable of great continuous achievements.

In a flock, all participants are identical in nature. The swarm has good reflexes; it can re-act. It lives the logic of exploitation, attack and flight. With the blink of an eye, one participant leads, before being superseded by another. No social structure is permanent.

We need a new balance between the swarm and the beehive, between the one and the many. We need to judge position, structure and quality, not just quantity, reflexes and speed. Uniqueness – not only by leading the swarm for a moment, but uniqueness because of true difference – must become important again.

Who is the Celebrity?

Rodrigo Maltez Novaes

C elebrity is a term originally associated with religion, and for millennia the Judeo-Christian God of the Western world, the God of theology, of the scriptures, held the place of ultimate celebrity (in the strict sense of the term). In Western monotheism no other "entity" (physical or metaphysical) could ever be celebrated above God, and the dialectic between God and his antithesis, the devil, fuelled the production of most of what we term Western culture. The origin of our culture lies in Ancient Greece, and this dual nature at the base of much of our thinking has roots in the tension between the cult of Apollo (sky) and the cult of Dionysus (earth), where sky and earth were in constant duality, constant contradiction. Friedrich Nietzsche explored the origins of the concept of tragedy in Western culture by analyzing this ancient relationship in his first book, *The Birth of Tragedy* (1872) and advanced the notion of the inseparable essence of these two apparently opposing forces that lie at the base of Western culture. From Apollo and Dionysus there later emerged God and the devil: the cult of all that is divine in opposition to the veneration of the earthly and mundane. Opposites and yet inseparable: chiasmic union. And if looked at from this perspective, the history of "worship" could, in a sense, be seen as a grand genealogy of what we today refer to as "celebrity culture," which also includes all that we do not celebrate, but reject. Although the nature of what we celebrate and reject today is very different, at root, this old dialectic of sky/earth or good/evil may still be identified in our contemporary relation to public personae and their image.

One of the main shifts in our attitudes towards the celebration of the divine occured during the Enlightenment: scientific reason, or in other words, Modernity, came to question the validity of celebrating one God above all else. But it was not until Nietzsche pronounced the "death" of God in his *Thus Spake Zarathustra* (1883), that the news, while not entirely coming as a surprise, generated a vacuum. Industrialized "culture" and "capital" filled the "gap" and, combined, became a new form of "religion." The full implications of what had happened

were not fully grasped at the time; only some decades after the publication of Nietzsche's book did the death of God became a reality. At the height of the industrial age, after World War I and with the emergence of America as a new economic and political world player, this newfound religiosity in culture and capital finally found its new cathedrals in the form of art galleries, department stores and the new picture palaces of Europe and America. The masses emptied the churches and filled these newly built arenas and public spaces created for a new type of "worship" by consumerism, that were seen by them as a symbol of their newly won democratic freedom to choose. A crisis of faith ensued, and thus celebrity and consumer culture as we know them today were born.

Celebrity culture in the early 1900s found its principal medium in the cinema, and saw the meteoric rise of personalities from the world of sports and entertainment into quasi God-like status. The nineteenth century's actors of the stage and concert halls, who had until then been kept on the margins of high society, leapt from the silver screen straight onto the clouds of a brand new celebrity heaven.

"[…] the West has another tradition, the pagan, culminating in cinema. The West makes personality and history numinous objects of contemplation. Western personality is a work of art, and history is its stage. The twentieth century is not the Age of Anxiety but the Age of Hollywood. The pagan cult of personality has reawakened and dominates all art, all thought. It is morally empty and ritually profound. We worship it by the power of the Western eye. Movie screen and television screen are its sacred precincts."[1]

In the first two decades of the twentieth century Hollywood's motto was "to have more stars than there are in the sky" or a new Pantheon of god-like personalities, a system expressly designed to produce celebrities – "cash cows" of the Hollywood studios. And, until television established itself in the mid-to-late 1950s, Hollywood was to remain the dominant celebrity-producing apparatus worldwide. During a period of world depression, the masses consumed filmic images as escapist fantasies. Thus, America established itself as the world's chief producer of cultural consumer goods for the masses. Of all the early Hollywood stars, only those who died in their prime managed to retain their god-like status: Rudolph Valentino's grave, for example, is still visited daily by adoring fans. James Dean and Marilyn Monroe jointly became, probably the most celebrated idols of the twentieth century. To wilt in front of the camera and expose one's humanity is unforgivable in the minds of adoring, loving fans and the unfading love they express means a continuous flow of cash. It is against this background that another well-established relationship finds a new face: love and money. We love money and we give money to all that we love in the age of free-flowing capital. Thanks to the people's love of God, the church filled its coffers and waged wars; and it is through our love of celebrities that media conglomerates now make their profit. To love is to consume, and we humans are passionate lovers. The apparatus that produce celebrities today have changed. Hollywood no longer holds the monopoly over the creation and support of celebrities. These are now prevalent in every field of human "culture" in the widest possible sense of the term, and now "celebrity" is also a byword for brands (neo-icons).

"There is no such thing as 'mere' image. Western culture is built on perceptual relations. From the soaring god-projections of ancient sky-cult to the celebrity-inflating machinery of American commercial promotion, Western identity has organised itself around charismatic sexual personae of hierarchic command. Every god is an idol, literally an 'image' (Latin, *idolum* from Greek, *eidolon*)."[2]

1 Camille Paglia, *Sexual Personae*, Vintage Books, New York, 1990, p. 32.
2 Ibid., p. 33.

Over the foregoing centuries the term and concept of "culture" has evolved and metamorphosed such that today it is not only associated with the production and consumption of cultural objects, but also with that of lifestyles and political movements, such as gay culture, black culture, native American culture (to name but a few examples). Hence, today, when thinking of celebrity culture with its revived paganism, we must also account for this terminological metamorphosis. By linking "culture" to "celebrity," we approximate two opposing terms; two opposing concepts, which may be significant. Both terms derive from Latin. Stemming from *colere*, the term "culture" has its roots in agriculture, of all that comes from the earth, and is of the earth; all that is of-this-world (mundane), and therefore with a source in human action. And the term "celebrity," originally *celebre*, is associated with worship, of all that is sacred and of other worlds; in other words, all that is not human, but suprahuman, and, again, of God. Originally, *colere* and *celebre* would not have been used together to form a secondary term. Consequently, since the evolution of both terms over the centuries has brought them together, we could say that today the act of cultivation, of waiting and of hoping, has become intrinsically linked to that of celebration, of elevation, of worship. In sum, we could say that we have amalgamated sky-cult and earth-cult into one term. And if what we worship today is all that is mundane, of the earth, could we then say that we essentially worship ourselves? But if we have pushed our own hopes and desires up onto a pedestal, we may have become alienated from our own interiorities. If we cultivate celebrities as ordinary men and women who have been selected arbitrarily in order to be elevated, if we see them as the fertile ground of our dreams and desires, then they become avatars of our own identities – national, cultural, sexual and personal identities. Identity: also from Latin, *idem-et-idem* or that which we repeat over-and-over. "In fact we might say that the whole purpose of existence is to try to reconcile the glowing opinion we have of ourselves with the terrible things that people say about us. And the combination of these two opposite opinions will be your identity."[3]

Erste Reihe (Front Row) 2001. Wood, velvet, plastic. 800 × 340 × 220 cm. Work demolished. Installation view Schauspielhaus Hamburg. All seats from the theater parquet had been replaced by one oversized replica. Courtesy of the artists and Schauspielhaus Hamburg.

Should we agree with Camille Paglia's assessment, then in our reawakened pagan cult of personality we have come to worship images of people of flesh and bone as we worshiped gods, believing them to be the very people they portray. This differs little from the Ancient Greeks or Egyptians, who worshiped statues as the living embodiments of their gods – perennially flawless entities. Thus, our contemporary celebration of images and expectations of celebrities are, in fact, an unsolvable paradox. As humanity is essentially flawed and fallible (unlike transcendental, metaphysical deities represented in stone), and since the image becomes tarnished as the person ages, the individuals they represent are then punished for something over which they have no control: the inexorable passage of time and its effects on us. By celebrating images (still or moving) that are immutable (like statues), but that are of real people, the paradox lies in the knowledge that while no one ever retains eternal youth one still feels the anxiety of watching them age as their images stay frozen in time. To celebrate images in this way is to celebrate memories turned into ideals: it is to celebrate the past as a desire for the future or, in other words, a desire to undo the process of entropy, which is the ultimate paradoxal desire. Images are stored in eternal artificial memories and are never forgotten. Celebrities age; their images do not. And in celebrating eternal youth, some pay a heavy price for not remaining forever young, for example, Britney Spears and Michael Jackson. Although many have managed the transition from child star to adult celebrity, many others have not been able to achieve stability in their mature years – with correspondingly disastrous effects on their personal lives.

In our age of passionate consumerism, markets are created and preserved by advertising campaigns that have images at their core; and inexperienced youth is the target of most advertisers: the less one reflects, the more passionately one spends. The passion of youth is exploited by targeting their innermost dreams and desires to belong, to love and be loved. Turned into consumers they quickly reach "plenitude"[4] as full members of the mass, because the opposite is a fear of rejection and notoriety (although the image of the "reject" is also exploited, packaged and sold as a "lifestyle" option). On the other hand, a position of true notoriety can only be achieved by actively embracing rejection and turning it on its head, throwing it back onto the world like many have done. Notoriety can also mean greatness, but a greatness that comes at high personal cost – all great men and women are loners. The twentieth century, for example, saw the rise of a number of notorious figures, especially within gay culture, such as Quentin Crisp, who was publicly "born" in an era of criminalized homosexuality which lasted through the 1940s, '50s and '60s and who not only accepted rejection right from the start, from childhood, but also saw in it a form of freedom. Hence, his rejection did not result in disappointment, and he turned notoriety into a "lifestyle," which Crisp saw as an idiom that, though naturally arising, must be deliberately maintained, or else embraced. True notoriety can only come from within. "Like a humming bird, I would let myself flutter freely around the cinema's garden without reservation, feeling happy as if in an impossible dream, even if the cinema stank of dirty dicks, cigarette smoke and the typical dampness of basements. [...] Love is an absolutely solitary feeling; and sucking my boyfriend's dick in that cinema, under the light of the porn film, I was in love."[5]

We reject what we fear the most. Quentin Crisp and Luís Capucho (a marginalized, notorious, Brazilian writer) have been despised and feared for showing us who we really are. They consciously chose to be eternally "other." They are true iconoclasts because they fight against all pre-established values imposed by society via images, and thus we reject this shattered image that reflects back at us our true human nature. And in so doing, this process reveals to us that what we reject has more to say about us; it is far more revealing than that which we choose to repeatedly worship. What we celebrate is the patina, the surface, because that is where the "apparent" value lies; but the reality that lies behind the *façade* is something we wish to ignore. A good example of this is Disney's Celebration town in Florida – a celebration of

3 Quentin Crisp, see http://www.quentincrispfinalencore.com/
4 José Ortega y Gasset, *The Revolt of the Masses,* W. W. Norton & Company, New York, 1994, p. 11.
5 Luís Capucho, *Cinema Orly,* Interlúdio, São Paulo, 1999 (transl. to English by Rodrigo Maltez Novaes – unpublished).

pure veneer: but if one peels away the surface what one might find underneath may not be so appealing. The worst and most famous serial killers "appeared" to be the most normal of people, perhaps because it is only by missing some aspects of our emotional dimension that it is possible to sustain such a perfect *façade*. Emotions are dirty things that we cannot control: it is the opposite of clean, lean reason that cuts "reality" like a knife into rations ("ratio" – reason). By celebrating the clean veneer of perfection we try to distance ourselves from the dirty reality of emotions that which make us flawed, or in other words, human. We err because we are humans and we are humans because we err.

So, if analyzed carefully, it is possible to identify in contemporary images the dialectic between good and evil being played out within the inner core of the meaning of images. For example, if an image of being perfect (perfect son/daughter, friend, partner, citizen, etc.) is closely associated with the image of divinity, then it is associated with godliness, and if God (Apollo) represents pure reasoned order, then this is a static image because it no longer represents process, but a final stop: it is utopian. And if the opposite image of the divine is devilish, then the devil (Dionysus) is pure process, it is the chaos into which we are thrown, it is the inexorable passage of time: life in all its dystopia, and the image of all that we reject. So, at the core of every image the dual nature of our thinking enforces itself repeatedly, subconsciously programming us from a very early age via the "consumer" game. For the philosopher Vilém Flusser, God and the devil are metaphors of active and reactive forces, as they are in Nietzsche's thought, and as reflected in the Chinese symbology of Yin and Yang: symbiotic opposing but inseparable forces, as already mentioned, but the very forces instigating the real revolutions of life. One cannot exist without the other and in the game of consuming images or goods associated with celebrities we may be projecting onto them that which we subconsciously feel to be missing in us. So we celebrate them by re-enacting the empty ritual of shopping: *idem-et-idem*.

"Shopping is not creating!"[6] With consumerism, however, it is not the products or images themselves that do us harm, but how we relate to them. In other words, it is to the mechanisms of desire that we are to look if we wish to understand how we relate to celebrities. The key is not in how to control these desires, but how to re-evaluate *the way* we desire. Our mechanisms of desire are deeply rooted and specifically programmed depending on the culture into which we were born. Hence, to understand and change these processes it is necessary to subvert the cultural program in order to alter our affections and only then free the self from desiring where the intention is to fill a gap. In mass culture, socio-cultural programming becomes most apparent on the surface; and it acquires greater significance because it reaches a wider audience by aiming at the lowest common denominator. It is, therefore, easy to self-replicate – an attribute facilitating quick feedback (observable by successful distribution and profit margins). Sales indicate an overall approval of the programming values within products and today's main consumer products are images and the ideologies they support. The image itself has become the celebrity, it is no longer a case of celebrating the image of a deity, an "icon," but the image itself has become the object of celebration.

However, images have changed over the centuries. Today, they are ontologically different. Images are no longer "traditional" or flat abstractions of volumes used as maps to guide us in the world. Images are now projects of new realities, they are technical (digital) images produced by apparatus that no longer re-present, but present the world. Today, contemporary apparatus such as hand-held mobile technological gadgets with cameras linked to the internet 24/7 are placing us on a different level; this is a generative level in relation to information, since they act as filters between us and the concrete (phenomenological) world. As a consequence of such developments our relationship to our own environment is changing. In contrast to the way in which television and the cinema worked, today we see, touch and hear the world through these generators and conductors of

6 Douglas Coupland, *Generation X*, St. Martin's Griffin, 1st edition, 1991.

information: digital media. Our senses are no longer informed by real objects but by projects of objects (technical images). Thus, our relationship with the world is redefined by our relationship to a zero-dimensional world projected at our senses from the realm of pixels: digital morphogenesis. The world as we know it has slowly disintegrated from a four-dimensional environment (beings thrown into a concrete world immersed in magical, "circular" time) into a zero-dimensional, calculable reality over the period of millions of years; ever since the moment we humans took a step back from our physical reality, we have been pushing the world away with our hands (praxis) in order to objectify it visually for the purposes of reflection (theory). Now the world comes back to us morphed again from digital calculi: a re-imagined, "calculated" world in post-historical, post-industrial, and even post-cultural time. This is not in itself a negative view. Many interpret the zero-dimension, the highest level of abstraction, as the final point in time and history, which to some yields a negative prognosis of the ultimate result of the socio-cultural transition in which we presently find ourselves immersed. But, for others, it is from the zero-dimension that we are now able to project ourselves towards a new concretion via digital morphogenesis as facilitated by new types of apparatus. However, in our relationship to this new type of image – of technical images produced by digital apparatus – it is vital to develop a critique of the way in which these operate so as to avoid becoming functionaries of the very apparatus we have created.

"When deciphering technical images, we must abandon all humanist categories, which, though suited for critiquing industrial and crafted products, are inappropriate for the post-industrial products from apparatus. We must admit that the idea which leads to their production, although a clockwork of human intentions, is in fact non-human. Effectively, it is an infrahuman intention, stupidly automatic and self-conserving. We must admit that apparatus, although human products, are supra-humanly powerful, and at the same time infra-humanly cretinous. And that as we are programmed by them, we become cretins, debasing our aesthetic, epistemological and political faculties to the level of apparatus. There is no hidden conspiracy; there is simply the automatic functioning of apparatus."[7]

In order to grasp what this means for us today, namely, in terms of how we see the question of our own personal freedoms, it is therefore necessary to consider the terms "apparatus" and "program" as being central to the development of a contemporary theory of freedom in the age of powerful technical images. This theory may be developed as a necessary act of iconoclasm versus the iconographic power of technical images. By looking at mass culture it is possible to investigate how the socio-cultural programming of individuals by apparatus and vice-versa, takes place. As we have seen, programming re-enforces pre-established systems of value by the re-enforcement of icons (images) or signs; and in order to transvaluate these values it is necessary to develop an iconoclastic approach for generating interventions that override, re-program and/or try to exhaust the program built into social apparatus. The programming hierarchy is fractal, it spreads and replicates itself infinitely, especially now with the internet as the fastest form of socio-cultural program dissemination. By re-enforcing the program we only generate redundant information, or noise. In order to create new sets of information it is necessary to override the program, to exhaust it and go beyond it. Programmers are themselves programmed and in turn they feed back into the apparatus their own sets of gathered information, and so generate a loop. Aspiring revolutionaries have to subvert the program loop by iconoclastic intervention in order to gradually infect the program with their unique sets of information, which will gradually become part of the overall program: but first, as a sub-set of existing programs to eventually emerge as main sets, so that the entire cycle may then begin again. In this sense one can only envi-

7 Vilém Flusser, *Imagem-Imagem Técnica: Critica do Aparelho,* conference paper delivered at the XVI São Paulo Art Biennial, 1981 (transl. from the original Brazilian-Portuguese to English by Rodrigo Maltez Novaes – unpublished).

sion revolution in semi-geological time and not in human time. True revolutions can only be (r)evolved over long periods of time. And, in this sense, to be free is to play against the program within the apparatus. Freedom is a set of self initiated strategies to be played against the programmatic nature of apparatus, and not a passive right to be endowed and secured for the individual by the "system." To be a player is within everyone's ability regardless of social status.

"Our religious traditions, which cast back to the inception of our history, have deeply anchored the notion of 'destiny' in our thought. Thus, the world and our existence within it, are seen to obey some purpose and to aim at something, though both purpose and aim are obscure. On the other hand science has familiarized us with the notion of 'cause'. Consequently, every event is seen as an effect of some causes and the cause of some effects, though each concrete event may not immediately display its 'deep causes' and its 'ultimate effects.' But, there are presently several reasons in support of the view that the concept 'program' is better suited to explain the world and our existence then are notions of 'destiny' and 'causality.' This implies, however, that we change our whole outlook." [8]

Now that images have become all powerful, every historical event seeks to become an image, an icon, to be celebrated (stored and disseminated) and with our hand-held digital apparatus we generate history in a different way. Whereas the pagan culminates in cinema and TV, the nature of contemporary digital apparatus is very different. In our celebration of images we have created devices that produce images, or in other words, we have placed ourselves at the generative end and no longer at the contemplative end, no longer at the waiting end. Cinema and TV are untouchable screens placed at the receiving end of a centralized source that emits images (information). Over these images we have no control,

and no say as to how they are produced. But with generative technology, we all produce, store and distribute our own images. These are the images which permeate all of our lives online. Consequently, our "culture" may well be very distant to that of the ancients, since we can no longer say that the significance of contemporary culture is derived from the same conditions which the word *colere* seeks to define. Thus, we could say that today "celebrity culture" is "image culture": the production, storage and dissemination of images by individuals. We no longer wait, but generate. We produce images from the world of quanta, and of particles: images that are no longer representations. And if we generate the very things we celebrate, and if we are of-this-world, we have then come full circle – we have ourselves become god-like as well as devil-like: the ancient metaphysical dialectic of good and evil is now within us, as we become lords of our own self-generated technical-realities.

8 Vilém Flusser, *Pós-Historia,* Duas Cidades, São Paulo, 1983, p. 25 (transl. from the original Brazilian-Portuguese to English by Rodrigo Maltez Novaes – unpublished).

Celebrities: Today's Gods?

Hermann Strasser

T̲h̲e̲r̲e̲ have always been celebrities, albeit not in equal abundance, individual significance and social function as is attributed them today. Contemporary paragons of the present-day star cult were still apparent in twentieth century class society, though in such cases emphasis was placed on the union of performance and charisma. Representatives of this ilk were the likes of renowned opera singer Maria Cebotari, sportsmen such as Max Schmeling, as well as former First Lady, Jacqueline Kennedy, the actress Grace Kelly and that machinery of attention called Hollywood.

But the youthful Elizabeth II of the United Kingdom was no less wont to sun herself in the glamorous spectacle of nascent media society, even though, and perhaps precisely because of the fact that she was obliged to make good the love affairs and pro-Nazi affinities of her predecessor, the abdicated King Edward VIII. And, lastly, it was also Elizabeth II who set the example for her daughter-in-law, Lady Diana, of how to ascend to mythical status. However, the decisive difference between the two, as we shall note later, is that Lady Di did not move somewhere "up there," as it were, but far more "at eye level" among mere mortals – though naturally, not without the aid of media strategy.[1] As was to be expected, her son, William and his wife, Kate Middleton, are already observed enthusiastically emulating the path taken by parents and grandparents.

Celebrity – What is it, in Fact?

In the 1920s, Albert Einstein was astonished to discover that he had been transformed into a sort of "cult figure," and that he felt like an idol. One of his contemporaries, Karl Kraus, would lampoon these socialites, these "Obertanen," and fume at the use of this "infelicitous appellation." For him it was unambiguously clear: the celebrity title would be dished out to all and sundry who had hitherto demonstrated no indication whatsoever of being in any way outstanding, such as to cabaret artists, film people, hairdressers or fashion designers.[2]

Diana and the Queen, 1982.

1 Ulrich Steuten and Hermann Strasser, "Die heilige Diana," in: *Die Welt*, August 25, 2007; Ulrich Steuten and Hermann Strasser, "Lady Di – die moderne Madonna," in: *Aus Politik und Zeitgeschichte*, vol. 52, 2008, pp. 22–27.
2 Quoted after Achim Graf, "Im Scheinwerferlicht," in: *Die Rheinpfalz*, vol. 42, February 19, 2005.

Hence, celebrities are acclaimed, famous, and prominent because, as the Latin word *prominere* indicates, they stand out. They stand out – but how?

Firstly, because the prominent individual is *perceived* by far more people than he himself knows. This has to do, not least, with the flood of images in present-day media society. The sheer number of celebrities increases simply by virtue of the fact that they are permanently in view on all television channels and in all parts of the press. In some circles, referring to celebrities is tantamount to discrediting oneself – celebrities as cause for embarrassment when presented by media such as *Die Bunte*, the *Bild-Zeitung*, *VOX* or *RTL*, German popular press and television channels.[3] Secondly, they stand out because they have something *to say*, namely, to all and everyone. In this way, they then evolve into opinion leaders and advisors in fields in which they have no expertise, and frequently welcome advertising media. No wonder that, meanwhile, the obtaining and securing of celebrity status requires the aid of agents, the so-called personality PRs. Thirdly, the celebrity reinforces his or her status by way of a *social attitude* consistent with public expectations effected, among others, by way of social engagement as well as by specially prescribed announcements, stage-managed public appearances and an elaborate homepage.

In other words, celebrity, or the being in a publicly prominent position is not necessarily the result of achievement or of selection, but, above all, of approval by "public grace:"[4] not for what he or she can do, but owing to effective self-salesmanship.

Why are Celebrities Becoming more Important?

Although we live in an achievement-oriented society, the importance of celebrities is increasing. In this society, selection, in the form of qualifications and professional prerequisites, including performance, in the sense of effort and results, occupies center stage whenever emphasis is placed on the acquisition of status, income and assets. This relates to the particular demands of our society and the significance of the media, as expressed, not least, in the increase of media attention for and by way of celebrities. Today, without the inclusion of one or the other celebrity eyecatcher on the title page, hardly any newspaper could be published.

On the one hand, we live in an *individualizing* society characterized by increased education and income, by greater mobility and, consequently, by people's more outward orientation. In this society, it is no longer God, nature or other powers that are considered the origins and the consequences of human action, but the individual. For the most part, the individual himself determines his way of life and lifestyle.[5] The formative potency of traditional institutions such as family, school, church, political affiliation and membership of a class has dwindled.

However, the search for meaning has not been rendered obsolete as a consequence; on the contrary, it has become all the more important since the individual must himself, to a great extent, assume responsibility for it. He is all the more obliged to rely on his own *communicative abilities*, since today, more than ever before, he is required to communicate. The search for meaning takes place in actual and virtual networks, with friends and professional colleagues, in clubs, and associations the membership of which tends, however, to be more short-term, based rather on personal advantage, and is consequently more precarious. This is because, "to be is to be perceived (or to perceive)," as Bishop Berkeley claimed in the eighteenth century, and the modern person is increasingly unable to withdraw from public scrutiny.

However, we not only live in an individualized communication society, but also in a society in the process of *globalizing* itself. We are obliged, at increasingly frequent intervals, to adapt to new situations. In a world marked by transformation and uncertainty – a "liquid modernity," as Hartmut Rosa has coined it – celebrity, as defined by applause and public perception, has become scripted life.[6] In themselves, the traditional means of distinguishing between shifting fashions, changing tastes and the

3 Ulrich F. Schneider, *Der Januskopf der Prominenz: Zum ambivalenten Verhältnis von Privatheit und Öffentlichkeit*, VS Verlag für Sozialwissenschaften, Wiesbaden, 2004, p. 24.

4 Neal Gabler, *Das Leben, ein Film. Die Eroberung der Wirklichkeit durch das Entertainment*, Goldmann, Munich, 2001, p. 195.

5 See Gerd Nollmann and Hermann Strasser (eds.), *Das individualisierte Ich in der modernen Gesellschaft*, Campus, Frankfurt/M., 2004.

6 Hartmut Rosa, *Beschleunigung*, Suhrkamp, Frankfurt/M., 2005.

necessary pecuniary means are not enough. Attention has become one of the means to the end of promotion. The provocateur has long-since become socially acceptable, indeed, in postmodern culture it is the image that has become the criterion for success.[7]

Finally, we are living in a *medial* society – some even refer to it as the "Google society" – in which the media have advanced to become the real agents of education. They supply us with a substantial part of our knowledge. But when this knowledge about the world and about ourselves is medially transferred, reality then becomes rumor – and the rumor mill becomes a self-seller: in other words, media, not only television, generate those themes without which they could not themselves exist. Meaning is attached to events via publicity. And a constant flow of novel worlds of meaning emerge with increasing rapidity.

Owing to the fact that the conditions of our life are becoming increasingly dependent on knowledge, modern man is confronted with a growing need of information. As paradoxical as this may sound, he knows increasingly less about the future. With the shortening of the half-life of knowledge by way of accelerated knowledge production, its presence is reduced. At the same time, the long-term effects of present actions are gaining – something which demographic change and increased life-expectancy unambiguously demonstrate. Not only has the demand for information increased, but so also have the requirements for orientational aids and yardsticks with which to evaluate things.

Among others, these orientations are supplied by the celebrity world, as well as the ranking lists, experts and consultants appearing in all other areas of life. Last but not least, with all the scandals and awards, celebrities ensure a sort of smoothly functioning social intercourse. Media gossip and chit-chat come as a sort of relief to the individual, because people, also the young, wish to know where they stand. Psychologists even believe that the glorification of celebrities can have a positive effect on those who suffer from low esteem. It reduces self-doubt, and thereby approximates the ideal self.[8]

And again, the medial scrutiny of celebrities in everyday contexts is particularly suited to this end. Madonna in Jeans is adjusted downwards with relish no less than was Lady Di when she bore with dignity the humiliation at the hands of the British Royal Family, and openly admitted to periods of depression to anorexia and suicidal states of mind. Celebrities thus become projection surfaces for the no less varied and ambivalent needs of identification as spurred on by mass media and commerce.

The Celebrity – that Orientation-Giving, "Profane God"

The greatest merit and decisive artistic contribution for new art made by Scandinavian artist-duo Elmgreen & Dragset with their exhibition *Celebrity – The One & the Many*, held at the ZKM | Museum of Contemporary Art treats of precisely such dilemmas. In their installation comprising an unadorned building, which also symbolizes our world, they juxtapose the cramped, and sometimes lonely, living conditions of the "many," and the apparently open, sometimes sunnier, though no less driven world of the "one" – that of acclaimed celebrity. Lastly, it is in such juxtaposition that the needs of the "many" for orientation, for liberation from the uncertainty of cramped conditions become evident. They search, quite literally, for breadth, and the one or the other even takes heel towards the wild blue yonder.

Thus, it comes as no surprise that some celebrities, who represent an ideal figure of identification for various target groups, actually advance to the rank of "modern saints." In our society, the "profane God" increasingly occupies the foreground.

The "religious God" as epicenter of religion in the original sense, is connected to the term *religio*, reconnection, belief in another world inspired by gods and which influences human action, thought and sensibility. For this reason, by religion, I also understand an horizon of meaning which is linked to a confession of faith.[9]

The "profane God," by contrast, centers on the search for meaning, since, between God's love and the laws

7 See Meryem Karadeniz, *Aufmerksamkeit als Aufstiegshilfe – Provokateure werden gesellschaftsfähig*, unpublished diploma thesis, University Duisburg-Essen, Institute of Sociology.
8 Jaye L. Derrick, Gabriel Shira and Brooke Tippin, "Parasocial Relationships and Self-discrepancies: Faux Relationships have Benefits for Low Self-esteem Individuals," in: *Personal Relationships,* vol. 15, no. 2, 2008, pp. 261–280.

of nature, between the unity and plurality of religions, there is an entire spectrum of possibilities and meanings of life. In fact, the idolatry of human beings is closer than adulation of the divine God. Some are worshiped and made superhuman because they are seen to incorporate the ideal of humanity. The worshipping of Lady Di shows that modern man is permitted a great deal, and everything seems possible to him. And yet he appears to be chained to the finitude of his actions. And even he yearns for liberation, for salvation.

The contemporary search for meaning goes hand in hand with a sense of belonging to scenes, to networks and to events, namely, to independently chosen societies. It is not uncommon for this to occur in emotionally charged, media-controlled events, such as the World Youth Day in Cologne, the World Cup and European Cup, the Eurovision Song Contest, but also with catastrophes and political events. These societies are short-lived, sometimes even mere moments which correspond to the increased striving for the expressive, emotional and aestheticized experience of social life in an otherwise individualized society.

And What May be Learned from This?

The individualized person no longer creates his identity from the earlier unity of individual and society. He must rather repeatedly reconstitute his identity, among others, by means of such emotional communitizations that facilitate the collective memory of the unproblematic unity of individual and society.[10]

As many sporting events will show, especially football and winter sports, it is the media-generated hyperbole and increased need for attention in the seeing and being seen, that clearly occupy center stage in the emotional community, and not so much the sporting achievement itself, or the waved flag. And, naturally, with the result that once the relevant state of excitement has begun to wane, the search for a new occasion of collective thrill begins to set in. Here, not infrequently, the meaning

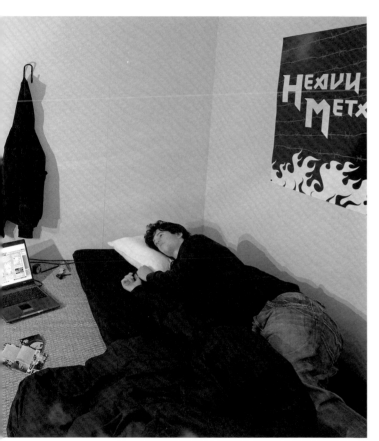

Virtual Romeo 2007. Wax figure, jeans, t-shirt, hooded sweatshirt, socks, mattress, pillow, duvet, electric guitar, amplifier, trophy, stickers, poster, flyers, volleyball, laptop. Installation view, ZKM | Museum of Contemporary Art, Karlsruhe, 2010. Courtesy of Galleria Massimo De Carlo, Milan.

9 See Georg Oesterdiekhoff and Hermann Strasser, "Die Traumzeit der Menschheit: Warum Menschen an Gott glauben oder geglaubt haben," in: *Land-Berichte. Sozialwissenschaftliches Journal*, vol. 12, no. 2, 2009, pp. 45–64.
10 Matthias Junge, "Die kollektive Erregung des public viewing – oder: die Tragödie der Identifikation und der Sozialität," in: Ronald Hitzler, Anne Honer and Michaela Pfadenhauer (eds.), *Posttraditionale Gemeinschaften: Theoretische und ethnografische Erkundungen*, VS Verlag für Sozialwissenschaften, Wiesbaden, 2008, pp. 189–201, here p. 193 ff.; Gerd Nollmann and Hermann Strasser, "Individualisierung als Programm und Problem der modernen Gesellschaft," in: Gerd Nollmann und Hermann Strasser (eds.), *Das individualisierte Ich in der modernen Gesellschaft*, Campus, Frankfurt/M., 2004, p. 18 ff.

rather than the search for meaning falls by the wayside, since meaning is something requiring time, something which neither we nor most celebrities have. While the latter may give many people orientation, most of them themselves rely on consultants for all areas in life – from nutrition through to imaging and personal trainers at the fitness studio.

Perhaps, today, one can learn more from such agnostics as the Dutch writer Cees Nooteboom than one can from many a pope or cardinal. In his novel entitled *Rituals*, Nooteboom concludes that the significance of all human constructs – to which church dogmas also belong – is to preserve us individuals from being reduced to a state of desperation. Whoever finds this to be insufficient, might be inclined to hold Niklas Luhmann's view that belief and religion help us reduce the infinite complexity of the world to a human, comprehensible mass.[11]

And, in order to successfully manage these human constructs and to reduce the complexities of the world, the externally oriented, and individualized contemporary man is dependent upon *impression management*. Society as a stage, occasionally as spotlight, provides the possibility of becoming prominent. In other words, while the means of human actions have changed, their objectives have not. The search for recognition and appreciation and the avoidance of disdain and contempt have always informed the basis of our way of acting. Only the *means* of realizing these aims have changed.

We are no longer part of the world if we are not acknowledged. And celebrities take place medially by showing, for strategic reasons, who they wish to be. Even if, under these circumstances, one's reputation within one's own system – in sports, economics, politics or science – should dwindle in proportion as it increases within the system of medially organized public life, the celebratory process still stands to gain in functional significance.[12]

Performance-oriented society does not, for this reason, abolish itself; it becomes something other. Thus, how long the precarious, rapidly changing relationship of dependency on the public, media and prominence will endure remains to be seen. A polemic, written by French author Stéphane Hessel bearing the title *Be Indignant!* has meanwhile been circulating around the world. Whether he, and his not only indignant readers, will be able to eliminate the deficiencies induced by medial celebrity civilization remains questionable; at least so long as it is not the political, economic and media-competent citizen who is desired but, above all, the consumer.[13]

Translated from the German by Justin Morris.

11 Niklas Luhmann, *Soziale Systeme: Grundriß einer allgemeinen Theorie*, Suhrkamp, Frankfurt/M., 1984, p. 46 ff.
12 Daniel Nölleke, "Die Prominenzierungsmaschine," in: *Neue Gegenwart. Magazin für Medienjournalismus*, no. 55, June 3, 2008.
13 See Joachim Weiner, "'Medienkompetenz' – Chimäre oder Universalkompetenz?," in: *Aus Politik und Zeitgeschichte*, no. 3, 2011, pp. 42–46.

I am meeting with Eric, a young Los Angeles-based paparazzo, at Andrea Zittel's Eagle Rock A–Z house, which I am renting for the month of February 2010. Eric has no idea who Andrea Zittel is, nor for that matter, Elmgreen & Dragset. Our names may be familiar to a very small group of people interested in contemporary art, but are utterly unknown to the millions who follow the lives of the kind of celebrities Eric tails day in and day out, throughout the year. Admittedly, I've never heard of half the, presumably, very famous people Eric tells me about. I'm more interested in hearing about day-to-day paparazzi reality; about what it is like to be such a link in the long chain that is celebrity-life mediation.

ID: Eric, would you mind introducing yourself?
EB: Well, I'm Eric Brogmus and am 22 years old. I have some college education, though not much, since until now I haven't really felt the need for it.
ID: Do you think you will?
EB: Yes, if I find something I really want to do which requires a solid education, then I might go through with it. But, I haven't really found anything yet. Taking pictures isn't that hard – it's just a lot of work to become known.
ID: So, you didn't train as a photographer?
EB: I had some training, though nothing extensive – some general classes. I've just been working, just shooting. I basically taught myself how to take photos, starting with point-and-shoot cameras, and then this job has taught me so much. When shooting celebrities, you have to shoot fast. You have to know what to do when the light is this way or that; you have to know how to change a camera immediately, and so on.
ID: I guess growing up in Los Angeles must have influenced your choice of work. After all, it is *the* place to be for photographing celebrities.
EB: I think so. If I'd lived in Colorado I might have been taking pictures of wildlife but, yes, you're right. I got turned on to the paparazzi just by spending time in Beverly Hills. They were always driving by in their BMWs or Mercedes snapping pictures – like the Secret Service. At

I'm gonna shoot Arnold Schwarzenegger

Ingar Dragset in conversation with paparazzo Eric Brogmus

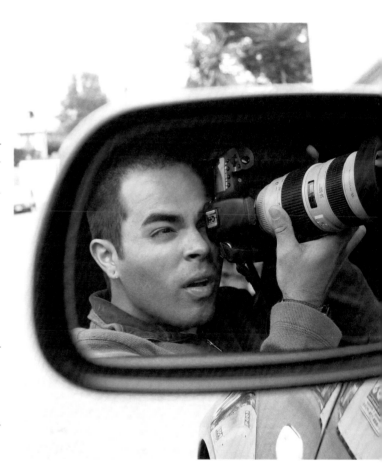

one point, I asked someone "What are you guys doing"? And he replied "I shoot celebrities." I straight away felt that this could be interesting.

ID: Is a flashy car part of the paparazzi paraphernalia? Does it belong to the "image"?

EB: Most times, yes. You do need a fast car. Take Britney Spears. She used to drive really crazy at 200 to 220 km/h on the freeway, and you had to keep up. This last Monday, for instance, I was working on Kellan Lutz … He was doing 200 on the freeway – and I was the only one who could keep up because my car is pretty fast.

ID: Which car do you have, then?

EB: A Volkswagen R32. It's like a super GTI, a German car.

ID: So, perhaps, what got you started was a childhood fascination with fast cars?

EB: Yes, seeing them in action. But I've always had a fascination with celebrities. My uncle is a movie director so I grew up idealizing celebrities, and actually meeting them. I have a different approach to the whole thing than others do. Most guys hide behind the tint in their car while taking pictures and people don't know about it. Sometimes that's good, but most times you get a better picture if they know or recognize you, and they tend to be friendlier.

ID: So, you are not the kind of paparazzo who hides out in the bushes waiting for the crucial moment.

EB: If I have to, but it's not my style. I'd rather be out in the open and have my subjects know about it: I just don't like stealing pictures.

ID: In some countries you have to obtain legal permission from the person you photograph, at least on their private property. You may take pictures of them, but when publishing the photo you have to ask for permission. What do you think of such legislation?

EB: Wow! They're trying to do that here now. I think it is good because it helps get rid of a lot of very dangerous people who do stupid things like jumping out of bushes and illegal trespassing. If I did such things, I could probably get a shot of Heidi Klum topless. I know they exist, but I don't go there.

ID: I'm quite glad nobody cares about artists. I walk around naked all the time, but nobody would want to see my bare buttocks in the magazines.

EB: (Laughing) Maybe some day … I'm sure it will sell somewhere – maybe in Berlin …

ID: Let's talk about your life. Do you live alone; do you have a partner at the moment?

EB: No, I'm just dating. My life is pretty crazy as it is, not many girls can keep up. If they want to hang out with me sometimes, then they have to come to work with me. Most times they are too scared to ride along in the car. The rides can be crazy. It's just the way it is. I was with a girl for five years, but it didn't work out. Now I am not even really into it. I'm more excited about work.

ID: Do you usually introduce yourself to people by saying "I'm a paparazzo"?

EB: Not usually. I say "I'm a photographer," and if they want to see my work I'll show them. It then becomes clear.

ID: Do you ever get bad reactions when people realize that you are a paparazzo?

EB: Yes, I do. Some people are totally disgusted. But probably the image they have is of the worst kind of guy – those who hide in the bushes, sit outside people's houses shooting them coming out their front door. That's not how I work. They are impressed when seeing the way I work. I like to go and shake a celebrity's hand. I like to say "Hi, thanks, I'm a fan of your work."

ID: One always hears wild stories about paparazzi behavior, such as a well-known photographer in England who started out by ordering pizzas for people, only to take snapshots of them when they opened the door. Another common trick has been to press the fire alarm and have people come outside. A bomb threat is another good one. But, you'd never do such things, is that right?

EB: I don't think I would … no.

ID: No tricks at all? Not even a sweet one, like pretending to sell flowers …

EB: I've done that.

ID: You've done that?

EB: Yes, to figure out if people are where they say they are. I would buy some flowers and say "Here are some

complimentary flowers from flowers.com." And for news stories – that's a good one – I sometimes knock on the door carrying a video camera and a bag and say "Hey, I'm a reporter, can I get a statement?" And mostly they oblige.

ID: Do you take single frames from the video footage and sell the images?

EB: Sure, I can take pictures off the video camera or just sell the audio file. It all sells.

ID: The quality of the image is not so important?

EB: If it's exclusive – if I'm the only person to have it, and it is a big story – it's not that big of a deal, because they can only get what I have. Let's say, somebody important just got married and I'm the only person to have pictures of the wedding. The quality will not be that important. But, if twenty guys have the same picture then the best quality image is what counts.

ID: What makes for a good paparazzo photograph?

EB: The magazines want full-front, no side shots. They want the image to be full-length so the whole body is visible, and the background out of focus. It should seem as if the person is walking right at you. The image should preferably look like real life; not too blurry or grainy, not too dark, not too bright.

ID: Of course. Do you work on your own?

EB: I work with a company. There's a team of guys in L.A. I work with, but mostly I'm by myself on a story. There is competition, too. But we're all friends. At least until it comes to the actual shoot, since we all want the best shot.

ID: It sounds a bit like sports.

EB: Yes, it's very competitive, but it's fun as well. There's a lot of camaraderie.

ID: Did you try and trick some of your competitors by, let's say, telling them to go somewhere else.

EB: Yes, just the other day, actually. Two celebrities came out of their house and another paparazzo saw them leave as well, but over my Walkie Talkie I told him: "I don't think that's them, it really doesn't look like them," and he believed me. Then I suggested we go grab some lunch, but I instead snuck back and got an exclusive shot of the celebrities.

ID: Did the other paparazzo find out that you'd tricked him?

EB: No, if he did he probably wouldn't talk to me any more. But one has to be careful, it's important to have relationships with people. For instance, if you're in a chase and you get stuck behind a car, and the others keep on going, then they're not going to tell you where they are going if they don't like you.

ID: How do you find out where the celebrities are? Do you have informants, people reporting back to you?

EB: In my company we pay motor companies, hotels, airport staff, and so on, to tell us when this or that person is coming in. I might get to know exactly were the limo is dropping off the stars, and go straight there. Sometimes, celebrities use fake names when traveling, but we have a list of the people with their aliases. We know that John Smith could be Leonardo DiCaprio, for instance. Or the celebrity's publicist will book his or her flight and the booking will be under the publicist's name. It's quite fun. It does help, though, to have a company with a lot of good information. If I was totally on my own it would be a lot harder.

ID: Could you imagine setting up a company of your own at some point?

EB: I don't want to be a paparazzo my whole life, and would prefer doing weddings and art work, landscapes. I think weddings are paid better in the end. I have a friend who's made six to seven figure sums doing this – you can make millions.

ID: Wow! Could this be Mr. and Mrs. Smiths' wedding, we speak of?

EB: Just people, normal people; rich people, but … still, they easily pay $ 10,000 a day.

ID: So, that way you'd have a more steady income and know what the next day will bring.

EB: It would be unrealistic to think that people would call me six days a week all offering $ 10,000 for wedding photographs, but that would be my dream. If shooting celebrities would make me the most money I think I would stick with it, but I know that this is basically just a learning experience for me, until I build up my base of clientele.

ID: So, right now you're hoping that when you get friendly with, say, Britney Spears, she might call you up for her next wedding?

EB: Kind of. I give my card out to all the celebrities. But they would probably prefer someone like Annie Leibovitz to do something like that, than some paparazzo. They would probably worry about me selling the images.

ID: I was going to ask you about that. Are people like Helmut Newton, Annie Leibovitz, Irving Penn or any of those star photographers an inspiration for you? Do you look at their work?

EB: Yes, but they didn't really start out shooting celebrities. They were just really very good photographers, and the celebrities came to them. I know that Annie Leibovitz was always working with celebrities, but that's because she is a great shooter.

ID: And, is there anyone in your field who inspires you, such as Ron Galella?

EB: Oh yes, he's huge. His approach to taking pictures is to capture the celebrities in their private environment when doing something a celebrity would not do – just walking down the street, taking a cigarette break or eating food. Real life – not directed – something very different from watching them on the silver screen. This is what people are drawn towards. It's a kind of cult fascination. The flip side of the coin is that there are people who buy the magazines and then hate the celebrity. I've had old ladies holding *People* magazine with my photo on the cover yelling at me "you stupid paparazzi!" And I reply "thank you! You just paid ten cents of my paycheck by buying that magazine!"

ID: Why do you think people are so interested in celebrities – is it just a "cult?"

EB: I think they're interested because it's such a different life. They want to see what these people seen up on the big screen get up to, and how they know to make so much money. They want to see them at the nail salon, just like everybody else; that they eat, just like everybody else, or that they do weird things, like Britney Spears shaving off her hair, or getting a tattoo.

ID: Do you think the celebrity cult is more about common people seeing the banality of the star's life, or more about getting a peak into its glamorous side?

EB: There is the red carpet glamour side, of course. There's more money, though, in showing what celebrities do in their daily life. That's what people really want to see.

ID: And recognizing something of themselves in the celebrity …

EB: Exactly. "Oh gosh, I do that too."

ID: What about the celebrities: who are they? What do you think of them, in general?

EB: They're just normal people, people who act, but happen to be famous. And the only reason I take their picture is because there is a demand: a new movie comes out and I'll take pictures of people in the movie because audiences are interested in what they do. When the new *Twilight* movie is out, they want to see Robert Pattinson and Kristen Stewart.

ID: So, maybe you can answer the question on everyone's minds: are they a couple or not?

EB: I've only managed to get a few of pictures of them together, unfortunately. I've seen them in a car together, and sneaking a kiss, but I haven't been able to get it on the camera. I've even crawled on a roof top and hung out in bushes to get them, but no chance. They are definitely together though.

ID: Through your work you must have a lot of information on famous people and know whether things written about them are true or false.

EB: Yes, sometimes we even create stories.

ID: Really? Knowing its all bullshit?

EB: If I want to sell a picture and if I know something is going to sell, yes. For instance, if somebody's husband is seen walking with a friend I'll say that they were seen out, that he has been spotted together with a mysterious woman. Who is this lady? That's a story. They were not even holding hands, but I'll take a picture from an angle from where it *looks* as if their hands overlap.

ID: So you are quite powerful, in a way. I mean, you can manipulate information and ultimately influence people's lives. Do you know how the celebrities feel about that? Do they care?

EB: Oh, they care. I mean, for them it's all about the right *image* – that's who they are: they *are* the image. They may be total jerks in real life, but they want people to see them in a certain way. Take Russell Crowe, for instance; though a real jerk in real life, he wants to avoid people seeing him like that. He wants people to see him as a nice guy, as a professional actor, but he would smash your camera if he got the chance.

ID: Has that happened to you – has somebody attacked you or been really aggressive towards you?

EB: Not anybody big. Probably, the most famous is Shia LaBeouf who threw his full cup of coffee over me while I was taking his picture.

ID: Ouch.

EB: He hates the paparazzi, even though we're the ones who made him famous in the first place. We started working on him a lot, putting him in the papers and the magazines.

ID: How did you respond?

EB: I thought, dude! I'm giving you free publicity! You have to pay somebody to take your picture if you want to be in a magazine, but I'm putting you out there for free! For him it's a game. For these people hating the paparazzi is a hobby. They don't have anything else to talk about or anybody else to bad-mouth, so they're going to batch the paparazzi. Without the paparazzi there would be no magazines. There would be almost nothing. Red carpet events – that's all you would see.

ID: Do you think we need such magazines?

EB: Well, we only need the magazines so long as there's a demand for them. During the most recent American economic downturn nobody bought magazines. They would go to the newsstand to read them before putting them back on the racks. At that time I made half as much money than previously. But now it's getting better; people have the extra five bucks to spend on a magazine.

ID: Do you feel that new media channels such as Twitter and Facebook have influenced your work?

EB: Yes. Now you can follow people in a different way. If Britney Spears was flying to Brazil or to London she'd write "flying out to London today" on Twitter. I'll be at home, and know that she is in London and I don't have to work it. Before, you might not know she's gone until a picture pops up on the Internet which could be a week later. Paris Hilton always says exactly where she is going. She posts messages such as "I'm going to Best Buy right now," and she will be there. She will post a picture of this or that movie she is going to rent. "I'll be sleeping in today," "I'm at my sister's house," "I'm at my girlfriend's house." If I wanted to I could probably follow Paris Hilton around all day long without seeing her, but know where she is.

ID: Does she do this to keep a kind of control over herself?

EB: She wants the attention. She doesn't have any window tint on her car; she likes to be followed, and you can see her inside. To put it bluntly, she is a media whore. She wants to be all over everything.

ID: I guess she is the prototype of someone who is famous mostly for being famous? Has she really done anything at all?

EB: No.

ID: Amazing.

EB: You know, her secret porn tape was leaked – I think she did that on purpose.

ID: You think so?

EB: Sure, like Courtenay Semel and Casey Johnson, the heirs of yahoo.com and Johnson & Johnson. They came to me and said "hi, we've made a porn tape, do you think you could market this?" They wanted me to put it out there and say that it leaked.

ID: What did you do?

EB: We sold it to the celebrity website *Mister Skin* for a couple of million dollars.

ID: What happened after you sold the tapes?

EB: Casey Johnson has since passed away. Drugs. She was diabetic. The other is in rehab.

ID: It's kind of a sad life, by the sound of it.

EB: It is. I mean they *are* rich, but they just want to be famous as well. I don't know why they should do the sex tape thing. To get more popular I guess, as inspired by Paris Hilton.

ID: Do celebrities often contact you directly?

EB: Not too often. But I've been friends with Courtenay Semel for a long time. She used to do set-ups with me. She would call me and say, "hey, I'm over here, come and take my picture." But she's not big, she wanted to be big – that's why she would call me. Some celebrities will do set-ups with the companies. They'll call up and say, "hey, we'll be at the beach on such and such day, can you send over a photographer?" They probably know they look great that day, flaunting their good looks in bikinis. Then the company will pay the celebrity to take that picture. Do you know Jon Gosselin from *Jon and Kate Plus 8* – the TLC show? Well, it's a failed show now, but they had eight or nine seasons. Gosselin has got a deal with our company. Basically, we take his picture and pay him money from the sales. I have a code, and he's got a code too, so when the picture sells I get a percentage of the sales. He makes money off his own pictures. People will do set-ups with us, informing us that they are at Taco Bell, for instance. But they still act as if they hate you.

ID: From what you're saying, it seems that celebrities are very different from each other in the way they deal with their fame and their lives.

EB: Yes, but they live in a different world. Just because of the kind of money they make – they can just throw money at their problems. If they have a drug or drinking problem they can go to rehab, if they want something, they just buy it. They have people do everything for them, they just pay the bills ... they don't care about anything.

ID: So you wouldn't want to be a celebrity yourself.

EB: I wouldn't mind. It could be nice. I wouldn't even mind the paparazzi!

ID: You would be friends with them, wouldn't you?

EB: Yes. It's funny, because the more the paparazzi are hated and the more attempts are made to escape them, so the more we run after them. This is what makes pictures all the more valuable. Have you heard of Matthew McConaughey?

ID: Actually, yes.

EB: He is very friendly with us, but sometimes he stays in

his house for a month at a time and won't come out. The magazines go crazy and cry out for a picture of him and the prize keeps going up and up and up. Then he'll come out and, boom, you make a lot of money!

ID: I had no idea that the market for images of single celebrities was still so big. So many people are famous, though not icons in the way they were back in Hollywood's heyday.

EB: There is definitely money out there. Not as much as there used to be. But look at the photo of Michael Jackson in the ambulance. The owner of the company that took the picture told me that they earned five to six million dollars just on that single image.

ID: That's pretty crazy.

EB: You can get a bunch of nobodies in a day by just walking around Beverly Hills, but you probably won't make a lot of money on it. If you work on somebody really big, like Heidi Klum you know you are going to make more money than if you got ten people who are not that big.

ID: So it's the potential pay that decides who you choose to photograph.

EB: Well, you follow the money, you know. Somebody might be really famous, but there may be nothing going on in his or her life. Take Nicole Kidman and her husband for example. There's not much point in photographing them. If there's a little story, if they've had a new baby, or the whole family is out in the park, well, then it might be worth it.

ID: I guess most celebrities are good when fairly young and good looking – you don't take many photos of older people do you?

EB: Not really, no. Sometimes I'll shoot them. Like Brian Cox, he is an old celebrity now. I haven't ever really seen any pap-shots of him, so when I saw him eating lunch once I shot him, and it was published even though he hasn't been in a movie for a while. It was a "this is what he looks like now" feature.

ID: I suppose your income must vary a lot from month to month?

EB: It does, but I do make $3,000 salary per month from the company for whom I work. Then I get twenty per-cent commission on everything I sell. It varies from a $500 check to a $5,000–$10,000 one, all depending on what I've shot. If I were completely freelance I wouldn't have any salary. I'd just be making a 60–70 percent commission on each picture. I could make more money that way, but if I'd had a dry spell I wouldn't make very much. So it's nice to be set up with a company who pays me. Luckily I haven't had a very bad month in a while.

ID: What's been your best moment as a paparazzo so far?

EB: I don't know … I like seeing people smile at me: just happy. I take pictures of them, and it's no big deal. The other day, I followed Matthew McConaughey's wife around. She went to the supermarket, nothing fancy, and I thought to myself "how can I get this girl to smile?" She was coming out of the store and I said, "hey Camilla, how you doing?" I was squatting on the ground, making a real fool out of myself. She smiled. She had bought charcoal for the barbeque and so I said "have a nice barbecue!", and "say hi to the kids for me." She laughed, and that makes for a great picture.

ID: Have your images been on magazine front covers?

EB: Oh yes, I have some of them with me and can show you afterwards. Do you know who Rebecca Romijn is? She is from *X-Men*, the naked boob chick. Well, she just had a baby and I was working on her for a month, for two months and still no pictures. One day there was only me and another guy working on her. He fell asleep in his car before she came out. I got the first picture of her after she had her baby, and she looked great, her body was just perfect. It was on the cover of all the magazines.

ID: What magazines would that be, *People* magazine, *Hello*?

EB: Yes, and *OK* magazine, *US Weekly*, *Star* magazine, *National Enquirer*. And my other big picture was shooting a Kristen Stewart and Robert Pattinson exclusive, as they hung out on a balcony. All the other paparazzi were waiting for them to come out from the front, but I just watched balconies. Then I saw them come out, and … boom! I think that photo made $50,000 or $60,000 for the company, and I got a pretty good chunk.

ID: What would be your dream-shoot? Imagine something that would be really cool.

EB: Leonardo DiCaprio in Speedos on the beach.

ID: Why is that?

EB: That would make so much money. Firstly, it would be so funny to see; everybody would want to see that. He's so serious and he hates the paparazzi. Or Britney Spears doing anything, such as eating out, since you barely ever see her doing much else than coming in or out of her car, and her security team is pretty crazy too.

ID: Are there other obstacles to your job than bodyguards, such as a protective family…

EB: The biggest risk in my job is crazy neighbors. One neighbor came out pointing a gun at us. The cops were called and he was arrested. The cops know we have freedom of the press – we have a right to sit on the pavement and photograph celebrities.

ID: How do you psych yourself up for a job? There's a lot of waiting in your job. It can get boring, I guess.

EB: You might wait ten hours for someone to come out, sometimes even days. You just have to be patient, to sit and wait and try not to get too antsy. Sometimes I sit and listen to music to calm down. Then when they finally do come out I have a total adrenaline rush.

ID: Like hunting, in some ways.

EB: It definitely has that dynamic to it. You scout, trail, hide and strategize. Not always, but if you want a picture of Salma Hayek you've got to hide, she'll never just give it to you.

ID: Are there any celebrities you think are particularly interesting today?

EB: All the Disney kids, like Miley Cyrus, Ashley Tisdale, Hilary Duff, Selena Gomez, Vanessa Hudgens, and Zac Efron. The youth want to see these guys in the magazines, so they are of particular interest. Britney Spears always sells, as do Matthew McConaughey, and Jennifer Garner. Any celebrities with babies – babies sell. The most *in* at the moment is anyone who has kids.

ID: That's what people are interested in, but is there anyone *you* are particularly interested in, or are you just not so interested in who these celebrities are?

EB: I don't really care. I don't idolize them as much as other people do. I like to work on Jennifer Garner or Matthew McConaughey just because I've worked them for so long. I know their routines, they're friendly with me; they recognize me. I talk to them and treat them like human beings and that's how they like to be treated. Many celebrities are surprised when I go up and talk to them. They say "oh, you're actually really nice." Do you know Billy Ray Cyrus, Miley Cyrus' dad? He always talks with me, and says things like "hey thank you, you're so respectful." Every time I take his picture I'll ask "hey, how are you doing – is it alright if I take your picture?" And he replies "oh, absolutely – let me get the family." It pays to be polite.

ID: Sometimes you see very unflattering shots in gossip magazines – something in the style of, "this is what they look like without make-up," or someone looking unusually chubby. Do you sometimes consciously try to make people look stupid?

EB: Yes, if it's somebody I don't like, such as Justin Timberlake who I hate; but I like his girlfriend. If he's eating I'll take a shot of him looking really dumb, or with a double chin. If he sneezes I'll shoot when he makes a grotesque grimace. With people I respect, I wait for them to finish sneezing or coughing.

ID: How come you hate Justin Timberlake so much?

EB: He's a jerk: following him drives you really crazy. He'll suddenly pull over, get out of the car and start yelling at you. I don't like him, simply because he's Justin Timberlake, I don't know why.

ID: That's funny. Is there any aspect of social concern in your field? I mean, there are loads of celebrity charity events and things one could focus on.

EB: Well, there's Brad Pitt and Angelina Jolie. I have some pictures of Brad. But they are always active doing charity work, donating money, and adopting children from all around the world. They give kids second chances for a good life, and I think that's really important. And I know for a fact they don't do such things to be popular. They do it because they have a heart for this kind of thing. The same goes for Jennifer Aniston, George Clooney

and Robert Pattinson who are all involved in a lot of good charity work. Not because they want to be *seen* like that, but because that's who they are. They have a lot of money, see a need and try to help out as much as they can. I like that, but there is not so much of a story to sell here. It's more something for the news.

ID: How far can you access people's private life? Do you follow-up on rumors? Let's say, you hear that Kevin Spacey is gay, or Anderson Cooper, or Tom Cruise …

EB: There is always something like that. Sometimes we'll investigate, but it doesn't happen too often. Usually such stories come and go very quickly. They make sure to be shot with a girl if a gay rumor begins to spread. I'm convinced that Tom Cruise is gay. I think that the whole marriage between him and Katie Holmes is a set-up. But you would never know because their security team is like the Secret Service. They have armored vehicles with ex-Navy Seals driving them; guys with guns.

ID: Are there any stories you know that would not be published?

EB: I've taken pictures of people smoking weed and doing drugs, but such pictures don't sell. The magazines actually don't want to ruin the celebrity's image or career. They want to keep up a certain image.

ID: If I really wanted to become a celebrity, what should I do?

EB: Come up with a sex tape (chuckles). Start hanging out with other popular celebrities, and go to the clubs where they go to get your picture taken with them. Then people would begin asking "who's the guy this person is with all the time?" And the magazines would start investigating to find out who you are. Sooner or later, depending on how much effort you put into getting shot and putting yourself in the public eye, whether for good or bad things, you could become famous, or just become a super successful actor.

ID: It might be a bit late for that. And with a Norwegian accent …

EB: It is possible, I think. In the business it's all about who you know. Look at Samantha Ronson. Nobody knew who she was, but now she's been Lindsey Lohan's

girlfriend for years and has become really famous, and for almost no reason.

ID: Do you think that with all the TV reality and talent shows that the idea and status of celebrity has now changed from what it was formerly?

EB: I don't know if the celebrities have changed as much as the technology they use has. Twitter has totally changed the whole game – and the digital camera, which is capable of taking *a thousand pictures* of one person in a single sitting. Before, when you were using film, you could only get around 32–36 pictures out of a roll of film, so you had to be sure that you took them well.

ID: What kind of camera do you use?

EB: I've got a couple of cameras. Let me show you. This one I call the "gang bang camera." It has a short lens, so if there's a group of people then they don't get crowded in on the image. I can take a bunch of pictures at once, with people walking towards me. The other one is not as fast, but is of better quality and it can shoot video. It's a Canon 7D. This is the one I use most, with a big lens for motifs at greater distances of up to a hundred feet.

ID: That's a mother-fucker of a lens you have there.

EB: It really is, and there is a funny story to it as well. Arnold Schwarzenegger was holding a speech at some kind of reception, somewhere in downtown LA. I went there, carrying my bag and the security team came up to me and asked what I was doing there. I told them I was "just going to shoot Arnold." and they freaked out. They jumped on me, handcuffed me, took my camera out and dismantled it. "I'm gonna shoot Arnold" – the wrong choice of words when you are working on somebody who has guys with guns.

ID: I should think so, but it is a great finishing line for this interview.

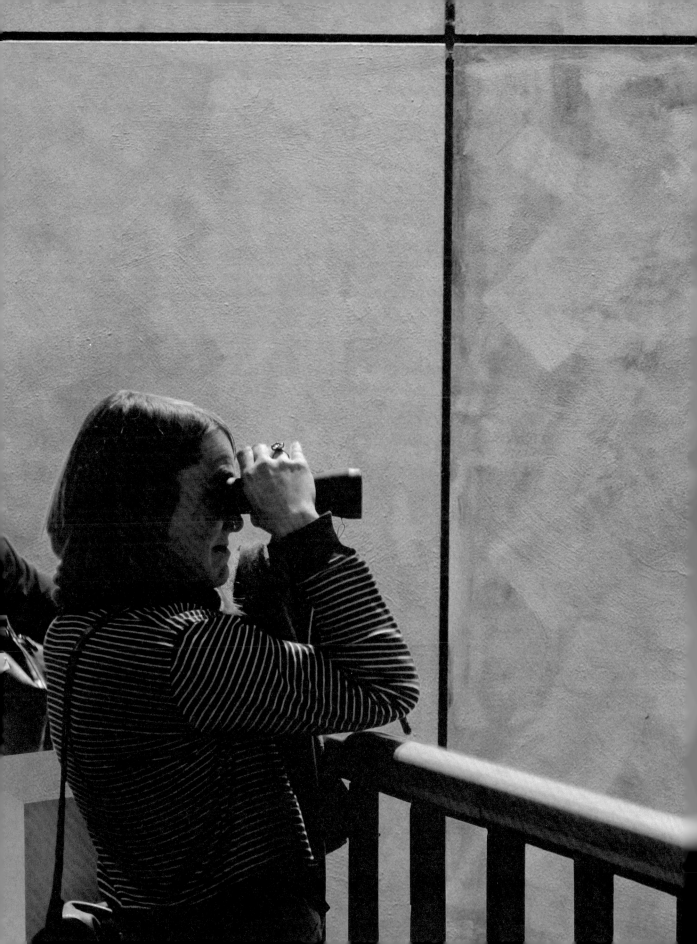

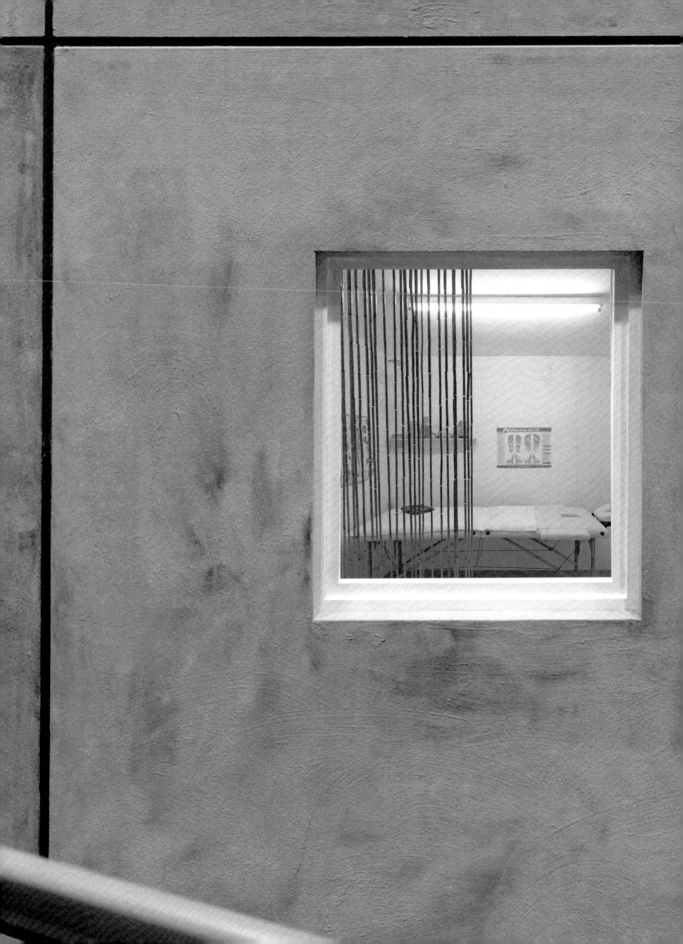

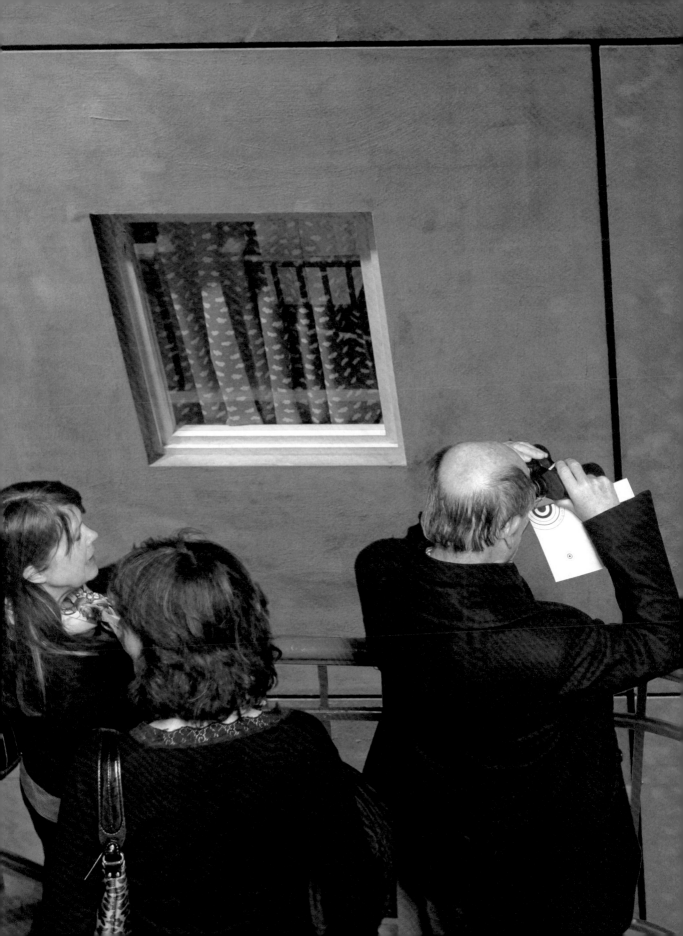

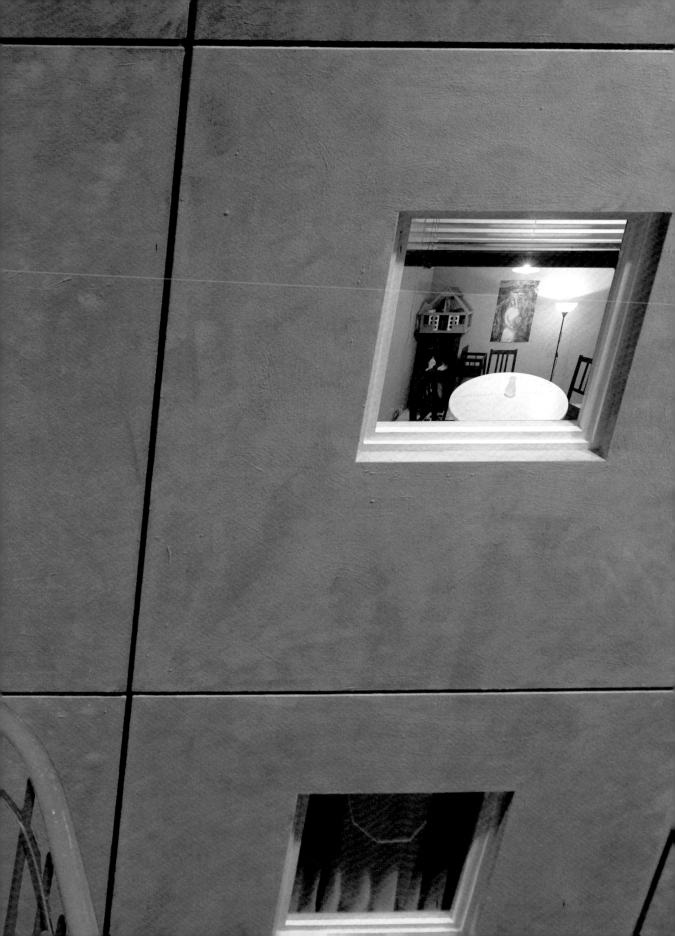

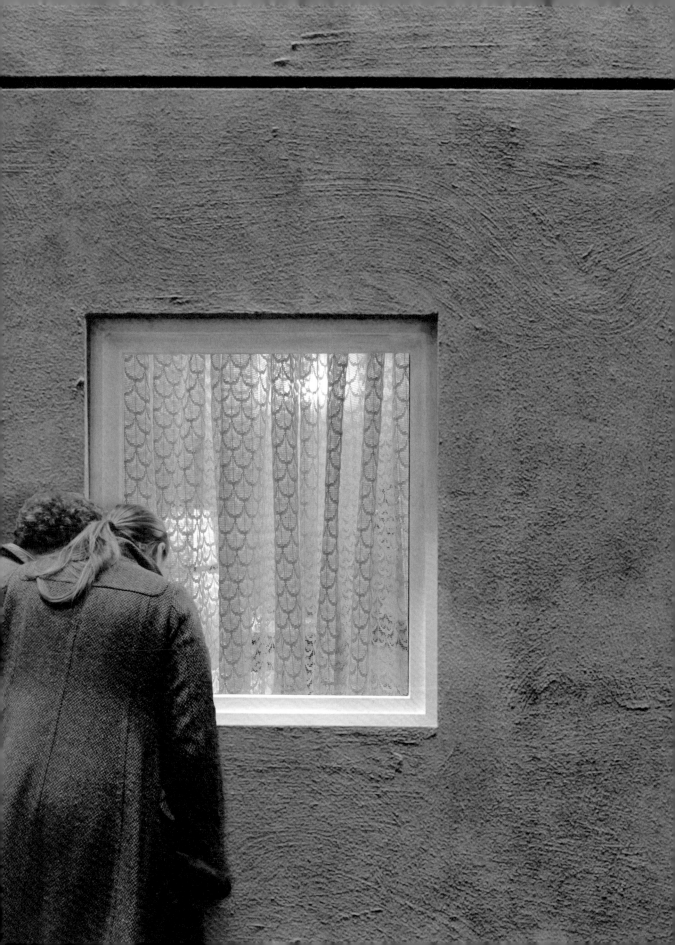

The Remote

An audio play for an apartment building, second floor, right

Characters:
Mother, early forties (M)
Daughter, late teens (D)

The dialogue can only be heard at street level, seeping out through a window with drawn curtains. Flickering light from a TV is visible through the curtains.

M: What are you watching?!

D: Hmpf, what does it look like …

M: Change the program sweetie – that slut looks like a whore.

D: But she's not. She earns millions.

M: A rich slut.

D: Mum, stop it. She's a singer, a superstar, everyone knows her. Except you, of course.

M: Superstar, kiss my sweet ass, in a few months she'll be out in the dark. She'll grow a fat ass, that bitch, you can see that; and that's good, 'cause she's gonna do nothing but sit on it for the rest of her life.

D: You're just jealous.

M: Jealous!? Not for the life of me would I stand half naked writhing like that in front of cameras.

D: You wouldn't be asked! Your fat ass would fill the whole screen. No one wanna watch that, trust me. Not even dad.

M: Your dad loved me. Without me, God knows what might have become of him.

D: And what has become of him? The best thing you can say about him is that he's a *regular*. The only place he's not a regular, is here.

M: There are a lot of things, you don't understand. I know that I'm the rock of his life.

D: Rock bottom.

M: Shut up! How dare you. Look at yourself, on *my* sofa, watching *my* television, and with *my* nail polish on.

D: It was quiet here before you came in. I wasn't saying anything, I was just sitting here. It was you who came in and started ranting … as usual.

M: I couldn't hear myself think for that shrieking bint on the telly. Even you got a better voice than that … that … whatever her name is. Not that she's singing anyway, it's miming … ha ha it's just fake … can't you see? You could go on one of them casting shows, whatever they're called, sweetie.

D: They won't have me, I've tried that. I went to an audition as they call it.

M: Did you? When did you do that? You don't tell me anything.

D: They said I've got a nice voice, but I wasn't the *character* they were looking for, meaning, "I'm sorry miss, you're too fuckin' *ugly*."

M: They didn't say that! You're beautiful sweetie. You … you … you've got a look of … youth about you. Radiant …

D: My ass is too big, thanks, and we both know where I got that one from. Small tits too.

M: They're all fine for … for a girl of your age …

D: I'm gonna have them made. Like Suzi, down at No. 8. She's modelling now.

M: Modelling!? They photographed her hands for the nail salon, that's all. You don't expect me to pay for a pair of new breasts, do you? Do you? It's not natural.

D: Who wants fuckin' nature! What do you know about nature? You just watch that Australian dude on *Animal Planet*. I can't believe you cried when he died. You've never even met him.

M: He was a lovely man, protecting the animals. You should find someone like him.

D: I don't want no stupid guy messing up my life. At least not until I get my breast implants.

M: You could come help out at the supermarket, we need someone for late shifts; I've asked you before. (Tries to sound sweet) You could get yourself a nice little flat or a room somewhere. Share with someone. That way you might meet people, make some new friends…

D: I've got friends. 110 friends on Facebook, ok.

M: Honey, not real friends. We don't even have a computer at home.

BREAK (SILENCE FOR 10 SECS)

D: And how many real friends have you got? Dad? I don't think so. Your sister? She doesn't like you, but she has no one else. Silvia? She only sees you 'cause it makes her feel better about herself. The other losers at the supermarket?

M: How did you become so rude! After all I've done for you, this is what I get. What have I done to deserve this? A good for nothing daughter, dreaming of bigger tits and a life on television?! (Screaming loudly) Get out! Out of this flat, out of my life!

D: I'm not leaving now. I started watching this program and I'm gonna watch it till the end.

M: No, you're not. I came home to see *Die Alpenklinik*. Give me the remote.

D: So you think that's reality, do you? *Die Alpenklinik*. Doctors and nurses don't look like that, do they? Can you imagine old Dr. Sawosnik down the road shagging that mean, ugly secretary with the dirty finger nails? That's what real life looks like.

M: When was the last time you were here? Is there something you haven't told me? You're not pregnant are you?! Have you been …

D: No, hell no, that's why I was there. Pills. I'm on the pill, mum, some of us actually have a sex life.

M: Who do *you* have sex with? I've never seen a lad around here!

D: Why would I take him here? If he saw this place …

M: How can you speak like that to your own mother!

D: I didn't want to speak to you! Leave me alone!

M: No, *you* leave *me* alone! *Die Alpenklinik* has already started. Now sod off, will you?

D: Suit yourself. I'll leave the remote here, under the sofa. You can bend down and pick it up yourself.

M: I can't bend down … my knees … my arthritis … you know that, you vicious little bitch. Give it to me – give me that remote right this moment!

D: I'm heading out. If you're too fat to pick up something from the floor, this might be a learning lesson.

M: You're not going anywhere before you get me that remote. Please … (sounds as if in pain) Please sweetie! If I get down on the floor I might not get up again. What if there is a fire in the house.

D: Who'd care. Burn in hell!

M: You were a happy girl, so full of life. Everybody in the building loved you. Then from one day to another nothing and nobody was good enough for you. You could at least treat your mother with some respect, the only one that's always been there for you.

D: I hate you! I hate this life! I hate all of you!

BREAK (SILENCE FOR 8 SECS)

M: But I love you sweetie (sobbing), don't you understand that! I will always love you. Even when you behave like this. I never gave up hoping, believing that life can get better.

D: But it's not!

M: Stop feeling sorry for yourself for a moment. Try to think about someone else just for a moment. Call that boyfriend of yours and invite him over, I'll make him a nice soup or something. I got some meat with me from work, it was the last sell-by-date today, and the manager gave it out for free.

D: And what do you want me to tell him? "Hi, it's me, do you wanna come over and eat some putrid meat together with me and my cadaverous mum? And we could all watch *Die Alpenklinik* together?" I'm sure he'd be thrilled.

M: Nothing is good enough.

D: I'm nineteen, I'm no kid anymore.

M: But you behave like one. Thank god you're on the pill.

D: I'm not on the pill. I lied.

M: Then what were you doing at the doctor's?

D: I got Chlamydia.

M: And what is Cam… Camp-myldia? It is not serious is it? What have you done?

D: It's an STD, a sexually transmitted disease. It is normal. No big deal.

M: Why don't you protect yourself?! Who is this boyfriend of yours? You could have got AIDS, that sickness thing!

D: He's not my boyfriend. He claims I gave it to him and now he doesn't wanna see me again. I've tried calling him for days and he doesn't pick up.

M: What a total jerk! And here I was thinking about making him a proper meal. I'm glad you never brought him around here. Treating my daughter … his girl like that, infecting her and everything, making her ill and leaving her to herself.

BREAK (SILENCE FOR 20 SECS)

M: Now let's watch the rest of *Die Alpenklinik*, there's still twenty minutes left. I've gotta see if Dr. Guth can save that poor little girl.

D: What about me? There's no tanned, good looking Dr. Guth looking after me.

M: I'm looking after you. Now hush, come sit down with me here on the sofa, and we'll have a good time together, sweetie – take the chips.

D: Aaaach. Whatever! Here we go again.

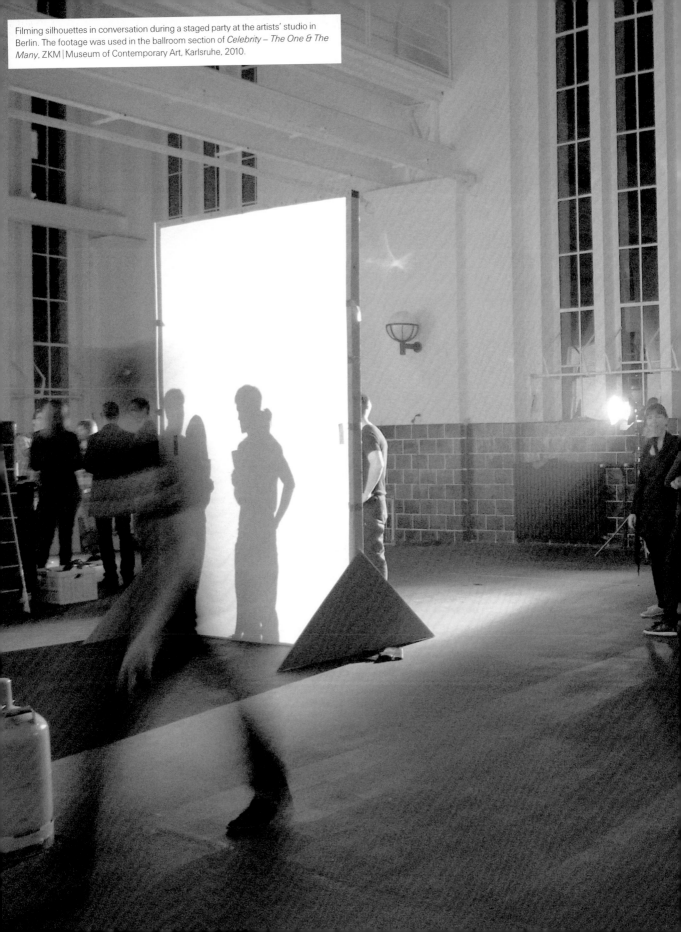

Filming silhouettes in conversation during a staged party at the artists' studio in Berlin. The footage was used in the ballroom section of *Celebrity – The One & The Many*, ZKM | Museum of Contemporary Art, Karlsruhe, 2010.

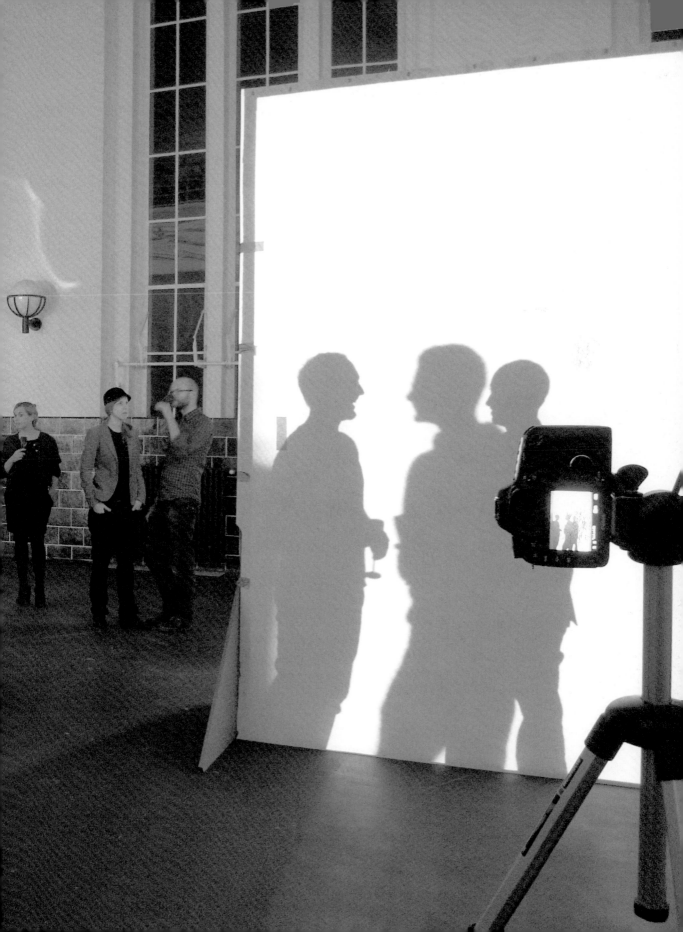

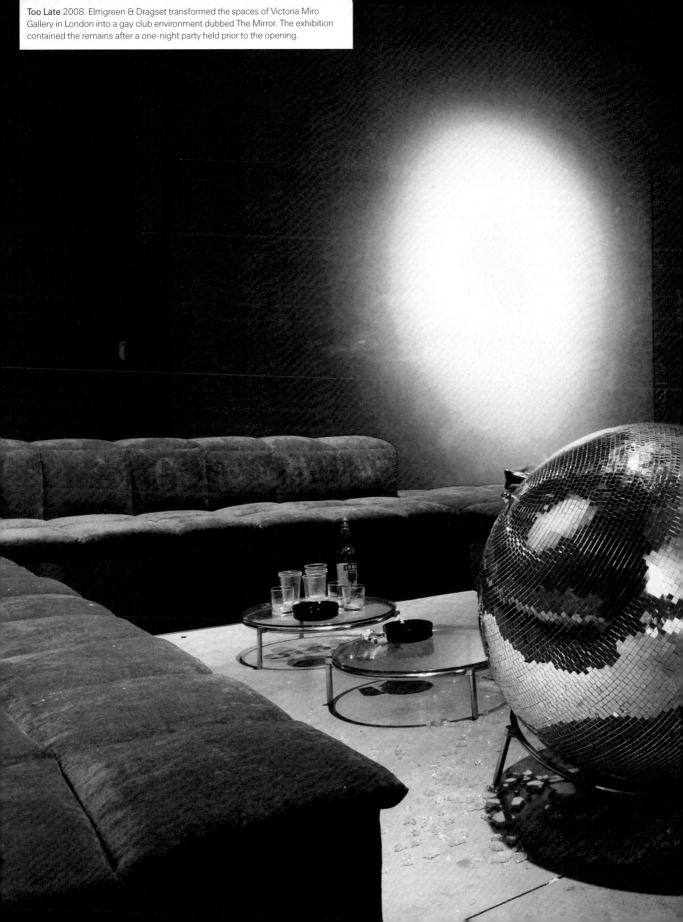

Too Late 2008. Elmgreen & Dragset transformed the spaces of Victoria Miro Gallery in London into a gay club environment dubbed The Mirror. The exhibition contained the remains after a one-night party held prior to the opening.

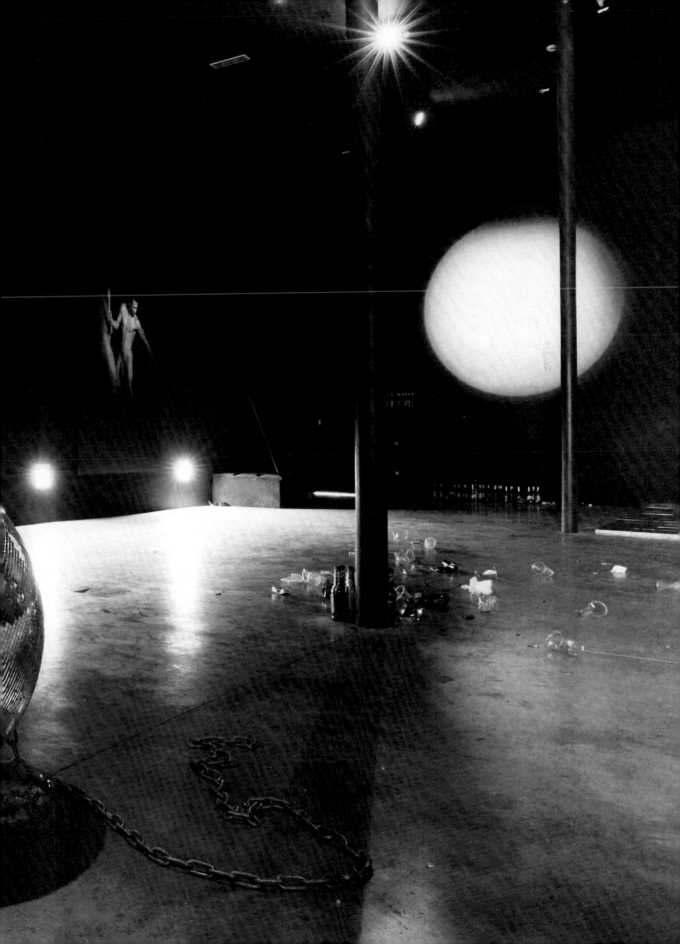

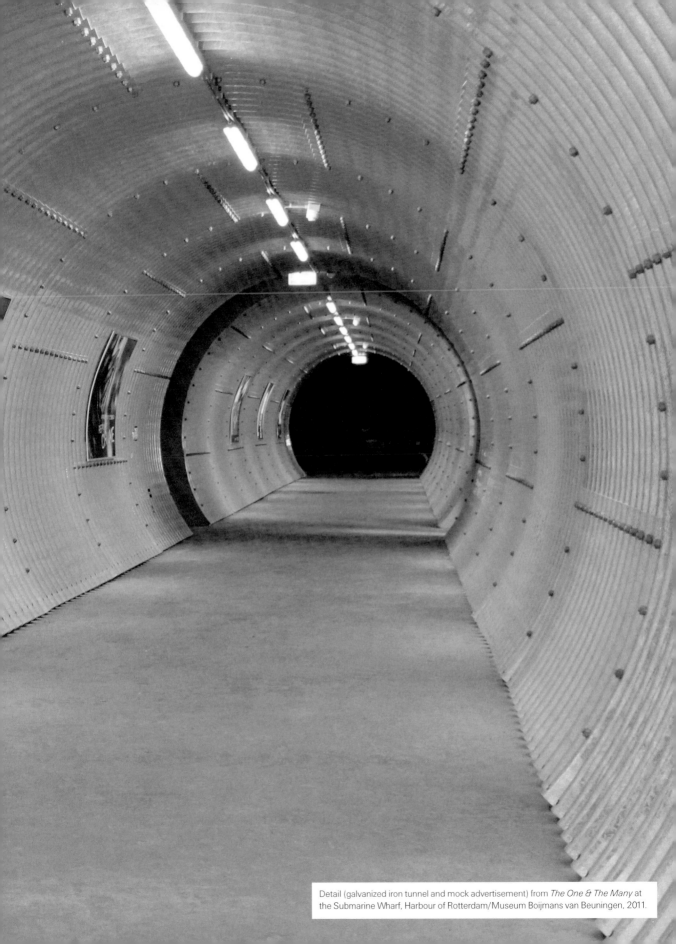

Detail (galvanized iron tunnel and mock advertisement) from *The One & The Many* at the Submarine Wharf, Harbour of Rotterdam/Museum Boijmans van Beuningen, 2011.

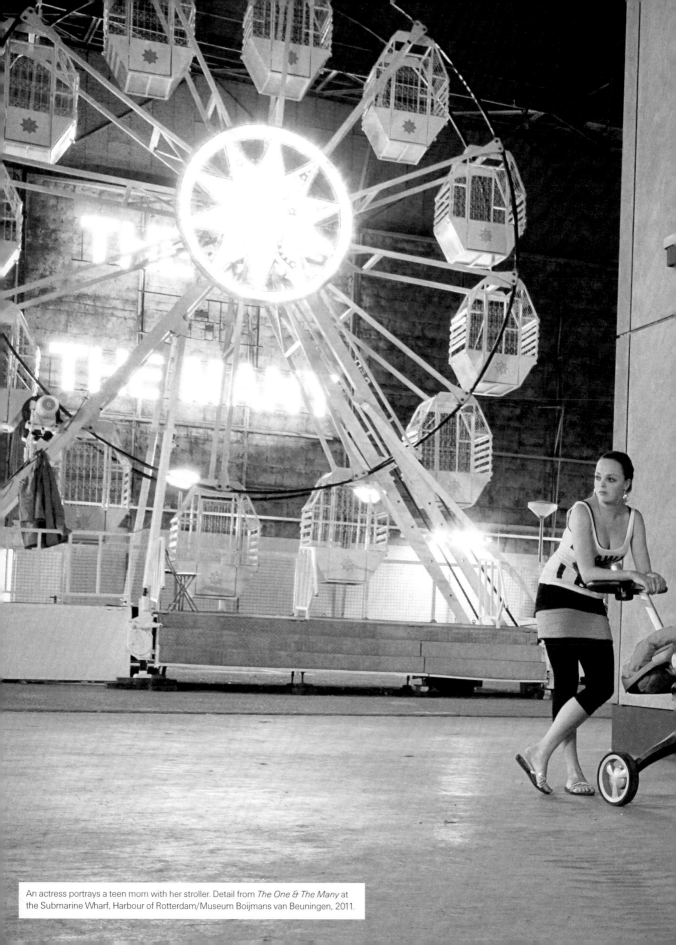

An actress portrays a teen mom with her stroller. Detail from *The One & The Many* at the Submarine Wharf, Harbour of Rotterdam/Museum Boijmans van Beuningen, 2011.

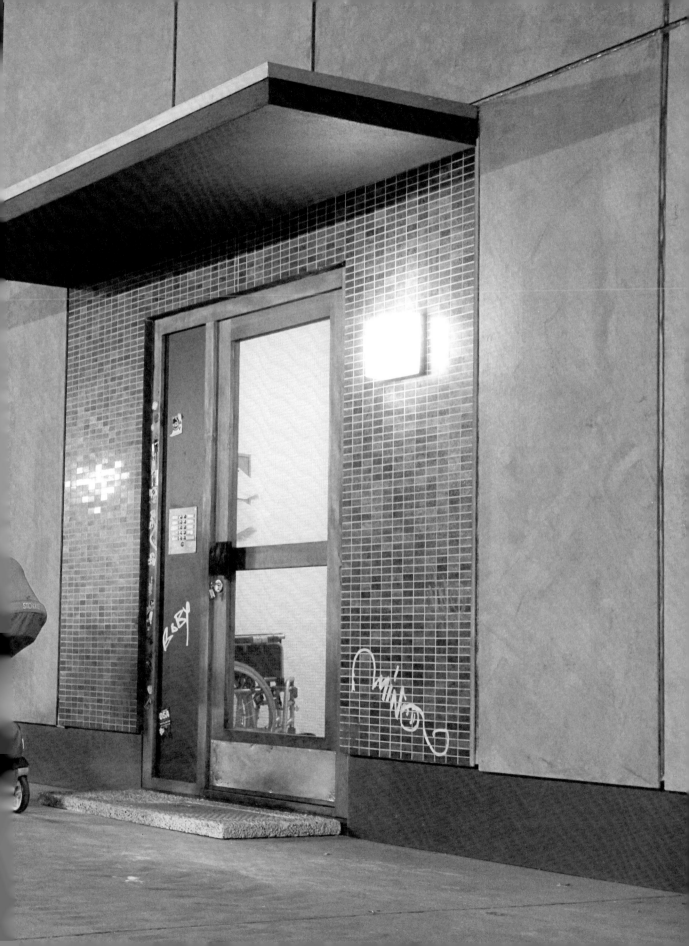

La Biennale di Venezia
53rd International Art Exhibition
The Danish Pavilion
and The Nordic Pavilion
07.06. – 22.11. 2009

Reader

Maja Gro Gundersen

Dominic Eichler

Harald Falckenberg

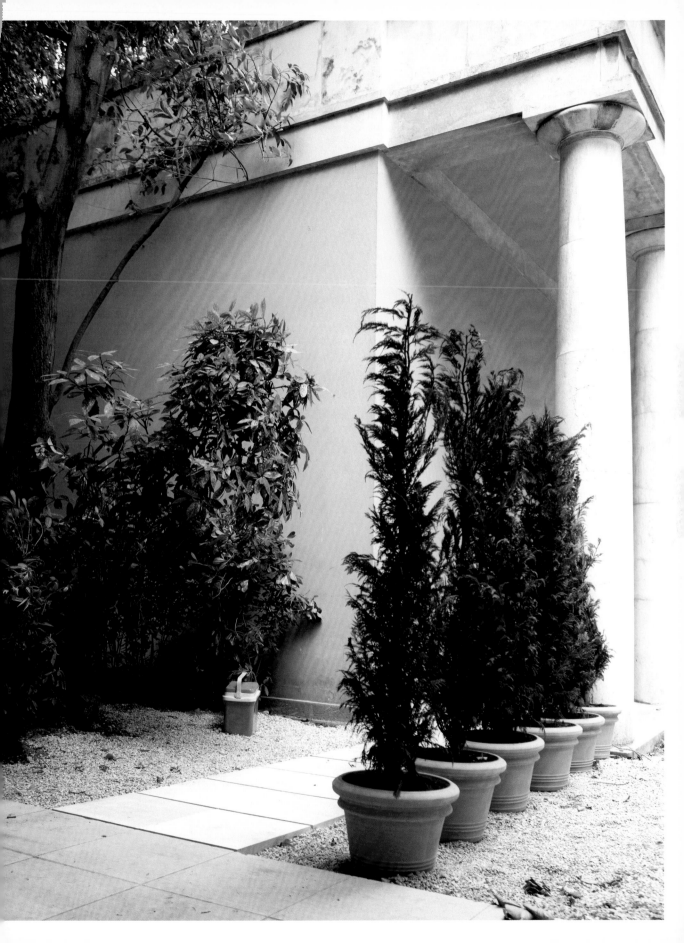

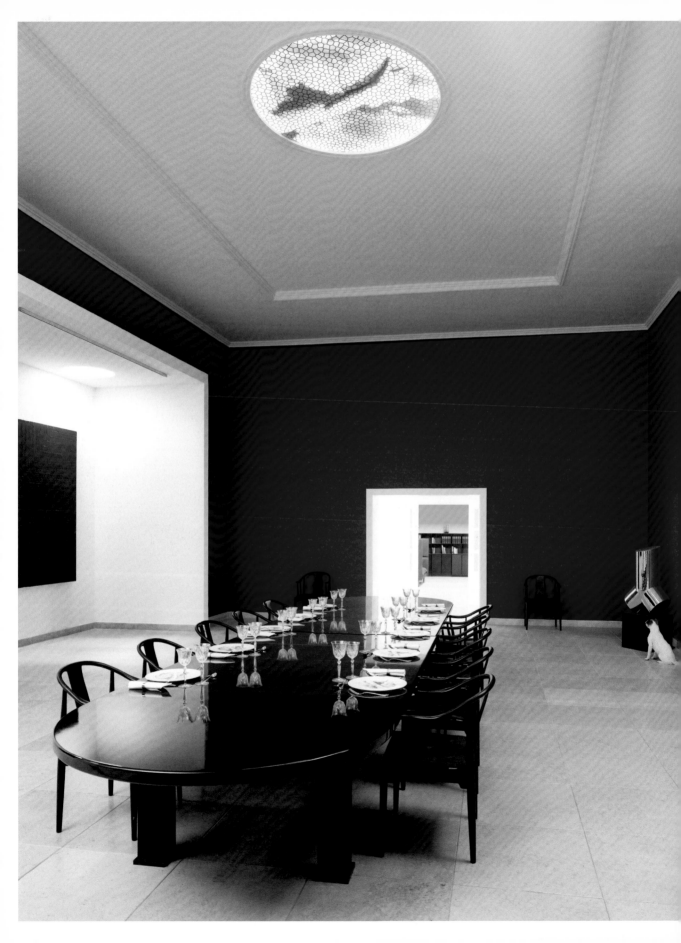

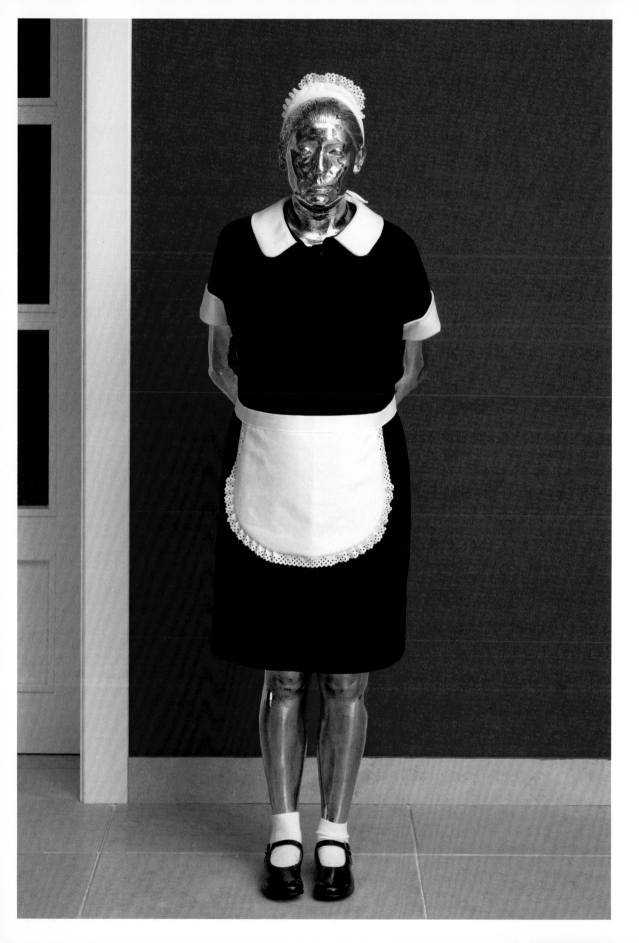

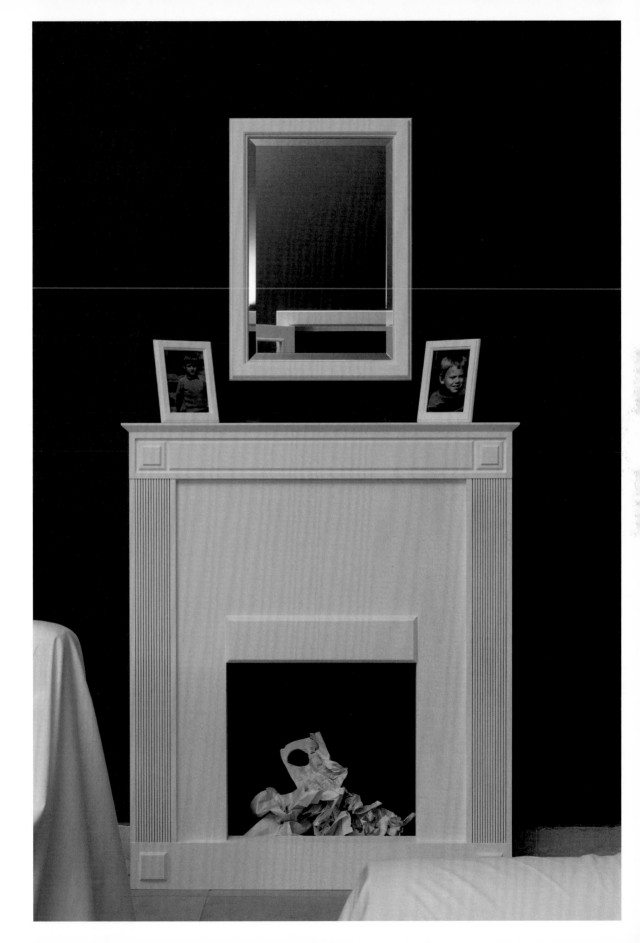

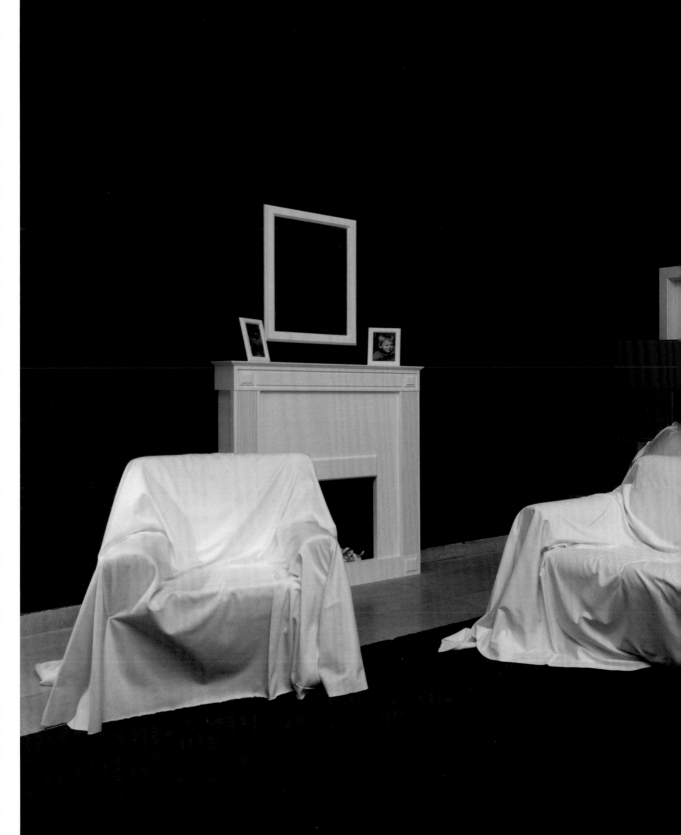

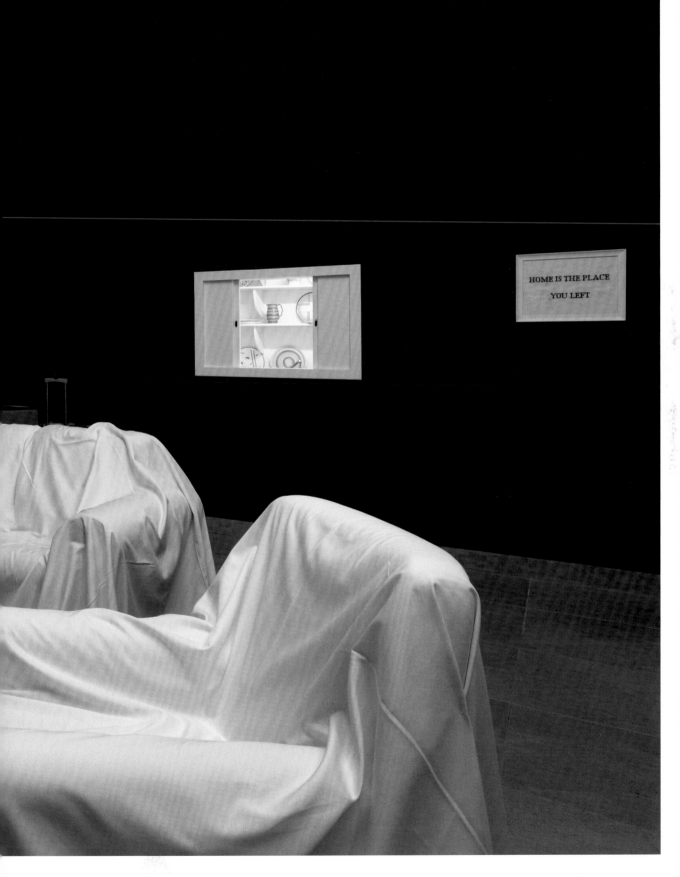

HOME IS THE PLACE
YOU LEFT

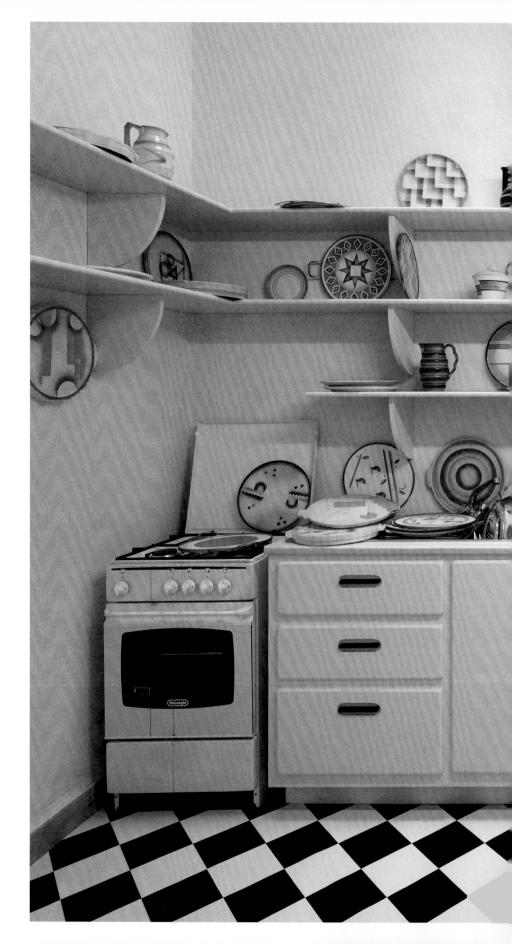

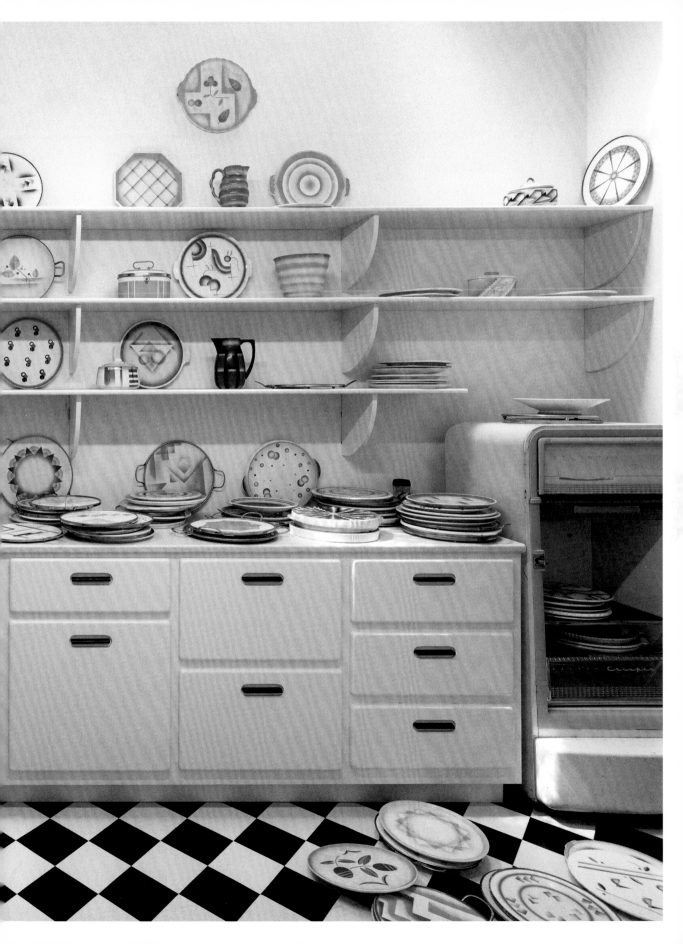

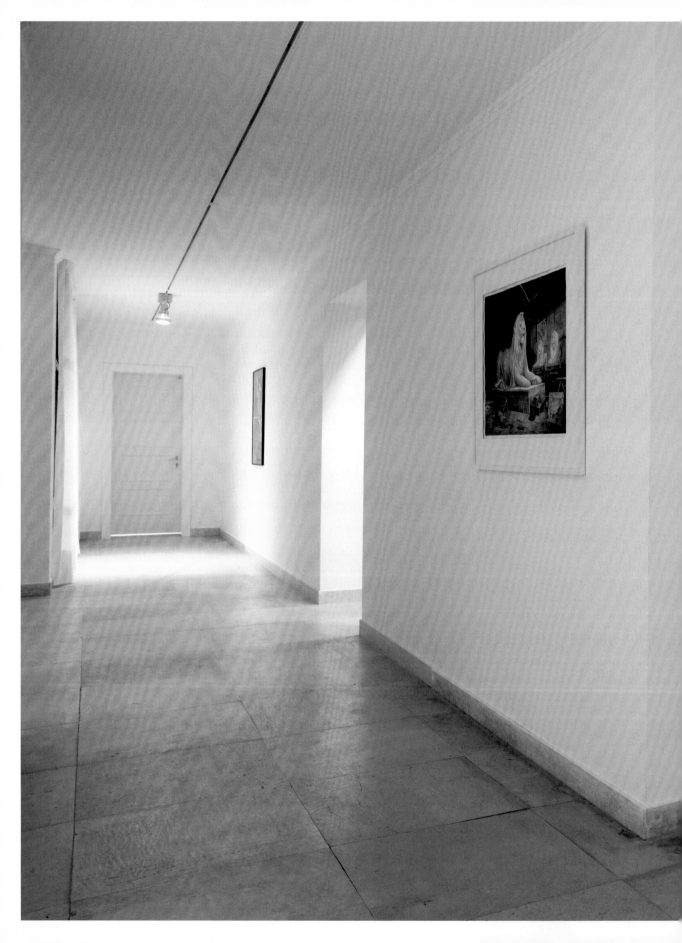

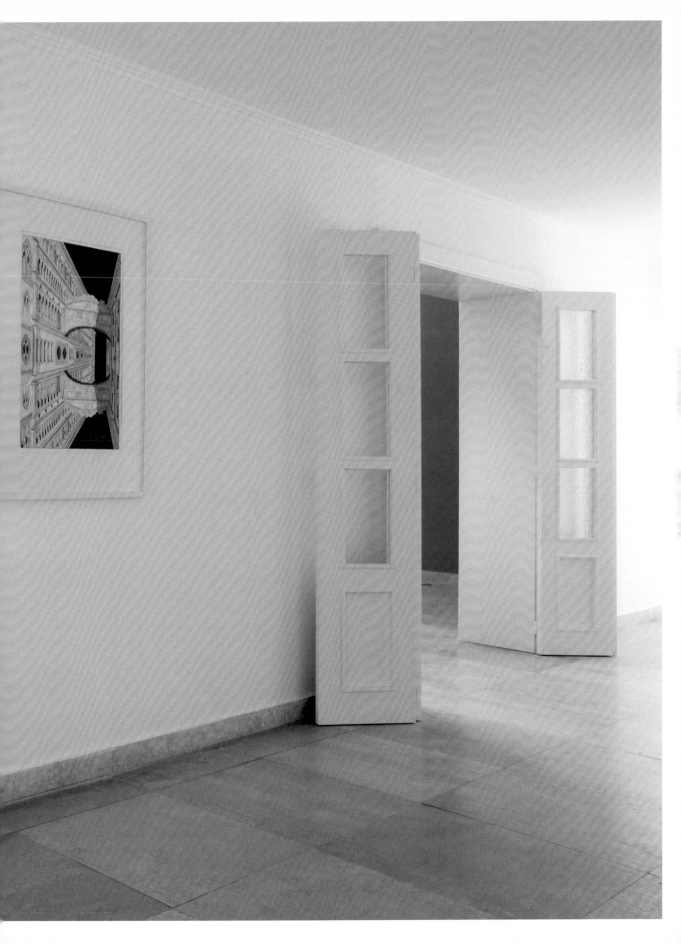

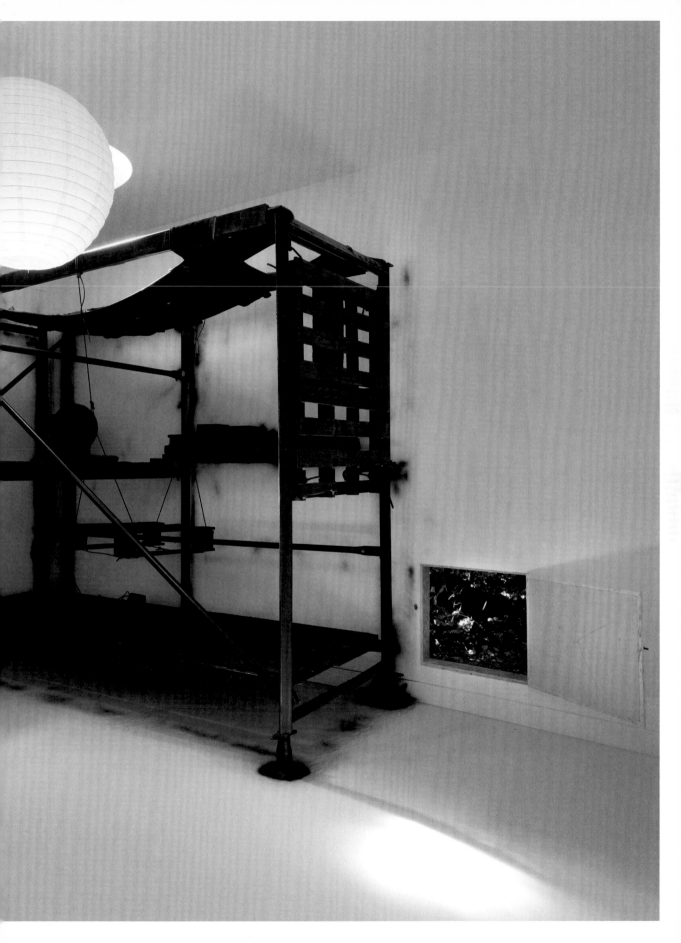

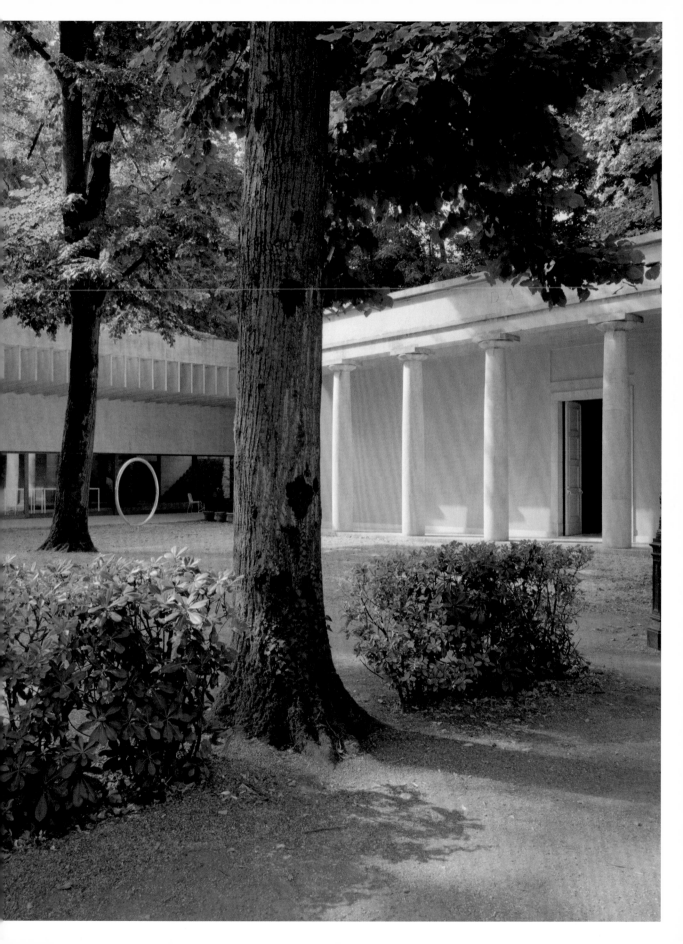

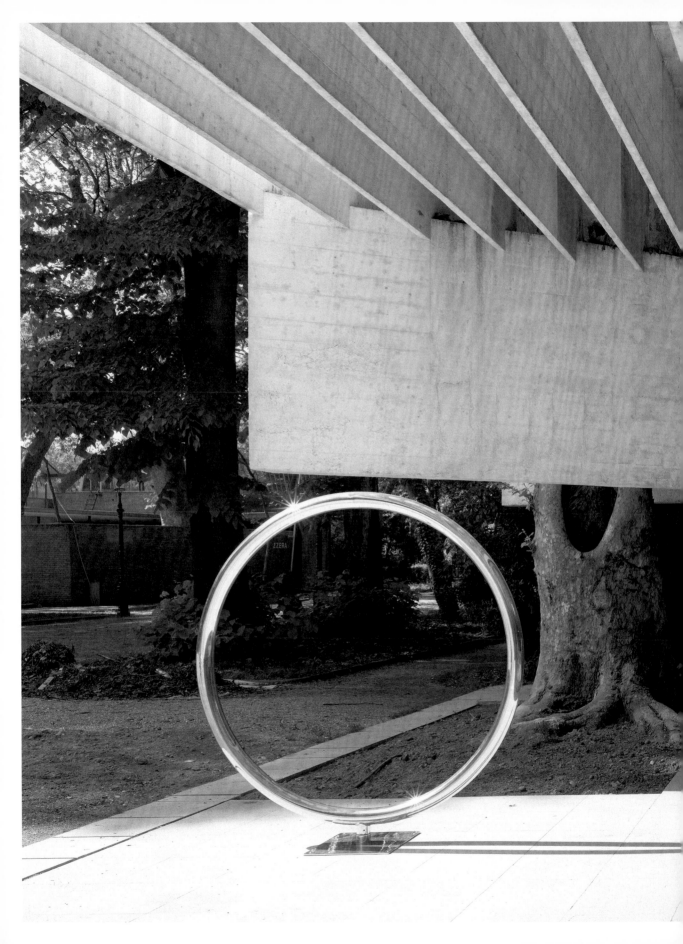

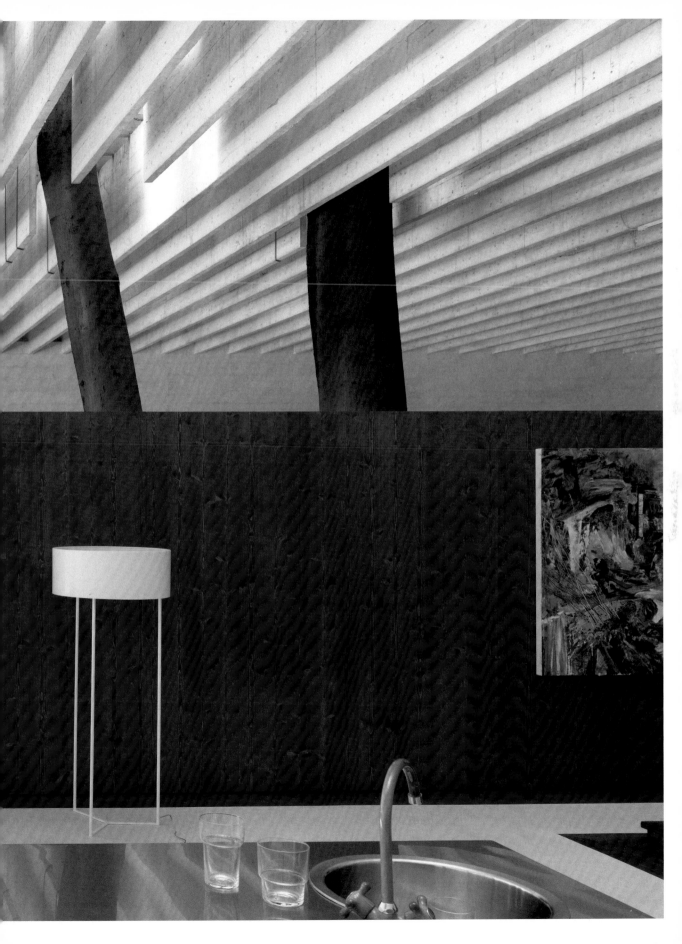

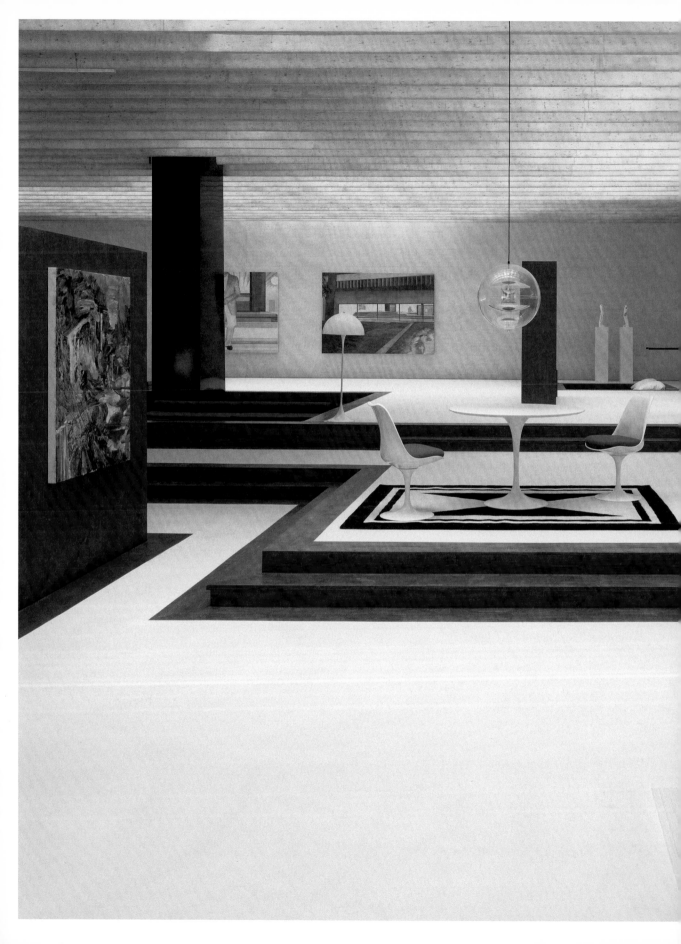

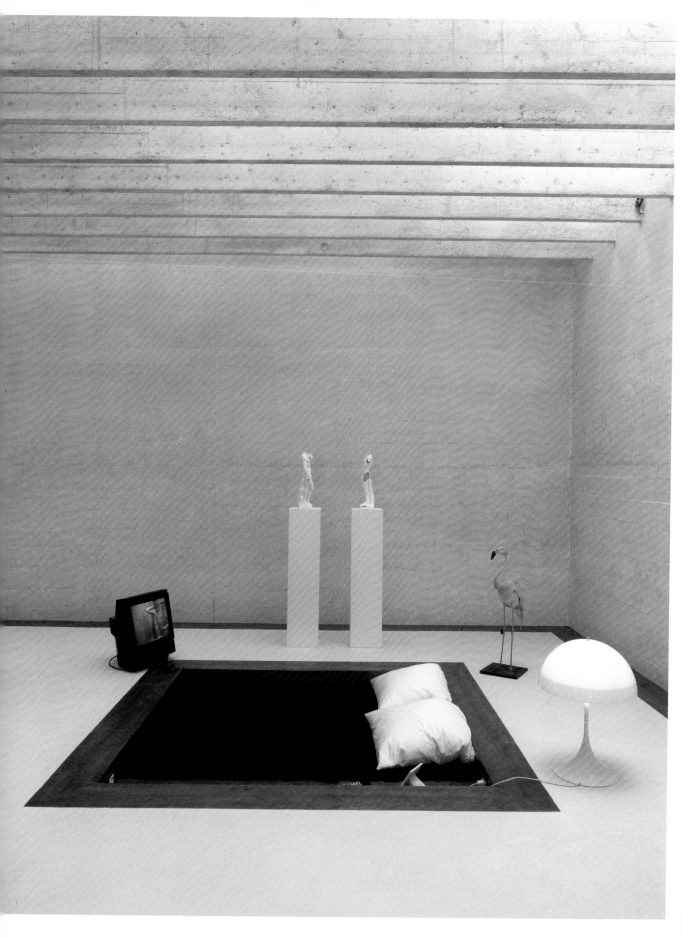

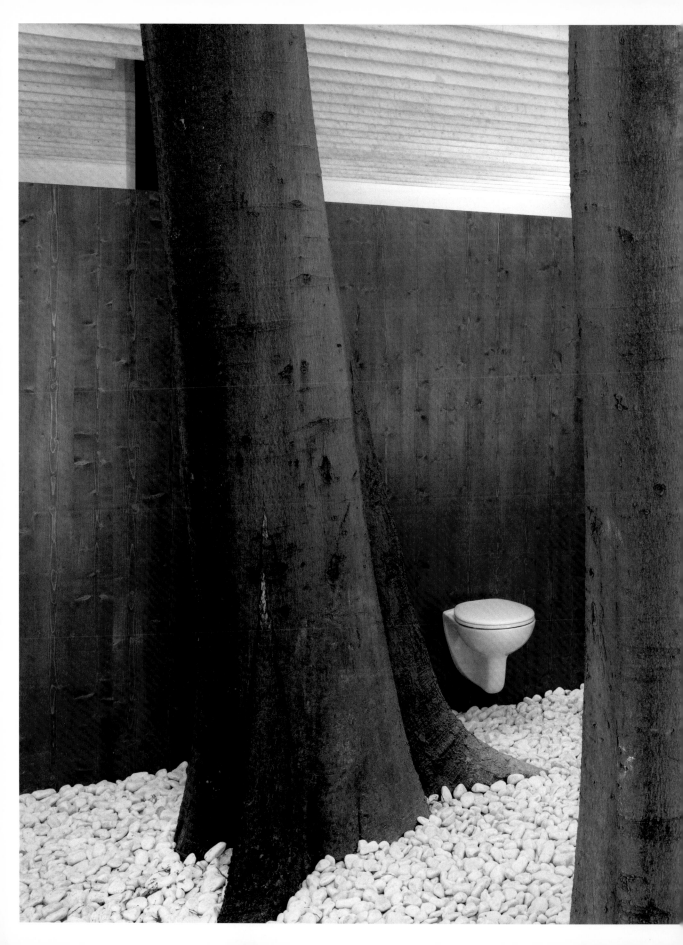

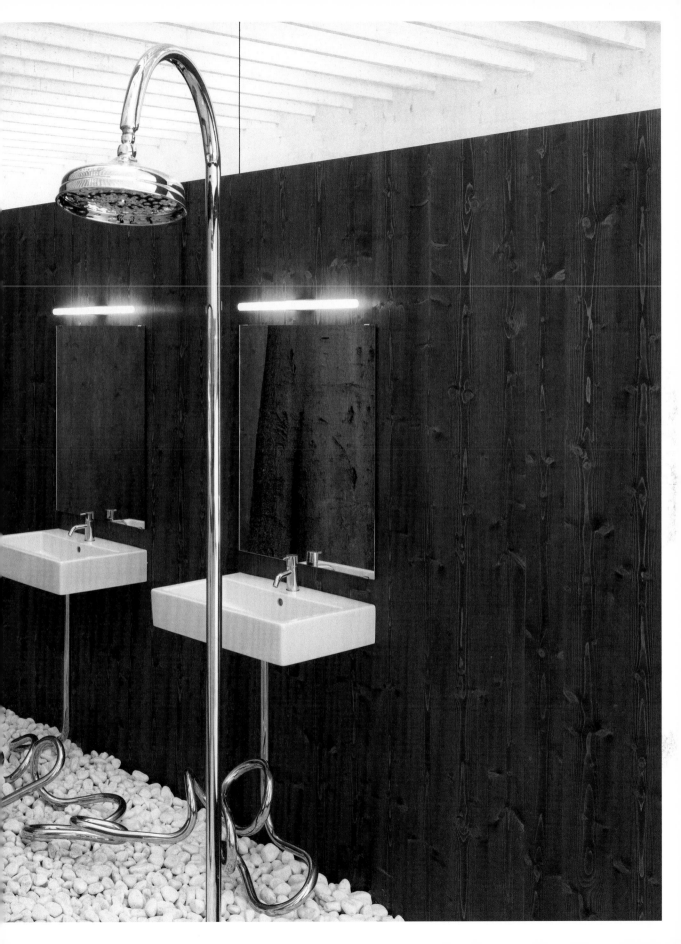

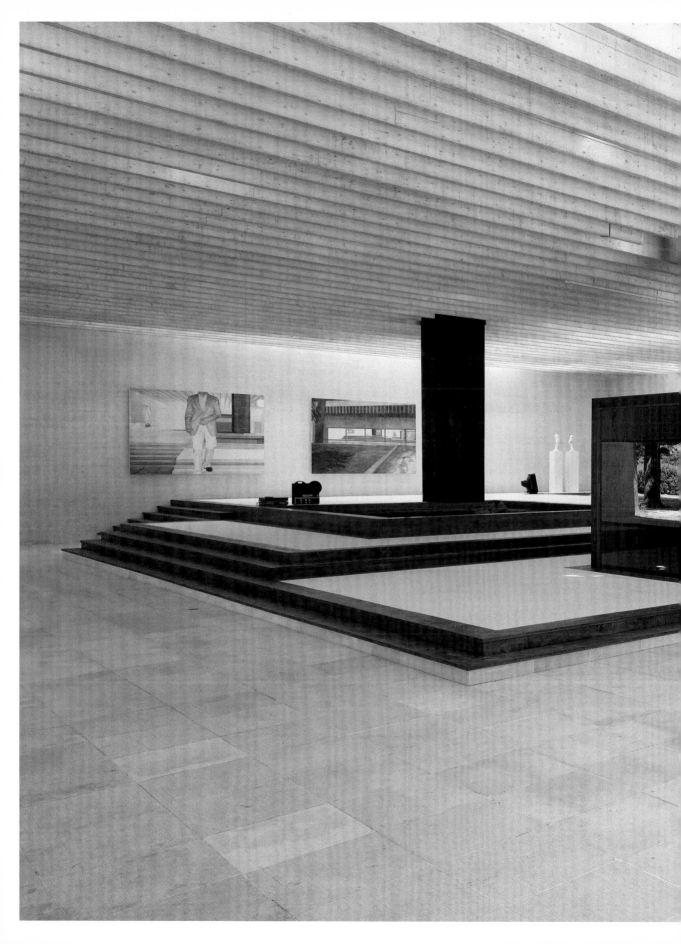

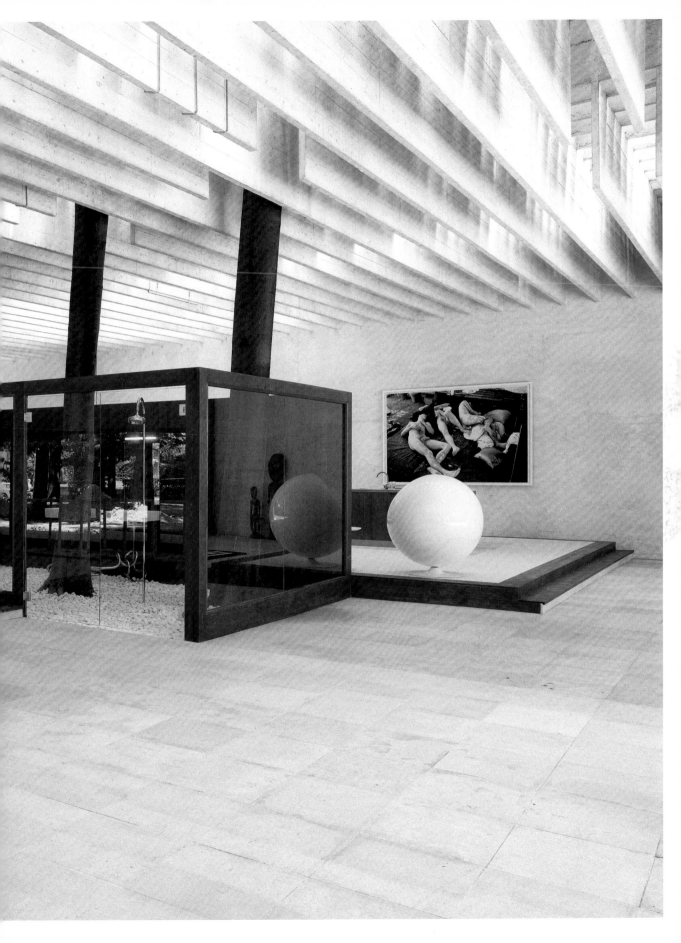

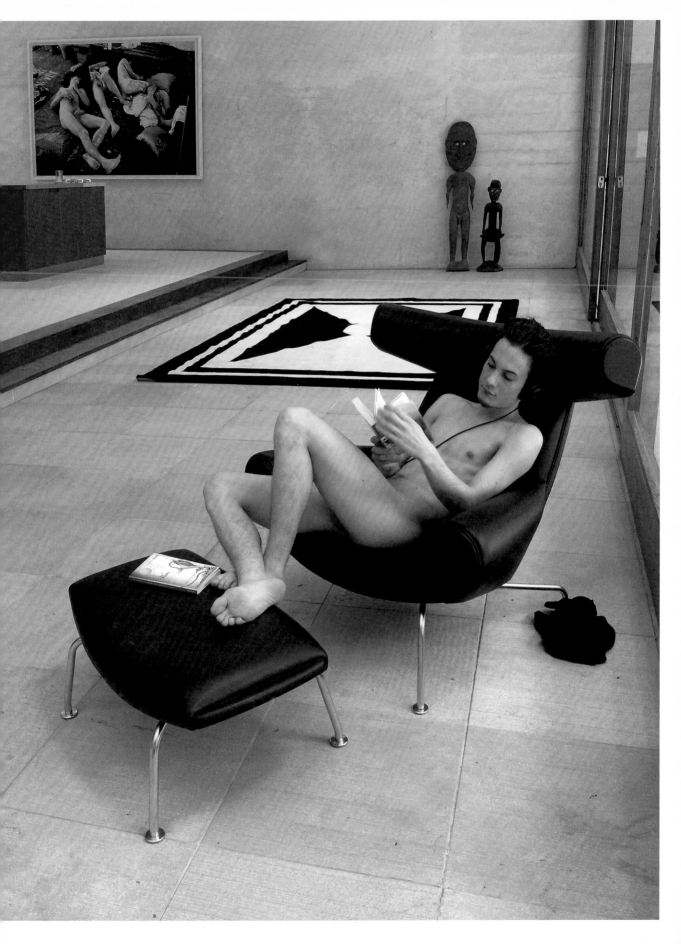

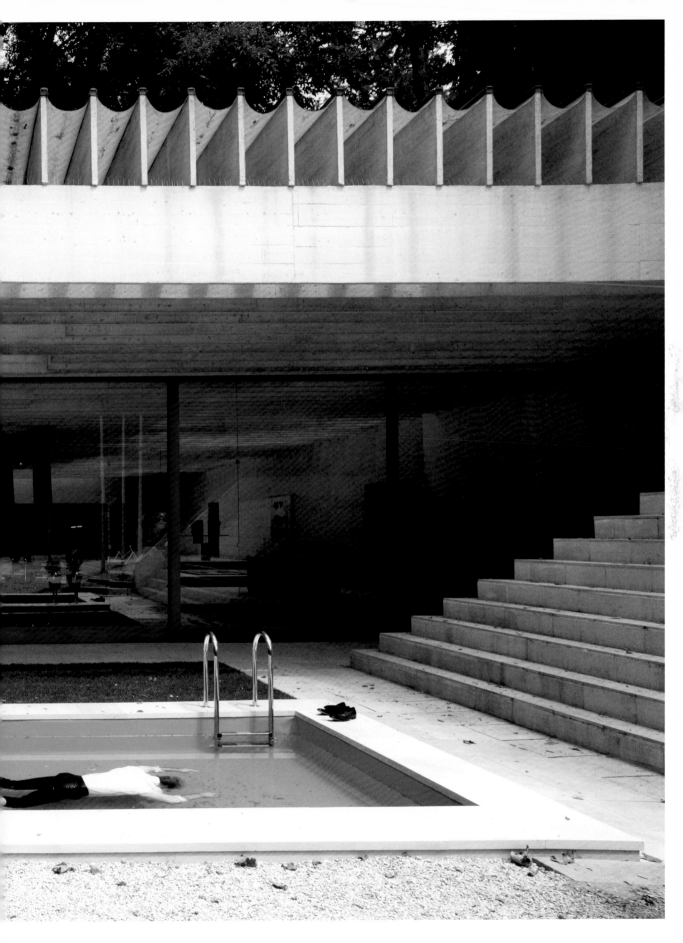

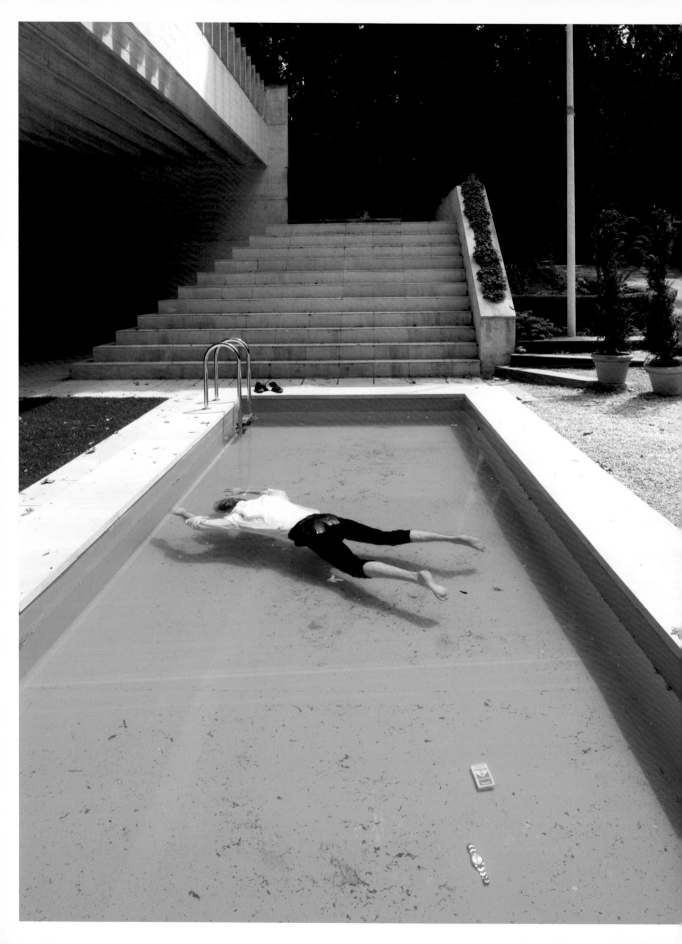

The Danish Pavilion
2009. Exterior view of A. Family's home.
"For Sale" sign designed by Elmgreen & Dragset and Jani Leinonen.
The Real Estate Agents
2009. Denise & Roger Foxwood. "Discretion. Integrity. Efficiency."
Performed by Trevor Stuart & Helen Statman.

Bellevue, July 17, 1994
2009. Painted bronze. 45 × 48 × 26 cm
Courtesy of Galleri Nicolai Wallner, Copenhagen.

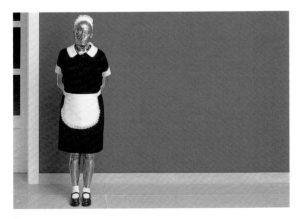

Rosa
2006. Gilded brass, steel, fiber glass with epoxy, garments, shoes.
153 × 46 × 44 cm. Courtesy of Collection Glenn Fuhrman, New York /
The FLAG Art Foundation, New York.

I will never see you again
2009. Mirror, lamp, fake flowers, console, keys.
Approx. 200 × 70 × 35 cm.
Courtesy of Galleri Nicolai Wallner, Copenhagen.

Sturtevant
Stella Arbeit Macht Frei
1989. Black enamel on canvas. 214 × 314 cm.
Courtesy of Galerie Thaddaeus Ropac, Paris / Salzburg.

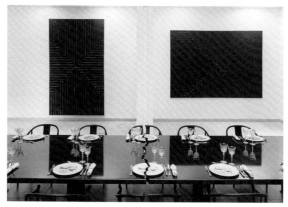

Table for Bergman
2009. Wood, paint, perspex, chairs, glassware, cutlery,
hand painted porcelain. 90 × 605 × 230 cm.
Courtesy of the artists and Galleria Massimo De Carlo, Milan.
In the background left: Sturtevant **Stella Die Fahne hoch**
1990. Black enamel on canvas. 320 × 203 cm.
Courtesy of Galerie Thaddaeus Ropac, Paris / Salzburg.

Torso of a (Forever) Young Man
2008. Wood and steel construction, fibre glass, high gloss varnish,
mp3 player, loud speaker, voice of James Franco. 133 × 62 × 45 cm
(including plinth). Courtesy of Victoria Miro Gallery, London.

Maurizio Cattelan
Untitled
2009. Taxidermy, Life size. Courtesy of Galleria Massimo De Carlo, Milan.

Jani Leinonen
Anything Helps (detail)
2005–2009. Cardboard begging signs, frames. Dimensions variable.
Courtesy of Galerie Gmurzynska, Zurich.

Martin Jacobson
Exhibition
2008. Ink washed drawing on paper. 73 × 102 cm. Courtesy of Stefan
Ortmark Collection, Stockholm.

Thora Dolven Balke
Safety Measures (detail)
2009. Polaroid photos, photo album. Dimensions variable,
photos 6.5 × 10.5 cm. Courtesy of the artist.

Norway Says
Duo
2008. Two Sofas, wool, wood. 180 (170) × 90 (85) × 75 cm
(135 cm folded up). Designed by Norway Says & Hallgeir Homstvedt.
Produced by L. K. Hjelle.

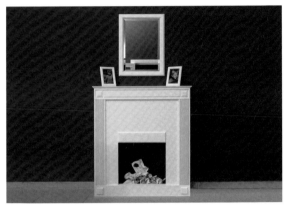

Untitled
2009. Paint, metal, wood, plaster, mirror, photos.
230 × 140 × 30 cm. Courtesy of Galleri Nicolai Wallner, Copenhagen.

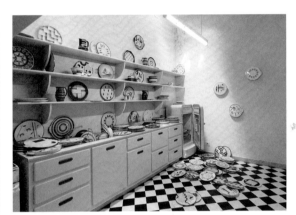

Private porcelain collection of Massimo De Carlo.

Laura Horelli
Haukka-pala / A-Bit-To-Bite
2009. DVD, color, Finnish with English subtitles, 25 min.
Thanks to YLE / Jarmo Oksa, Courtesy of Galerie Barbara Weiss, Berlin.

Nina Saunders
Delicate Landscape
2009. Mixed media. 77 × 120 × 118 cm.
Courtesy of Andréhn-Schiptjenko, Stockholm.

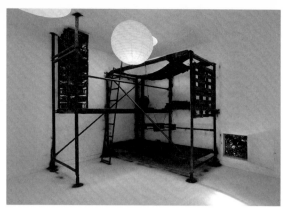

Klara Lidén
Teenage Room
2009. Mixed media. 270 × 435 × 430 cm.
Courtesy of Reena Spaulings Fine Art, New York.

Massimo Bartolini
Black Floor
2009. Wood, tiles. 53 × 881 × 761 cm.
Supported by the Danish Arts Council's Committee for Visual Art
Courtesy of Galleria Massimo De Carlo, Milan.

The Nordic Pavilion
2009. Exterior view of Mr. B's home.

Jonathan Monk
Maquette for a Giant Spinning O
2006. Aluminum. ø 194 cm.
Courtesy of Galleri Nicolai Wallner, Copenhagen.

Guillaume Bijl
Sorry
1987. Mixed media. 8 × 15 × 15 cm.
Courtesy of Private Collection, Gent.

Hernan Bas
The act of pollination
2009. Acrylic on linen over panel. 127 × 101.6 cm.
Courtesy of Victoria Miro Gallery, London.

Terence Koh
David, David It's a Long Cold Winter
Let's Rest Forever till We Fall Asleep
2007. Cracked plaster, glue, acrylic, powder, plinths. 170 × 28 × 28 cm.
Courtesy of Peres Projects, Berlin/Los Angeles.

Pepe Espaliú
Carrying VI
1992. Iron. 143 × 200 × 107 cm. Courtesy of Pepe
Cobo y cía, Madrid, and Colección Helga de Alvear, Madrid.

Han & Him
Butterflies
2009. Steel frame, glass, swimming trunks, name plaques.
180 × 150 × 6 cm. Courtesy of the artists.

Broken Door
2009. Mixed media. 105 × 23 × 7 cm.
Courtesy of Galleri Nicolai Wallner, Copenhagen.

William E. Jones
Compilation
2009. 150 Films including "All Male Mash Up" and "The Fall of
Communism as Seen in Gay Pornography". Video, color, sound. 60 min.
Courtesy of David Kordansky Gallery, Los Angeles.

Tom of Finland
Wall with various works. Courtesy of Tom of Finland Foundation,
Los Angeles.

Marriage

2004. Two Mirrors, two porcelain sinks, taps, stainless steel tubing, soap. 178 × 168 × 81 cm. Courtesy of VERDEC Collection, Belgium, and Galleri Nicolai Wallner, Copenhagen.

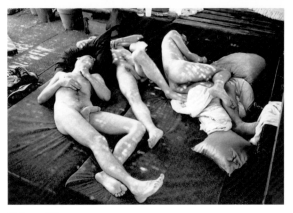

Wolfgang Tillmans
FKK / naturists

2008. C-print mounted on forex in artist's frame. 181 × 269 × 6 cm. Courtesy of Galerie Daniel Buchholz, Cologne / Berlin; Maureen Paley, London; Andrea Rosen Gallery, New York.

Vibeke Slyngstad
The Nordic Pavilion I and II
2009. Oil on canvas. 182 × 260 cm.
Courtesy of Galleri MGM, Oslo.

Simon Fujiwara
Desk Job
2009. Desk, photos, documents, text.
Dimensions variable. Courtesy of Neue Alte Brücke, Frankfurt am Main.

Henrik Olesen
Cubes (after Sol LeWitt)
1998 / 2008. Polystyrene, milk carton, adhesive tape, composite packaging. Cubes each 100 × 100 × 100 cm. Courtesy of Galerie Daniel Buchholz, Cologne / Berlin.

Death of a Collector
2009. Mixed media. 100 × 600 × 200 cm.
Courtesy of Galería Helga de Alvear, Madrid.

inpointing *The Collectors* as a project was not easy. We were faced both with an exhibition of works produced by a total of twenty-four different artists, an exhibition curated by the artist duo, Elmgreen & Dragset – ergo, a presentation of artistic material – and with a wide-ranging *Gesamtkunstwerk*, which was something in and of itself: a total installation-like conversion of the Danish and the Nordic (the commonly shared Swedish/Finnish/Norwegian) pavilions for purposes of conjuring up the private dwellings of two fictional collectors. In this sense, the project was akin to the world of theater. Accordingly, the act of visiting an exhibition and of becoming acquainted with a number of artworks meant entanglement in an oeuvre-related and distinctively theatricalized universe, where it was above all the fictional element that played a significant role as the platform for encountering the works.

Elmgreen & Dragset built further on an ambience already present, by and large, in the Giardini, where the Danish and Nordic pavilions happen to be located next to one another. Prior to their intervention, it could be said of the area's appearance that it was like a tranquil suburban street, and that the pavilions resembled a couple of splendid private homes for members of a higher social class – or, perhaps, what they really are, namely, two ambassadorial residences. A large *for-sale* sign posted outside the Danish pavilion and a swimming pool outside its Nordic counterpart enhanced the domestic impression, and as soon as one stepped inside one or the other place, what came into view were various kinds of domestic interiors. These latter largely consisted of artworks, but also involved applied design and various other types of objects. Among others, the presentation included parts of a Swedish collection of flies, a Weimar porcelain collection and a few Polynesian sculptures on loan from a private collector. Moreover, among the artists listed was Norway Says, the furniture design group, which contributed a three-piece living room set. In the guise of interior design elements, several of the implied artworks made their appearance as ordinary domestic necessities, such as sofas, television sets, staircases, desks

Around and Through The Collectors

Exhibition as Theater and Work of Art
Maja Gro Gundersen

Outside the Danish Pavilion at the 53rd Venice Biennale, 2009.

and the interior of a teenager's bedroom. Discerning the categories was often difficult, though wherever there was one, the name of the producer of an actual piece of work was not indicated. Thus, if one sought to distinguish "the minor" from "the major" works, one was then obliged to cross reference with the exhibition pamphlet, which designated them on a floor-plan drawing.

The two homes were staged such as to intimate different stories. Outside the Danish pavilion, the large *for-sale* sign was clearly displayed. Those who turned up early to the Biennale were able to enjoy the privilege of being taken on a guided tour with two actors who, posing as real estate brokers, furnished tidbits of revealing gossip about the residents in the house; the "A. Family" affected by divorce. As for the other visitors, they merely had to peer into the doorway before the cracked family idyll thrust itself forward: "I WILL NEVER SEE YOU AGAIN!" was scrawled across the mirror in the foyer. Porcelain objects placed on a shelf had been shattered before being glued back together in a somewhat disjointed fashion and a bouquet of wilted flowers in cellophane suggested that they had never been delivered to the intended addressee. A dining table had been ceremoniously set in the living room, even though it was split right down the middle in a dramatic and almost surreal manner. When opening a door and entering a burnt-out Gothic-looking teenager's bedroom, the door would slam shut behind you due to a counterweight that had been attached to a string. At the same time, displayed on the architect's table were sketches of what I had heard was supposed to have been the immediate cause of the divorce, namely, the remodeling of the house, thus constituting an ironic commentary on the Danish pavilion's already existing composite architecture, embodying, as it does, a remarkable *clash* between an original neo-classicist and a later functionalist structure.

Inside the Nordic pavilion at "Mr. B.'s," it was natural in one's capacity as viewer to imagine having arrived to inspect *the scene of the crime*. In the pool outside the host himself lay floating, outstretched and face down, while his Prada shoes were placed on the edge of the

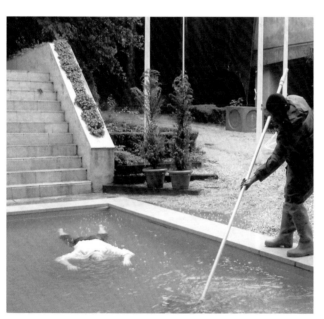

An attendant cleans the pool at the Nordic Pavilion, 53rd Venice Biennale, 2009. Floating face-down in the pool is the fictional character Mr. B.

pool, hence prompting uncertainty as to whether he had fallen victim to his own death wish, or had been assisted along the way by one of the young men who happened to be hanging around inside the house. As one snooped about curiously inside the pavilion, one might have been tempted to envision the entire staged production as a re-construction of the comings and goings of the deceased resident, or as some kind of clue in solving the case of his mysterious demise. In Elmgreen & Dragset's version, the pavilion itself – designed by the Norwegian architect Sverre Fehn (completed in 1962) – was given a smooth and yuppie-ish interior – albeit containing clear and dis-tinct references to experimental architecture, as can be seen in the Californian Case Study Houses. It was filled with extraordinary details like a fireplace and seating area sunk into the floor, and a bathroom that opened up, transparently, towards the neighboring family. The place also offered a profusion of more or less explicitly gay references. Everything smacked of an eccentric dweller. A telling, almost metaphorical feature was a black leather sofa furnished with a decidedly over-sized, cylindrically formed cushion running along its length, which formed an unsightly load on this item of furniture. On the bed, which – much like the aforementioned fireplace seating – was sunk down in the open space, one could recline in the host's place and watch short video sequences of gay porn from various socio-historical perspectives as creat-ed by the American artist William E. Jones. To complete this array of paraphernalia there was an intimate tableau of condoms, lubricating jelly and a picture of a naked male body conveniently within reach while a few Hock-neyesque paintings on the rear wall presented blurred renderings of the interior, including a nobly dressed and anonymous dandy-figure. On another wall there hung a framed collection of used bathing trunks bearing the title *Butterflies* and, almost as a sort of extension of Mr. B.'s collection, there was also a group of beautiful young men, perfectly alive. Much like fixtures, these lads simply lolled around on furniture. One of the particularly effec-tive elements that were to fuel our picture of the place's resident and his collecting mania was a desk tableau in

Stahl House, Case Study House No. 22, Pierre Koenig architect, 1959, Los Angeles.

one of the room's corners on which there were a pair of smashed spectacles, some cigarette butts, a typewriter and a collage-like storyboard for a novel about a man seeking to relive his sexual history by writing an auto-biography – an eccentric, cyclical story, which involved architecture, objects and design, and effectively charged the surroundings with a sexual symbology pertaining to the author's person. As soon as the gaze zoomed in on masculine potency, Fehn's cool and pathos-filled modernist architecture, where living trees are allowed to shoot up right through the interior space, suddenly took on a (perhaps hard-earned) phallic tone.

An Artistic Process of Curating

As exhibition, *The Collectors* presented its material inter-actively, whereas it was actually the almost cartographic organization that cast light on the individual works. Con-versely, it was also the choice and the organization of the works – their chances of working together – that "made" *The Collectors*. Elmgreen & Dragset's role lay in a hybrid borderland region between artist and curator, namely, between the creative freedom of the artist and the demand, typically imposed on the curator, to adopt a certain functional, anonymous role. Regardless of whether the project was initially conceived as an exhibi-tion or an artwork, we were confronted with a presenta-tion of material of a different oeuvre – this was firmly established and clearly highlighted in the accompanying brochure that visitors could obtain at the pavilions' en-trance areas – and *The Collectors* was the manifestation of a preponderantly instrumentalized approach. In this sense, Elmgreen & Dragset appeared to shift effortlessly into an embodied reflection of that category of cura-tor Nathalie Heinich and Michael Pollak would refer to as *the exhibition auteur*:[1] a creative authority, similar to that of the film director announcing a break with the characteristic neutral rhetoric hitherto associated with the role of curator. The *auteur* is characterized by his/her way of handling the exhibition medium as a creative range of possibilities, and by acting independently in re-lation to the material on exhibition.

As mentioned, it was not exactly a dryly specialized or standardized professionalism that characterized Elm-green & Dragset's curatorial effort. What were being cre-ated here were neither any illusions about the absolute consensus response nor, for that matter, a presentation true to the work. In fact, quite the opposite was being practiced and thematized: an invested appropriation, a presentational manifestation of a subjective interest and a personal engagement in displaying the materials, evinc-ing an extraordinary infatuation or unsettled account and a *freestyle*, exploratory interrogation of them. If the actual curator's role is regarded as thematic in *The Col-lectors*, then the parallel between the fictional collectors' and Elmgreen & Dragset's curatorial practice would seem obvious. For rather than standardized readings and the quest for objective presentations, the fictional col-lector characters' roles in the exhibition, and Elmgreen & Dragset's own roles appear to point out an unbridled, personally motivated and covetous intercourse with both the artworks and the thematic mediation – an obvi-ous "use" of the works as a mirror of their own practical life and their own view of the world: these can appear both effortlessly playful and a way of taking them seri-ously – a way of bringing them "to life" by means of con-textualizing them. Such an approach may be considered a tribute to the articles, and a way of allowing them to make an impact on "lived life," or "acted praxis": here, on the collectors' life, self-awareness and perspective on the surrounding world and on Elmgreen & Dragset's "super-artwork" – as practical reflection on the surround-ing world and on the very act of producing an exhibition. In contrast to the ideal of an unobtrusive and restrained strategy of curating that seeks to redeem something col-lectively adopted – something essential – about the indi-vidual works, Elmgreen & Dragset's manner of curating might be called *curating by appropriation*. One may well refer to *The Collectors* as an appropriation-exhibition-and-artwork that not only builds on inter-textual loans, but on the direct use of a considerable quantity of other

1 Nathalie Heinich and Michael Pollak, "From Museum Curator to Exhibi-tion *Auteur*. Inventing a singular position," in: Reesa Greenberg, Bruce W. Ferguson and Sandy Nairne (eds.), *Thinking about Exhibitions*, Routledge, London, 1996.

artists' works. To some extent *The Collectors* was the sum total of its individual appropriated works and the specific "re-circulation" of them, which was then staged.[2]

Several voices in the discussion of the exhibition have expressed a need to render visible not so much the criteria and thought that lie behind any exhibition, but far more the fact that appraisals have indeed been brought into play. The stance taken here is that the appraisals are not naturally given, but rather – to be sure – *invested*. It is, perhaps, precisely this attitude that *The Collectors* was saluting by clearly "disclosing" that, as an exhibition, and in keeping with its featured collections, it was a result of commitment and *not* calculated appraisal.

Room of Imagination

In other respects, *The Collectors* also opens up a "new" exhibition rhetoric. Two parallel "reality levels" were at play in *The Collectors*: real and fictive. And, as already mentioned, on the fictive level there were two private villas – more specifically, collectors' homes. And here there was really occasion for multiple meanings as far as concerned the works' category-related status, which, in this instance, related to the question as to what object or phenomenon *type* they could obviously be registered. This rendered more relevant a number of other approaches to the works than would have otherwise been the case had these same works appeared in a conventional exhibition. What supervened in the fiction was a certain equivalence between "art" and other types of objects. Klara Lidén's *Teenage Room* (2009) could, in principle, be both an artwork and a sample of interior design, notwithstanding its obviously dysfunctional character. And Maurizio Cattelan's stuffed dog, *Untitled* (2009), could be a stuffed family pet, a work of art or a collected curio. (A small photograph of the dog on the A. family's bulletin board insisted on the first of these.) And we could continue with the work positioned alongside Cattelan's, Jani Leinonen's *Anything Helps* (2005–2009), which consists of a number of gold-framed and apparently origi-

2 It ought to be noted that some of the works were produced especially for the exhibition, and so, in a certain sense, may be rightly referred to as "site specific." But here, perhaps, one may also speak of an appropriation of other artists' *praxes* within the overall context of the exhibition creation.

Fredrik Sjöberg's fly collection, Danish Pavilion,
53rd Venice Biennale, 2009.

nal beggars' signs from some of the world's large cities, each of which was endowed with a small brass plate that cast light on the place of origin. Here, we could not be certain whether what we were looking at was a work of art, or simply a material that "the collector" himself had gathered. There were artworks that, taken alone, one had also sought to pass off as something they were not – as deliberately rendered copies of other artists' originals – like Sturtevant's replica-paintings, *Stella Arbeit Macht Frei* and *Stella Die Fahne Hoch*. Apparently, at this exhibition, the farther one went into detail so increasingly less inclined the fiction would be to *ever* come to a halt. The fluid boundaries between ordinary object and artwork, and between original and copy were also disclosed in the compact collection of flies that were meticulously mounted inside glass vitrines in a formation prompting associations with an air force display. While the vitrines do not resist formal categorization as an artwork, they do possibly elicit the impression of being one – especially in the company of Martin Jacobson's drawings, among which they were hung. The fly collection could certainly encourage one to think this was an artistically ironic interpretation of Damian Hirst's renowned butterfly paintings. The titles of the books in the A. Family's bookcase, for that matter, amounted to a potent scenographic element that could serve to remind the visitor of nomadic objects: *Grande Dizionario Enciclopedico (A–Z)*, *Bibliomani, Janson's History of Art, Das Souvenir, All Families are Psychotic, Kunstsammler und ihre Häuser, The Sex of Architecture* and *Selection – Confusion*. Each one of the volumes appeared to be smitten with the gratifying stability that may be linked to the securing of objects and phenomena in more or less encyclopedic systems. But, taken together, the titles pointed to the possibility of a veritable chaos among the systems and around and between the attributions of meaning each of them was supposed to be proposing.

The curious *bag-alogue*, which replaced a traditional exhibition catalog, was another thing that kept *The Collectors* ambiguous. We were dealing with a canvas bag containing a collection of small multiples made by the

exhibiting artists and fragmentary text contributions by a number of various authors, and much of the contents were articles that most ordinary people might have lying about in the bottom drawer of their desk without really being able to explain why. There was a very lifelike pea made of plastic, a collection of postcards, a disposable lighter that advertised "used swimwear," a badge, a handkerchief, a notebook with a handwritten story as well as a tiny book about flies, printed in such small font that it was necessary to use a magnifying glass – included in the bag – to read the book. Most of the objects were of a type that, typically, slide down without even being noticed into folks' pockets, dresser drawers and secret hiding places: articles that have a curious charm or an oddly arbitrary sentimental value. If you buy the *bag-alogue*, you then get to take home a little collection that will almost inevitably wind up in the company of similar thingamajigs one has collected. However, all the small objects are distinguished by revolving around the exhibition's theme without addressing it in a suggestive manner. The fiction is at once sustained and abandoned, but what is remarkable is that there are none of the typical expository texts illuminating the theme, the works and the artists included in the bag. On the back of the bag, certain parallels are drawn between the Biennale guest and the collector with a number of quotations relating to the visit to the Biennale. "In Venice you can fall in love with a lamppost" runs one of the quotes, while another contends "At the Biennale, you're on a marathon hunt for a new masterpiece. You want to see a new face and fall in love. It's like speed dating." Such small statements were gathered and compiled by the sociologist, Sarah Thornton. Several of them appear in her book, *Seven Days in the Art World* (2008). If, like me – and presumably like many other visitors to the Biennale – you have read the book, you might like to note that these quips were uttered by some of today's most assiduous art collectors with whom Thornton had been conversing at Venice Biennale in 2007.

When discussing art experiences and even experiences in general, it is difficult to distinguish between subject

Aerial view of the Giardini, 53rd Venice Biennale, 2009.

and object: in this case, viewer and work. And to be able to interpret *The Collectors* in the way suggested here, spectator activity and preconceived assumptions are required in various modes. This requires the recognition of certain cultural codes and forms: here, for example, the special and distinctly Western form of "the private home," its expected environment and composition. And this requires especially that one moves around inside and outside the two pavilions with a hungry eye for special codes and with a commitment geared toward gathering them together into a fabric for a fiction. Involvement was certainly part of producing the fiction, and not in an automatic way, that is, not as a sheer response to what one experienced. Calling forth some sort of universe around the two collectors' homes was a highly *performative* act, and the presence of the visitors and their fanciful search for clues to gather a story took on a pivotal role as part of the work.

An important feature about the cozy domesticity was that it was *out of place* at the Biennale, and thus appeared as a construct. The sphere of intimacy stood in sharp contrast to the Biennale's spectacular and decidedly extroverted event-character. The home-like scenarios derailed the expected perception of place, and tore the viewer out of the surrounding Biennale reality, displacing him / her into a universe where the private was being displayed via artifacts that, like the private life itself, were nothing other than elements of a stage set for a feature film. Notwithstanding its immediately static character, *The Collectors* made its appearance as a springboard for an extended narrative: a widening of the fictive space that would also include a temporal structure. Accordingly, one could imagine both the times of an antecedent history – whatever could be referred to as a "before-now" – and a continuous development, where one was actually playing a role in determining the narrative's continued course, namely, that which one may refer to as a "looking-ahead now." Here, the home-like scene sparked the conventional assumption that the private home provides us with insights into its residents: a perception which, in the context of contemporary culture has defined itself,

Aerial view of the Nordic Pavilion, 53rd Venice Biennale, 2009.

especially in inside-the-home-of reports in magazines and interior design programs broadcast on television. Here, the living room furniture, the knick-knacks, the closet and even the refrigerator are supposed to clue in viewers and astute "lifestyle experts" on what attitudes, lifestyle and personal identity can be deduced on the basis of such items. At the same time, historical traditions also exist for regarding the dwelling as a *symptom*, from which social and cultural affinities can be deciphered. The idea about the home as emblematic of identity – and the interior as the manifest expression of a particular lifestyle – was an essential precondition for the reading. However, there were also other cultural codes that gave sustenance to the narration. Familiarity, for example, with thrillers like *Twin Peaks*, the legendary 1990s television series, meant that one was accordingly well-equipped to draw on a fictional tradition of regarding absurd and paranormal scenarios as demonstrations of frames of mind and initiated dramas. This could prove relevant in relation to Elmgreen & Dragset's interconnected sinks in Mr. B.'s transparent bathroom, for example. Or to Klara Lidén's teenager bedroom, with the raised axe as a substitute for the conventional sign on the door warning that crossing the threshold is "at one's own risk," and the small open hatch leading out to an archetypal "secret spot" in the bush-covered backyard. Meanwhile, the dead man floating in the pool conjured up a particularly evocative crime scenario in direct allusion to the movie *Sunset Boulevard*. Hence, by looking at any one scene, one might easily imagine something that had gone before and something that came after. Inside the Danish pavilion, we moved over into the psychological thriller or, as Elmgreen & Dragset suggest in their title for the large split-down-the-middle dining table, *Table for Bergman* (2009), a heavy and compact Ingmar Bergmanesque family drama that was brought to light in the cracks and fissures of the house, which had all too literally been hammered out. Providing a further kick-start to the fantasy was the fact that the pavilions were playing on the dramaturgical point in a narrative immediately *following* a climax: a kind of vacuum that simultaneously exudes what has just happened and that retains, as an afterimage of the genuinely dramatic, an underplayed energy. Accordingly, the collectors and the stories were distinguished as what, in the realm of painting, is called *Leerstelle* or blanks. Accentuated vacancies that stimulated the sense of fantasy provided occasion for focusing an especially ferocious interest on that which still *was* palpably present: namely, the place and the items. The act of *poeticizing further* on whatever had been left behind, namely, the works, then became a legitimate way of finding out about them.

The Rules of the Game

Elmgreen & Dragset's project had several features in common with live role-playing, which is a kind of total theater and a counterpart to the open theater, with its ordinary human participants. Here, people also work with a common history, a fiction that the participants create together within the contextual frames of a form of play. As is the case in *The Collectors*, people operate in live role-playing with an altogether concrete variant of the theatricalizing praxis. When we zoom out and move a bit further away, we can see that what *The Collectors* basically has in common with live role-playing is that "what is interesting" arises when participants are interactively engaged. On this account, there is thus a need in both cases for the participant to move in and take possession of his/her "role" and make the administration of it an affair of dedication. In the framework of role-playing, people have tackled this need by operating with a provision known as *collaborative fiction*, supposed to ensure that the participant establishes contact with the frames within which he or she can play-act. The idea subsumes a number of agreements between the participants which, in addition to the person-gallery and a set of established narratives and localities, also touch upon the kind of guidelines valid for the interaction and on which the particular game in question is constructed. The collaborative fiction is supposed to ensure the sense

of confidence required for a participant to "dare to cross over the border from reality's comfortable familiarity and into the fiction's unpredictable universe,"[3] as well as to see to it that the participant will become conversant with the possibilities of interactivity inside the game itself. As a visitor in *The Collectors*, however, one was faced with the challenge of there being no clear fictional contract. There was no tradition established, nor any genre defining itself around an exhibition form of the kind Elmgreen & Dragset were presenting. Neither was there any conventionalized behavioral codex on which we were able to draw as visitors. Nor could one find any written or oral presentation of the new conditions applicable in this hybrid exhibition space. Consequently, one was compelled to get out there on one's own and piece together one's own so-called "collaborative fiction contract."

Quite evidently, *The Collectors* appeared to be pointing toward the art experience as an exchange, toward the experience of the exhibition as being a partially improvised affair, inasmuch as the fiction was not fully unfolded until fabricated in the visiting public scanning the intercourse of the exhibition particulars. As can be sensed here, this gave rise to a certain sense of puzzlement – a mildly schizophrenic disruption; for what is one to do when, as a member of the visiting public, one is suddenly provided only with cues for a manuscript? However, it was precisely this sense of bewilderment that inspired me to reflect on whether or not, typically, something valuable is lost in traditional exhibitions.

Translated from the Danish by Dan A. Marmorstein.

3 Janek Szatkowski, "Rollespillets udfordring – udfordring til rollespillet. Elementer af en interaktiv strategi," in: Kjetil Sandvik and Anne Marie Waade (eds.), *Rollespil – i æstetisk, pædagogisk og kulturel sammenhæng*, Aarhus Universitetsforlag, Århus, 2006, p. 159.

Y ou can imagine my surprise to learn that I have been pronounced dead. I felt that I should warn you before getting too wound up in my story. But I can also reassure you that my expiry is quite as concocted as my fabled liveliness. You will never hear the dissonant notes and abandoned symphonies that occupied me during my entire illusory life – though it is art, not music, which brings us together now.

I would introduce myself properly, but I have no name to offer. There are plenty of questionable ideas out there about people like me. Occasionally, I recognize myself amongst them. To most, I am simply a "gay art collector" – a mythic creature the general public happily pretends to have once met or ignorantly claim to understand, and all too often in a disparaging way. Do you know the feeling just after the end of an affair, when the much pawed over "other" fades from view to retreat into the fictional? I confess my library is rather full of these nonfictions, and I myself am in the library of many others – if only like one of Joe Orton's scandalous collages. Yours if you like. Look me up. In the late 1980s, I read Alan Hollinghurst's archaeological novel, *The Swimming-Pool Library*, and found parts of myself in nearly all of his characters too, even though London was never my thing. Too many people there are so bitten and biting back.

What do I look like? In my mind, I am still as fluid and dapper as the sinless Dorian depicted in a painting I own by Vibeke Slyngstad … That picture feels at least partly true to my sense of myself and is a bulwark against the evidence to the contrary in retail mirrors, or in other people's expressions when it's late and we've over-indulged. Just when you get used to something about yourself there is always a small change. In a single evening you can play out your entire life. It's probably conceited to let an artist paint you – and afterwards buy her efforts. Then again, artists aren't naïve, and I suppose they bank on things working out when they render a collector – though that can go horribly wrong. The paying muse is an awful critic. I'm not cynical; I am relentlessly enthusiastic. I just think that patronage must

Another Death in Venice

Dominic Eichler

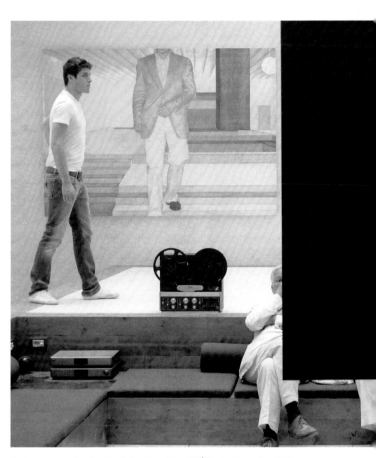

Performing guard in the Nordic Pavilion at the 53rd Venice Biennale, 2009.

involve some realism. I am not isolated, sad or lonely – I refuse to fulfill that prophecy, despite being in what you could call the etcetera-etcetera phase of life. In a way, merely through the existence of this fading watery portrait, the idea of me is on permanent loan to the busy world of images, whatever provenance may be in store for it. What art would still be produced if its fate were known in advance? My head is cut off in the composition. I love that blue jacket. If I still had it, I would wear it now. Or I would hang it over a chair and sit down to work at my music. The linen and my notes would keep me company and remind me of the ocean or the sky – expanses that I love because when you look at them you really are everything and nothing. My pool seems safer: it has boundaries and frames my Han & Him swimming trunks, which themselves are a kind of sexy frame.

You know, women friends, even those slightly younger than me, complain of being invisible on the streets. Maybe they are thinking of years and years of happily ignoring advances, crude or subtle, when their bodies, all dots and dashes, telegraphed sex wherever they went. Oh, I assure you, I do have women friends, despite my emotional bias and physical needs. I once envied their apparent ease. In the past, the codes we needed to master involved so much treacherous care and attention. To further complicate things, they also changed again and again over the years for better and worse over generations – their lawmakers and doctors of the body and mind, with the messy project of sex liberation in the West, with Feminism and Gay Liberation and, amongst academic friends, with their queer palaces of thought. And with that, the scourge AIDS. It's heart wrenching to think that there was and still is so much fear and anger directed at women and men like me. The cultured middleclass version of this deadly derision is a snide or belittling remark about one's efforts. Maybe you get now why I wanted to own a black leather couch complete with a bomb?

When people talk of "gay collectors" buying from "gay artists" represented by "gay gallerists," they are not being gay at all. Rather, their cast-iron heads were forged in the witch-hunting 1950s, in the era of McCarthyism, an epoch which, contrary to popular belief, didn't fall with the Berlin Wall. Hate has roots like ivy. In the end, it all amounts to the same thing: the expression of a fucking "naturalized" death-wish shared by too many cultures. Nature is a jolly whore and he shouldn't be misused to justify murderous phobias. It is a small mercy that my body, at times lugged around resentfully, is beyond that now. I have a couple of large steel "carrier" sculptures by the Spanish artist Pepe Espaliú. He had himself carted around in them like a Baroque prince when he became ill from AIDS. They are dark things that function like reminders when so many of the most brave and fierce are no longer here to disagree with us. I wish they were, even if they'd laugh at my small collection and question my motives or my will to live. I don't always feel up to carrying the baton.

I feel like celebrating. Those lost ones won't hold it against me, even if I turn myself into a monstrous caricature on par with a toxic mixture of Noel Coward and Elizabeth Taylor in *BOOM!* – that brashly idiotic film, both too early and too late.

I want to share with you some of the dried dates from my personal oasis, the ones which I pretend to have brought back from a trip with friends to North Africa. After all, there's no need to apologize for getting older and for feeling sorry for yourself too. (Or coping with being told you are dead, for that matter.) I am too comparatively privileged in most assets except youth to feel victimized. Except, that is, in an abstracted Warholian way, when there is a cause to support. (I do wonder if my art collection is a progressive political act? It is some comfort that I share this worry with the artists I admire. Are we enlisted as diplomats, commanders, foot soldiers or sycophants in the struggle – what struggle and whose? Perhaps others need to be the judge of that.) As passive activists, many of us have ambled in the margins of demonstration marches – if the weather was good. Recently for instance, some friends and I went picnicking for gay-marriage and same-sex couple adoption, although I don't have the slightest desire to exercise these rights. Leave others to their domestic incarcerations! We should all at

least thumb through Foucault, you know. Isn't it queer that on some occasions we are so silent and others so loud, and sometimes mix up which occasion is which? Thankfully, the critical choices and hairy entanglements of a juicy life are no longer my concern. I have had many so-called special friends and life partners – both really infuriating terms. The most horrible and enduring one, of course, is myself. I just don't know how to break it off. Did you see the work in my bathroom? Not exactly a white cube. The connected twin sinks in there are my artist friends Michael and Ingar's little joke about where we put our dirt – right into each other. Forgive me if I'm too glib about serious matters; it's because seriousness is too regularly co-opted by people I disagree with.

In my attitude to sexual communities and alternative groupings I feel closer to Wolfgang Tillmans. His explicit images of random scenarios with Berlin boys make me feel brave and in touch – even if I wouldn't dare sleep with them in a stoned huddle like the one in the photograph I have. Wolfgang told me the scene is actually totally innocent, not post-coital. Talking of pictures and pretty men, flowers that they are, Hernan Bas told me that the fellows in his pictures like *The act of pollination* are ready for plucking, not fucking.

You would understand why I get a belated thrill from this talk if you also knew that in the 1960s (yesterday), I still felt as timid and innocent as an early David Hockney. Much like the brushwork on a painting like *We Two Boys Cling Together*, the details that remain in my head from that period are rather sketchy and earnest. Who was it that put on a T-shirt, "If you remember the 1960s, you weren't there?" Hockney, like a lot of us, needed the diplomatic effects of sunlight and a swimming pool in a place far from our point of origin in order to relax and to not fear colour or lots of buttocks and pricks semi-attached to young, grinning faces. If I could, I would like to own Cecil Beaton's portrait of Christopher Scott and Henry Geldzahler taken in front of Hockney's double-portrait of the couple. It's a goddamned hilarious double-take. I feel like someone invisible between them, or in the wings. I don't know if Geldzahler is really a

role model but I liked what Frank Stella had to say about him in that film *Who Gets to Call It Art?* He said that Geldzahler was the kind of curator who "lived with us, dug us, promoted us, curated us, saw on the instant what was genuine about us (or not), made us famous, hung out with us, partied with us, slept with some of us …" It crossed my mind then and now that I might prefer owning and hanging around Beaton's photograph over, say, a Robert Mapplethorpe picture. But I missed out on all of them anyway. Knowledge and access are different things.

Collectors like stories about the ones that got away. As I tell you all this, I feel increasingly naked, my tanned chest like that of Aristotle Onassis on his yacht cruising with the widow Jackie. Listen to me sailing backwards, when I know better. I sip wine where the commas are. Do I come across like Rupert Everett on the red carpets or other banana skins? I know I'm not as articulate as Bruce Chatwin. I am no porcelain doll. Much like a doll, however, I have the advantage, strictly speaking, of never being born. Every single afternoon I could rewrite myself late into the night. If I told you that my mother was an aging Mae West and my father was a little German actress … Marlene something, would you believe me? Actually, my mother was William S. Burroughs and my father is unknown. I don't lie, I embellish. We are all born into our version of the ordinary. For pansies that's a life-long challenge: a personal affront from beginning to the end. It doesn't matter if the setting is Shanghai, Cairo or a stiff townhouse in Amsterdam.

In the late 1960s, I was as closeted as most Pop canvases despite the personal bravery of some of their makers. Actually, speaking of closets, I didn't really realize I owned that imprisoning and sheltering piece of ever-so common furniture – a family heirloom – until then, because for most people like me, there was not much of an "out" to come out into. The Bitter End Café was great actually. Even now – though I have given up temporality completely, I hear that that "outland" is actually just an archipelago of liberal urban islands threatened by global warming. Back then my friends were reading Frank O'Hara. I might have known him; plenty did. We all smoked and tried to be smart and fast-witted about things. Fags with fags, how else could you light up a stranger's face? Goddamn that Fire Island dune buggy. Though white wine seems to fuel tears of happiness better, I still sip the occasional Manhattan, but New York, New York, has changed, and I have let it be. In any case, my sexuality, which I don't separate easily from the rest of me, is so damned transatlantic. I have known Norwegian fjords in summer, Icelandic hot pools, a spot in the Glyptotek in Copenhagen next to a painting that cheers me with its barely veiled pun on a young fellow's weapon, and Swedish islands – where I sailed in a wooden boat with a friend that I found and lost just as easily after we dipped our oars in each others' tidal water. That makes me sound so outdoorsy or *Brokeback Mountain* – don't get me wrong, I like views as much as anybody else, but I hope my life is a paper monument to a very different tale or two! I could never be as purely hardcore European as Jean Genet as recorded by Edmund White (now there's a biography that you could easily kill someone with!) – nor for that matter as taut and uncomfortably straddling as Henry James (my beasts were in the streets, not the jungle) – my time is altogether another. Perhaps what I am really trying to get at is that I could never subscribe to a Nation or nationhood, nor, for that matter, to teams or groups or any other kind of mob. The gay community always seemed even more fictional, if an utterly necessary one. I like art and art has art worlds. Maybe a "gay world" would be a possibility though it sounds slightly menacing. Perhaps art circles and gay circles are best – provided they are open, not vicious, at least in their internal workings. What is the geometrical name for the place where circles overlap? I have become a crumbling tangent. Fixed points can turn you into a potential target. Dear, charming Jasper Johns's targets have a complicated handmade texture, which is good. You don't have to be an archer in front of them; you can also just slide up next to his painting's micro-canyons. Looking at things from behind like painter Richard Hawkins showed us or from the periphery is another queer gift to the world.

Relatively safe in Italy, Cy Twombly got away with this too, in a modern way.

It strikes me as flattering but absurd that my Italian summerhouse is on display to you as art. I don't think I will keep it. It isn't on Capri, after all. I imagine you strutting in and looking around at the things gathered there in lieu of me. Perhaps it's my absence which makes this prospect remotely palatable. I hope that you forgive me. I hope that these words build a bridge between us though I am afraid of heights or at least pretend to be when faced with a choice like a gulf or a thin line. My artworks are stepping stones, often placed far apart from each other without reassuring handrails. Group exhibitions are all too often emotional and intellectual obstacle courses, aren't they? Horrendous is the process of selection and the inevitable acutely felt blanks. I trust the idea not of completeness, but intuition and my broken Rubik's Cube subjectivity – a quintillion variations in a square shape. Rubbish! (Speaking of which, have you read Michel Tournier's novel *Les Météores*? I see myself in his trash- and sex-collecting gay uncle character, Alexandre Surin.) In fact, I have nothing much to do except this anymore – i.e., go on and on. I have to believe in the artists who have lent their talents and works to our common purpose. I confess it was partly due to vanity that I have allowed this to happen. And even worse, a dangerous congenital nostalgia for Venice – a city with a layout and smell not entirely dissimilar to the cellar of a huge nightclub – that's a cheap thought, I know: off-the-cuff and ahistorical. We make the world we need. No wonder Diaghilev drowned here (perhaps with poor Nijinsky's schizophrenic ravings still ringing in his ears). Have you seen his flat white marble tombstone on the island of San Michele?

Venice is to die for! That's entirely too romantic, of course, and I have absolutely no intention of popping an artery on a dirty Lido beach watching oil tankers drift by, stressed out to the max by an unattainable golden youth. Michael and Ingar assured me it was a good idea, and I do love those two boys and I would do anything to please them – even if that meant only to exist. Truthfully speaking, I have no choice. They have created me or, rather, prodded this version of me into being, along with a bevy of help. They are my ambassadors. I am their Frankenstein servant come to life. Life through art. What can I do but accept? That's what collectors must do – support artists and the art they love. But love is not an easy street. It may be as unfathomable as the murky water here or the charms of a gondolier whose meter is always running. As always, I am satisfied with what we have and have not done.

Being overly organized in life is for amateurs. Do you know about my house? It was designed by the Norwegian architect Sverre Fehn in 1958 and erected in 1962, if I'm not wrong (which thankfully happens occasionally). It had a previous owner (an ulterior motive) and leads a kind of double-life as The Nordic Pavilion for the Venice Biennale. This probably accounts for its glass jewelry box character. Considering the neighbors, I would have been happy with a few more walls! But I still fell for the building and its inbuilt uncertainty about inside and out. Only later did I read of the concept of the "glass closet." Taking things too literally is only a start. The architect once said: "I always thought I was running away from traditional Norwegian architecture, but I soon realized that I was operating within its context." So naturally, I had to make a few changes for me, for my art and for visitors. I felt that I really needed a bit of split-level drama, some ups and downs, and highs and lows. Speaking of low: did you see my Henrik Olesen? His reinterpretation of Sol LeWitt's cubes made from styrofoam? I saw them at a small Berlin gallery in the 1990s with an empty milk cartoon placed beside them. I hated them when I first saw them, by the way. I really misunderstood them; they didn't have any obvious appeal to me. I thought that like so much smart 1990s art, they were too Oedipal in relation to Minimalism and Conceptual Art. I also drink black coffee, though I am prescribed green tea. I got annoyed, which – in the language of a glossy magazine – was the beginning of a wonderful new affair. Now I love them, for their emptiness, for their structural dodginess, and for the fact that they are pure wobbly frames and

that – in a sculptural and conceptual sense – they play with gravity and lightness. Their tentative hold seems right to me, though painful.

But I was talking about the layout of the house. Ingar says it's still relevant to have no walls, just levels and not much strictly defined space. He says it all points back to a time where Scandinavia met the world, when experimentation with ideas of individuality, collectivism, and optimism signaled new directions in designed living. Personally, I just want to hang out without too much interruption. There is a sense of progress when journeying from the fireplace to the bedroom or the other way around – all day, tired of myself. If the height of the floor changes you know where you are. You're not just rolling around and around like giddy ice skaters in a rink.

It's annoying, but there is so much of ourselves in objects – however you look at them. Art tries to help you to see this differently, but it doesn't ever wholly succeed. It's a funny thought to me when I think that I am being made public in a manner I didn't anticipate – although people with means and of my age do tend to make their houses implicitly public. I'm quite conscious that I am part of a class who don't just "get by" like billions of others, but rather have their "world of interiors" that look as if they are about the notion of living without actually doing it. And all this luxury is complicated by the idea that all along I have been scrupulously discreet. I have always compartmentalized things like art from my life. "Modern Spartan" used to be hip. Now I find myself spilling out everything that is important to me as a member of that imaginary class of "gay collectors," while knowing all too well that this terminology in lesser minds is synonymous with questionable taste. Did you notice my cheeky, identity-snatching concept work? It's from Simon Fujiwara. He borrowed my first person and pretended that I write convincing erotica as a hobby in a sexualized version of my space. He supplied all the words. His words are perhaps braver than me. One hundred days of Sodom, I have always firmly believed, are not enough. Actually, at times, I admit, I get a thrill from succumbing to all the tried and tested forms of homoerotica and to "exaggerated" decoration. Susan Sontag had some thoughts on what I'm talking about (though not necessarily guilty of). In her "Notes on 'Camp'"… let me get it out and read it … she ventured – yes, my goodness, it was in 1964 already – "The experiences of Camp are based on the great discovery that the sensibility of high culture has no monopoly upon refinement. Camp asserts that good taste is not simply good taste; that there exists, indeed, a good taste of bad taste. (Genet talks about this in *Our Lady of the Flowers*.) The discovery of the good taste of bad taste can be very liberating. The man who insists on high and serious pleasures is depriving himself of pleasure; he continually restricts what he can enjoy; in the constant exercise of his good taste he will eventually price himself out of the market, so to speak. Here Camp taste supervenes upon good taste as a daring and witty hedonism. It makes the man of good taste cheerful, where before he ran the risk of being chronically frustrated. It is good for the digestion."

I ask myself: do I resemble or resent her remarks? Is there a high camp of high Modernism? I should think so. Can architecture driven by security concerns become camp? I think so. Is poking someone on Facebook camp? If only. Nearly fifty years on, I surround myself not with camp classics but rather with what goes down in the trade as serious and international "emerging contemporary art." I hope they actually do emerge and then soar. I know that young art doesn't make you young, but my money can give them something to go on with. Terence Koh has done some things, not for me, but for himself and good for him. Irritating, fucked-up, totem-like, pseudomystical, and speedy cult things that take more than enough of the complications of a post-identity world on board. I struggle to keep up. Crude *objet d'art*, if you will – as crude as Pompeii but with less dust and more fresh plaster and other materials.

But since we have established the fact that I am indeed a "gay collector," I thought I should own up to some of the seedier ambivalence of that politic – that's why I acquired a new discovery, a film made by William E. Jones, which has some rather creepy fellows in it, cast-

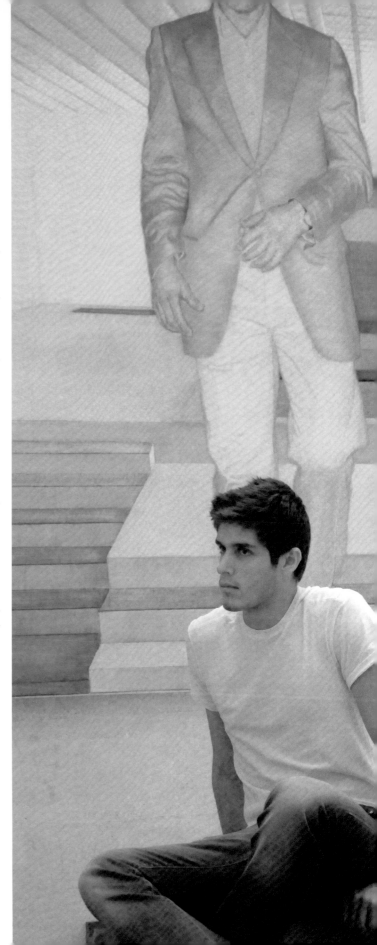

ing boys from the street like slaves or horses. In the garden, offering quite a counterpoint, is Jonathan Monk's remake of Leonardo da Vinci's perfect circle according to Monk's own measure. The space within is the absent body and we all get to think about whether or not we fit in. A male can be a void.

Despite rumors to the contrary, gay collectors live in the world with all of its rough juxtapositions, just like anybody else. It's a funny thing to fantasize about being in a long lineage of troublesome if illustrious figures such as Scipione Caffarelli Borghese, Frederick the Great, or once one of the wealthiest men in Europe, William Beckford. A friend recently gave me a scholarly book that gave me a whole lot of other names of eminent men between 1750 and 1920, whom I didn't know I might resemble – Edward Perry Warren, or Paul Brandt and his partner Werner von Bleichroeder, who typically reached back to Antiquity and the Renaissance for aesthetic solace and justification.

In a similar vein, just the other day I was gripped by the spectacle of the auction of Yves Saint Laurent and his partner Pierre Bergé's collection. I have never been introduced, but from the things one reads in newspapers, I wish I had been. Mr. Bergé told *The Economist* that it was the funeral of his collection … "Everyone would like to attend their own funeral, but it's impossible and this is the closest thing," or something like that. And I read somewhere else, I forgot where, that their collection is a self-portrait, a half-zero of nothingness! I realize what I have achieved – if anything at all – is something far more modest in scope. That's not a value judgment, however. If you've got it, why not flaunt it, right? Not that they had any (I don't think), but no Fabergé eggs for me, thank you. Instead, I have Guillaume Bijl's queer eggs – three billiard balls in a bird's nest.

It's wrong to have favorites, but I hope you come across my Tom of Finland drawings. I bought them late, but I don't regret it. Those pictures are partly about not regretting anything. I wonder if others like them will finally find homes in more serious museums, or if it is still left to people like me to treasure them? Those drawings

also demand that we live bravely and together, not alone. Some poetic lyrics by W. H. Auden and Chester Kallman come to mind. I offer them here, alongside everything that I have forgotten:

When you see a fair form, chase it.
And if possible embrace it,
Be it a girl or a boy.
Don't be bashful: be brash, be fresh.
Life is so short, so enjoy.
Whatever contact your flesh
May at the moment crave:
There's no sex life in the grave.

First published in: *Elmgreen & Dragset, The Collectors, Bagalogue/Calendar*, 53rd Venice Biennale, published by the artists, 2009.

A rt as such does not exist. It is the result of an ongoing and always open process of representation, perception, and acceptance. In recent decades, the criteria by which art is judged have undergone a fundamental shift, impacting all authorities concerned: art museums and institutions; broadsheet criticism and art magazines; books and catalogs; art history and cultural studies; galleries, dealers, and auction houses; art fairs, biennials, and triennials; artists and collectors of contemporary art. One may adopt a critical position, conform, or build alliances. But ultimately, no one escapes the art system with its complex weave of social and economic interests.

For a long time, art was something for a small circle of experts and connoisseurs with exquisite taste, and it was judged accordingly in terms of the extraordinary and the sublime. In the late 1950s and the 1960s, this changed. With new collage techniques, happenings, and performances, artists like John Cage, Jasper Johns, Allan Kaprow, and Robert Rauschenberg declared war on Abstract Expressionism, preceding the emergence of Minimal, Conceptual and Pop Art as new artistic currents. In political and social terms, the field was dominated by the protagonists of the counterculture and the protest movements, the beatniks, hippies, and students of the 1968 uprising – against the Vietnam War and the global rule of capital; for flower power, free love, and drugs. In Europe, artists articulated their protest in movements like Situationism, Arte Povera, Fluxus, and Vienna Actionism, all claiming to unite art and life in a new vision of society. The traditional definition of art was expanded to include political, social, and theoretical issues – something many traditional art historians still haven't come to terms with. The logical consequence and commercial flipside of this development from "high" to "low" was the founding of international art fairs, beginning in 1967 with the Kunstmarkt in Cologne, followed in 1970 by Art Basel. Freed from its ties to prestige and elitism, art became a commodity.

In the late 1960s and the 1970s, this development entered its theoretical phase. Post-structuralism, deconstruction,

Dreams that Money can Buy

Art as Dream Factory or Force of Opposition. A Collector's Perspective
Harald Falckenberg

Crash...Boom...Bang! 2008. Stainless steel, birch plywood, canvas, paint, stencilled lettering, packing materials. 410 × 277 × 264 cm. Courtesy of Victoria Miro Gallery, London.

and the much discussed "linguistic turn" with signifier and signified as key criteria became the discursive blueprints employed by analysts and philosophers such as Richard Rorty, Roland Barthes, Gilles Deleuze, Jacques Derrida, and Michel Foucault. The death of the author was proclaimed, along with the end of the geniuses and the art superstars. The linguistic turn refers to art becoming a *lingua franca* of signs and symbols. Interventions by artists like Michael Asher, Robert Barry, and Daniel Buren were directed against museums and the apparatus of producing and distributing art. At art academies in the 1970s, painting was largely abandoned. Critical art defined itself in terms of social relevance, with installations, environments, photography, film, and video as its preferred media.

The antagonism forged in the 1960s and '70s between art oriented towards the market and mass tastes on the one hand, and, on the other, a critical understanding of art as a system of social practices directed towards a transfer of knowledge and experience across disciplines ("breaking down boundaries") continues today. There was one thing the two camps agreed on: abandoning the distinction between high and popular culture. Consequently, the crisis of the museums, of art history, and cultural journalism as the traditional authorities for judging art was a foregone conclusion. How was one to react? By polemicizing, like renowned art historian Anne-Marie Bonnet, who described the relationship of the museums to modernism as a "fateful affair." Or by resisting, like Eduard Beaucamp, conservative art critic for the German newspaper *Frankfurter Allgemeine Zeitung*, who called on museums to block the landslides of young contemporary art?

But the landslide could not be stopped. In his treatise *The Language of Post-Modern Architecture* (1977), Charles Jencks announced "the death of modernism." It was a settling of scores. The great political and artistic visions of the twentieth century for the creation of a new society, even a new humanity as proclaimed to the generation of 1968 by Che Guevara with the figure of the "Hombre Nuevo," had failed. The following period has

gone down in history as postmodernity, an age without binding systems or standards. Architecture and art anticipated what occurred in political terms a decade later with the collapse of the Eastern Bloc.

Hamburg and above all Berlin – where in 1978 Martin Kippenberger took over the SO 36, a bar specialized in punk and new wave – threw down the gauntlet to Cologne and Düsseldorf, the traditional bastions of German post-war art. "Junge Wilde" as Kippenberger, Werner Büttner, Albert Oehlen, and Georg Herold began their absurd and anarchic pogo dance through the cultural landscape. Full of pomp, often biting off more than they could chew, they mounted their ironic and cynical attacks on false pathos, soul-destroying correctness, and the luster of bourgeois posing. The glue that held this group together was their laughter in the face of everything. They weren't interested in alternative models for society, seeking instead to subvert the prevailing system of order and culture with caustic mockery, at most pointing to rudimentary utopias and romanticisms that were doomed to failure. In the early 1970s, Joseph Beuys insisted: "Every human being is an artist." A decade later came Kippenberger's laconic response: "Every artist is a human being."

In the 1980s, "desire" and the pleasure principle of consumer society became a leitmotif. The Pictures Generation began its triumphant progress. After long years of theory-based art forms, painting – known in art market jargon as "flatware" – was back in vogue. The Junge Wilde, Neo-Expressionists, Transvanguardia, and protagonists of Appropriation Art like Richard Prince, Jeff Koons, and Haim Steinbach became figures in a movement that abandoned all scruples concerning the commercial exploitation of art and engaged offensively with the art market. Thought was no longer spared for the elitist notion of an artistic oeuvre as a life's work. Bad painting, deskilling, and fast careers in the pop-star vein were the order of the day. *From Criticism to Complicity* was the telling title of an event at Pat Hearn Gallery in New York, in 1986. Artists had become complicit with the market. Desire and pleasure were now associated with addiction, and the combination of hedonism and narcissism constituted the extravagance that has always been a driving force in the art world. What a change! Just twenty years earlier, in 1963, Marcel Duchamp, perhaps the most important artist of the twentieth century, had his first major retrospective at the age of 76, five years before his death, in provincial Pasadena, away from the acknowledged international centers of the art world.

The art boom of the 1980s – it has been claimed that in terms of value, more art was sold in this one decade than in all the preceding centuries – came to an abrupt halt at the end of 1990. In economic terms, the culprits were the end of Japan's dreams of global expansion and the collapse of the market for new technologies.

In the years 1990 through 1997, the art market almost came to a standstill. Artists went underground and organized in self-help groups, picking up on strategies and techniques of intervention and deconstruction from the 1960s, and '70s. In the 1990s, the notion of "Kontextkunst" [context art] gained currency, focusing not on the artwork but on the underlying conditions, on the social, institutional, and site-specific framework, and on the artistic praxis as a working model. The aim was a humanization of society, with feminism, gender, AIDS, urbanity, and post-colonialism as central issues. This development is represented by artists like Fareed Armaly, Andrea Fraser, Renée Green, and Christian Philipp Müller. Niklas Luhmann's system theories on the functioning of the art world were widely discussed. And the idea of "art as operating system"[1] was offered as a blueprint of an artwork's path from its conception by the artist into the hands of the buyer. Art theorist and media expert Peter Weibel, who coined the term "Kontextkunst," put it as follows: "The art product becomes almost invisible measured against historical expectations. The old question: Is that art? is replaced by the question: Where is art?"

Documenta 10 and 11 were platforms for critical art. The biennials and triennials that emerged during the 1990s, now numbering over fifty per year, also accorded it a central position. The "linguistic turn" was followed by the "pictorial turn" and "visual culture." The image had

1 Thomas Wulffen (ed.), "Betriebssystem Kunst," in: *Kunstforum International*, no. 128, 1994.

Safe/Dot Painting 2004. Canvas, paint, stainless steel safe door, combination lock. 138 × 152 × 5 cm. Courtesy of the artists and Mimi and Filiep Libeert Collection, Belgium.

asserted itself as a communicator of global cultural and political issues, and new academic courses in visual and cultural studies established themselves alongside art history. At the biennials and triennials, control was taken over by a network of curators operating internationally. "Impresarios and masters of ideas," as Beaucamp polemically put it, "who play the part of super-artists, training insecure individual artists to become living proof of their theories." This was impressively illustrated in 2007 by documenta 12, curated under the concept of a "migration of form" by Roger M. Buergel and Ruth Noack, who promised a turning away from the dictatorship of the market and who drew great praise ahead of the exhibition. The outcome was devastating – the only thing that added up was the visitor numbers.

From 1998, the art market came back to life. The lust of the 1980s had been replaced by calculation, the place of hot desire taken by cold greed. The most influential factor here was probably the decision by international auction houses to include young contemporary art in their programs. On December 8, 1999, the collection of Berlin artist Herbert Volkmann, with works by a number of still young but well known artists, was auctioned at Christie's in London. The auction was a shock as it went against the career-building work performed by galleries. Many, artists included, saw it as a betrayal. Anger on the part of gallerists, however, was limited. They soon saw the opportunity for strategic bidding as a means of keeping market prices for young art stable and – better still – pushing them up ahead of planned exhibition openings. A decisive influence was exerted by the grand-master billionaires Bernard Arnault, François Pinault, and Charles Saatchi, who openly began to harness art to their global market strategies – aided and abetted by the many speculators and financial jugglers who, faced with a superfluity of cash, invested in young art, long-term via dubious funds, and short-term by returning it to the market via auctions. This created an unprecedented art boom, outstripping the turnover of the 1980s many times over.

After the "decade of desire" in the 1980s, the period from 1998 through 2008 is likely to go down in art history as the "decade of greed." The development of recent decades is not without its ironies. Beginning with the avant-garde aim of moving art beyond elitist notions and anchoring it in people's lives, it has now returned to a society of the spectacle with sponsoring and large-scale events, and a market with prices affordable only to a few rich individuals and exquisite art institutions. This can certainly be understood as a refeudalization of art under altered conditions – as symbolized by the exhibition of post-Pop works by Jeff Koons at the Palace of Versailles, funded to a large extent by Koons collector and Christie's owner François Pinault and curated by an employee of Pinault's and Laurent Le Bon from the Pompidou Center. The show opened on September 10, 2008. Coming just a few days later, however, it was September 15, 2008, that was to enter the annals of art history as the day that highlighted the links between art, commerce, and speculation like no other. This was the day Damien Hirst bypassed his gallerists and principal patrons Charles Saatchi, Jay Jopling, and Larry Gagosian – possibly with their support – and sold over two hundred works specially made for the auction at Sotheby's in London, raising the incredible sum of 111 million pounds. It was also the day that Lehman Brothers Bank in New York, a key player in international finance, declared itself bankrupt, with consequences that are still affecting entire economies around the world. In the meantime, the speculators have disappeared, and with them the art market that set such excessive store in the hype surrounding the young and the new. More and more galleries are having to close, and yet the media continue to report record prices paid at auctions and leading galleries. The superrich are not bothered by the crisis. Their money is on established art, which they buy as an investment. The current state of affairs sums up the development already captured in 1986 by the notion "From Criticism to Complicity."

Art as a status symbol and luxury accessory for the rich people of this world is just one aspect of a more general development. Art has risen – or perhaps we should say: sunk – from its former status as a critical authority and force of opposition to that of a new dominant culture

and mass media in post-industrial society. This has to do with the wishes, desires, creativity, and individuality of people who no longer see themselves as being represented by politics and who insist on sovereignty in the cultural domain. According to statistics from the Berlin Institute for Museum Research, 107 million people in Germany visited museums in 2009, more than football stadiums or cinemas.

Yet the museums find themselves in a still unresolved crisis of meaning. Originally created as bulwarks of the educated bourgeoisie, they are now required to maximize their visitor quotas with large numbers of exhibitions in order to avoid cuts to their already scanty state subsidies. There is little money left over for maintenance of the collection, new acquisitions, or research, leading to a reliance on societies of friends and businesses in the form of public-private partnerships. Exhibitions are increasingly co-financed by galleries, art dealers, and collectors. Today, the rule of thumb for the larger museums is that eighty percent of visitors come for temporary shows, and just twenty percent for the permanent collection. As a result, the independence of museums is in jeopardy, and with it their authoritative role in the assessment of art. The once much-used term "museum piece" now carries little weight.

Classical criticism is also in trouble, being especially hard hit by the general decrease in advertising revenues in the media. Of course there are still outstanding critics writing for leading broadsheets. But the funds available are not sufficient to adequately cover the flood of public and private events. Besides the very small number of staff writers, there are many poorly paid freelancers who depend on other jobs as writing catalog essays and curating exhibitions to make ends meet. All too often, their pieces are based on pleasantries, since negative commentary might lose them future jobs. Coverage reflects reader interest in major events, new museum buildings, developments on the art market, and personal stories about collectors. Fewer and fewer column inches are devoted to art.

The clear winners of the way art and culture have developed over recent decades are the art market with its international fairs, galleries, and auction houses, and the big museums in New York, Paris, London, and Vienna, whose special exhibitions draw several million visitors every year. These are joined by the bi- and triennials and large-scale events like documenta, and, last but not least, the many art magazines attempting to offer an overview of a world now beyond the grasp even of experts. Art as the new dominant culture is firmly in the hands of the mass media. The borders separating art from design, fashion, and advertising have long since been crossed. Art and culture are tapped for their creative potential on all levels of the media and marketed as society gossip. Here is how German tabloid *Bild* reported the opening of the Art Cologne fair on April 15, 2011: "Important art, even more important VIPs! Art has become the religion of high society. The guest of honor at the opening was Gabriele Inaara Begum Aga Khan. She was better looking than much of the art on display."

This development is relentless and not just a passing hype, as some unshakeable optimists think. Art as religion, a theory put forward not only in tabloid newspapers, may seem absurd, but it touches on the spirit of a society looking – beyond the jaded, opinion-poll-driven pragmatism of politics and the unresolved global culture wars – for a common denominator in postmodern times. The result of this search for new guiding values is necessarily vague. For many, it is certainly a matter of the often romantic desire for an untainted world of higher meaning. But behind such rose-tinted views of the art world as a source of salvation stand the hard currencies of money, power, and prestige. The art world is a participatory model in the sense of the old surrealist idea of *Dreams That Money Can Buy*. The dream factory of art is accessible to all – whatever their budget.

In the course of this development, the status of the artist has been enhanced hugely, to the point of idolization. But the price of this success has been high: affirmation of the art system, bowing to the dictates of taste, and dependence on gallerists and curators. Creating something distinctive and new while participating in the system, however, is a balancing act mastered by only a few artists.

One can observe a return in art to style, skill, knowledge, and the long-scorned portraiture of power. Pictures and works that are politically correct but stand little chance of gaining access to the mass media networks with their focus on taboo-breaking and transgression. The stars of the scene are doubtless those artists who take artistic fate into their own hands and use a paid staff to create a self-made institution.

On account of their personal connections to artists, gallerists, auction houses, museums, and critics, collectors are among the most important networkers in the art system. But few are aware that they are participating under the conditions of the art system in a role-playing scenario that is only temporary and which comes to an end when the show is over. In January 2002, I wrote a piece for the *Frankfurter Allgemeine Zeitung* titled "Restricted access. Museums no longer want private collections." Increasingly, this is the reality. So much of the time and money available to art institutions is consumed by their exhibition programs that little remains for collection-related activities. Single works and ensembles that fit into the collection are welcome, but usually no more than this. The reluctance of museums to take on collections is one of the main reasons for the setting up of so many private museums in recent years. But for personal and financial reasons this solution, too, is only temporary in most cases. The old dream that one's collection might become a monument to oneself is a thing of the past.

The result of this survey is sobering – which is not necessarily a bad thing. We see professional businesspeople and speculators, museum directors and critics who can no longer do what they want to do, beguiled collectors chasing dreams, and exhausted artists who have submitted to the imperative of smooth functioning either as accomplices of the market or as "cultural workers" in the socio-political field. Art as a force of opposition? Since the early 1960s, a battle has been fought against the subjective. Today's art system has developed various forms of dependence and manipulation. It seems essential to redefine the artist as subject and figure of resistance.

Translated from the German by Nicholas Grindell.

Capitalism Will Collapse From Within 2003. Canvas, paint, stainless steel safe door, combination lock. Painting: 120 × 200 cm. Safe: 90 × 90 cm. Courtesy of the artists and Mimi Dusselier Collection, Belgium.

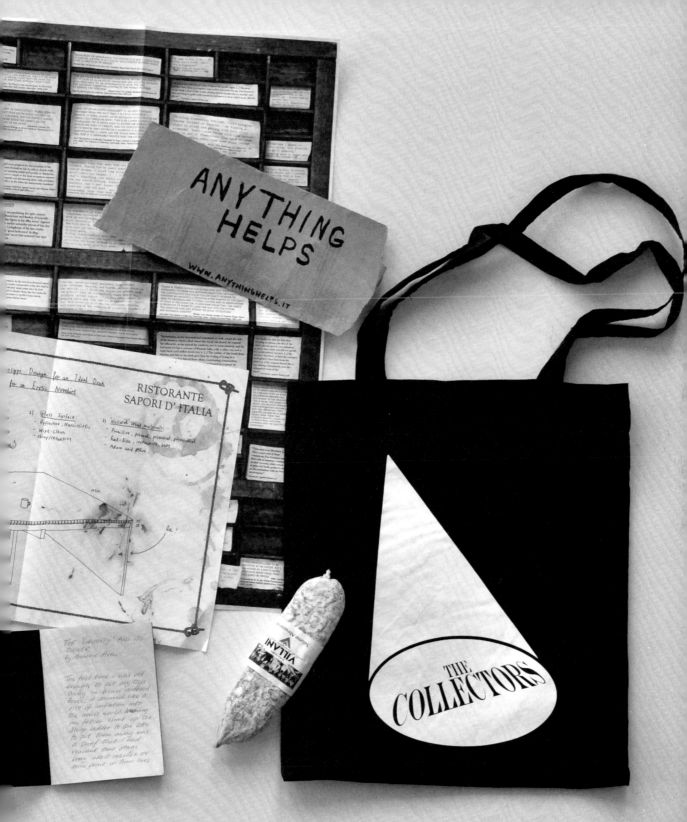

Welcome to TimesPeople
Get Started

TimesPeople Lets You Share and Discover the ... Recommend

HOME PAGE | TODAY'S PAPER | VIDEO | MOST POPULAR | TIMES TOPICS Try Times Re...

The New York Times Art & Design

Search All NYTimes.com

WORLD U.S. N.Y. / REGION BUSINESS TECHNOLOGY SCIENCE HEALTH SPORTS OPINION ARTS STYLE TRAVEL J...

ART & DESIGN BOOKS DANCE MOVIES MUSIC TELEVISION THEATER

Artwork to Display, or to Enjoy With Eggs

By RANDY KENNEDY
Published: July 3, 2009

To the many tricky questions that have arisen in the field of contemporary art, two more have been added in recent weeks: How do we get the salami? And once we get it, what are we going to do with it, besides making sure that someone doesn't tuck into it by mistake?

Enlarge This Image

Hazel Thompson for The New York Times
A salami given by an artist at the Venice Biennale. More Photos »

The cured-meat item in question is, as you might expect, not an ordinary one. For the 53rd Venice Biennale, which got under way last month and concludes in November, 500 of this particular kind of fat-studded salami were chosen to be more than just cold cuts by the Italian artist Maurizio Cattelan, known for provocatively funny work involving taxidermied animals and comical sculptures. They were elevated to the status of works of art — ready-mades in pig casing — in conjunction with a highly theatrical installation for the Nordic and Danish pavilions created by the artistic team of Michael Elmgreen and Ingar Dragset.

The pavilion was transformed meticulously by the two artists into what looks like two well-appointed homes of wealthy collectors: one owned by a family that has put its just-so house and all its expensive artworks up for sale, the other owned by a novelist neighbor — apparently, judging from bits of evidence, a gay party boy — who is nowhere to be seen until you walk out the back of the house and see a body, presumably his, floating face-down in the pool.

Multimedia

Slide Show
Art Imitating Lunch

Called "The Collectors," the installation became one of the more popular attractions during the Biennale's opening days, presenting itself as a dark, funny post-mortem on the suffocating world of the international art-collecting class in an economy (once) run amok.

In that spirit, actors posing as well-dressed agents for the fictional Vigilante real estate company handed out goodie bags to people who took a "buyer's tour" of the family's house. And unbeknownst to most of those who walked away with the bags, they contained much more than a tchotchke or a catalog. Maybe as a way of implicating the visitors as collectors themselves, the bags contained limited editions of small works by prominent artists like Terence Koh, Hernan Bas, Jonathan Monk — and Mr. Cattelan.

Interactive Feature
A Wealth of Art in Venice

And so began the unlikely questions at the intersection of art and salami.

More than a decade ago the library of the Sterling and Francine Clark Art Institute in Williamstown, Mass., began to concentrate on collecting rare artists' books and other, less conventional booklike works produced by artists around the world since the 1960s, and it has since built substantial holdings.

Related

Times Topics: Venice Biennale

Blog

ArtsBeat

The latest on the arts, coverage of live events, critical reviews, multimedia extravaganzas and much more. Join the discussion.

More Arts News

A booklet and paper dress-up doll by Clémentine Deliss, titled, "Between Object and Organ: Powerless Collections." Design by Andreas Koch.

A collection of postcards by Martin Jacobson

In 2007 the institute decided it would be a good idea to begin gathering such materials at the Biennale; the Clark's librarian, Susan Roeper, and her colleagues knew that these materials often turn out to be important and are very difficult to obtain from galleries or publishers after Biennales end.

"The only way to get it, really, is to be there," Ms. Roeper said.

So in 2007 and again this year, the Clark asked Thomas Heneage, a veteran London art-book dealer, to be there in its stead, making his way through the Biennale as its personal catalog and art-book gatherer.

When Mr. Heneage (whose wife, Carol Vogel, is a reporter at The New York Times) returned to his hotel room after a visit to the Nordic Pavilion, he said, he casually upended his goodie bag.

"And suddenly there rolled out onto my hotel room floor this salami," he said. "And I was a bit thrown because I hadn't been expecting to see a salami. And I picked it up and said, 'Well, it looks pretty good, and I think I'll eat it later.' So I put it into the hotel minibar fridge."

But after reading the materials in the bag and examining all the other tiny art objects, he realized he was in possession of a bona fide art salami, with potential historic value — especially because, he surmised, most people who came across their salamis would either eat them or throw them away.

He quickly e-mailed the Clark with one of the strangest bibliographical communiqués he had ever sent. "It's not every day you get to ask a museum library if they would like a salami," he said.

Ms. Roeper said her initial reaction was one of giddiness, "like, how cool is that?"

"And then it became a practical one of, 'Well, how are we going to get this thing here?' " she said. "You can't mail it. You can't fly with it, or it might get seized." The museum has yet to work out the particulars fully with customs officials, but she said: "I think we'll be able to get good guidance on this from other institutions. I'm not worried — we'll get the salami." (For now, it is filed in Mr. Heneage's bookshop refrigerator.)

Asked how the salami would be stored in the library, Ms. Roeper said she hoped her conservation experts "could refer me to a good housing solution," but added that she did not expect to be able to preserve it for decades, like a book. "Sometimes you just have to accept loss as the natural state of these materials," she added.

Mr. Cattelan, reached this week by phone in New York and told about the predicament, laughed uproariously and said that as far as he was concerned, somebody should have dined on the salami long ago. Asked why he decided to make an "edition" of store-bought salami, he said simply: "Always, when I am reading an art catalog and it's not a very good catalog, I wish I had a sandwich to eat. I wanted to do something nice for people."

He added that if the Clark were unable to import the salami, he would happily go to Little Italy to buy a replacement.

"I will customize the catalog for them, yes," he said. "It doesn't matter which salami, really — only that it is a salami that is very, very delicious."

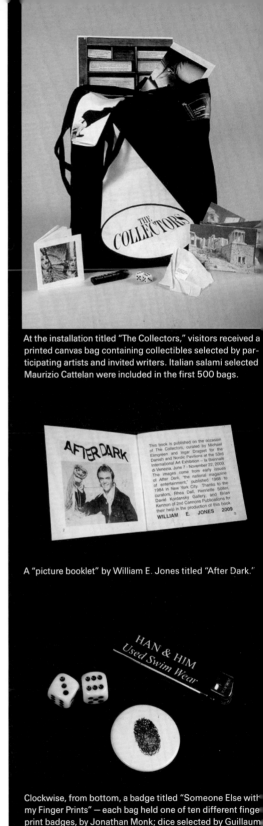

At the installation titled "The Collectors," visitors received a printed canvas bag containing collectibles selected by participating artists and invited writers. Italian salami selected Maurizio Cattelan were included in the first 500 bags.

A "picture booklet" by William E. Jones titled "After Dark."

Clockwise, from bottom, a badge titled "Someone Else with my Finger Prints" — each bag held one of ten different finger print badges, by Jonathan Monk; dice selected by Guillaum Bijl; and a lighter, titled "Used Swim Wear," by HAN & HIM

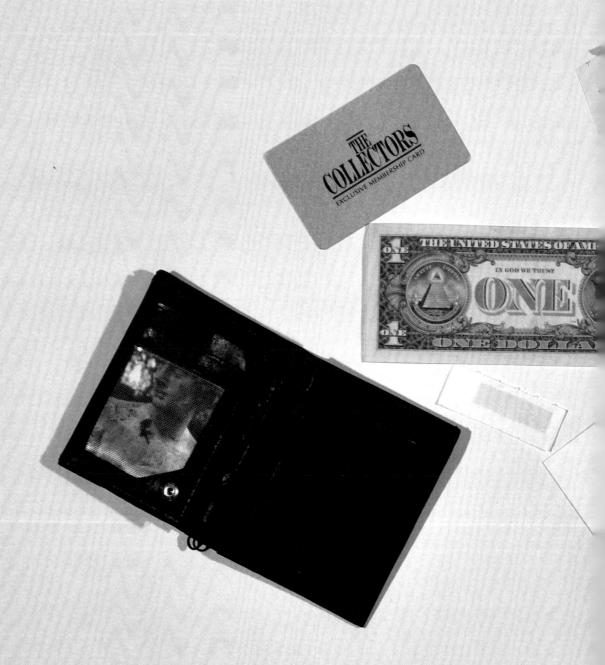

Edition for *Texte zur Kunst* 2009. Mixed media.
10.5 × 8 × 2 cm. Courtesy of the artists.

(I'm getting around the fact that I don't know if there are 31 days in August)

Tuesday ?, Venice, Italy

Dear B – My Wounded Wood Dove,

Greetings from the Adriatic Pearl. It's magnificent here, I'm delighted to be here, and don't want to hear another word about Berlin. I'll never go near that Berlitz German book again - no more „Was ist das" und „Wo wollen Sie hin" for me. All that's lacking here is yourself, tripping between the pigeons and the cats.

It's calm after the giant art hurricane. Quiet as in a desert (though encapsuled by canals). I'm not sure whether we are protected or trapped in this place but I like my voluntary exile. Living in Berlin is a like living in the bedroom of a psychotic teen. It expects the whole world to change with every new pubic hair it sprouts forth. Oh, but my Venice! No progress, no regress! Timeless beauty everywhere – flattering and suspect.

I'm really so foolishly pleased with such vast extents of art that I'm falling into a bottomless pit of delight. I can't tell you how my legs ached last week or, what's more remarkable, how little I minded. Forgive me - the high aesthetic life doesn't, alas, make for inspired letters...

...Which brings me to the weather: At the beginning of the week, the sun went into hiding for a couple of days, and when it came back, it had turned as gold as a grape. The most intoxicating light! It's truly a marvel to know Venice well, to see what you think you can know turn in a day into something more exquisite, more blazing than you think you can bear - the hard whites go cream and roses, and the dry stucco: rich as autumn leaves. You realize, being here with me would be the only way out of dreary letters about the weather! Come see for yourself - ought we begin to plan?

I started a poem last night... and then dropped it and went back to my insufferable novel. It would be just too boring not to finish it, and besides, once I have finished it, I'll be free to entangle myself in something else. It's not for want of inspiration - the lodgings are simply majestic. The house is as delicious as a crime story, and it's ALL glass - can you imagine? They call it 'modern'. Perverse, I call it - but appealingly so. In any case it's a brilliant contrast to the rest of the city. Quite the fox among the pigeons, if you'll excuse the crudity of my pun. Speaking of transparency, the droves of scantily clad young men sunning themselves by the pool never seems to cease (You, my dear, are the one thing I want in my bed – when are you coming?). The neighboring family seems none too amused - although it seems to be the one thing that distracts them form their protestant self-absorption. They are 'Northern Europeans' and thus they have a great appetite for the strangest kind of unhappiness. I'm starting to think of myself as a great philanthropist. A Charity Man. I'm certain they would have killed each other if they didn't have my darling boys to complain about!

I am kicking in the love pool, and you are being covered in my splashes.

I do miss you,

J

ARAS.Aufrufanlagen.de

Bitte warten
Sie, bis Ihre
Nummer

106

aufgerufen
wird. Danke !

HAHN GmbH Ingenieurbüro Berlin

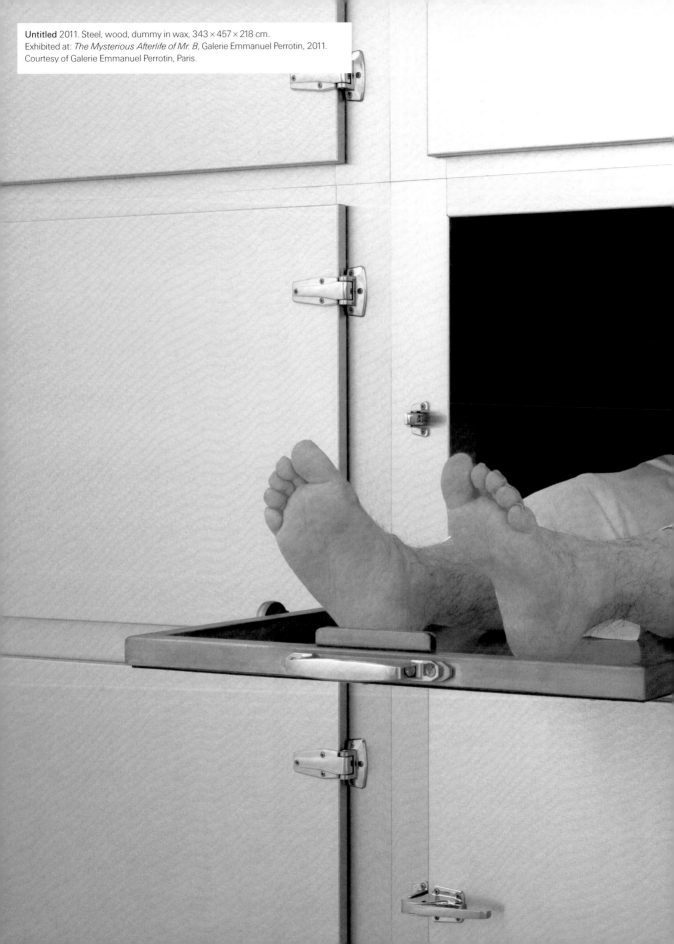

Untitled 2011. Steel, wood, dummy in wax, 343 × 457 × 218 cm.
Exhibited at: *The Mysterious Afterlife of Mr. B*, Galerie Emmanuel Perrotin, 2011.
Courtesy of Galerie Emmanuel Perrotin, Paris.

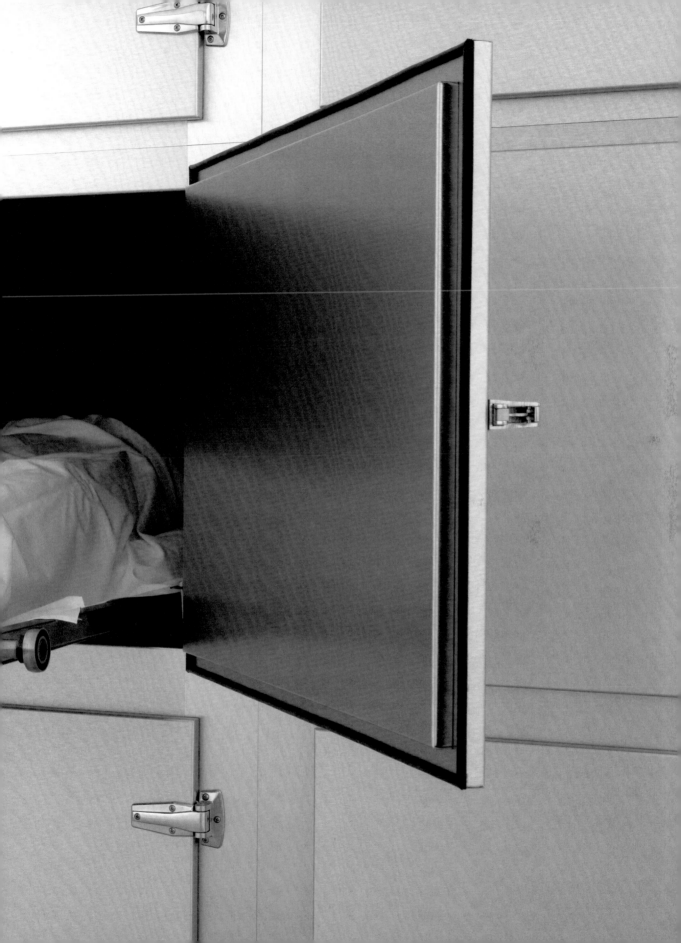

Bergen Kunsthall, Norway
26.05.–21.08. 2005

BAWAG Foundation, Vienna, Austria
16.09.–26.11. 2005

Serpentine Gallery, London, UK
26.01.–26.02. 2006

The Power Plant, Toronto, Canada
25.03.–28.05. 2006

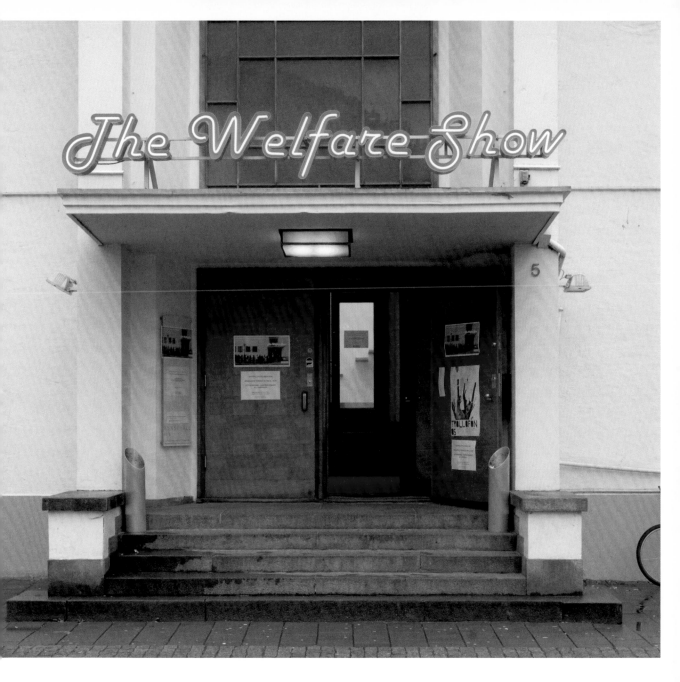

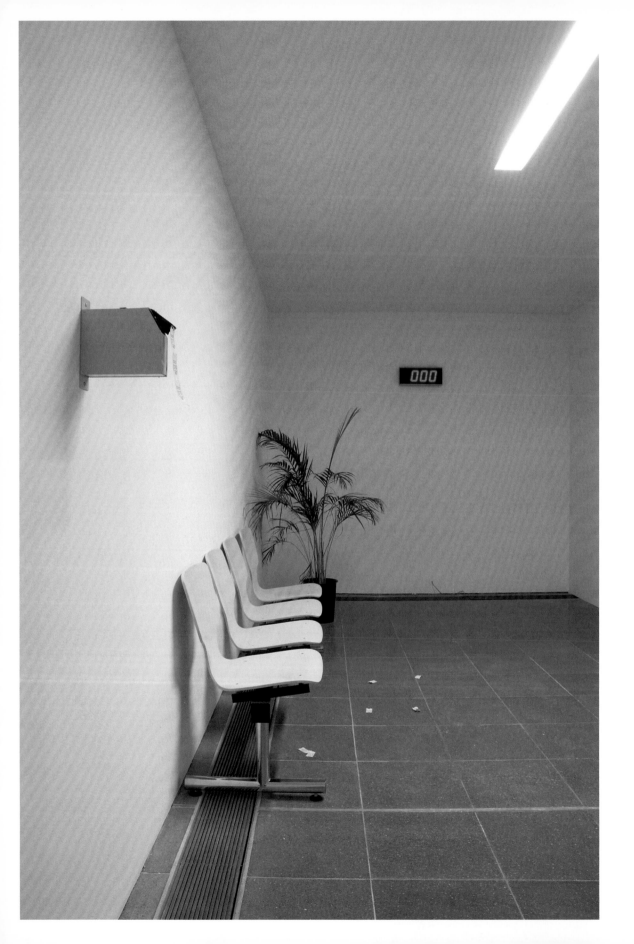

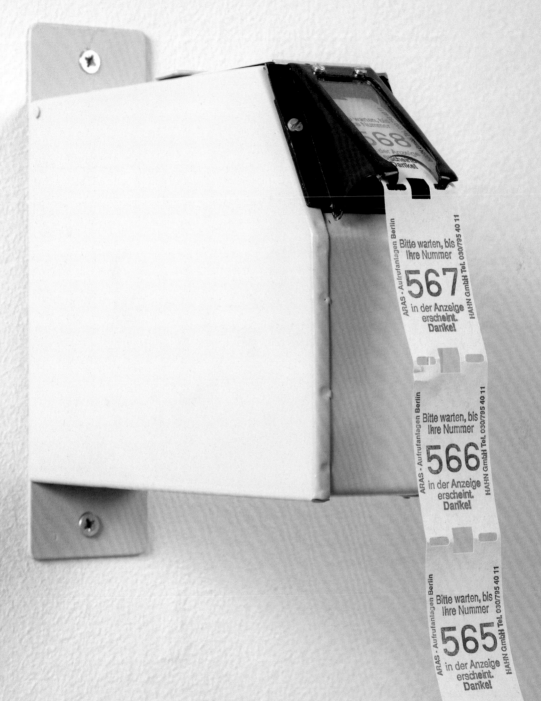

ARAS - Aufrufanlagen Berlin

Bitte warten, bis
Ihre Nummer

567

in der Anzeige
erscheint.
Danke!

HAHN GmbH Tel. 030/795 40 11

ARAS - Aufrufanlagen Berlin

Bitte warten, bis
Ihre Nummer

566

in der Anzeige
erscheint.
Danke!

HAHN GmbH Tel. 030/795 40 11

ARAS - Aufrufanlagen Berlin

Bitte warten, bis
Ihre Nummer

565

in der Anzeige
erscheint.
Danke!

HAHN GmbH Tel. 030/795 40 11

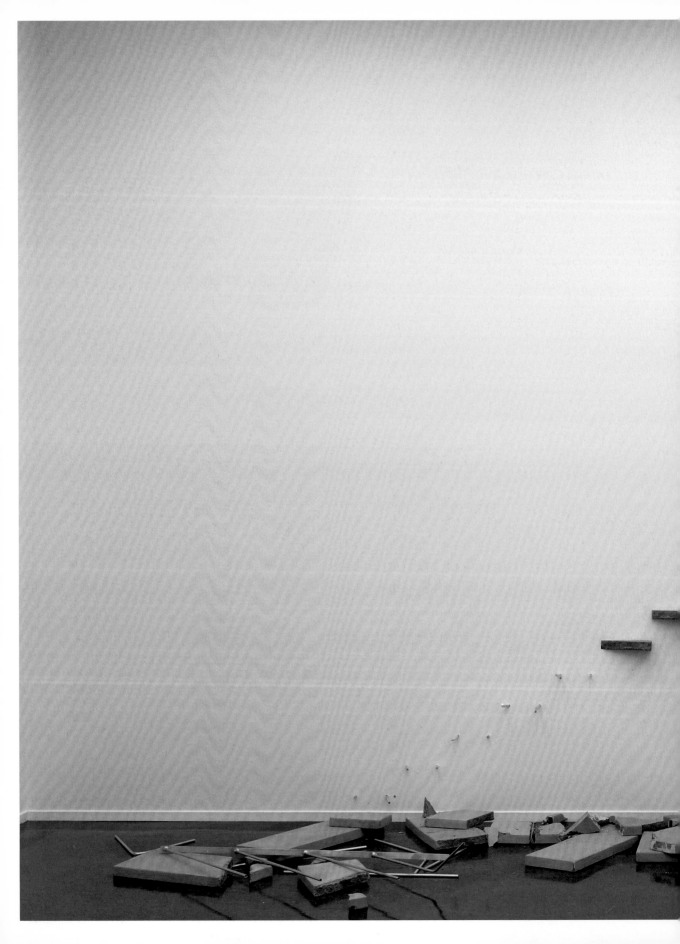

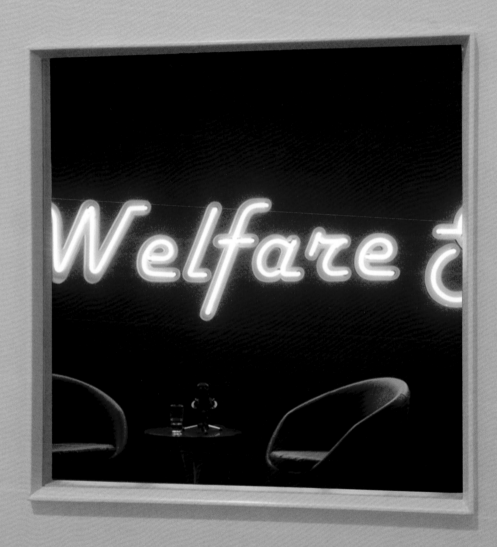

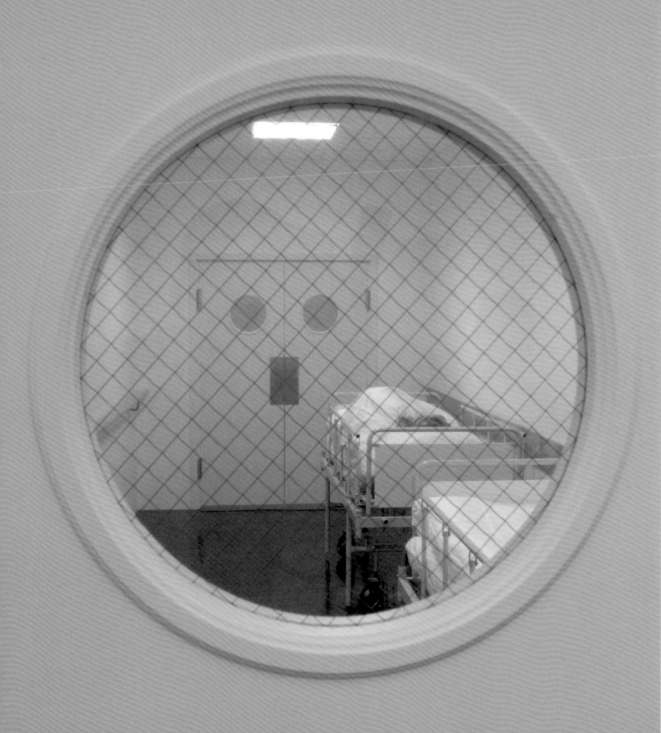

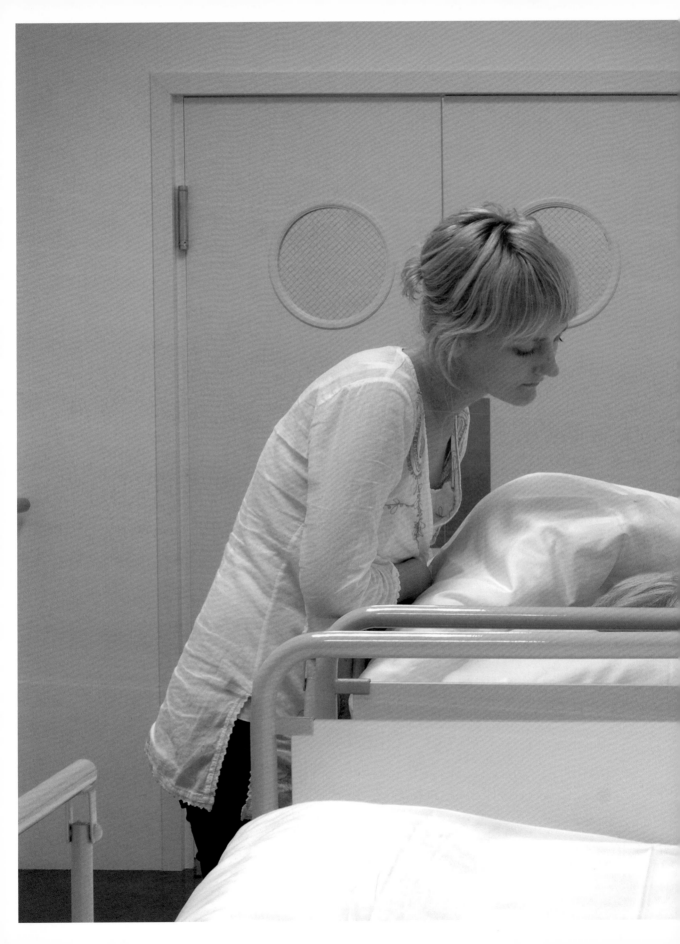

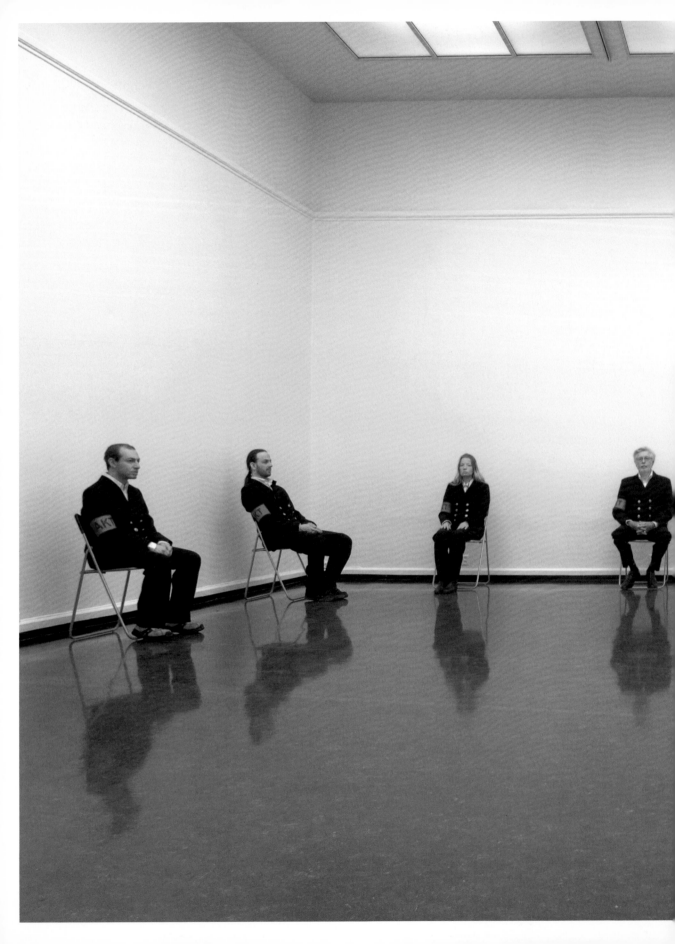

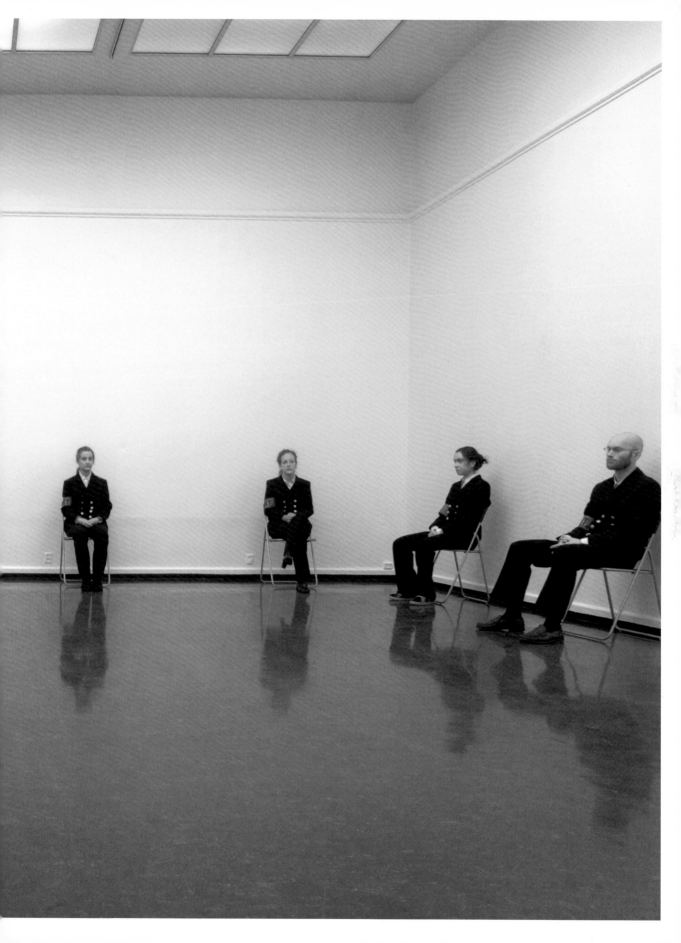

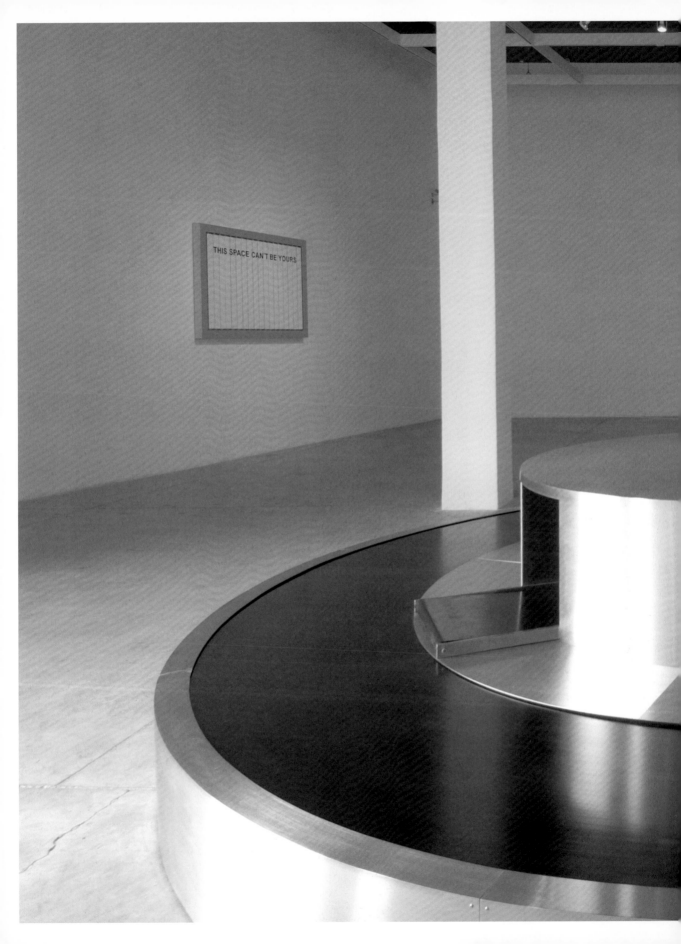

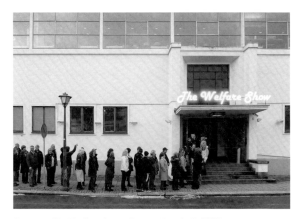

Entrance, The Welfare Show, Bergen Kunsthall, 2005.
Courtesy of the artists.

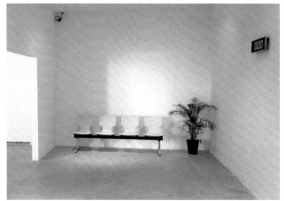

It's The Small Things in Life That Really Matter, Blah, Blah, Blah
2006. Wood, door handles, hinges, paint, electronic number display,
number dispenser, potted plant, seating arrangement with 4 seats.
Dimensions variable. Courtesy of the artists.

Social Mobility Fig. 1 (Administration)
2005. Aluminum, wood, styrofoam, iron, concrete, profile lettering.
Collapsed stairs leading to administration doors. 430 × 700 × 200 cm.
Courtesy of Galleri Nicolai Wallner, Copenhagen.
Social Mobility Fig. 2 (Emergency exit)
2006. Courtesy of Galleri Nicolai Wallner, Copenhagen and Thyssen-
Bornemisza Art Contemporary, Vienna.

Untitled
2006. Wood, handles, hallway with five doors. Each door:
206.5 × 100.5 × 4.5 cm. Courtesy of Galleria Massimo De Carlo, Milan.

Interstage
2005. Hospital beds, bedding, wax figure, pajamas, wooden molding, wood doors, modular ceiling, aluminum railing, light armature. 250 × 700 × 300 cm. Mockup of a hospital corridor with a lonely patient lying in a hospital bed. Courtesy of Galleri Nicolai Wallner, Copenhagen.

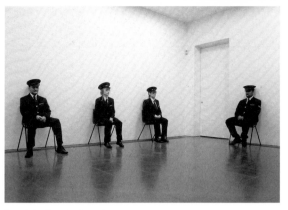

Re-g(u)arding the Guards
2005. Museum guards in empty gallery. Between six and twelve uniformed museum security guards sitting along the walls of an otherwise empty room, watching the audience and each other. In the London version the guards were recruited from the unemployment office. Courtesy of the artists.

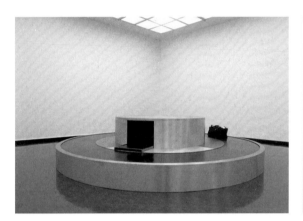

Uncollected
2005. Aluminum, wood, rubber, travel bag, flight tag. Baggage claim carousel with a piece of left luggage. 100 × 500 cm. Flight tag varies from location to location, such as IBZ–LUT (Ibiza to Luton) for the London version. Courtesy of Galleri Nicolai Wallner, Copenhagen and Galleria Massimo De Carlo, Milan.

This Space Can't Be Yours
2006. Billboard with rotating panels, aluminum frame, plot. 146 × 209 × 13 cm. Courtesy of the artists and Galleria Massimo De Carlo, Milan.

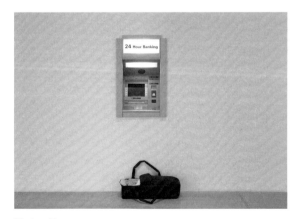

Modern Moses
2006. Carrycot, bedding, wax figure, baby clothes, stainless steel cash machine. Ca. 37 × 71 × 16 cm (Baby carriage), ca. 94 × 76 cm (cash machine front). Courtesy of Galleria Massimo De Carlo, Milan.

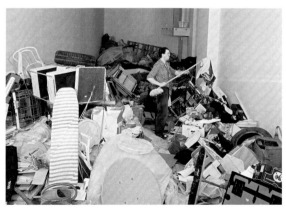

Untitled
2005. Mixed media. Dimensions variable. Two viewing points with coin operated telescopes. One located at the entrance from which one could observe the guests in a posh restaurant across the street. The other located in the BAWAG Foundation director's office with a view into an exhibition space dumped full of rubbish with a performer rummaging through it. Courtesy of BAWAG Foundation, Vienna.

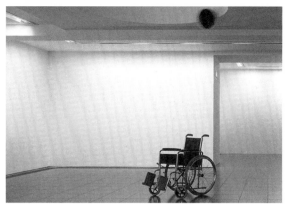

Birthday
2002. Wheelchair, balloon, helium. 240 × 101 × 57 cm.
Courtesy of Galleria Massimo De Carlo, Milan.

Socks at Woolworths.
2006. Mural painting. Dimensions variable. Courtesy of the artists.

The Welfare Show
2006. Neon sign, wooden door, glass window, chairs, table, microphone, glass of water, papers. Dimensions variable. Neon sign: 57 × 447 × 22 cm. Dark and empty television recording studio set under neon "The Welfare Show" sign. Courtesy of Galleria Massimo De Carlo, Milan.

Go Go Go!
2005. Brushed stainless steel platform, acrylic glass, polished stainless steel pole, light bulbs, light controls, mop, bucket with dirty water, floor sign. Platform: 50 × 170 × 120 cm, pole length variable due to installation (max. 6 m). Courtesy of Galleria Massimo De Carlo, Milan.

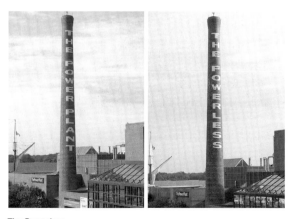

The Powerless
2005. Documentation exists as a series of 7 C-prints in one passepartout. Each: 22.5 × 14.5 cm, framed: 40 × 142.3 cm. Conversion of The Power Plant's signage on an industrial redbrick chimney to "The Powerless." Courtesy of The Power Plant, Toronto.

Untitled
2005. Telescope. Coin operated telescope, through which viewers can see the Kunsthall accountant working on the other side of the exhibition wall. 150 × 58 × 68 cm. Courtesy of the artists and Bergen Kunsthall.

o kick off the Frieze frenzy in London in October of 2008, Michael Elmgreen and Ingar Dragset opened their installation *Too Late* at the Victoria Miro Gallery. While Frieze lost prominent headline coverage to angst-ridden articles on the United Kingdom's financial crisis, the art fair put its best foot forward. Its directors coordinated with prominent galleries and caterers to distract attention from stories of a bedraggled Gordon Brown attending to the effects of a deregulated Anglo-Saxon economy. The opening week of *Too Late* also coincided with a one night showing of a "play" by Elmgreen & Dragset called *Drama Queens* at the Old Vic, as well as with a special publication insert in the journal *Art Review* authored and formatted by the duo. All three pieces – one could say, presciently – offered occasions for pondering the speculative foibles of art market malaise. Such pieces followed and preceded other projects in which Elmgreen & Dragset explore the pleasures and perils of art market enmeshment. As recounted in other parts of this volume, *The Collectors* used the context of the Venice Biennale to show the menacing underside of art world fetishization, while *Celebrity – The One & The Many* critiqued the superficiality of such a culture even as it displayed their (and our) absorption by it. One might well wonder what, if any, relation *The Welfare Show* has to Elmgreen & Dragset's ongoing examination of the insidious conviviality of art world institutions. Why this exploration of social welfare institutions by a duo who enjoys and endures such a prominent place on the biennial circuit? What place does social welfare occupy in this catalog's trilogy?

While I do a more extended examination of the context and content of *The Welfare Show* as it circulated in 2005 and 2006, I would like to suggest that the links between these elements in Michael Elmgreen and Ingar Dragset's *œuvre* are rooted in a primary ambivalence widely shared across the globe. Such an ambivalence shuttles between an identification with the liberatory pleasures and flexible freedoms promoted by private, capitalist systems and an identification with the collectivist dreams and shared protections of public, socialist imagining. Before and since

Welfare Melancholia

Elmgreen & Dragset's Ambivalent Structures
Shannon Jackson

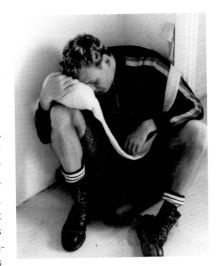

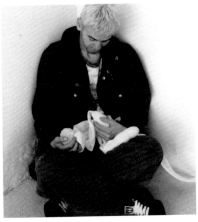

1 **Untitled** 1995. Studio Matts Leiderstam, Stockholm. Images from Michael Elmgreen and Ingar Dragset's first collaboration. Courtesy of the artists.

the financial crisis of 2008, nations and citizens have been struggling to redefine national and economic systems in an effort to respond and propel changing definitions of the social. And our own shuttling between the freedoms, precarities, protections, and constraints of each solution – the bail-outs and the tax breaks, the directive to conform to austerity measures in the same moment we are directed to consume – betrays a pervasive ambivalence about the future of the social. Hence, it is within this kind of twenty-first century context that Elmgreen & Dragset's explorations of both welfare systems and market systems turn out to have a strange continuity.

In what follows, I introduce the work of Michael Elmgreen and Ingar Dragset by considering its relation to a changing century's discourse on power, structure, and institution. I then move on to a lengthier analysis of *The Welfare Show* to ponder the ways in which its forms and its reception bespeak the paradoxes of institutional transition within liberal social welfare and neoliberal models of marketization. What I am particularly interested in here, are the ambivalences that emerge when "institutional critique" is directed at public institutions. I conclude by returning to *Too Late, Drama Queens,* and other recent works sited in a context that grappled with the freefall in both market yields and in pension reserves. Throughout Elmgreen & Dragset's experiments, we see the possibilities and perils of launching a socio-economic intervention from within – very much *within* – an art world space. Elmgreen & Dragset's mixed-media work resides, after all, in a decidedly mixed economy.

Structuring Powerlessness

Born in Denmark and Norway respectively, Michael Elmgreen and Ingar Dragset have worked together since 1995. Initially co-creating performances before moving on to ever larger sculptures and installations, their work now enjoys art-world *cachet*. At the same time, they consistently engage issues of social space by developing formal vocabularies that extend and rede-fine the concept of institutional critique. Chronicles of their early biographies usually make reference to their personal heritage as Nordic queers. Though the artists do not have formal art degrees, Elmgreen spent some time writing poetry and Dragset studied the Lecoq tradition at drama school. Elmgreen held odd jobs as an interior decorator and also worked occasionally in a home for the elderly. Dragset worked as theater instructor for children and mentally handicapped youth, as well as in hospitals as a nurse's aid. Mentioned less – though we will learn about it later – is the fact that along the way they also received unemployment benefits and educational subsidies from a Scandinavian welfare state. When asked about the roots of their collaboration, it is performance that emerges as a kind of personal and professional glue between them. Dragset helped Elmgreen knit some "abstract pets" for one of his art installations, small items that "the art audience could hug and nurse and feel confident with."[1] "In Stockholm nobody feels relaxed at openings, so we had to show the audience how to feel confident and how to use these knitted pets, and then everybody thought it was a performance – so it became our first performance … by coincidence."[2] [FIG 1] The coincidental turn to performance takes shape as demonstration, a primary interaction to induce future ones, a gestic engagement that animates and is animated by the theatrical prop. Indeed, even before a more considered turn to sculpture and installation, Elmgreen & Dragset's sense of performance was rooted in an interest in the structuring potential of the object world. "Almost any cultural object is performative. If you take the coffee pot, it's waiting for us to make coffee in it. If you have a chair, it's waiting for you to sit on it. […] So I don't see the objects that we're doing totally apart from the performances we're doing. It is all part of the same system."[3] While their interest in the specific form of performance art waned, their preoccupation with its attendant systems continued. Around 1997, they decided to move from Northern to Continental Europe, specifically to Berlin, to reorient their careers and launch a series of projects under the

1 Hans-Ulrich Obrist, "Performative Constructions: Interview with Hans-Ulrich Obrist," in: *Powerless Structures,* exhib. cat., Reykjavik Art Museum, Reykjavik, 1998, n.p. Also available online at: http://www.nicolaiwallner.com/artists/micing/text1.html (accessed December 2010).
2 Ibid.
3 Ibid.

concept of *Powerless Structures*. Announcing that the title "is derived from our misreading of Foucault,"[4] in a roundabout way they entered into a larger discussion on questions of institutional relations, invoking inherited social frames for pitting and pitching selves and structures in opposition to each other. Foucault "speaks about how the structures themselves can impose no power – only the way we deal with them … any structure could in fact at any point be altered or interchanged with a new set of structures … These nomadic tendencies have certainly had an impact on our work and on our ideas of a more flexible public infrastructure."[5] In characterizing the goal of their interventions, "flexibility" was often cited as their word of choice. "New museums and McDonald's are the most standardized forms in the world now … the problem with them is that they are not flexible."[6] Indeed, "inflexibility" was the worst thing that they could say about a social space. Whether it was a social welfare operation, a store, a museum, or – following the Foucauldian analogy – a prison, increased flexibility was the goal of aesthetic intervention.

Even if they had turned away from the biographical inflections of performance art, an interest in agential resistance within structures still very much animated their theatrical replacements of the object world. An earlier performative subjectivity thus gave way to a performativity of space, one that did so to engage the legacies of a different kind of sculptural theatricality linked to the Minimalist gesture. Their 1997 piece sited at the Louisiana Museum of Modern Art in Denmark installed a diving board through one of the museum's panoramic windows, perching the board with Hockneyesque ebullience inside (and outside) a museum itself perched high on the edge of a cliff overlooking the Baltic Sea. [FIG 2] In 1998, they found themselves in Reykjavik, Iceland, this time offering *Dug Down Gallery / Powerless Structures, Fig. 45* in which they embedded a white cube gallery structure in the ground in front of the Reykjavik Art Museum, a gesture that altered the spectatorial relation to the gallery. [FIG 3] That relation, by virtue of its dug-down infrastructure, was no longer at eye level, or rather, looking at

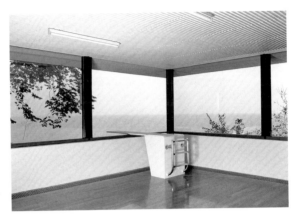

2 **Powerless Structures, Fig. 11** 1997. MDF, slide-proof rubber, aluminium, glass. 60 × 75 × 200 cm. Courtesy of the artists and Louisiana Museum of Modern Art, Humlebæk.

3 **Dug Down Gallery / Powerless Structures, Fig. 45** 1998. Wood, paint, office furniture, halogen spots. 220 × 320 × 500 cm. Galleri I8 in the public park of Kjarvalsstadir, Reykjavik Art Museum, Iceland. Courtesy of the artists.

4 Brian Sholis, "Interview: Michael Elmgreen and Ingar Dragset," in: *Ten Verses*, 2003. Available online at: http://www.briansholis.com/interview-michael-elmgreen-and-ingar-dragset/.

5 Ibid.

6 Quoted in: John McGee, "Elmgreen and Dragset: Suspended Space," in: *Metropolis*, 456, October 2003. Available online at: http://metropolis.co.jp/tokyo/456/art.asp.

7 Hans-Ulrich Obrist, op. cit.

8 Erin Manns, "Artworker of the Week #55" (includes interview with Elmgreen & Dragset), *Kultureflash*, November 2005. Available online at: http://www.kultureflash.net/archive/142/preview.html (accessed May 2009).

9 Daniel Birnbaum, "White on White," in: *Artforum*, April 2002, p. 101.

eye level no longer meant looking above ground. Other pieces such as *Powerless Structures, Fig. 111* at Portikus in Frankfurt, Germany, in 2001, altered the perceptual apparatus of the gallery by refiguring the space, this time by arching the hall's floor and skylight by over a meter, creating an elastic wave within the once austere and rational white cube of the gallery. [FIG 4] Like many artists associated with institutional critique, alterations of "white cube systems" propelled their work, whether that white cube was the undoing of a gallery space, as above, or the undoing of a sculptural object. In their *Suspended Space* (2002), they stacked pieces of walls and ceilings at odd angles, producing a configuration where no flat surface appeared to be self-supporting; in their *Powerless Structures, Fig. 187* (2002) at Klosterfelde in Berlin, both the gallery and sculptural conventions where undone by a cubed packing crate, suspended in the process of crashing through the gallery ceiling.

If in Foucault's *History of Sexuality*, they had decided to learn that "all structures can be altered or mutated. […] the patterns could be different. It was just a question of imagination,"[7] then Foucault's status as queer precursor was part of that mix. "We both grew up being fags from the suburbs, which kind of teaches you not to take too much for granted … So you start to wonder if things really are as they have been shaped through tradition and conventions, or if they inhabit the possibility of developing into something else, something more open."[8] That openness or unrecognized flexibility was thus also something that had a sexual politics, one that launched "a gay infiltration of Minimalism's famously macho aesthetics;"[9] Elmgreen & Dragset cite the influence of Félix González-Torres as a precursor for such an infiltration.[10] In *Cruising Pavilion / Powerless Structures, Fig. 55* (1998), queer politics joined with Minimalist precedents to prompt both a relational and spatial expansion located outside an art institutional space.[11] [FIG 5] In offering "a visually spare gay cruising area – to accommodate all kinds of encounters and transactions," Elmgreen & Dragset thus politicized the referent for "the relational" in an emerging discourse of relational art.

4 **Powerless Structures, Fig. 111** 2001. Plywood, perspex, aluminium, vinyl, fluorescent lighting. 480 × 750 × 1500 cm. Portikus, Frankfurt am Main. Courtesy of Galleri Nicolai Wallner, Copenhagen.

5 **Cruising Pavilion / Powerless Structures, Fig. 55** 1998. Wooden boards, cherry wood, paint, perspex, rubber, matting. 230 × 400 × 400 cm. Marselisborg Forest, Århus, Denmark. Courtesy of Galleri Nicolai Wallner, Copenhagen.

10 Hans-Ulrich Obrist, op. cit. With González-Torres, "we hung out and spoke a lot about how gay people suddenly discovered the use of Minimalism, as the ultimate kind of infiltration into the history of high art. So dealing with Minimalism was a kind of challenge for a gay person – also to break the stereotype image of gay people being, you know, interested in camp and being very feminine in their way of expressing themselves."

11 Brian Sholis, op. cit.: "A park in Aarhus, Denmark, became the site of a gay cruising pavilion; its form mimicking the architecture of galleries while mixing private with public and to bring before visitors the activities that are often conducted in parks, however surreptitiously."

Welfare's Power and Powerlessness

To launch an art career in Western Europe in the mid-nineties, especially a career that invoked the art discourse of institutional critique, was to live in a context that was developing very specific ambivalences toward concepts such as institution, system, or governance. It was also to live in a context that was developing very specific, if not fully-processed, attachments to concepts that could occasionally be placed as their opposite – say, "flexibility," resistance, or agency. In the presumably "post-socialist" era conveniently marked as "post-1989," phrases like "the fall of communism" and "the end of the welfare state" mobilized a variety of systemic changes that we have come to associate, again in fast and vague terms, with neoliberalism and globalization. The systemic changes launched in post-national nations were, and are, uneven, varied, and changing. But the discursive context they shared is one that questioned the historic role of the state in managing interdependent systems of human welfare, including those that regulated provisions for healthcare, social security, unemployment, disability, pensions, transportation, utilities, dependent care, and more. Increasingly read as "anachronistic" structures whose bureaucracy constrained human beings, policy-makers across the European Union and North America were encouraged to create societies of increased flexibility and more opportunities for individual life choices. Curiously, in art worlds and other contexts of the critical humanities, politically left discourses that valued agency and resistance strangely chimed with neoliberal discourses that valued individual choice and deregulated flexibility. On the one hand, these discourses came from vastly different sensibilities. Flexibility and choice were the terms of a neoliberal mantra that argued for deregulated capitalism. Agency and resistance were the terms of a critical mantra of the left that argued against constraining operations of social power. Oddly enough, however, a discourse of flexibility and a discourse of resistance could work in unwitting reciprocal support.

If institutions were not to be trusted, if regulation constrained, if bureaucracy was a thing to be avoided, and if disciplining systems of subjugation were everywhere, then a generalized critique of system pervaded not only neoliberal policy circles, but also avant-garde artistic and intellectual circles of the left where freedom was increasingly equated with systemic *in*dependence. Arguably, then, a number of people were misreading Foucault.

When Michael Elmgreen and Ingar Dragset began making *Powerless Structures*, social theorists were coming to terms with the concept of structure posed within discourses that opposed flexibility and constraint, or others that re-labeled the same opposition "risk" and "security." Anthony Giddens's widely circulated book, *The Third Way,* would try to loosen oppositions between terms such as flexibility and security (and the capitalist and socialist frames attached to them). Giddens's project eventually ensconced him within the advisorial offices of Tony Blair, the U.K. prime minister credited, or to Tony Benn blamed, for the neoliberalization of New Labour.[12] Meanwhile, Giddens's sociological counterpart in Germany, Ulrich Beck, achieved a different kind of critical renown in articulating the economic and sociological puzzles within the language of "risk." His *The Risk Society* and subsequent books (again, almost one a year) underscored the degree to which the operations of flexibility necessarily invited the experience of risk, imagining social life and its choices as a gamble toward an unknown future, one whose apparently individuated freedom masked the threat of individual precarity.

Within the domain of the critical humanities and political theory, Wendy Brown would try to clarify the discursive field in which terms such as "liberal," "neoliberal," "welfare state," "capitalism," "Left," and "Right" were bandied about. For Brown, it was crucial to remember that a tradition of liberal democracy differed notably from a neoliberal configuration in which all actions are figured as those of a *"homo economicus"* propelled by the exhaustive logic of "market rationality."[13] Liberalism, by contrast, was based on conceptions of rights-based equality and freedoms, a compromise appeal to non-

12 See Tony Benn's article, "Utopias and the Welfare State," reprinted in this collection, pp. 350.
13 Wendy Brown, "Neoliberalism and the End of Liberal Democracy," in: *Edgework: Critical Essays on Knowledge and Politics*, Princeton University Press, Princeton, 2005, p. 40.

market morality that underwrote the formation of welfare states – albeit not exactly the emancipation of labor that some leftists hoped for under socialism. "Put simply," says Brown, "liberal democracy has provided over the past two centuries a modest ethical gap between economy and polity. Even as liberal democracy converges with many capitalist values … the formal distinction it establishes between moral and political principles on the one hand and the economic order on the other has also served to insulate citizens against the ghastliness of life exhaustively ordered by the market and measured by market values."[14] For Brown then, the over-riding question was how to formulate a social vision of the Left in an environment where even liberalism's compromises had been eroded. As the language of entrepreneurial speculation now saturated everyday life, it also rationalized the dismantling of a liberal welfare state, paradoxically robbing leftists of the object whose inadequacies had been an object of critique. Such critique had, in fact, defined what it meant to lodge left critique, finding in liberalism's compromises evidence of "its hypocrisy and ideological trickery, but also … its institutional and rhetorical embedding of bourgeois, white, masculinist, and heterosexual superordination at the heart of humanism."[15] How could one continue to call for the public radicalization of social structures, however, when neoliberal mechanisms had already undone them? What to do when even a mild variant of patriarchal humanism could not fight an empowered *homo economicus?* Brown used the language of "melancholia" to characterize leftist critical ambivalence – a state that needed to reckon with the "psychic / social / intellectual implications for leftists of losing a vexed object of attachment."[16] While, classically, melancholia refers to a subject's refusal to relinquish a lost love object, critical leftists were now losing an object that they had loved to hate, a distasteful object made more complicated by the fact that it was also one that the leftists – again to quote Brown – "cannot not want."

Debates amongst European and North American intellectuals about self and structure and changing socio-economic systems cannot be adequately represented by any list that I could offer in this essay. But I use that brief snapshot above to give a general sense of the domain in which we find the operation of institutional critique emerging and, more particularly, of the generalized mistrust of "structure" that would welcome a series like *Powerless Structures*. To look at these post-1989 debates from the vantage point of 2011, however, prompts a new set of questions. Rather than asking how social structures can be radicalized, we now find ourselves asking whether they can be retained at all. What do we do, meanwhile, with our mistrust of social structures, the affect of skepticism, doubt, and irony that has energized our immanent social critiques? What, furthermore, do we do when a critical language of flexible resistance becomes appropriated by a discourse of flexible markets? What do we do when mistrust in social regulation paradoxically supports a project of economic deregulation?

Michael Elmgreen and Ingar Dragset moved to Berlin, in part, to give themselves new challenges and new opportunities as artists in an international city that combines relatively low rent with relatively high artistic energy. To make such a move also meant leaving a Scandinavian social system; that group of generous, rigorously organized states lauded as examples of successful welfare societies. In many ways, "Scandinavian" is the mythic signifier of a supportive state structure, perpetually referenced within the European Union as a high tax / high service model that may not last, and invoked by various of North American and especially U.S. artists whenever they wish that their lives were better. For Elmgreen & Dragset, however, Scandinavia's reputed systems of care were not necessarily worth the constraints that they created; moving to Berlin was partly about finding a less normative environment. "It was quite a relief when we first arrived here from the hyper-organized Scandinavian society, where anyone thinks that the world is about to go under if the bus is five minutes late."[17] The exchange of a Scandinavian system for a continental one, specifically the mix of economic capitalism within a well-funded

14 Ibid., p. 46.
15 Ibid., p. 53.
16 Ibid.
17 Brian Sholis, op. cit.

social state that has characterized the German model, thus provided the ground for their investigation of structures and their interest in flexible architectures. Socially, they were equally concerned with the normative dimensions of citizenship that constitute certain aspects of the Scandinavian welfare system. The heterosexism of family provision was one example. Before their move to Berlin, they created a piece that parodied new same-sex adoption laws; for *Human Rights / Funky Hair* [FIG 6], they adopted a nine-year-old boy for a day, dyeing their own hair red and yellow, and his orange. "Most rights are given only to obtain further government control with certain groups that don't fit into the dominant cultural system. It is wrong to claim that we have obtained any gay rights. What we have been given is a set of diminished heterosexual rights to enter the institution of marriage, and even that is not in any way comprehensive. We have been given the opportunity to be second-rate citizens with second-rate citizens' rights instead of being what we always were – outcasts."[18] By thus framing their post-1989 performance piece, we find Elmgreen & Dragset engaging in a version of what Wendy Brown identifies as a queer "Left" critique of liberalism, criticizing "its hypocrisy and ideological trickery [and] ... its institutional and rhetorical embedding of bourgeois, white, masculinist, and heterosexual superordination at the heart of humanism."[19] *Human Rights / Funky Hair* (1996) read same-sex rights not as a benevolent welfare privilege, but as a system of social and sexual subjugation. The Nordic welfare system was one whose liberal accommodations they would continue to criticize from the Teutonic sidelines. Notably, the creative criticality they found on those sidelines was made possible by a strain of Anglo-Saxon "neoliberalism" taking hold in a Berlin-based speculative art market.

In/stalling Welfare

Elmgreen & Dragset's large-scale installation, *The Welfare Show*, began in the Bergen Kunsthall in Norway in the same year their homage to / critique of Prada opened in Texas. From there, it moved to the BAWAG Foundation in Vienna, to the Serpentine Gallery in London and on to The Power Plant in Toronto. The project brought together a variety of media in a multi-roomed installation that dramatized "the administered society." It showed their interest in moving from institutional critique's signature investigation of art institutions to the wider critique of "forms of bureaucracy associated with institutional systems extending beyond the white cube, the welfare system included."[20] As escapees from a Scandinavian welfare model to a continental model in Berlin, Elmgreen & Dragset's piece was a timely engagement with complex issues. More importantly, however, the travels and travails of this project also exemplify a wider network of symptoms as artists, intellectuals, and citizens are currently attempting to launch a critique of social structure. As Wendy Brown suggests, such a position often spawns unprocessed ambivalence and renewed melancholia as artist-citizens critique a form they "cannot not want."[21] As the show altered and responded to the contradicting associations attaching to the word "welfare" within each region of the world, it exposed some unintended ironies in the critique of bureaucracy. It fitfully slid between an effort to render welfare "powerless"... and an impulse to lament the fact that it already was.

The title of *The Welfare Show* has multiple resonances. At the first level, it places the "the show's" spectacular character next to a presumably unspectacular form "welfare," placing a stage beneath quotidian bureaucracy. It also invokes the genre of the talk show, a televisual form that promises debate and engagement while offering pre-packaged banter and controlled catharsis.[22] In the mechanized land of the experience economy, the "show" is also the word attached to the extravaganzas of product display, usually located in conference centers, office parks and corporate campuses where purveyors and buyers gather to share goods, and are ensconced in surrounding hotels with roughly the same shampoo samples and mini-bars. Such mixed associations provocatively struc-

18 Michael Elmgreen and Ingar Dragset, "London, July 9, 2008," in: *Art Review*, October 2008, n.p.
19 Wendy Brown, op. cit., p. 53.
20 Alex Coles, "Exhibitions: Michael Elmgreen and Ingar Dragset," in: *Art Monthly*, 294, March 2006, p. 294.
21 Wendy Brown, op. cit., p. 53.
22 Elmgreen & Dragset note: "Important social issues undergo a certain kitchification through these talk and quiz shows, which might pretend to care about the subject matters that they deal with, but in fact they leave you as viewer completely ignorant and passive," quoted in: Erin Manns, op. cit.

tured the binder-cum-catalog that accompanied the exhibition. An array of sociological texts were gathered alphabetically in a distressed, charcoal gray binder that could have been a corporate catalog or a social worker's casebook. With an old-fashioned and nearly non-functional clip and ring-system, one could barely turn the heavily card-stocked pages from the A's (Adoption, Age, Architecture, Army, Art) through to B (Bureaucracy) and on down the alphabet where E included Economy, Education, Ein-Euro-Job, Environment, Ethics, and Exclusion, where K only equaled Kindergarten, and where P included Patriotism, Pension, Police, Postmodernism, and Poverty. W stood for Wealth and Work, but also a self-referential *The Welfare Show*. The binder ended with Zoo as the only entry under the letter Z.[23] For Peter Osborne, the catalog both defined and undermined the "'pan-European' aspirations" of the project, "as if intellectual seriousness (which includes 'politics' of course) is something of an embarrassment (at best, a hostage to fortune) that needs to be presented under the covers of history, under the cover of pastiche."[24]

Visitors to *The Welfare Show* entered the space and could choose to go either right or left. This apparent sense of choice was soon forestalled by the antiseptic hollowness in every direction – and by the fact that everyone would ultimately finish exactly where they began. *Birthday*, a resuscitated older piece, placed on view an empty wheelchair with a single balloon attached to it. Though an apparatus enabling mobility, the wheelchair was stalled as a static display. That sense of suspended tension was endorsed by the attached balloon; it was held down by the chair even as it seemed to hold it up, invoking both its territorial function as a toy and the aerial possibility of flight. In keeping with a critical stance on liberalism's pieties, the artists hoped to comment on the degree to which disability rights discourse "infantalized" the disabled. But the strength of the work came from a more complex formal resonance, which is to say, a formal ambivalence that exceeded any singular reading. Questions of stasis and movement, flight and constraint, continued in other portions of the installation. *Social Mobility* was

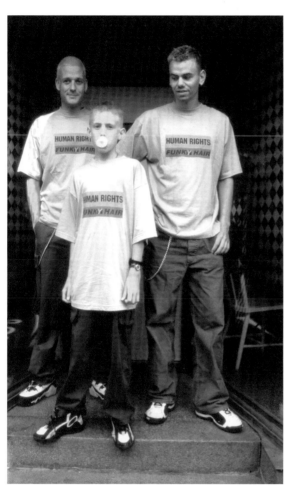

6 **Human Rights, Funky Hair** 1996. Performance. Prosjekt Hårsalongen, varios locations in Malmö. Courtesy of the artists.

23 Michael Elmgreen, Ingar Dragset, et al., *The Welfare Show*, exhib. cat., Walther König, Cologne, 2006.
24 Peter Osborne, "Elmgreen and Dragset's *The Welfare Show:* A Historical Perspective," in: *The Art of Welfare*, Office for Contemporary Art Norway, Oslo, 2006, pp. 19–40, here p. 39.

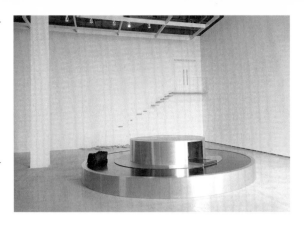

an anonymous institutional space with a less then accessible stairwell perched high above the floor, leading to a mythic doorway labeled "Administration." To examine the crumbling structure perched a few meters above the ground, receivers had to crane their necks with each step closer to the piece. The erosion could have symbolized a defunct welfare state that we no longer needed or a defunded welfare state that we needed back. In a nearby portion of the exhibit, the thwarted promise of mobile subjectivity appeared in different form. Within *Uncollected, 2005* [FIG 7], a lone bag orbited round and round a circular baggage claim, never to stop circulating, never to be picked up.

The central social themes of care and abandonment were particularly active as receivers moved through the depressingly lit, low-ceilinged corridors expressly constructed for *The Welfare Show*. *Modern Moses* [FIG 8] consisted of a reproduction of a cash machine with a mannequin baby lying in a portable crib underneath, juxtaposing the flexible convenience of 24-hour banking and the inflexible weight of 24-hour parenting. Moreover, this suggestion of familial abandonment interacted with the suggestion of public abandonment in *Interstage*. [FIG 9] In this case, visitors saw a hospital corridor encumbered with waiting gurneys and, in one case, a prostrate mannequin waiting for medical attention that would never arrive. That mannequin could have been languishing in an inefficient state-funded institution, or it could have been languishing in a private healthcare operation that would not dare to treat a patient without private health insurance. *Go Go Go* [FIG 10] – a retitled echo of their guiding light Félix González-Torres's piece – reproduced his pole dancer's pole with the trappings of a cleaning person assembled around it, juxtaposing an index of sexual labor (and pleasure) and custodial labor (and displeasure).

Elmgreen & Dragset made different decisions about the spectatorial dynamics of each piece. Several pieces, such as *Social Mobility* or the comfortable chairs of a television studio beneath a neon sign on which *The Welfare Show* was written, were placed as bicameral spectacles before a viewer who was not allowed to enter, but had

7–9 see index

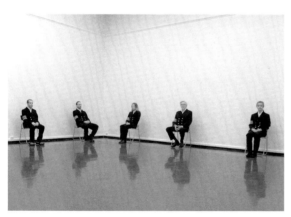

10–12 see index

to view from without. "Throughout our practice we have worked with what you could call denials," Elmgreen & Dragset said, "installations which at first appear as if they were meant to be interactive but in fact don't allow any kind of direct participation by the spectator."[25] *Interstage* included a handrail but – framed as a "stage" separated with framed frontality from the crowd of receivers – was not a rail to be held. The sense of withdrawn invitation appeared in other portions of the exhibit. The potential interactivity of the cash machine in *Modern Moses* was forestalled by a similarly roped off spectatorial dynamic. Some, however, were spaces to be entered, though environmental entrance did not necessarily mean relationality. In *It's the Small Things in Life That Really Matter, Blah, Blah, Blah, 2005,* [FIG 11] spectators were invited to enter a reproduced waiting room, with chairs, a forlorn indoor plant, and a blinking number sign that never changed from zero. The chairs were rooted to the wall, disallowing visitors any potential for rearrangement. As they sat down, thereby becoming sculpturally rooted to the wall themselves, visitors were asked to think about the number of places in which they had found themselves waiting. The pieces also varied in the indexical references to the human, ranging from the metonymic index of the baggage or empty wheelchair to the representational mimesis of a mannequin. Probably the most discussed element of the piece is the one the indexical methods of which most explicitly invite the language of performance. In *Re-g(u)arding the Guards* [FIG 12] Elmgreen & Dragset used the social practice convention of hiring unemployed citizens (the "delegated performance" strategies that now appear in so much social practice art), this time to wear guard uniforms and sit in chairs spaced evenly around a single gallery room.[26] The opening of *The Welfare Show* in Norway could be interpreted as an oddly complicated form of homecoming. It came at a moment when Nordic governments were gradually developing different interpretations of a "third way," and specifically "welfare for work" or "flexi-security" programs with varying social benefits and varying degrees of perceived success. While Elmgreen & Dragset

25 Erin Manns, op. cit.
26 Claire Bishop, "Live Installations and Construction Situations: The Use of 'Real People' in Art," in: *The Art of Welfare,* op. cit., pp. 61-86; see also Bishop's other contributions to the discussion of social practice in *October* and *Artform.*

reportedly tried to maintain an attitude of agnosticism toward these policies at the opening,[27] they occasionally indulged in the role of artist-as-policy-wonk to make clear their discontent with welfare principles.

"The piece developed partly from our own experiences with the welfare system in Scandinavia in the 1990s. The Danes were the first to send people out in all kinds of ridiculous jobs in order to force them to receive full unemployment money. Some of these jobs were absolutely meaningless and others were sort of hidden cultural subvention; a lot of cultural institutions took on staff from the unemployment office, but didn't have to pay for them themselves … This idea of working for your social welfare has later been widely exported – most recently to Germany, where they have created so-called Ein-Euro-Jobs. Most research shows that these initiatives do nothing to get rid of actual unemployment but in some cases cover up statistics and real problems. Everyone knows that it is impossible to keep up the economical models of today and at the same time believe in full employment, but somehow we are not meant to fully realize this. The absurdity of politics forms the rationale of this piece."[28]
In Norway a small crowd at the opening included a delegation from the Office of Contemporary Art in Norway who were "not keen on receiving the guards undivided attention; everyone exited almost as quickly as they entered."[29] But as a national event funded by an oil-rich nation seeking to develop its global cultural status, everyone in attendance had to be a good sport. At receptions and dinners – coinciding with the hundredth anniversary of Norway's autonomy from Sweden – groups "chatted amiably about relative levels of Finnish and Norwegian melancholy, cultural isolation, and private sponsorship of public art."[30] The day after the opening "the Crown Prince and Princess were down the block to cut a red ribbon and inaugurate *The Welfare Show*. Word came back that prison food – literally – was served to the Royals at the officials-only lunch."[31]
A general sense of good, if somewhat bemused, humor pervaded the conference hosted later by the Office of Contemporary Art Norway that invited art historians, economic scholars, and Norwegian politicians to engage in discussion. The motley assembly of perspectives meant that nearly every locution risked a misfire: the inevitable lay expressions of confusion endemic to policy-meets-art conversations. "But can't you explain it to a complete amateur?" inquired trade specialist and former Norwegian Minister of Labor, Victor Norman, of *The Welfare Show*. "Are you thinking of communicating with anyone?"[32] But within the awkward conventions of the post-show panel, these stumblings traversed and revealed intriguing questions. There were tussles between welfare researchers and politicians of different political parties: Victor Norman, a proponent of liberal democracy (which is to say, in Norway, a member of the conservative party) offered his definition of welfare solidarity as "collective egotism, if you like, or perhaps even selfishness."[33] In response, Norwegian sociologist Thomas Hylland Eriksen, a progressive critic of liberal consensus, pressed him further: "Exclusion is probably the main social problem that we are going to have in relation to trust, to solidarity, to support for the welfare system and so on."[34] Meanwhile, art theorists offered their own contextualization of *The Welfare Show* within histories of community art and social practice. Peter Osborne worried that Claire Bishop was not sufficiently critical of the "meglomaniac" instrumentalized use of "human beings within these installations." Bishop argued that we should be worrying more about art within state-run structures of instrumentalization that receive "prioritized government funding" rather than art staged in "the relatively neutral or staged confines of a gallery space." For her, then, the constraints of government funding systems were clearly more worrisome than the "neutral" autonomy offered by gallery systems. The conversation became variously heated when Norman began to imagine the incarnation of welfare ideals. When his ideal of "collective egotism" met questions of monetary distribution, he proposed a "mutual contract" that assigned certain casting policies and fixed social arrangements. "What if we simply paid the people on disability pensions to drink their coffee and talk to people in homes for the elderly

27 Brian Sholis, "Noblesse Oblige," in: *Artforum,* May 29, 2005. Available online at: http://artforum.com/diary/id=9054.
28 Erin Manns, op. cit.
29 Brian Sholis, op. cit.
30 Ibid.
31 Ibid.
32 Marta Kuzma, Peter Osborne, Claire Bishop, Thomas Hylland Eriksen, Victor D. Norman, Michael Elmgreen, Ingar Dragset, "Panel Discussion," in: *The Art of Welfare*, op. cit., p. 130.
33 Victor Norman, "Crumbling from Within: The Microfoundations of Welfare States," in: *The Art of Welfare*, op. cit., pp. 97–114, here p. 100.
34 Thomas Hylland Eriksen, "Response to Victor Norman," in: *The Art of Welfare*, op. cit., pp. 115–132, here p. 114.

instead of doing it in the shopping centre? Then they would be doing a job." And it was at such an experiment in social arrangements – a policy wonk's aesthetics of relationality – that Dragset & Elmgreen began bristling. As Michael Elmgreen said: "I think I consider the morality of participating in the workforce very differently than you do. I was on social welfare for several years in order to put myself together as an artist. Because I never entered a heavily subsidized and very expensive art academy, my education was very cheap for the state of Denmark. What I am trying to say is that there are people who refuse to work and use their time in a productive way."[35] Having crystallized the dilemma of locating aesthetic flexibility within a system of public security, the transcript records show a significant "pause."[36] Marta Kuzma, the director of the Office for Contemporary Art Norway and the panel chair, stepped in to politely request a change of subject.

If targeting the constraining apparatus of a system of care was the genesis of the piece for a Norwegian context, things seemed to change, adapt, and compensate when in London and later in Toronto, where national debates on social welfare, pensions, labor, disability, and healthcare had a different discursive character. It was in this move that Elmgreen & Dragset, and their curators could be found altering verbiage around the piece, now mixing a concern for public institutions in the midst of critiquing their constraints. It is in the self-antagonizing responses surrounding the piece that *The Welfare Show* exhibits the symptoms of a certain kind of melancholic position – one that underscores the "psychic / social / intellectual implications for leftists of losing a vexed object of attachment."[37] The ambivalence that surrounded the tour of *The Welfare Show* bespeaks a larger ambivalence as artists, intellectuals and citizens announce their suspicions of the last vestiges of liberal democracy in the same moment that neoliberal models paradoxically push that critique along. In a variant of the Left melancholic, the welfare melancholic remains attached to an object, a system, a bureaucracy, and a support structure whose inadequacies he or she loved to hate.

The lead up to the show in London included a high degree of wisecracking as critics anticipated that "this could probably rank with snuggling up on a sofa with the latest copy of *Understanding your Tax Code*."[38] By extension, a Toronto critic would worry that this "sounds pretty dull … About as exciting as *Newsnight* on a slow day?"[39] Perhaps such Anglo-Saxon suspicion of bureaucratic reflection prompted Elmgreen & Dragset to sound the tones of a different type of policy wonk.

"It's scary how the term Public has become such a 'dirty' word – something that makes people yawn and which is associated with dull and ugly spaces and heavy bureaucracy. Public should remind us of solidarity and acceptance but instead the neo-liberal economy has managed to give the terms such a bad reputation that most citizens today just think in terms of saving tax money and seem to be okay with the ongoing process of privatization … The control mechanisms of the welfare state – a construction built upon uniformity and regulations – have been its big failure. However, these mechanisms don't disappear with the public responsibility just being handed over to private companies and initiatives. The structures of control remain the same, since uniformity generates the lowest costs and biggest profit. This kind of fear blocks any progress. In the show we have tried to create a feeling of being trapped into a grey-and-white loop where you as an audience have very few possibilities of choice – a feeling of total powerlessness."[40]

Elmgreen & Dragset here thematized the turn to market rationality in the management of heretofore non-economic domains of life. In Brown's terms, they suggested that the solution to liberalism's public faults could not be neoliberalism's private speculation. What was interesting, then, was how this adjustment of discourse and goal – one that was now concerned about the loss of a liberal public institution, not only its limitations and encroachment – interacted with the perception of powerlessness induced by the antiseptic installation. Elmgreen & Dragset clearly hoped that a critique of "uniformity" was transferable between liberal democratic / welfare states and neo-liberal / capitalist systems, where the first was

35 "Panel Discussion," in: *The Art of Welfare,* op. cit., p. 124.
36 Ibid.
37 Ibid., p. 53.
38 Rachel Campbell-Johnston, "We were only being boring," in: *Times Online*, January 24, 2006. Available online at: http://entertainment.timesonline.co.uk/tol/ arts_and_entertainment/article718165.ece.
39 Soren Johansen, "Michael Elmgreen and Ingar Dragset: The Welfare Show," online at www.londontown.com/LondonEvents/MichaelElmgreenandIngarDragsetTheWelfareShow (accessed May 2009).
40 Erin Manns, op. cit.

uniformity "with regulations" and the second was uniformity for the "biggest profit." What this adjusted concern about the rise of the neo-liberal economy did not entirely succeed in determining was how important the critique of uniformity is in enabling processes of privatization, the equivocations on "public responsibility" of which are rationalized by "flexibly" and the offer of more "possibilities of choice."

A certain kind of site-specific heterogeneity can be found by tracking shifts in reception. Indeed, with melancholic ambivalence, the heterogeneity of perception shows this piece both reinforcing extant suspicions of welfare administration and simultaneously provoking its well-intentioned defense. Consider, for instance, one critic's response to *It's the Small Things in Life That Really Matter, Blah, Blah, Blah 2005*: "The work could allude to waiting lists for socialized health care or be interpreted as social security or other public office. It is a generalized but potent comment on how much time we waste … Ask not for whom the queue waits: we are all diminished as we shuffle forward in a post office queue or hold for a response from a call centre."[41] Such a response shows the piece eliciting the inchoate grumblings of anti-systemic individualization, one that sees the public systems as themselves oppressive. The sentiment does not know exactly where to place the blame, indulging the inconvenienced laments of "a flexible self" that wants care to come speedily, personally, and without the time-delaying "shuffle" of "bureaucracy." Such a response leaves unquestioned precisely who is "diminished" – the client wanting a response or the post office worker or call centre operator who personally balances the multiple claims of others? It was just this question that was posed by a Toronto journalist who was concerned that "The installation portion of *The Welfare Show* doesn't give justice to the extent to which those who staff and fund the system are themselves afflicted with burnout." As she towed her eleven-year-old, an engagement largely lacking in irony, *The Welfare Show's* catalog provided the antidote, especially the C entries that included "Canada Pension Plan:" "It highlights the arbitrariness of the actuarial models that

are the basis of government and corporate finance of social and healthcare systems," she wrote, "and, by implication, reveals the fragility of these systems."[42] For this receiver, the catalog was not pastiche.

Many responses were anti-rhapsodies to the feeling of powerlessness induced by entry in the environment. For one critic, certain mannequin-like aspects of the exhibit were overloaded with social concern. Criticizing *Modern Moses* and *Interstage* – "the commentary is far too literal and so the freedom the duo usually grant the beholder to roam is usurped." He turned Elmgreen & Dragset's own discourse of flexibility back on them by asking for more "judicious … flexible scenario[s]."[43] For Adrian Searle, the inflexibility was central to its unpleasant success. "This is horrible. This is grim. These are the circles of hell or, if not, then a purgatory where the soul might die of indifference … a world of accumulated blank hours, of institutional anonymity, of boredom, trepidation, impotence and seething inner rage … part airport, part hospital, part day center, part art gallery. They're all delivering a service and we are all customers now. Am I supposed to tell you, on a scale of one to ten, how satisfied I am?"[44] While for some, the expression of "horror" was an index of success, for others it indicated the failure of the piece. Probably, no response exceeded the expression of disappointment more than that of another blog critic who criticized the whole principle of *The Welfare Show* as an art exhibit in the first place.[45] With critique after critique of each portion of the exhibit, she also showed her political stripes. "[A]lthough *The Welfare Show* is free at the point of delivery, it really is absolutely free, in the sense that I was not being asked, or rather forced, to convey a large portion of my earnings to it in order to keep in action something I neither want for myself nor wish to impose upon others."[46] She concluded her review by urging her readers to consult the conservative and libertarian writers whose criticisms of the welfare state she found much more trenchant. Her response thus highlighted the ambivalent predicament of the piece. Its critical edge depended upon its ability to target liberal receivers for whom the compromised,

41 Colin Martin, "BMJ: Medication Publication of the Year," February 18, 2006, n. p.
42 Andrea Demchuk, "The Welfare Fate," in: *The Rubicon*, May 31, 2006, pp. 15–22. Available online at: http://therubicon.org/2006/05/the-welfare-fate/#more-47.
43 Alex Coles, "Exhibitions: Michael Elmgreen and Ingar Dragset," in: *Art Monthly*, 294, March 2006, p. 294.
44 Adrian Searle, "The Lost World," in: *The Guardian*, January 31, 2006. Available online at: http://www.guardian.co.uk/culture/2006/jan/31/3.
45 Bunny Smedley, "What's the Welfare Show Got To Do with the Welfare State?," in: *Social Affairs Unit Weblog*, February 17, 2006. Available online at: http://www.socialaffairsunit.org.uk/blog/archives/000784.php.
46 Ibid.

but still necessary goals of public welfare were a given. Receivers for whom those values were not a given could find their positions oddly reinforced.

The portion of the exhibit that provoked the most urgent and varied response was also the one that most explicitly deployed the techniques of theatricality. In *Re-g(u)arding the Guards*, Elmgreen & Dragset used the convention of hiring unemployed citizens, this time to wear guard uniforms and sit in chairs spaced evenly around a single gallery room. This use of "real people" in a constructed situation thus bore a more obvious relationship to the discourse of social practice in its deployment of persons and relations of exchange as the substrate of the art event. In Norway, twelve guards appeared from a rotating cast of 36, whereas in London the cast was reduced to seven. The Scandinavian – and Continental – context of the Ein-Euro-Job might have prompted both the change in cast size as well as the different ways that the cast was received. The "meaninglessness" of the Ein-Euro-Job was less resonant for receivers who lived in British or North American contexts where even that provision was harder to find.[47] As a reduced, anti-relational relational exhibit, *Re-g(u)arding the Guards* also varied in the brand of interaction it elicited. As noted above, Norwegian art professionals ran out of the room as soon as they walked in, but others lingered longer. The critic above who valued interpretive flexibility found it in this scenario, partly because the guards themselves were socially engaged: "occasionally plucking up the courage to make a pithy comment to an unsuspecting passerby. Their presence is intimidating but it is funny too … With it, both the duo's deadpan sense of humor and the beholder are allowed to roam freely." For "horrified" critics, however, there was nothing humorous to be found in the depressing non-presence of the security guards: "they just sat there looking into space, like I didn't exist. Like they didn't exist either."[48]

At the conference sponsored by the Office of Contemporary Art Norway, Claire Bishop – the Anglo-Saxon critic most known for her critiques of the social practice form – focused most intently on this portion of the ex-hibit. "In Elmgreen & Dragset's installation the guards are themselves the focus of the observation. We watch them, watching us, watching them: guarding and regarding each other. This surfeit of care – there are more guards than necessary for an empty gallery – might lead us to consider, in the overall context of the exhibition, the excess concern of a welfare state. But this reading is strained and certainly not implicit in the work, which seems instead to focus on the intersubjective dynamic of our encounter."[49] As should be expected from Bishop, this is a very helpful account of the relations of exchange made possible by the ambiguous situation constructed by this section of *The Welfare Show*. At the same time, it seems strange that the question of the piece's relation to welfare is so easily sidestepped. How could a reading of welfare not be implicit in a piece titled *The Welfare Show?* Is there a concern that finding such a reading might compromise the piece with an undemanding literality? If, as she noted above, government funding priorities are themselves more intrusive than market ones, do the resonances of "welfare" have to be kept at bay to preserve the art's legitimacy? If welfare is read as a "surfeit of care" and a site of "excessive concern," its heteronomous encroachment threatens to unsettle the gallery's presumably "neutral" autonomy.

Finally, in the ambivalences of its presentation and the ambivalences of its reception, *The Welfare Show* mimicked the flurry of irreconcilable principles and affects that animate contemporary discourses on social structure. From a certain angle, it cultivated the radical agenda of a critical Left, emboldened by a reading (or misreading) of Foucault, one that mistrusted the bureaucratized legacies and liberal compromises of Old Left social structures. Given the easy slippage, however, from anti-bureaucratic skepticism to neoliberal individualism, the piece and the verbiage surrounding it teetered around this critical agenda. The pieces, the publicity, the interviews, and the accompanying texts clustered as back-formations around each other, shuttling between critiques of welfare's instrumentalization and the dangers of not having a welfare system at all.

47 Erin Manns, op. cit., n. p.
48 Adrian Searle, op. cit., n. p.
49 Claire Bishop, "Live Installations and Construction Situations: The Use of 'Real People' in Art," in: *The Art of Welfare*, Office for Contemporary Art, Oslo, 2006, pp. 62–63.

The denizens of *Re-g(u)arding the Guards* crystallized the conundrum in their sentient sculpturality. And to my understanding, it does not seem strained to read it within the ambivalences of a welfare imaginary. The piece's complex dyadic – interpersonal interactions of gazing and being gazed upon – also invited larger systemic questions about power and powerlessness in the spatially encumbered, temporally ambiguous, interpersonally contingent experiment that might be called social welfare. Museum guards inhabit that paradoxical place in a system of care, both charged with protecting and experienced as constraining viewer spectatorship. They are also cast as functionaries in a system of surveillance, but are themselves relatively weak as agents within it – powerless structures indeed. Finally, these performers were all unemployed, that is, they were individuals who might receive some form of public allocation. Whether or not they would or should seem to be the systemic question to be asked in this unnerving personal exchange. As they stared, mumbled, shifted, or – in several notable cases – ran out to the toilet, the intimacies of intersubjective encounter both structured and were structured by the cumbersome claims of systemic reflection.

Belated Melancholia

The ambivalent effects of *The Welfare Show* provide a more complex frame for returning to the network of the 2008 pieces mentioned at the outset (and, by extension, the later pieces addressed in other parts of this catalog). Poised once more between criticizing an institutional world and announcing their absorption by it, Elmgreen & Dragset reused the conventions of the art world genres in which they were sited. Victoria Miro Gallery publicized *Too Late* as an installation that provided "a mental image of a party that's already over: lights still blinking and disco ball sadly spinning, but there's no one on the dance floor and the last round has been served a long time ago."[50] [FIG 13] *Art Review*, meanwhile, was pleased to offer the duo's meditation in print, with a spe-

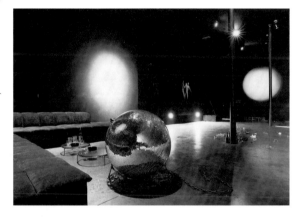

13 **Too late** 2008. Exhibition view Victoria Miro Gallery, London. Courtesy of the artists.
14 **Drama Queens** 2007. Mixed media. Skulptur Projekte Münster. Courtesy of the artists.

cial insert called "The Incidental Self" lodged between gallery publicity and other advertisements for luxury goods. Elmgreen & Dragset's ambiguous engagement with what the gallery-collector-magazine system of aesthetic administration extended somewhat unconventionally by incorporating a traditional theater. The Old Vic – currently headed by celebrity actor Kevin Spacey – promoted *Drama Queens* as a fundraiser for the theater's creativity fund.

Coinciding with the October opening of the Frieze Festival, *Drama Queens* and *Too Late* addressed an anxious milieu. In October of 2008, British and international newspapers all around the world could report on nothing but "the financial crisis" afflicting the investment banks and financial institutions run by the same social class that normally buys the art world's art. One art blogger wondered whether any artist would "seize the moment by creating something or a situation that provokes global artistic thought on a par with the original Frieze exhibition curated by Damien Hirst twenty-five years ago that was actually facilitated by the capricious nature of the art market and the economy at that time." London newspapers and blogs began to trot out twenty-year-old copies of the notorious *Labour Manifesto*. That manifesto was, at the time of the first Frieze exhibit, understood to be the "longest suicide note in history," but its 1983 platform for economic regulation and social pensions now sounded kind of good after all to those feeling the effects of having refused them. The caprices of the 2008 economy were of a different nature or, depending upon one's perspective, made visible the darker side of a capricious system that trades in a dereferentialized brand of speculation. Whether imagined as a system that exchanges art objects or one that exchanges credit swaps, however, there is usually a moment when the referent rears. And this was one of them. With Societé Générale's scandal being tried and the collapse of Iceland's economy just around the corner, various members of the art world prepared to "expect the worst."

If "performance" was something that Elmgreen & Dragset felt that they had left behind in earlier parts of their career, then the creation of *Drama Queens* marked a different kind of return to the form. [FIG 14] This performance piece was wholly different to others, however, not only because it took place in a storied theater rather than a gallery corner, but because, by virtue of the location, it labeled itself a "play" rather than "performance art." In a literalization of Michael Fried's castigation of Minimalist sculpture, *Drama Queens* turned "the silent presence of another person" into a noisy, populated stage. The play embodied as characters seven iconic art works: Alberto Giacometti's *Walking Man*, Hans Arp's *Cloud Shepherd*, Barbara Hepworth's *Elegy III*, Sol LeWitt's *Four Cubes*, Ulrich Rückriem's *Untitled (Granite)*, Jeff Koons' unstoppable *Rabbit*, and Andy Warhol's *Brillo Box*. The text alternates between group dialogue and caricatured soliloquies that repeat art critical statements as the internalized monologue of a sculpture. Says Koons' *Rabbit*, "They said I was nothing, an empty gesture, a superficial if kind of clever decoration. Others said that I embodied a devastating critique of the economy of the superficial."[51] The show was advertised as "a play by Elmgreen & Dragset" with text by Tim Etchells, the head of Forced Entertainment, one of the most innovative theaters in Great Britain.

The piece, which had been performed earlier in Münster as part of the Skulptur Projekt 2007, as well as other sites, was a fundraiser for the Old Vic. In joining celebrity actors (Jeremy Irons, Kevin Spacey, Joseph Fiennes) to celebrity art markets, the hope was that theater could cash in on some of the art market's residual revenues – before realizing that an economic crash would make the gesture "too late." The night's event made use of another art world convention – the auction. Celebrity artists, curators, critics, and collectors gathered in the audience to laugh at the play's inside-jokes – whose references they knew better than any standard theater subscriber – adjourning afterward to watch the auctioning of an Elmgreen & Dragset sculpture to benefit the Old Vic. In what might be a sign of the limits of mixing theatrical and visual art world, but probably of the financial crisis more generally, the sculpture failed to meet its

50 Victoria Miro Gallery, "Press Release: Elmgreen and Dragset: Too Late," October 2008.
51 Tim Etchells, "Drama Queens," available online at: http://www. timetchells.com/index.php?option=com_tag&tag=Drama%20 Queens&task=view&Itemid=9.

35,000 pounds target. As the auctioneer's gavel pounded to give one buyer the piece for 25,000 pounds instead, Tracy Emin – the British female artist famous for self-exposure and her own imbrication in other fundraising scandals – arose to promise a suite of drawings that commemorated the evening. The artist Chantal Joffe bid 10,000 pounds for them, thus making sure that the Old Vic had met its financial goals through an artist-to-artist to artist-to-theater network of economic reciprocity.

As if itself a commentary on the Sunday night performance at The Old Vic and the struggles of its auction, *Too Late* opened the next day a few Tube rides away at the Victoria Miro Gallery. Offering the "mental image of a party that is already over," *Too Late* had an acute resonance when sited in London at a high-rolling, star-studded art fair. The anxiety about the cessation of a financial circuit coincided not only with anxiety about the support of art making, but also with anxiety about the maintenance of a party circuit. *Too Late* was poised to give visitors a space to linger in the dregs of excess. With a disco ball spinning, and spilled glasses scattered, the space wallowed in its own hangover. The effect was another version of the form of "denial" at which Elmgreen & Dragset's non-relational aesthetic excels, replicating a space that dreams of a certain sociality while refusing to offer it, making highly marked social spaces exceedingly lonely. *Too Late* was both an enactment of durational art and its plasticization, a reference to time on the clock and to the metaphysical question about whether past gambles could be undone. *Too Late* thus positioned the party atmosphere of the "art fair" as itself the new object of institutional critique. At Frieze and other art-world sites, the institutional enmeshment of the artist does not so much occur at a board meeting as often as it does a party; art institutional power exerts itself over cocktail napkins as much as over contracts. The party scene of this artistic *mise-en-scène* troubles what we understand to be the significance of the relational turn in art. Here, a relational aesthetic is not so much a counter to hierarchical institutional power, or even a benign escape from it. The convivial relation is in fact the very site of art world authority, where speculative interpersonal exchange energetically propels the next speculative market exchange. With *Too Late*, Elmgreen & Dragset held up a "mirror" to the hierarchical conviviality of the art world; a lonely but inaccessible "VIP area upstairs" played music, "but only as a distant sound like a teaser from a place to which we (as ordinary guests) are denied access."[52]

While unclear whether *Drama Queens* or *Too Late* counted as the signature work that responded to the market precarities of London in 2008, they stood in kinship and as counterpoint to the twenty-year-old interventions of Damien Hirst, thus producing an art context that mirrored, however misshapen, all kinds of anxiety-ridden reflections on whether past mistakes were coming home to roost, whether something could be done or whether it was, in fact, too late. When tracing Elmgreen & Dragset's work, from performance art to *Powerless Structures,* from the immanent critique of liberalism in *The Welfare Show* to the immanent critique of neoliberalism in *Too Late,* we do not find definitive visions of new social utopias. What we do find is an ongoing meditation – sometimes playful, sometimes horrific – on the perils and possibilities of systemic imagining. Symptomatic of the neoliberal identifications pervasive in the period in which their art work has flourished, the years between *The Welfare Show* and *Too Late* remembered, forgot, and then remembered again the social embeddedness of the artists themselves.

In preparation for a project that would take similar shape in Léon, Spain, after Frieze, their *Art Review* text recorded – in journal-cum-blog tones – "The coach is full of men who didn't get any sleep last night. They've all been making art … Just a few leftovers from a real party, a couple of balloons, a few bottles, a broken chair, scattered flyers on the ground. Nothing spectacular, but everything, every little scrap, will be cast in bronze, and painted in realistic colors. A day after that lasts for ever."[53] Such a project thus began as a highly embodied multi-subjective exchange, even if it ended in a petrified sociality. Elsewhere in the same *Art Review* text, we find reflection on the convivialization of the artist's profes-

52 Victoria Miro Gallery, "Press Release: Elmgreen and Dragset: Too Late," October 2008.
53 Michael Elmgreen and Ingar Dragset, "Elmgreen and Dragset: The Incidental Self," in: *Art Review*, 26, October 2008, n. p.

sion. It appears in notes to a friend who has a higher tolerance for cocktail conversation. While the text intersperses plenty of diatribes against "middle class" values and the "bourgeois" families from which these artists escaped, there is enough indulgence in narratives about the cosmopolitan lives of hotel hopping artists at Prada weddings for the reader to notice the political and economic impurity of Elmgreen & Dragset's personal "escape." "We feel pure joy, and then a moment's panic: how long can this last? This has been a strangely familiar feeling, actually, over recent years. This vaguely precarious feeling, underlying dread amid the celebration of riches, continues to bubble, anticipating a burst. And the sales! … the last decade has seen no downturn in the art market, in spite of all other economic sectors behaving like rollercoasters. How long is this party gonna last?!" In such statements, couched as readymade diary entries for a wider reading public, Elmgreen & Dragset displayed their enmeshment within the speculative life of a *homo economicus cum artist*. Implicitly, they also revealed the neoliberal economic identifications on which their previous critiques of liberalism's "powerless structures" had depended. No doubt it was not the first time that a radical critic of liberalism turned out to have its own neoliberal investments. Intriguingly, the allure of a seemingly unfettered construction of self – whether it was resisting bureaucracy, schmoozing at a party, or selling a piece of art – seemed to be accompanied by a certain kind of dread. The pleasures of escaping the constraints of one supporting apparatus were still dependent upon the precarity of another. Indeed, Elmgreen & Dragset's most consistent contribution might be their recognition of the precarity of the individuated biography to which they and we are pleasurably tied.

To be tied to such pleasures, however, is also to be tied to new ambivalences, risks, and precarities. Sited at Frieze at a moment when biographies were reportedly breaking down with repossessed homes and bankrupt banks, the transformation of July's sociality into October's petrification created a piece that, at the very least, achieved the modest but important goal of responding to its moment. Perhaps it was because of the renewed interest in Scandinavian liberalism in 2008 that Elmgreen & Dragset agreed to another (parodic) homecoming, accepting an invitation to curate both the Danish and Nordic pavilions at the Venice Biennial 2009. Linking the two "houses," they staged an oblique narrative of a dysfunctional family who lived next door to a wealthy gay male collector, one whose body floated face down in his pool. And it was perhaps the same set of interests which prompted them to put a different title on the "after-party" they made for MUSAC in Léon. Advertising itself as another reflection on the "problems we face when a voracious public sphere encroaches on the private," its title was actually far more ambivalent: they called it *Trying to Remember What We Once Wanted to Forget*. As if hoping that it was *not* in fact "too late" to re-install the "voracious public sphere" that they had wanted to forget, Elmgreen & Dragset's reflections on selves and structures continued with the unabashed intensity of a welfare critic's melancholia.

have been told that there are about seven hundred and fifty people in this hall and – if the average age is forty – this means there are thirty thousand years of experience gathered together. If everyone were my age, we would have sixty thousand years of experience. I say that quite seriously because the real value is the discussion we have and because I think the issues raised by this exhibition are extremely important. I don't know whether you have all seen the exhibition, so please allow me to say a little bit about it:

You enter and there is a wheelchair in an empty room ... there is no patient, it is bare. You follow the route and come to a cashpoint, below which is a baby in a carrycot – just left there. You walk along the corridor – a hospital corridor – and there are two beds, one has a woman in it and the other is empty. You look through a window and there is a carousel of the kind you see at airports with a bag on it, going round and round and round. You go into another room which is absolutely empty apart from six security guards sitting there saying nothing, doing nothing, with nothing to protect. You come to one of those places where, if you are queuing up, they give you a numbered ticket and you wait watching the wall until your number comes up. And there is a flashing sign that says: zero, zero, zero.

You come out thinking: if this is the welfare state, isn't this a new form of tyranny? I think it's a brilliant piece of work because it makes you think. But I must admit that my impression when I came out was, that whatever the artists had in mind they have created another pattern of gloom, which would make many people think there is nothing whatsoever we can do about it. I didn't know whether it was Nordic pessimism, which is a peculiar characteristic I've noticed again and again. The effect on me was to say: God, if this is what people have worked for all their lives, why should it be depicted in this way?

Then I had two other thoughts about it, because it is an exhibition that provokes thought. The first is that if anyone watching it were given a million pound note, none of that would matter. If you have a million pound note, you don't queue up, you just buy what you want. If you're

Utopias and the Welfare State

Tony Benn

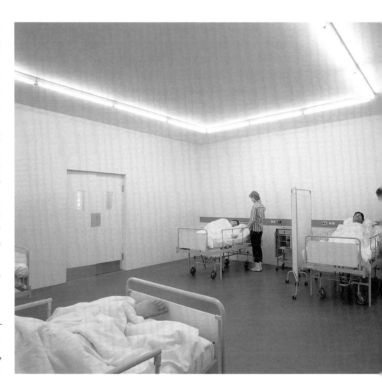

Please keep quiet! 2003. Hospital beds, wax figures, pajamas, bedding, swinging doors, tables, sink, mirror, ward screen, books. Hospital room with four beds occupied by three male figures. Courtesy of Galleri Nicolai Wallner and Statens Museum for Kunst, Copenhagen.

ill, you go and get the doctor you want. So it teaches you something about capitalism, namely, that money is an escape from this type of bureaucracy. The second thing – I look at it in relation to my own life – is that it's a wonderful lesson about socialism: a hundred years ago, you didn't have to wait for a hospital bed, because there was no health service. So it makes you think about all the efforts that went in to produce the welfare state and what it is that makes things better in society: the fuel of progress. I think it is worthwhile to look back on history and find out how things are ever made better. I'm not, I hope, offering an easy course, that's not my objective at all. Just to understand *why* what's happening to us is happening to us, and how from past experience we can see *how* we might make progress. That's all. It's a very modest approach.

One of the most important ingredients in life is hope. And if you feel as I felt when I came out of the exhibition – oh God, what a waste of time, I will go home and watch *Big Brother* instead of going to make a speech tonight – then nothing would ever happen. Every society has an element of hope. For example, religion gives you hope with the idea that it will all be all right in the end. If you went to a Bishop and you said, "Bishop, it's a very, very unfair world." The Bishop would answer, "I know, my son. But if only the rich are kind and the poor are patient, we will all be rewarded in Heaven." But then people said, "Why that's wonderful news, Bishop! Can we not have all that whilst we're still alive?" And this is how social movements were created out of religion. If you look at the Book of Genesis, on which I was brought up, you will see that there is not only Adam and Eve in the Garden of Eden. There is also a guy called Cain who killed his brother Abel. So God had a word with Cain, who answered back, "Am I my brother's keeper? What's it got to do with you, if I kill my brother?" The phrase "We are our brother's (and sister's) keeper" also appears in other forms. Such as "an injury to one is an injury to all." "United we stand, divided we fall." "You do not cross a picket line." That came from the Book of Genesis, not from the Kremlin. All these ideas fed into our thinking.

Then of course, if you go through history, it is the people who explain the world that give you hope. Knowledge is power, there is no question about it – if you know something, you are more powerful than if you don't. In this way, the great religious leaders were teachers. I think of Moses as a teacher. He said that one should not worship the Golden Calf. I took that as an attack upon monetarism. Or you get Jesus saying, "Love thy neighbor as thyself." Now that's a bit of great teaching. If you look at the founders of religion, not the organizers of religion, but the founders, such as Mohammed and Buddha, they have all got something to say to you and, if you would follow their advice, then you would allow life to be better for everybody.

When I visited Rome, I was shown the prison where Galileo was held for heresy. Galileo's offence was that he had a row with the Pope about the universe. The Pope said that the earth was the centre of the universe. "No," Galileo said, "You made a terrible mistake, your Holiness, we are part of the universe and we go around and round." So they put him in jail. Galileo explained the world. Darwin explained the world. Freud explained the world. Marx explained the world. Marx explained that the real problem of the world is the conflict between rich and poor – now who could disagree with that? When I look back on history, I find that it's the teachers who are the most interesting people, because they fire a pyrotechnic into the sky and for a moment you can see where you are, where you've come from and what the choices are.

The other people that matter are the people who organize: all is well with a wonderful idea, but if you don't do anything about it, nothing happens. Therefore, movements are important. I am not interested in kings, presidents, dictators, prime ministers, emperors … they come and go. They don't leave any footprints in the sands of time. Teachers leave footprints in the sands of time and so do organizations. Wherever you look at the struggles for freedom – colonial freedom or the antiapartheid campaigns – they were not about individuals, they were all concerted movements. Mandela didn't end apartheid, he was in prison all the time. It was the South Africans

who ended it. From this you learn some very important lessons about how progress is made.

When I look back over history, I find that the people I remember are the people who explained and the people who *did* things. I'll give you one example: the Peasants Revolt in 1381. The peasants regarded the poll tax as unfair. (I don't think Mrs. Thatcher heard of them.) The people marched on London. And there was a man called the Reverend John Ball, who in his most famous sermon claimed: "Things will not go well in England until all property is held in common." The idea survived, although all those involved at the time were hung, drawn and quartered. Then you come forward to the English Revolution, when the most fantastic ideas came up which are still with us. Such as "No man is good enough to be another man's master." Or the diggers who said: "The earth is a common treasury, it is a crime to buy and sell the earth for private gain." Now if that isn't an environmental argument that appeared four hundred years ago, I don't know what is. Thomas Paine, who wrote *The Rights of Man*, said something that makes a lot of sense to me: "My country is the world. My religion is to do good." Now can you imagine a more relevant thing to be saying now, with religious wars going on? These things keep me going. When I look at the changes that have taken place in my life, they are all a product of this idea.

If you want to go to the root of progressive change, to real democracy, it's the trade unions who must be given the credit. Up until 1834 – which may seem a long time ago, but to me it is only sixteen years before my grandfather was born – only five to ten percent of the population had the vote, they were all rich men and the laws they made were to keep everybody down. Then a group of farm workers in Dorset formed a union, on the grounds that if you go and see the farmer alone he can not only sack you, but he also owns your cottage and can throw you out. But if you all go together, he'd have to listen because he's got to keep his farm going.

And then came the Chartists and the Suffragettes, claiming the right to vote for all male citizens over the age of twenty-one – this is the important moment of democracy. Up until that point, if you were rich, you didn't need a mortgage, you owned your castle. You didn't send your kids to school, you hired a tutor. If you were ill, some doctor or quack would look after you. You didn't need unemployment benefit, because you never worked anyway. And when you retired, you still had your castle. When democracy came along, there was a shift of power from the marketplace to the polling station, and people could vote for the things they needed but couldn't afford. Power moved from the wallet to the ballot. That was a revolutionary move. Don't make a mistake about it. I don't think the people at the top have ever come to terms with democracy, because it allows people who have no money to change society by passing laws that erode the privileges of the rich.

I was looking the other day, because a German journalist came to see me, at an old copy of Hitler's *Mein Kampf*, which I bought when I was eleven and have kept ever since – I had a fight with my brother who tore it in half, but the book is still there in two bits. There is one thing that Hitler says which is really interesting, he says, "Democracy inevitably leads to Marxism." Now you work that out. What he said was: if you give the poor the vote, they will vote for an equal society, which will then challenge the privileges of the rich. He then launches into a bitter attack at democracy, parliament and all the filth of parliament, because that was the only way in which the German ruling class could maintain their power. I think that is a very interesting way of understanding the power of democracy.

Of course, when Bush speaks as if an American empire will bring democracy, I don't really think he's studied his history. Because I was born in an Empire in 1925, and when I was born, twenty percent of the population of the world was governed from London. And during the time we had an Empire, there was no democracy anywhere. We ran it all ourselves. I was trained to fly in Rhodesia, which is now Zimbabwe, and when I was there, there was no democracy at all. In 1897, the year my Mum was born, Cecil Rhodes stole all the land from the Afri-

cans and gave it to the white farmers – forty thousand whites, six million Africans – and no African had a vote at all. They even passed a law in the Southern Rhodesia Legislative Assembly that it was a criminal offence for an African to have a job, and now we lecture Mugabe about democracy.

So you get an idea of the determination there is, to control us. And of course there are lots of ways of controlling us. One of them is fear. I think that playing up fear – particularly today with all the terrorist stuff – is a significant attempt to keep us under control. It wasn't always of course the Muslims, if you go back a bit it was all the colonialist national leaders who were troublemakers, if not terrorists. I've met so many terrorists in my life, who have had tea with the Queen as the head of Commonwealth countries and it really makes you wonder. I met Gandhi. He wasn't a terrorist, but they locked him up of course: when he was in England in 1931, the year I met him, someone asked him: "So, what do you think of civilization in Britain, Mr. Gandhi?" He answered: "Well, I think that's a very good idea." And he was locked up. You realize that the fear of the liberation movements justified our sending in armies and keeping people down.

What interests me about the First World War – my Dad fought in it and my uncle was killed – is that it was a war between three grandchildren of Queen Victoria. The King of England was a grandchild of Queen Victoria, the Kaiser of Germany was a grand child of Queen Victoria and Queen Victoria's granddaughter was married to the Tsar of Russia. Millions and millions and millions of people died. Why? Why? The First World War was an imperial war. And it drove Russia to Communism and Germany to Fascism, and triggered the Second World War, in which my brother was killed. So we've had two World Wars. For what? What was it about? Who benefitted? These are questions, which make you think.

Then, of course, we had the Cold War. We were told that the Red Army was going to take over the Serpentine Gallery and that you would have to read the works of Marx and Lenin if you were there. Now there wasn't a word of truth in it, not one word. The Russians had lost twenty-five million people in the war, and, as we now know, the Red Army couldn't deal with Chechnya, they couldn't have taken on the whole of NATO. But it kept people under control. The point I want to make is, if you want to control people, keep them frightened. And also, make them feel they won't succeed. One of the ways of making people feel that they won't succeed is by simply saying so. Mrs. Thatcher made what I think is the most powerful statement I've ever heard in my life, she said, "There's no alternative. Whatever you do, whatever you think, whatever you organize, it won't work. Don't even try." It worked with an unquestionably paralyzing effect. A bit like *The Welfare Show*: it's all hopeless, we'll all end up lost in bureaucracy and so on.

Another way of keeping people under control is to make everyone seem like a failure. I don't know about you, but I find all this naming and shaming and league tables business absolutely outrageous. I had a pacemaker put in after the Labour conference last year. I heard the Prime Minister's speech and collapsed. So they took me off to hospital and put a pacemaker in. When I came out, I discovered that the hospital where I'd had my pacemaker put in was at the bottom of the league tables. And I wondered: if a hospital has problems, try to help. If a school has problems: don't name it and shame it. People want a bit of help. They have now invented a lot of organizations that are really accountable to nobody. They are not allowed to help the institution, they are there to report its failures. Have you heard of the authority called Post Com? They fined the post office eleven million pounds because of late deliveries. It's our money. Now I'm going to pay that fine by putting more money on the stamps. It's all about putting us down. They want to have an especially gifted group, who get educated to run the world, the rest are shunned into the labour market to take orders. Thank God they haven't done it in the health service, otherwise you would only have hospital treatment if you were a "specially gifted patient." This whole idea of especially gifted ... As if we aren't all human beings who succeed here and fail there.

We will only make progress if we think it can be done. The World Social Forum set up in Porto Alegre a few years ago has a philosophy, which is not: "There's no alternative," but "Another world is possible." I believe that. I think that is what it's about. If you believe it, you make the effort, and if you don't believe it, you go and watch *Big Brother*. Encouragement is the fuel that makes progress. Now, if you go on a demonstration it gives you such a boost and makes you realize you are really not alone. I believe that collective activity encourages you to believe that you are not alone. They always try to make out you're isolated, unrepresentative, you're a rebel, a troublemaker, all that. The media are always trying to put you down. But when you get together, you realize you're not alone; and if you do something yourself, even less so. After all, a lot can be done in the way you live and work to improve conditions.

Since this is about utopia, I have brought with me a little bit of what Thomas More said about his idea of utopia: "To my mind Utopia is not only the best country, but the only one that has the right to call itself a republic. Elsewhere people are always talking about the public interest, but all they really care about is private property. In Utopia there is no private property, people take their duty to the public seriously. […] In Utopia where everything is under public ownership, no one has any fear of going short. So long as the public storehouses are full, everyone gets a fair share, so there are never any poor men or beggars. Nobody owns anything, but everyone is rich. For what greater wealth can there be, than cheerfulness, peace of mind and freedom from anxiety." This was in 1516, five hundred years ago.

I don't believe that utopia is the name of a railway station and that I've got a ticket for it. Socialism, democracy and utopia are ways of thinking about the world and they help us in bringing about a better one. But every generation has to do it all over again. I know this now because many of the rights, which I thought we had – like jury trials – have been taken away. And there was never a battle over it.

Today the word "utopia" is most often used in the sense of "Oh don't be ridiculous, that's a utopian idea." I often think about that. When my mother was born, women didn't have the vote. And when she demanded the vote as a young girl, the reaction was, "Oh that's a utopian idea. Don't be stupid! Women don't have the vote. What a ridiculous idea!" And yet the knowledge that there was something you wanted and were prepared to organize for produced results. And that is how change is made.

This text was originally a speech given by Tony Benn at the Serpentine Gallery in London in February 2006.

First published in: *Elmgreen & Dragset: This is the First Day of My Life*, Hatje Cantz, Ostfildern, 2008.

Opposite Page:
Spelling U-T-O-P-I-A 2003. Glass, wood, alphabet building blocks, performing chimpanzee. Utopia Station, 50th Venice Biennale. Courtesy of Galleria Massimo De Carlo, Milan. Performance installation: glass pavilion with live chimpanzee learning to spell "Utopia" with the aid of six alphabet building blocks.

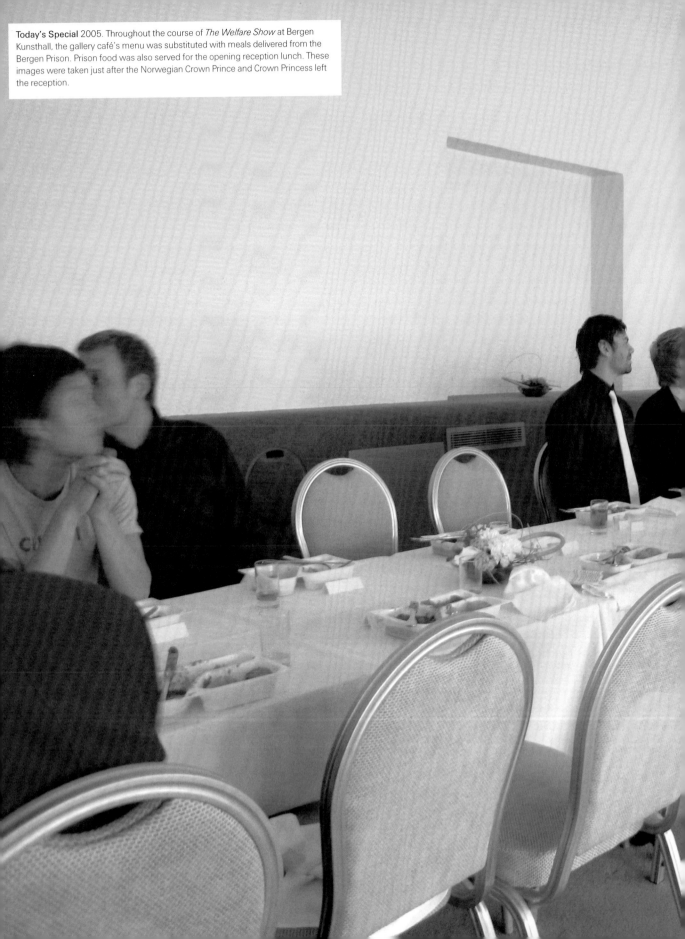

Today's Special 2005. Throughout the course of *The Welfare Show* at Bergen Kunsthall, the gallery café's menu was substituted with meals delivered from the Bergen Prison. Prison food was also served for the opening reception lunch. These images were taken just after the Norwegian Crown Prince and Crown Princess left the reception.

HKH Kronprinsesse Mette-Marit

HKH Kronprins Haakon

Assembling pages for the Welfare Show catalog, Berlin, 2005.

A Adoption, Age, Architecture, Army, Art

B Bureaucracy
C Canada Pension Plan, Capital, Cheating, Children,
 City Planning, Class, Crime, Culture
D Death, Democracy, Design, Discrimination,
 Dream (American)

E Economy, Education, Ein Euro Job, Environment, Ethics,
 Exclusion
F Flexibility, Freedom, Future
G Gender, Gentrification, Gini Coefficient,
 Globalization

H Health, Hierarchy, Homeless, Homosexual Rights
I Immigration, Individualism, Integration,
 Intelligentsia
J Justice

K Kindergarten
L Language, Leisure
M Majority/Minority, Marriage, Marx, Media, Medicine,
 Monarchy, Motivation, Museum, Music

N Nation, Nationalism, Nature, Neoliberalism, News
O Ombudsmann, Outsourcing

P Patriotism, Pension, Police, Postmodernism, Poverty,
 Public Space
Q Questions
R Racism, Religion

S Sæbe-Direktivet, Sex, Social Housing, Social Services,
 Solidarity, Statistics, Strike, Subversion,
 The Swedish Model
T Tax, Tourism
U Unemployment, Unwort des Jahres

V Vollbeschäftigung
W Wealth, The Welfare Show, Work

X Xenophobia
Y Youth
Z Zoo

Language	Author	Elmgreen & Dragset	→ Motivation		Subject	Page/of	83
—	Image	Just a Single Wrong Move (2004)			ETHICS	1/1	E

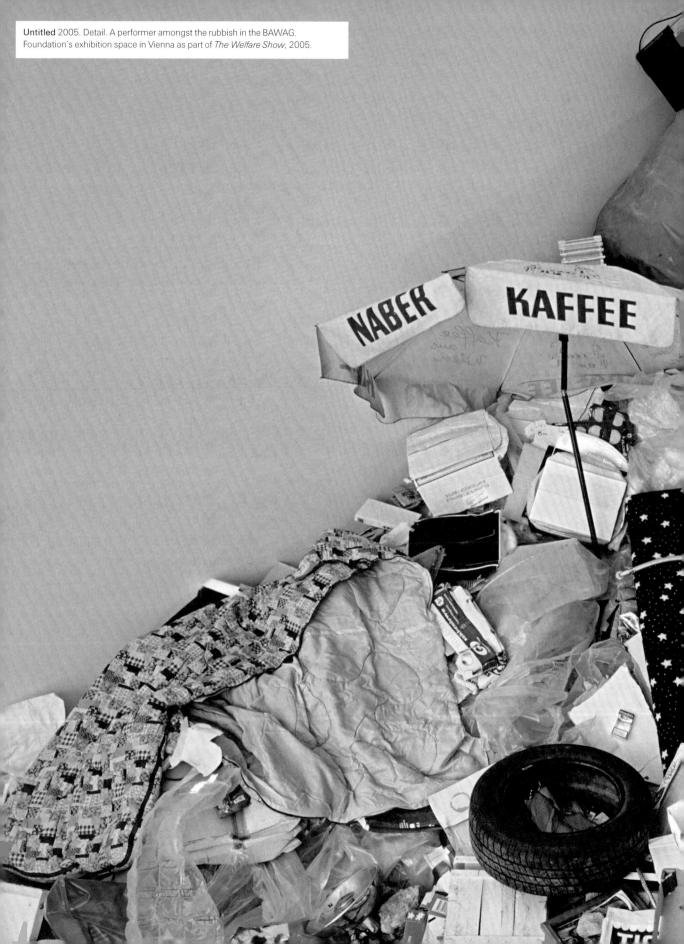

Detail from *The Welfare Show* at BAWAG Foundation, Vienna.
A coin operated telescope provided a better view into the
high-end restaurant across the street, frequented by bankers
and politicians. (A week after the opening of the exhibition
the restaurant installed curtains.)

Following pages (368–369):
For *The Welfare Show* at The Power Plant, Toronto, 2006, the
institution agreed to repaint the logo on their signature chimney so
that it read THE POWERLESS instead of THE POWER PLANT.

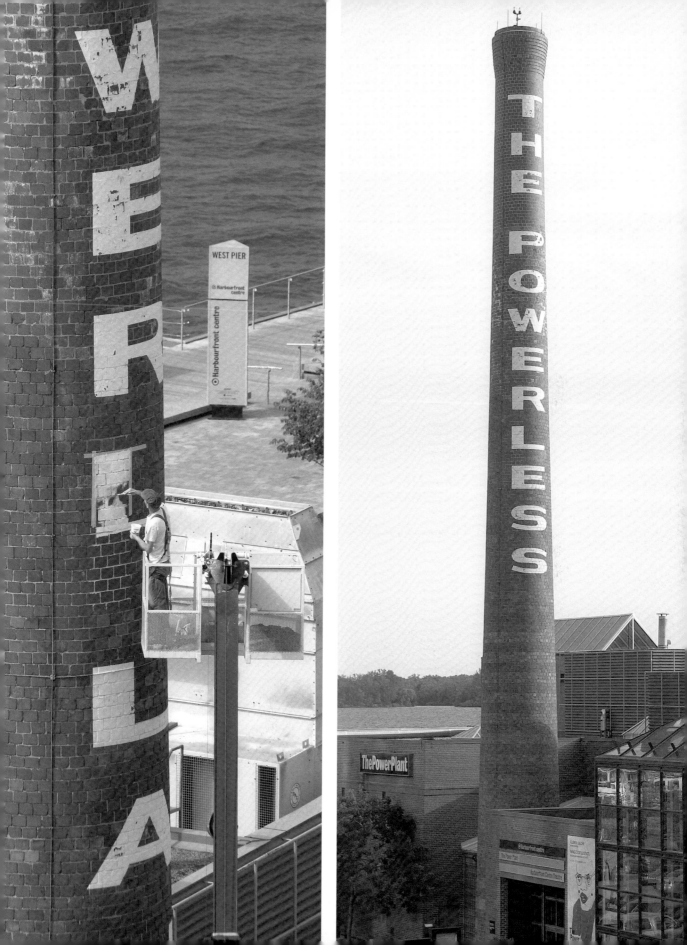

Authors' Biographies

Andreas F. Beitin

born 1968 in Uetersen, studied art history, applied cultural studies, and contemporary and modern history in Münster. He subsequently worked for an international art consultants for several years. His dissertation thesis centered on the motif of the scream in twentieth-century German painting and graphics. Andreas F. Beitin first came to the ZKM | Museum of Contemporary Art in 2004 as a research assistant / scholarly advisor. He has been curator since 2006. He became Head of the ZKM | Museum of Contemporary Art in April 2010. As curator, co-curator and project manager he has worked on numerous internationally acclaimed exhibitions at the ZKM | Museum of Contemporary Art, including *Light Art from Artificial Light*, *Paul Thek in the Context of Today's Contemporary Art* and the large-scale anniversary exhibition *just what is it … 100 Years of Modern Art from Private Collections in Baden-Württemberg. 10 Years Museum of Contemporary Art at ZKM*. He curated the first large-scale solo exhibition in Germany for the internationally successful artist duo Elmgreen & Dragset. *Celebrity – The One & the Many*.

Tony Benn

born 1925 in Marylebone / UK, became the youngest MP in the House of Commons in 1951. During the Labour governments of 1964–1970 and 1974–1979, Benn held the positions of Postmaster General, Secretary of State for Industry and for Energy, and Minister for Technology. Benn was also an elected member of the National Executive Committee of the Labour Party from 1959 to 1994, and Chairman of the Party in 1971 and 1972. His political affiliations shifted further to the left, in proportion as his passionate disdain for the injustices of capitalism grew. During the 1980s, he was one of Margaret Thatcher's most outspoken critics and fought against the erosion of the welfare state and the demolition of the trade unions. In 2001 Benn retired from Parliament to "devote more time to politics." In February 2003, he traveled to Baghdad and was the first Westerner in twelve years to interview Saddam Hussein. Later he became the first president of the Stop the War Coalition. His diaries, which cover the period from 1940 to 2007, have been published in nine volumes, and he is the author of many other books, including *Arguments for Socialism, Arguments for Democracy, Fighting Back, Common Sense, Free Radical* and *Dare to be a Daniel: Then and Now.*

Dominic Eichler

born 1966 in Ballarat, Australia, studied English literature and law at the Monash University in Melbourne. He works as critic, artist, musician, curator, and co-founder of the contemporary art space Silberkuppe. He is a contributing editor of *Frieze – Contemporary Art and Culture* and writes for *Texte zur Kunst*. In 2005 he was awarded the AdKV Prize for Art Criticism. He lives and works in Berlin.

Harald Falckenberg

born 1943, studied law in Freiburg, Berlin and Hamburg, and received his PhD in law with a dissertation on "Comparative International Law." He has been working as the general manager of a company in the petroleum industry since 1979. In 1977 he became an honorary judge at the Hamburg Constitutional Court. He is a private collector, President of the Kunstverein Hamburg, and Professor of Aesthetics and Art Theory at the Academy of Fine Arts Hamburg.

Georg Franck

born 1946, studied philosophy, economics and architecture. Holding a doctorate in economics, he became a practicing architect and town-planner in 1974. In addition, he worked in software development and produced a planning information system, which went on to the market in 1991. Furthermore, he has written widely on subjects ranging from philosophy, economics and architecture. His publications include: *Ökonomie der Aufmerk-*

samkeit [The Economy of Attention], Mentaler Kapitalismus [Mental Capitalism] and *Architektonische Qualität [Quality in Architecture]*. He has held the chair of computer-aided planning and architecture at the Vienna University of Technology since 1994.

Sacha Goldman

is a film and media producer in the field of arts and culture. He has been manager of a film production company for the past twenty years. He worked as a UNESCO Media adviser and is currently Secretary General of Collegium International, a think tank network bringing together heads of state, philosophers and scientists. A long-time follower and friend of Paul Virilio, he has undertaken numerous press and film projects with the latter, such as the film *The Last Frontier* (2010), which he produced and directed.

Maja Gro Gundersen

born 1981 in Hobro, Denmark holds a B.A. in art history and media science and an M.A. in art history. From 2006 to 2008 Gundersen worked as an assistant at Galleri Image, Århus. Together with Kirstine Schiess Højmose and others she curated two exhibitions in public space (Århus, 2005 and Copenhagen, 2009). She has published articles in various media. She currently works as an assistant exhibition architect and coordinator at the Royal Library in Denmark, and as a freelance journalist at *kopenhagen.dk*, a Danish website focused on contemporary art.

Martin Hartung

born 1983 in Magdeburg, studied art history, evangelical theology and cultural anthropology at the Martin-Luther-Universität Halle-Wittenberg. From 2005 to 2008 he was exhibition assistant at the Kunsthalle Bremen, the Museum der Moderne in Salzburg and the Herzog-Anton-Ulrich Museum in Braunschweig. From 2008 to 2009 he worked as a curatorial associate of the Dia Art Foundation in New York. From 2009 to 2010 he was assistant curator at the Vitra Design Museum in Weil am Rhein. He worked as research assistant/scholarly advisor at the ZKM | Museum of Contemporary Art in Karlsruhe, from 2010 to 2011. Currently he works as curatorial assistant at the Department of Media and Performance Art at the Museum of Modern Art, New York.

Shannon Jackson

studied modern thought and literature at Stanford University and earned her PhD at Northwestern University in 1995. From 1991 to 1994 she was Lecturer at the Northwestern University. From 1995 to 1998 she worked as Assistant Professor of English and Literature at Harvard University. She later became Assistant Professor at the University of California, Berkeley. She has been Professor of Rhetoric and Theater, Dance and Performance Studies since 2005. From 2008 to 2009 she was visiting professor at the Université de Paris VII. She is author of numerous books and articles, among them, *Social Works: The Infrastructural Politics of Performance* (2011), *Professing Performance: Theatre in the Academy from Philology to Performativity* (2004) and *Lines of Activity: performance, Historiography, and Hull-House Domesticity* (2000).

Wolfgang Krischke

born 1959, studied German language and literature, linguistics and history in Göttingen before going on to receive a PhD from the University of Hamburg. He works as a journalist, author and lecturer on linguistics at the University of Hamburg. He published *Die Casting-Gesellschaft. Die Sucht nach Aufmerksamkeit und das Tribunal der Medien* in collaboration with Bernhard Pörksen.

Tom Mole

received his PhD from the University of Bristol. He taught at the University of Bristol and the University of Glasgow and is presently Associate Professor in the De-

partment of English at McGill University in Montreal. His research interests range from the Romantic period in Britain, the cultural history of celebrity, to the theory and practice of interdisciplinarity. He is a founding member of the FQRSC-funded Interacting with Print Research Group. He is author of *Byron's Romantic Celebrity* (2007), and editor of *Romanticism and Celebrity Culture* (2009).

Rodrigo Maltez Novaes

is a Brazilian/British visual artist, doctoral candidate at the European Graduate School in Saas-Fee and Research Fellow at the Vilém Flusser Archive at the Universität der Künste, Berlin. His research work centers on a comparative study of Flusser's concept of apparatus and those by Benjamin, Foucault, Agamben and Althusser. Maltez Novaes is the translator and editor of the first English edition of *Vampyroteuthis infernalis*, by Vilém Flusser, 2011.

Max Otte

born 1964 in Plettenberg, studied at the University of Cologne and the American University in Washington, D.C. before going on to receive his PhD from Princeton University. From 1998 to 2000 he was Assistant Professor for International Economics and International Management at Boston University. He founded the IFVE (Institut für Vermögensentwicklung) in Cologne, in 1999, later going on to become its director. In addition, he is a Professor of International Business at the FH Worms University of Applied Sciences. He is also the author of numerous books and articles including *Der Crash kommt* (2006), in which he predicted the financial crisis.

Bernhard Pörksen

born 1969, studied German language and literature, journalism and biology in Hamburg and at Pennsylvania State University. He was a trainee at the *Deutsches Allgemeines Sonntagsblatt*. After earning his doctorate degree in 1999, he went on to teach at the University of Greifswald. He

subsequently became Research Assistant and Assistant Professor for Journalism and Communication Studies at the University of Hamburg. In 2006 he taught communication theory and media culture at the University of Münster. He has been Professor for Media Studies at the University of Tübingen since 2008. Author and publisher of numerous articles and books, he co-wrote *Die Casting-Gesellschaft. Die Sucht nach Aufmerksamkeit und das Tribunal der Medien* (2010) with Wolfgang Krischke.

Hermann Strasser

born 1941 in Altenmark im Pongau, Austria, studied economics and sociology at the University of Innsbruck and the Free University of Berlin. In 1967 he earned his PhD at the University of Innsbruck. He subsequently received a Fulbright Scholarship and completed his PhD in sociology at Fordham University, New York in 1974. During this period he also worked as Teaching Fellow and Research Assistant. In 1971/1972 he became Assistant Professor at the University of Oklahoma, Norman. From 1972 to 1977 he was Assistant Professor of Sociology at the Institute for Advanced Studies, Vienna. He received his habilitation at the University of Klagenfurt in 1976. From 1978 to 2007 he was Professor for Sociology at the University of Duisburg-Essen. He has been professor emeritus since 2007. He is author of over 200 articles in both national and international journals, co-author and co-editor of thirty publications, among them *Modern Germany* (2000), *Globalisierungswelten* (2003), *Das individualisierte Ich in der modernen Gesellschaft* (2004), *Endstation Amerika?* (2005), *Woran glauben?* (2007), *"Das da draußen ist ein Zoo, und wir sind die Dompteure": Polizisten im Konflikt mit ethnischen Minderheiten und sozialen Randgruppen* (2008), *Köpfe der Ruhr* (2009) and *Hans Weber – Lebens(t)räume* (2010).

Sarah Thornton

studied history of art at the Concordia University, Montreal, and earned her PhD in the sociology of music from Strathclyde University, Glasgow, with a thesis on *Club*

Cultures: Music, Media and Subcultural Capital. She was Lecturer of Media Studies at the University of Sussex and Visiting Research Fellow at Goldsmiths, University of London. Thornton worked for one year as a brand planner in a London advertising agency. She now writes on contemporary art for *The Economist* and other publications. She contributes to broadcasts by BBC TV and radio, ZDF television, and NPR radio and is a frequent guest speaker at conferences. She is the author of *Seven Days in the Art World*, which has been translated into several languages.

Paul Virilio

born 1932 in Paris, is a philosopher, urbanist and cultural theorist. His work focuses on the development of technology in relation to power and speed. He coined the term "dromology" to explain his theory. The Second World War profoundly impacted Virilio as a child. He received his initial training as an artist and worked with Henri Matisse on stained glass windows in several Paris churches. He later attended lectures in phenomenology by Maurice Merleau-Ponty at the Sorbonne and studied architecture. In May 1968 Virilio was nominated Professor by the students at the École Speciale d'Architecture. He became Director of Studies in 1973, and director of the magazine L'Espace Critique in the same year. He co-curated the *Bunker Archeology* exhibition at the Centre Georges Pompidou Paris in 1975. In 1989 he became the director of the program of studies at the College International de Philosophie de Paris, under the direction of Jacques Derrida. He retired from active teaching in 1998. However, since 1998, he has periodically held intensive seminars at The European Graduate School. His numerous books have been widely published and translated, among them *Speed and Politics: An Essay on Dromology* (1977), *The Strategy of Deception* (2002) and *Art as Far as the Eye Can See* (2007).

Peter Weibel

born 1944 in Odessa, studied literature, logic, philosophy, and film in Paris and Vienna. He became a central figure in European media art on account of his various activities as artist, media theorist, and curator. He has been Professor at the University of Applied Arts Vienna since 1984; from 1984 to 1989, he was head of the Digital Arts Laboratory at the Media Department of New York University, Buffalo. In 1989 he founded the Institute of New Media at the Städelschule in Frankfurt am Main. From 1986 to 1995, he was Director of Ars Electronica in Linz, its Artistic Consultant and later Artistic Director; he was commissioner of the Austrian pavilion at the Venice Biennale from 1993 to 1999. From 1993 to the present he has been curator at the Neue Galerie Graz, and, since 1999, Chairman and CEO of the ZKM | Center for Art and Media Karlsruhe. In 2007, he was awarded an honorary doctorate by the University of Art and Design Helsinki. In 2008 he was Artistic Director of the Biennale of Sevilla Biacs3. Since 2009 he has been Visiting Professor of the University of New South Wales in Sydney. He is also curator of the Moscow Biennale of Contemporary Art, 2011.

Selected Bibliographies

——Ingo Arend, "Elmgreen & Dragset. Die Zukunft der Wohlfahrt," *getidan.de*, February 28, 2011. Online at http://www.getidan.de/kolumne/rundgang/ingo_arend/14255/die-zukunft-der-wohlfahrt.

——Clemens Bomsdorf, "Actors are playing us, but we might interfere," in: *The Art Newspaper*, December 19, 2010, p. 39.

——Clemens Bomsdorf, "Klischee und Vorurteil," *art-magazin.de*, February 28, 2011. Online at http://www.art-magazin.de/kunst/35211/elmgreen_dragset_karlsruhe.

——Elke Buhr, "Holt mich hier raus. Elmgreen und Dragset übers Starsein in Karlsruhe," in: *Monopol*, no. 11, November 2010, pp. 115–116.

——Elke Buhr, "Stars, Stalker & Voyeure," in: *Monopol*, no. 12, December 2010, pp. 60–66.

——Jean-Max Colard, "Desperate Houses," in: *Les Inrockuptibles*, February 12, 2011, pp. 108–109.

——Sandra Danicke, "Mit dem Champagnerglas vor der Tür," in: *Frankfurter Rundschau*, November, 24, 2010, pp. 35–36.

——Hans-Dieter Fronz, "Berühmte unter sich," in: *Badische Zeitung*, December 18, 2010.

——Barbara Gärtner, "Sogar der Kamin bleibt kalt," in: *Süddeutsche Zeitung*, November 9, 2010, p.11.

——Daniela Gregori, "Große Themen für Karlsruhe. Ein Gespräch mit Peter Weibel," in: *Parnass*, no. 1, March/April 2010.

——Michael Hübl, "Elmgreen & Dragset. Celebrity – The One & The Many Museum für Neue Kunst im ZKM Karlsruhe," in: *Kunstforum International*, 206, January/February 2011, pp. 347–349.

——Swantje Karich, "Wir sind nichts als Voyeure," in: *Frankfurter Allgemeine Zeitung*, November 5, 2010, p. 31.

——Hans-Joachim Müller, "Wir stellen nur dumme Fragen, wir haben keine Antworten," in: *Art*, 2, February 2011, pp. 32–41.

——Matthias Weiß, "Fegefeuer falscher Verheißungen, Karlsruhe: Elmgreen und Dragset im ZKM," in: *Kunstzeitung*, November 2010.

——Carsten Bauhaus, "Mysteriöse Junggesellen," in: *Männer*, September 6, 2009, pp. 86–87.

——Ina Blom, "What Subject Of Taste," in: *Texte zur Kunst*, September 2009, pp. 86–93, pp. 135–138.

——Lisbeth Bonde, "Hjemlig hygge," in: *Weekendavisen*, Nr. 24, June 12, 2009, p. 2.

——Kari J. Brandtzæg, "Nordisk nabolag," in: *Dagbladet*, June 7, 2009, p. 42.

——Alix Browne, "Home Team / A Pair Of Artists Play House," in: *The New York Times Magazine*, May 31, 2009, p. 58.

——Rachel Campbell-Johnston, "A spectre of death in Venice," in: *The Times*, June 9, 2009, p. 14.

——Barbara Casavecchia, Dan Fox, Jennifer Higgie, "Written On Water. The highs and lows of the 53rd Venice Biennale, 'Fare Mondi Making Worlds,'" in: *Frieze*, September 2009, pp. 124–127, p. 130.

——Julia Chaplin, "A Night Out With Massimiliano Gioni. An Artistic Voyage," in: *The New York Times*, June 7, 2009.

——Thomas Crow, "Acting the Part," in: *Artforum*, September 2009, pp. 226–230.

——Laura Cumming, "On your vaporetto to the far pavilions," *The Observer*, June 7, 2009, pp. 14–15.

——Damien Delille, "Nord á Venise," in: *Blast*, Summer 2009.

——Diedrich Diederichsen, "Venice '09. When Worlds Elide," in: *Artforum*, September 2009, p. 13.

——Richard Dorment, "Venice behind the mask," in: *The Daily Telegraph*, June 8, 2009.

——Elena del Drago, "I padiglioni alla Biennale," in: *Il Manifesto*, June 7, 2009, p. 11.

——Pierpaolo Ferrari, "Danimarca e paesi nordici," in: *Uomo Vogue*, May/June 2009.

——Ana Finel Honigman, "Venice Preview: Elmgreen & Dragset," *interviewmagazine.com*, May 28, 2009. Online at http://www.interviewmagazine.com/blogs/art/2009-05-28/venice-preview-elmgreen-dragset/.

——Marta Galli, "Elmgreen & Dragset. I'll Show You the Place Where the Heart Is," in: *Muse Magazine*, June 2009, pp. 80–91.

——Ángeles García, "De paseo con Barceló por la Bienal," in: *El pais*, June 5, 2009, p. 46.

——Alex Gartenfeld, "Postcards from Europe," in: *Whitewall*, Fall 2009, pp. 124–125.

——Kelly Grow, "The Artworld's Olympics," in: *The Wall Street Journal*, June 5, 2009.

——Ruth Händler, "Ein Holzhaus dümpelt im Wasser, ein Ausstellungspavillon mutiert zur Tatort-Villa, eine Cafeteria wird Skulptur: Auf der Biennale in Venedig verschwimmen die Grenzen von Kunst und Architektur," in: *Häuser*, September 2009, pp.124–129.

——Charlotte Higgins, "Blood, oil and designer rugs: the world's top artists get set for the Venice Biennale," in: *The Guardian*, June 3, 2009, p. 23.

——Charlotte Higgins, "Venice Biennale diary. How festival mingles works and pleasure," in: *The Guardian*, June 6, 2009, pp. 22–23.

——Silke Hohmann, "Es ist eingerichtet. Ein Rundgang zur Venedig-Biennale 2009," in: *Monopol*, July 2009, pp. 28–33.

——Heinz-Norbert Jocks, "The Collectors: Michael Elmgreen & Ingar Dragset – ein Gespräch," in: *Kunstforum International*, 198, August/September 2009, pp. 182–193.

——Michael Kimmelman, "A Small World Crammed on a Grand Stage," in: *The New York Times*, June 11, 2009.

——April Lamm, "Two Worlds Of Interiors," in: *Sleek Magazine*, Autumn 2009, pp. 44–60.

——Susanna Legrenzi, "A casa di Mister B," in: *iO*, June 13, 2009, pp. 134–137.

——Emmanuelle Lequeux, "Notre sélection. Le pavillon nordique," in: *Beaux Arts*, June 2009.

——Holger Liebs, "Küche zu verkaufen. Pavillons und Penthouse – Die Künstler in den Staatenhäusern der Biennale," in: *Süddeutsche Zeitung*, June 6/7, 2009.

——David Lister, "Please look now," in: *The Independent*, June 5, 2009, pp. 4–5.

——Barbara A. MacAdam, "53rd Venice Biennale," in: *ARTnews*, Summer 2009, pp. 118–119.

——Lynn Macritchie, "Melancholy Giardini: The National Pavilions," in: *Art in America*, September 2009, pp. 105–107.

——Silke Müller, "Selbstmord in Venedig," in: *Stern*, June 2009, pp. 102–105.

——Paola Nicolin, "Radical Reconstructions," in: *Abitare*, June 2009, pp. 36–41.

——Costanza Paissan, "Quel décor domestico dal gusto dissonante," in: *Alias – Il Manifesto*, May 30, 2009, p. 9.

——Peter Richter, "Schämt euch doch selbst," in: *Frankfurter Allgemeine Zeitung*, June 6, 2009, p. 23.

——Adrian Searle, "Bodies, babble and blood," in: *The Guardian*, June 9, 2009.

——Skye Sherwin, "Elmgreen & Dragset. Danish and Nordic Pavillon," in: *Art Review*, Summer 2009, p. 91.

——David Velasco, "500 Words: Elmgreen & Dragset," *artforum.com*, June 1, 2009. Online at http://artforum.com/words/archive=200906.

——David Velasco, "Scene & Herd: It's Reigning Men," *artforum.com*, June 5, 2009. Online at http://artforum.com/diary/id=23056.

——Carol Vogel, "A more Serene Biennale," in: *The New York Times*, June 8, 2009.

——Ossian Ward, "Broken Homes," in: *The World Of Interiors*, November 2009.

——Fan Zhong, "Two for One," in: *Interview*, June/July 2009, p. 41.

——"Eyewitnessed Pictures of the Week," in: *The Guardian*, June 6, 2009, pp. 22–23.

——"Picture story of the week. Er, is this a watercolour?" in: *The Sunday Times*, June 7, 2009, pp. 10–11.

The Welfare Show

___Ariane Beyn (ed.), *Elmgreen & Dragset: The Welfare Show*, exhib. cat., Bergen Kunsthall; BAWAG Foundation, Vienna, 2005; Serpentine Gallery, London; Power Plant, Toronto, 2006; Buchhandlung Walther König, Cologne, 2005.

___Rachel Campbell-Johnston, "We were only being boring," in: *The Times*, January 24, 2006, pp. 17–18.

___Alex Coles, "Exhibitions: Michael Elmgreen and Ingar Dragset," in: *Art Monthly*, 294, March 2006.

___Andrea Demchuk, "The Welfare Fate," *therubicon.org*, May 31, 2006. Online at http://therubicon.org/2006/05/the-welfare-fate/.

___Anne Katrin Feßler, "Knietief im Wohlstandsmüll," in: *Der Standard*, September 20, 2005.

___Harald Flor, "Sorgshow," in: *Dagbladet*, May 25, 2005, p. 37.

___Helena Grdadolnik, "Welfare State," in: *Canadian Architect*, April 2006.

___Shannon Jackson, *Social Works – Performing Art, Supporting Publics*, Routledge, Abingdon, Oxon, 2011, pp. 182–209.

___Betty Ann Jordan, "Rooms with a View," in: *Toronto Life*, April 2006.

___Sarah Kent, "Welfare State of Mind," in: *Time Out London*, February 15–22, 2006.

___Marta Kuzma, Peter Osborne (eds.), *Elmgreen & Dragset: Verksted No.7 – Art of Welfare*, symp. cat., Office for Contemporary Art Norway, Oslo, 2006.

___Erin Manns, "Artworker of the Week #55 – Elmgreen & Dragset," in: *Kultureflash*, November 9, 2005.

___John McGee, "Elmgreen & Dragset: Suspended Space," *Metropolis: Japan's No. 1 English Magazine*, 456, October 2003. Online at http://archive.metropolis.co.jp/tokyo/456/art.asp.

___Sarah Milroy, "Ambush," in: *Globe and Mail*, April 15, 2006.

___Melanie Puff, "Michael Elmgreen & Ingar Dragset 'The Welfare Show' Serpentine Gallery," in: *Kunstforum International*, 180, 2006, pp. 389–392.

___Lotte Sandberg, "Albinofisk i velferdssamfunnet," in: *Aftenposten*, May 26, 2005, p. 7.

___Daniel Sander, "Traum von Raum," in: *KulturSpiegel*, September 2006, pp. 12–16.

___Nadja Sayej, "Michael Elmgreen and Ingar Dragset. The Welfare Show," in: *Parachute*, 123, July/August/September 2006.

___Adrian Searle, "The Lost World," in: *The Guardian*, January 31, 2006, pp. 18–20.

___Brian Sholis, "Scene & Herd: Noblesse Oblige," *artforum.com*, May 29, 2005. Online at http://artforum.com/diary/id=9054.

___Supitcha Tovivich, "Power Structures," in: *art4d*, April 2006, pp. 64–68.

Acknowledgments

O ur first and foremost thanks must go to the two artists Michael Elmgreen and Ingar Dragset who, with their grandiose works and installations of recent years, have enriched the art world with highly innovative and extraordinary approaches. They dedicated themselves to the realization of the exhibition in Karlsruhe with incredible commitment and, along with the team at the Berlin studio, lent their outstanding support to this mammoth project; in this connection Jan Sauerwald and Nils Grarup are given our sincere thanks for their professional supervision. Many thanks go to OCA Office for Contemporary Art Norway and The Danish Arts Council for financially supporting the exhibition. We would also like to express our gratitude to the lenders of those works of art included in the exhibition. For supporting us with an entirely fitting accompanying program we thank ZAK | Centre for Cultural and General Studies, Karlsruhe, especially Caroline Robertson-von-Trotha.

Our heartfelt gratitude extends to Christofer Gutmann General Manager of Pollux, who, together with the two companies Käshammer and Arnholdt and with the support of the ZKM technical team, achieved that incredible master stroke of realizing the social housing at the ZKM | Museum of Contemporary Art within economically reasonable limits.

We would also like to express our gratitude to the ZKM technical team who, together with freelancers and with the assistance of Concern Art, achieved enormous feats; we feel ourselves particularly beholden to Martin Haeberle for his overall technical management, as well as to Sebastian Hungerer for managing the technical project. Our appreciation goes to Rainer Gabler, Christof Hierholzer, Ronny Haas, Dirk Heesacker, Werner Hutzenlaub and Gisbert Laaber; and, no less the freelancers Tom di Stefano, who carried out the work on the ballroom, together with Manfred Schmieder and Joachim Hirling, as well as Manfred Stürmlinger, Volker Becker, Claudius Böhm, Moritz Büchner, Erdoan Coban, Raphael Dobler, Daniel Heiss, Mike Marsh, Marco Preitschopf and Boris Dworschak for the graphic support.

Many thanks also go to the teams at the ZKM | Museum of Contemporary Art, in particular Isabel Meixner, Marianne Meister, Ingrid Walther and Martin Hartung, and at the Berlin studio of Elmgreen & Dragset, namely to Anja Schiller, Sandra Stemmer, Katrin Dölle, Anita Iannacchione, and Fina Esslinger.

Our praises go to artist and graphic designer Andreas Koch for his perceptive and no less convincing design of the present publication. We are much indebted to the ZKM editors of the present volume, Ulrike Havemann who, together with Idis Hartmann, accompanied the publication process from start to finish with great dedication. We thank the translators for their subtle translations into the English language and Justin Morris for his sound sense of language in the proof-reading phase of the English texts. Last but not least, especial thanks extend to all the authors for their knowledgeable and enlightening as well as pioneering written contributions.

Peter Weibel (Chairman and CEO of the ZKM | Karlsruhe)
Andreas F. Beitin (Curator/Head of ZKM | Museum of Contemporary Art)

Exhibition

Elmgreen & Dragset
Celebrity – The One & The Many
Exhibition at the ZKM | Museum of Contemporary Art
ZKM | Center for Art and Media Karlsruhe, Germany
07.11.2010–27.03.2011
www.zkm.de

Curator/Head of ZKM|Museum of Contemporary Art Andreas F. Beitin
Chairman and CEO ZKM Peter Weibel
General Management ZKM Christiane Riedel
Head of Administration Boris Kirchner
Project Management Isabel Meixner (ZKM),
Jan Sauerwald (Studio Elmgreen & Dragset)
Registrar Marianne Meister
Technical Management Martin Haeberle
Construction Management Sebastian Hungerer
Contractors Pollux: Christofer Gutmann, Axel Käshammer
Concern Art: Martin Boukhalfa, Lutz Fezer, Heiko Hoos

Studio Elmgreen & Dragset Jan Sauerwald, Anja Schiller, Nils Grarup,
Sandra Stemmer, Katrin Dölle, Anita Iannacchione, Fina Esslinger
Special thanks to Walter Grüninger, Philip Friedrich, Dieter Münch,
Heinrich Funk, Lisa Bergmann, Angelika Cohen, Ralf Cohen,
Felix Grünschloß, Tom Hahn, Robert Hamacher, Dirk Heesakker,
Heidi Herzig, Christof Hierholzer, Miho Kssama, Katrin Lautenbach,
Hans-Dieter Schmidt, Alina Schmuch, Bernhard Schmitt, Vincent
Jos Schneider, Daniel Torz, Franz Wamhof, Tobias Wootton, Annika
Martens, Eva Derleder, Samuel Zonon, Froehlich Collection, Heinz Peter
Hager, Pierre Fakhoury, Galerie Emmanuel Perrotin/Paris, Victoria Miro
Gallery/London, Galleri Nicolai Wallner/Copenhagen, Galleria Massimo
De Carlo/Milan, Galería Helga de Alvear/Madrid, Taka Ishii Gallery/Tokyo.

Elmgreen & Dragset
The Collectors was initiated and organized by: The Danish Arts Council
and Office for Contemporary Art Norway, and funded by The Nordic
Culture Fund, The Arts Council Norway, FRAME Finnish Fund for Art
Exchange and Moderna Museet, Sweden.

Elmgreen & Dragset
The Welfare Show was initiated by Bergen Kunsthall, Norway and pro-
duced in collaboration between Bergen Kunsthall; Bawag Foundation,
Vienna; Serpentine Gallery, London and The Power Plant, Toronto.

Founders of ZKM

Partner of ZKM

Partners of the Exhibitions

Publication

Editors Peter Weibel and Andreas F. Beitin
Concept Elmgreen & Dragset

ZKM | Publication Program Museum of Contemporary Art
Ulrike Havemann, editor
Idis Hartmann, assistant

Editorial Team Ulrike Havemann, Idis Hartmann, Anja Schiller, Anita Iannacchione
Proof-reading and Copy editing Justin Morris
Translations by Lisa Damon, Charlotte Eckler, Justin Morris, Dan Marmorstein, Jonathan Uhlaner, Nicholas Grindell, Michael Turnbull
Design Büro für Film und Gestaltung: Andreas Koch, Berlin, Germany
Typeface Dante MT and Univers BQ
Lithography Büro für Film und Gestaltung, Berlin
Printed and bound: DZA Druckerei zu Altenburg
Paper Hellofat matt 130 gr/qm
Special thanks to Linda-Marie Müller, Ferial Nadja Karrasch, Martin Hartung, Jillian May, Udo Meinel, Eric Brogmus, Elmar Vestner, Sandra Stemmer, Katrin Dölle, Jan Sauerwald

First published in the United Kingdom in 2011
by Thames & Hudson Ltd, 181A High Holborn,
London WC1V 7QX

British Library Cataloguing-in-Publication Data
A catalog record for this book is available from the British Library

ISBN 978-0-500-09364-1

Printed and bound in Germany

To find out about all our publications,
please visit **www.thamesandhudson.com**.
There you can subscribe to our e-newsletter, browse or download our current catalog, and buy any titles that are in print.

Photo Credits pp. 16–17, 22, 26–27, 29–31, 47.3, 48.3–6, 49.1–6, 56, 64, 114–115, 169, 183–186, 188–193: ONUK; pp. 15, 18–21, 23, 25, 34–35, 38–44, 47.1, 47.4, 48.1–2, 91: Udo Meinel; pp. 24, 61, 66, 86, 172, 177, 180, 198–199, 303, 327.3, 359, 367: Elmgreen & Dragset; pp. 28, 32, 47.2, 93: Fidelis Fuchs; p. 37, 355: Armin Linke; p. 54: Jan Engsmar/Petra Bauer; p. 57: Fourth Plinth Commission; p. 58: Idis Hartmann; p. 63: Lizette Kabré; p. 69: News of the World, Screen shot www.newsoftheworld.co.uk; p. 75: Paul Nadar/Pix Inc./Time Life Pictures/Getty Images; p. 78: Marcello Geppetti Media Company; p. 83: © Istituto museale della Soprintendenza Speciale per il Polo Museale Fiorentino; p. 89: © NBC Universal; p. 92: Kjersti Berg; p. 94: Collection of the Bank of Spain; p. 96: © 1961 Walter De Maria; p. 97: © Tate © Carl Andre/VAGA, New York; DACS, London 2006; p. 98: Pez Hejduk; p. 99: Studio Blu; p. 100, 346.2: Roman Mensing; pp. 104–105: © Nordisk Tonefilm/Folkets Hus och Parker; pp. 106–109, 288–289, 292–293, 361–363: Elmar Vestner; p. 123: Frederik Busch; pp. 126, 133: Cameron McNee; p. 129: Stephen Brayne; p. 137: © all rights reserved International Classic Films LLC; p. 144: Tim Boyle/Getty Images; p. 148: © 2005 CERN; p. 151: Danny Bright; p. 152: Sacha Goldman; p. 154: Erik Frohne; p. 160: Schauspielhaus Hamburg; p. 166: Terry Fincher/Princess Diana Archive/Getty Images; pp. 194–195, 241: Sandra Stemmer; pp. 196–197, 346.1: Thierry Bal; pp. 200–201: Tot en met ontwerpen; Cover and pp. 207–225, 227–233, 235–239, 242–246, 249–251.4, 251.6–254.1, 254.3–254.6, 263, 350: Anders Sune Berg; p. 251.5: Laura Horelli; p. 254.2: Wolfgang Tillmans; p. 259: Chu Yun; p. 260: © 2011 Stahl House ® Inc., Mark Stahl Photographer, www.stahlhouse.com; pp. 264–265: © 2011 Google; pp. 268, 270, 274: Kirsten Lilli; p. 277: Victoria Miro Gallery, London; pp. 279, 283: Oren Slor; pp. 285, 360: Andreas Koch; pp. 286–287: Montage Andreas Koch; pp. 290–291: Screen shots www.nytimes.com/2009/07/04/arts/design/04salami.html; pp. 294–295: Guillaume Zicarelli; pp. 301, 304–305, 313–317, 327.1, 328.3, 329.6, 340.3, 341.3: Thor Brødreskift; pp. 302, 306–311, 322–324, 327.4, 328.2, 328.4, 329.1–4, 341.1–2: Stephen White; pp. 318–321, 327.2, 328.1, 328.5, 329.5, 340.1–2, 368–369: Rafael Goldchain, The Power Plant, Toronto; pp. 328.6, 364–366: Wolfgang Wössner; p. 332: Matts Leiderstam; pp. 334.1, 335.2: Bent Ryberg; p. 334.2: Borkur Arnarson; p. 335.1: Wolfgang Günzel & Wonge Bergmann; p. 339: Prospekt Hårsalongen.